Surface and Depth

Surface and Depth
Dialectics of Criticism and Culture

Richard Shusterman

CORNELL UNIVERSITY PRESS

ITHACA AND LONDON

First published 2002 by Cornell University Press
First printing, Cornell Paperbacks, 2002

Printed in the United States of America

Library of Congress Cataloging-in-Publication Data

Shusterman, Richard.
 Surface and depth : dialectics of criticism and culture/Richard
Shusterman.
 p. cm.
Includes bibliographical references and index.
 ISBN 0-8014-3828-4 (alk. paper)—ISBN 0-8014-8683-1 (pbk. : alk.
paper)
 1. Aesthetics, Modern—20th century. 2. Aesthetics—Social aspects.
3. Analysis (Philosophy) I. Title.
 BH201 .S485 2002
 111'.85—dc21
 2002000167

Cornell University Press strives to use environmentally responsible suppliers and mate-rials to the fullest extent possible in the publishing of its books. Such materials include vegetable-based, low-VOC inks and acid-free papers that are recycled, totally chlorine-free, or partly composed of nonwood fibers. For further information, visit our website at www.cornellpress.cornell.edu.

Cloth printing 10 9 8 7 6 5 4 3 2 1
Paperback printing 10 9 8 7 6 5 4 3 2 1

For Talia

We live amid surfaces, and the true art of life is to skate
well on them.

RALPH WALDO EMERSON

Deep calleth unto deep.

PSALM 42

Contents

Preface

For as long as I can remember, I have happily surrendered myself to the seductions of art's sensuous surface, only to find myself wanting more— some deeper sense of its underlying nature, function, and cultural role that could explain, even justify, my passion for its beauties and meanings; some deeper account of interpretation and criticism that could illuminate the logic through which those experienced beauties and meanings could be discerned and communicated. This double desire for sensuous surface and explanatory depth has shaped my philosophical life and directed much of my research to the field of aesthetics. But it often seemed that this duality of desire pulled me in different directions. How could I properly appreciate art's surface meanings and qualities without understanding the cultural contexts and underlying practices that structure their creation and perception? Yet probing more deeply into the underlying logics of art, culture, and criticism threatened to take me away from those captivating surface qualities and meanings that first prompt our efforts of understanding. Though a full appreciation of aesthetic experience should bring us to consider the deeper sociocultural conditions that shape such experience, our cognitive zeal to explore these conditions tends to displace our initial interest in aesthetic experience and its qualities of appearance. To T. S. Eliot's lament that "we had the experience but missed the meaning," I could add the worry that a one-sided search for deeper meanings and framing conditions risks losing touch with the vivid immediacy of aesthetic experience and direct appreciation of art's surface qualities.

In more than twenty years of studying aesthetics, I have often sensed this tension between surface and depth analysis, between experiential immediacy and its underlying cultural frame. But rather than face it squarely, I simply worked around it as I pursued the particular aesthetic issues that claimed my attention. This book is finally an attempt to confront this tension, or dialectic, of surface and depth in a more systematic and sustained manner by showing how it emerges with respect to a variety of key aesthetic problems and important theorists from a wide range of traditions. The problems covered by this book are certainly diverse: the

logic of interpretation and evaluation; the nature of taste; the scope and methods of aesthetic inquiry; the definition of art; the nature and function of conventions; the relationship of art to nature, history, and society; the methods and functions of literary reading and criticism; the role of aesthetic experience; and the nature of aesthetic unity and purity. In treating these issues, I examine a rather heterogeneous collection of theorists: from Plato and Aristotle, through Hume, Kant, Hegel, and Croce, to crucial twentieth-century thinkers like T. S. Eliot, T. W. Adorno, Alain Locke, John Dewey, Jacques Derrida, and Pierre Bourdieu. Paying particular attention to analytic philosophy's contribution to aesthetics and philosophy of culture, I consider the work of G. E. Moore, J. L. Austin, Morris Weitz, Monroe Beardsley, J. O. Urmson, Nelson Goodman, Hilary Putnam, Stanley Cavell, George Dickie, and David Lewis. But I devote especially detailed studies to Ludwig Wittgenstein, Arthur Danto, Richard Rorty, and Joseph Margolis.

What unifies my discussion of these diverse themes and theorists is their contribution to the complex dialectic of surface and depth, whose richness and ramifications this book aims to explore and emphasize. The chapters that constitute the book draw on earlier arguments I first formulated in articles that span the length of my philosophical career, one dating back to my days as a graduate student at Oxford. All of these earlier texts have been revised (and most of them radically rewritten) so as to contribute more effectively to the book's central argument and together constitute a more integrated whole. Earlier versions of these chapters have profited from the helpful criticism of many more people than I can now name or even remember. But I want to acknowledge some individuals and institutions that especially deserve my gratitude.

Temple University has provided me with various research opportunities, and these were supplemented by senior fellowships from the National Endowment for the Humanities and the Fulbright Commission. I am grateful to my research assistants from the New School, Michael Scoville and Josh Michael Hayes, for help with preparing the manuscript. Through both critical discussion and their excellent work of translation, Jean-Pierre Cometti, Rainer Rochlitz, and Heidi Salaverria enabled me to see and correct some troubling ambiguities in my original formulations. I also thank Pierre Bourdieu, Noël Carroll, Curtis Carter, Arthur Danto, T. J. Diffey, Richard Eldridge, Rita Felski, Winfried Fluck, Astrid Franke, Hans Ulrich Gumbrecht, Peter Hacker, Leonard Harris, Michael Krausz, Hans-Peter Krüger, Joseph Margolis, Paul Mattick, Graham McFee, Brian McHale, Christoph Menke, James Miller, Daniel O'Hara, Richard Rorty, Martin Seel, Anita Silvers, Meir Sternberg, J. O. Urmson, Julie Van Camp, Emil Visnovsky, Tetsuji Yamamoto, and Eddy Zemach for comments on one or more of the chapters. Special thanks go to Garry Hagberg, who

read preliminary versions of all the essays for Cornell University Press and provided some very insightful suggestions. Any author should be extremely grateful to have an editor as perceptive, supportive, and reliable as Roger Haydon of Cornell University Press. I thank him for the many ways he improved this book. I am also thankful for Bruce Acker's deft copyediting.

Most of the texts that constitute the book were first delivered as lectures in a variety of academic venues, but the final chapter had a more unusual debut. It was delivered, in German, at the Frankfurt Opera to open a magnificent conference on Ästhetik der Inszenierung and was followed by a performance of *Don Giovanni*. I am very grateful to the conference organizers, Professors Josef Früchtl and Jörg Zimmerman and Dr. Martin Steinhoff (the director of the Frankfurt Opera), for their generous invitation, and to Dr. Steinhoff's charming assistants Kirsten Thomas and Beate Maurer for graciously helping me with some last-minute questions of pronunciation and for giving that opening night so much style and glamour that it will always shine in my memory as a vivid aesthetic experience in the fullest and deepest sense. My deepest debt of thanks and good fortune is to the enduring friendship of Erica Ando, who continuously inspires me with the thrill and dazzle of opening night, even when we share a quiet evening at home, with our baby Talia taking center stage.

I thank the editors and publishers who printed earlier versions of these chapters for their permission to revise and republish this material. More than one of the chapters originated in the *Journal of Aesthetics and Art Criticism*, and I wish to give its editor, Philip Alperson, a special acknowledgment for his helpful advice. The original published sources are as follows: "Analyzing Analytic Aesthetics," in Richard Shusterman (ed.), *Analytic Aesthetics* (Oxford: Blackwell, 1989); "The Logic of Interpretation," *Philosophical Quarterly* 28 (1978): 310–24; "Croce on Interpretation: Deconstruction and Pragmatism," *New Literary History* 20 (1988): 199–216; "Wittgenstein and Critical Reasoning," *Philosophy and Phenomenological Research* 47 (1986): 91–110; "Of the Scandal of Taste: Social Privilege as Nature in the Aesthetic Theories of Hume and Kant," *Philosophical Forum* 29 (1989): 211–29; "Convention: Variations on a Theme," *Philosophical Investigations* 9 (1986): 36–55; "Pragmatist Aesthetics: Roots and Radicalism," in Leonard Harris (ed.), *The Critical Pragmatism of Alain Locke* (New York: Rowman and Littlefield, 1999), 97–110; "Eliot and Adorno on the Critique of Culture," *Theory, Culture, and Society* 19 (1993): 25–52; "Aesthetic Blindness to Textual Visuality," *Journal of Aesthetics and Art Criticism* 41 (1982): 87–96; "Art in a Box," in Mark Rollins (ed.), *Danto and His Critics* (Oxford: Blackwell, 1993), 161–74; "Pragmatism and Culture," in Michael Krausz and Richard Shusterman (eds.), *Interpretation, Relativism, and the Metaphysics of Culture* (New York: Humanity Books, 1999), 186–201 (in rewriting chapter

11, I also used arguments elaborated in an interview conducted by Günter Leypoldt and published as "The Pragmatist Aesthetics of Richard Shusterman: A Conversation," *Zeitschrift für Anglistik und Amerikanistik: A Quarterly of Language, Literature, and Culture* 48 [2000], 57–71); "Bourdieu and Anglo-American Philosophy," in Richard Shusterman (ed.), *Bourdieu: A Critical Reader* (Oxford: Blackwell, 1999), 14–28; "Art as Dramatization," *Journal of Aesthetics and Art Criticism* 59 (2001), 363–72.

I gratefully acknowledge permission to reprint the poem "l(a". Copyright © 1958, 1986, 1991 by the Trustees for the E. E. Cummings Trust, from *Complete Poems: 1904–1962* by E. E. Cummings, edited by George J. Firmage. Used by permission of Liveright Publishing Corporation.

RICHARD SHUSTERMAN

December 2001

Surface and Depth

Introduction

Aesthetics is pervaded by a powerful yet paradoxical doubleness: it stresses both surface and depth, impassioned immediacy of experience yet also cool critical distance of judgment. Etymologically tied to sense perception and traditionally preoccupied with notions of external beauty, aesthetics has often been defined by its distinctive focus on surface appearances, especially those paper-thin textures of images and words that form the fictions of painting, literature, and cinema. "Beauty is only skin deep" goes the ambiguous adage, whose disputable message is nonetheless useful in reminding us that one of the distinguishing virtues of aesthetics is its defense of the deep value of surfaces. Although other branches of philosophy and science strive to break quickly through to bottom-line realities, aesthetics affirms, as it cultivates, the rich and productive power of sensory appearance. As aesthetic experience revels in the sumptuous show of artworks, so aesthetic criticism lovingly dwells on teasing out their surface qualities, the way these elements fit together as a seamless, seductive skin. Not surprisingly, aesthetics is traditionally described in German thought as the realm of superficial *Schein* (appearance, illusion), in contrast to the deeper realm of *Sein* (being) that marks the true quest of philosophy.

But aesthetics also penetrates beneath the crust of appearance. We may enjoy a primitive aesthetic experience without probing beyond our immediate impressions, but art can be more fully appreciated through interpretation, and this activity is generally conceived as going beneath the surface to uncover the deeply buried meaning of the work. This may be too narrow a view of interpretation, by ignoring formalist interpretive strategies that eschew depth metaphors of uncovering hidden meaning but rather confine their aesthetic interpretation to a coherent account of the work's surface features and their interrelations. But surely much interpretation does indeed plunge well beneath the aesthetic surface. Often digging deeper than the artist's innermost conscious intentions, interpretation even extends beneath the work's specific features and structure in

order to fathom more general meanings. It may explore, for instance, those meanings that relate to the underlying cultural traditions, social structures, and economic forces whose constellation and transformations provide the framework that enables the work to be created and understood as having the kind of artistic identity and features we ascribe to it. Nineteenth-century novels, for example, are interpreted not only in terms of their more particular themes but as expressing (though the very form and flourishing of this genre) the basic social forces connected with the rising dominance of the middle-class and liberal individualism. Works of twentieth-century conceptual art are similarly construed not just as comments on the specific concepts they individually showcase, but as more extensive, more penetrating commentary on the artworld as a whole and even on the still wider cultural world in which any artwork today must find its place and meaning. And beneath all these different levels of interpreting art, aesthetics further probes into the most basic principles of meaning, relevance, and purpose that govern our interpretive practices in general.

The equally crucial topic of evaluation displays the same range of levels. The sensory surface of an artwork can evoke spontaneous aesthetic reactions of delight or distaste that neither aim to clarify or to justify themselves. However, aesthetic criticism goes deeper in order to test, explain, and validate our verdicts by more carefully probing a work's precise properties and structure and by showing how they contribute to its value. Deploying different forms of reasoning, these critical justifications sometimes invoke general aesthetic principles of value, such as unity, intensity, and complex fullness. And so aesthetics is drawn yet deeper—to probe those principles and logics used to justify its verdicts by taking a cooler, critically distanced view on its own practices. Some thinkers push aesthetic inquiry even further to articulate the underlying cultural practices and social structures—including the basic rules of reason and human interests—that shape not only our principles of evaluative reasoning but also, it is claimed, our most intuitive experiences of beauty. For even the most immediate experiences of aesthetic surface seem conditioned by habits and categories of perception and by dispositions of feeling that involve cultural mediation and social training. We misunderstand aesthetic immediacy when we see it as entirely unmediated.

Aesthetics surely gains in knowledge the more it digs beneath the sensory surface, yet this metaphoric trajectory of ever increasing depth presents a paradoxical image. On our round earth, the deepest soundings should eventually bring us through to the surface again. This image evokes the book's central argument, which has a double movement. Aesthetic criticism is ultimately forced to go beyond perceptual appearance and even beyond its own critical logic and artistic principles in order to

better ground and understand itself in terms of the wider cultural context that provides the empowering background for the practices of art, without which artworks could not have the meaning and values they have. Aesthetic experience and art criticism cannot adequately explain or ultimately justify themselves without probing into the deeper, less-visible cultural structures that may not be part of the content of art's experience but which nonetheless significantly frame and shape it. This step of the argument, the drive toward depth analysis and emphasis on the nonperceptual in art, is far more prominent today, while the concepts of aesthetic experience, surface, and spontaneous pleasure have (to use Walter Benjamin's phrase) "fallen in value."

However, my argument continues, the aesthetic drive toward depth attains its fulfillment only by breaking back through to the surface. In other words, just as aesthetic experience can be fully appreciated only by going beyond it, so the deeper logics of culture cannot fully understand or justify themselves without recognizing the power of aesthetic experience as something that sustains and helps justify these deeper cultural structures that, in turn, ground aesthetic experience. Even if our aesthetic experience rests on deeper social reality, it cannot be simply reduced to a sociological construction. If its perceptual surfaces and pleasures depend on a nonperceptual background of history and theory, they in turn provide the excitement that enables art to sustain a history and generate theory.

In short, surface and depth are essentially connected complementarities. Reciprocal in function, they form the fullness of the aesthetic whole. There is some depth to any surface, and what lies beneath the surface— the undersurface—both has a surface and *is* itself a surface of some kind. This book thus argues for greater recognition of the rich dialectical connections between surface analysis and depth analysis in aesthetics, between the appreciation of aesthetic content as spontaneously experienced and the surrounding, mediating cultural structures that frame and enable such experience. The argument is developed not in the realm of frictionless abstraction but through a close examination of various case studies in the interconnecting logics of criticism and culture that the different chapters of the book present. These essays offer not only evidence for my thesis but aim to provide the reader with handy critical portraits of some of the most influential figures and schools of aesthetic analysis of the past few centuries, many of which still dominate contemporary discussion of the arts and culture.

The three parts of the book embody the following narrative logic. I begin by showing how the aesthetics of analytic philosophy turned from preoccupation with perceptual surface and with simple models of critical reasoning in order to insist on art's deeper historical and institutional dimensions. This recognition that the historically changing frame of culture

structures our experience is likewise shown to motivate the guiding aesthetic principles of deconstruction and pragmatism. The thrust of the argument here is that analysis of aesthetic judgment and critical reasoning leads to an impasse which requires that we go beyond the logic of criticism to a more encompassing analysis of the logic of our cultural practices.

The second section of the book therefore turns its focus to the concept of culture. Beginning with the seminal theories of Hume and Kant that helped define modern aesthetics and sought to ground the aesthetic in nature, the essays in this section go on to explore more closely the nature/culture distinction—including a close analysis of the concept of convention, which has played a crucial role in challenging long-reigning theories of naturalism not only in aesthetics but in philosophy of language and gender. The remaining essays in this section explore important issues of social philosophy (of tradition and change, individualism and communal norms, freedom and authority, class, purism, and cultural mixing) that underpin the logic of culture. But they also probe the deeper metaphilosophical question of what kind of philosophy, if any, does culture really demand. By focusing on theorists who also exercised a strong practical influence in the shaping of twentieth-century art (from the modernist poetics of T. S. Eliot and the avant-garde aesthetics of Theodor Adorno to Alain Locke's manifesto for the Harlem Renaissance), these essays study the strategies of cultural politics and assess their powerful impact on the criteria of criticism and the logic of aesthetic argument.

The final section of the book critically examines four contemporary theorists who have helped push aesthetic inquiry beneath the perceptual surface and into the fertile background of culture, history, and social institutions from which art generates its dazzling display of forms and meanings. Noting the advantages of this turn to the underlying cultural context, the essays in this section also show how this tunneling drive toward increasing cognitive depth courts the devastating danger of losing sight of aesthetic experience and its more perceptual and immediate values. Such oversight, I argue, sometimes mars the deep-reaching theories of Bourdieu, Danto, Margolis, and Rorty; so I conclude that aesthetic theory is best when its vision embraces both surface figure and cultural ground, even if it seems hard to maintain and express these perspectives simultaneously. The book ends by proposing a theory of art that tries to combine both perspectives through the concept of dramatization, a concept that includes both the foregrounding of immediate experience and the underlying cultural frame through which such foregrounding is enabled.

Attractive as I hope this line of argument will be to the reader, its true power lies not in the sleek schematic form in which I introduce it here. Its

strength instead rests on the detailed discussions and complex interlinking of themes that emerge from the wide-ranging case studies the book presents in its thirteen essays. These studies have their own special interest quite apart from the book's general argument. Irreducible to mere steps in that argument, they also resist clear summary in terms of it. Let me, however, highlight some of the interlocking themes in the book's successive chapters.

II

The first chapter begins with a critical sketch of analytic aesthetics, still the dominant philosophical tradition in Anglo-American aesthetics and one that deeply informs my own philosophical style. In outlining the prime aims, themes, and methods of analytic aesthetics, I show how its recent history reveals a persistent drive from surface toward depth, a direction almost implied in the meaning of analysis as breaking something down to its most elementary parts. If analysis began by defining the aesthetic in terms of immediate perceptual appearance or "the look of things," it gradually moved its focus to the perceptually invisible background factors that make a situation aesthetic and constitute an object as a work of art—the institutional framework of art and the contexts of art history. Analytic aesthetics was likewise governed by a strong self-image as metacriticism. This meant not simply looking beneath the aesthetic surface to discover art's deeper meanings, but further probing beneath the interpretations and judgments of art criticism in order to explain or justify the underlying logic that governs them. With the aim of uncovering the essential logic of interpretation, analytic aesthetics could harbor the hope of putting art criticism, at least of the nonevaluative sort, on a firmly cognitive and objective basis.

The next two chapters thus turn to a deeper exploration of the logic of interpretation. I begin by considering analytic philosophy's classic theories of this logic and show how they fail due to insufficient attention to the logical plurality of interpretive practices whose relative validity depends in large part on the deeper aims those practices seek to achieve. This question of aims drives aesthetic analysis further into the cultural background that generates and supports them and thus structures our practices of criticism.

Chapter 3 continues the study of interpretive logic by introducing the two schools that most seriously challenge the hegemony of analytic aesthetics: deconstruction and pragmatism. I show how deconstruction revives the central doctrines that helped make Benedetto Croce's aesthetic theory so dominant in the early part of the twentieth century and thus one of the prime targets against which analytic aesthetics directed its early attacks. Affirming the essentially linguistic nature of art as expression,

Croce and deconstruction likewise advocate a historicist insistence on the irresistibly changing, dynamically generative, and contextually conditioned nature of linguistic meaning. But if the meaning of an artwork is determined by every changing context rather than guaranteed by some permanent semantic essence that both provides the goal and warrant for analysis of meaning, how can we ever reach a firmly valid interpretation of work? I respond to this question by elaborating a Wittgensteinian pragmatism that can absorb the Crocean–deconstructive sensitivity to flux and context without abandoning the notions of interpretive validity and objective meaning. It does so by reinterpreting these notions pragmatically and contextually in terms of deeply entrenched cultural traditions of interpretation and consensual communities of meaning and practice.

Chapter 4 develops the themes of validity, pluralism, and historicism by focusing more fully on Wittgenstein's influential aesthetic theory and extending our account of critical reasoning to issues of evaluation. Articulating the different ways he prompted analytic aesthetics to probe deeper into the underlying culture that informs aesthetic perception and judgment, I show how Wittgenstein fruitfully unites the strengths of analytic and pragmatist philosophies—a sensitivity to the logic of concepts and language, together with a pragmatic appreciation of the practical functions and cultural practices in which aesthetic language, like all language, is embedded. But I also argue that we need to go further than Wittgenstein in recognizing the complex plurality of critical logics by appreciating more fully the political forces and social stakes involved in the culture that underpins aesthetic criticism.

The essays of part 2 thus plunge deeper into the social and cultural foundations of aesthetics. I begin by showing how crucial social conditions that relate to cultural privilege are systematically veiled by the aesthetic naturalism of Hume and Kant, who construed our judgments of art and beauty as verdicts of taste. Although their enlightenment theories dominated early modern aesthetics by grounding aesthetic judgment in the basic sensory and cognitive faculties of human nature, a closer examination of their arguments reveals the necessary and determining role of social factors, without which the faculty of aesthetic taste cannot be exercised. Taste cannot be simply a natural faculty; it is also a product of cultural conditioning, determined in significant part by entrenched social norms and conventions of practice.

Convention, indeed, is often thought to constitute the deepest ground of language itself; so if the languages of art and criticism are based on conventions, then aesthetics should surely consider the question of what a convention is and how the conventional relates to the natural. Chapter 6 takes up these issues by examining the major efforts of analytic philosophy to explain the concept of convention, ranging from Russell and Quine

through Wittgenstein and Austin, and finally to still more contemporary thinkers like Hilary Putnam and David Lewis (author of the most rigorous and systematic study of convention to date). In exploring the difficulties of these theories, we discover not only the irreducible variety of convention but also the shifting, flexible, and contextually dependent character of the natural/conventional distinction. If this implies that there is no fixed line or clear gap between nature and culture, it does not entail the conclusion that there is never any point or validity in distinguishing between the two. Nor does it imply that everything is only cultural (since socially constructed), so that naturalism (in aesthetics or elsewhere) must be an incoherent notion.

The next chapter further explores the productive dialectics of nature and culture that I find essential to pragmatist aesthetics. Contemporary theory is polarized between philosophies that stress art's natural roots and those that instead define it in terms of historically constructed social conventions. But pragmatism insists that art is both a natural and cultural fact; that culture and art both emerge from nature and reshape it; and that nature and culture are deeply interdependent notions. Having made this argument in previous books, I here explore the synthesis of naturalism and cultural constructivism in the work of a much-neglected pioneer of pragmatist aesthetics, the African American philosopher Alain Locke.

Although he anticipated most of the naturalistic themes in Dewey's pragmatist aesthetics (themes that emerged still earlier in Emerson), Locke is also careful to stress the sociocultural factors essential to art's creation and reception. Advocating the superior creative energies of the Harlem Renaissance, Locke explains this expressive power as the product both of African Americans' closer bonds to nature and of their new exposure to the latest cultural developments through their increasing concentration in cosmopolitan centers like New York City. And though he appeals to naturalist-sounding notions like "blood descendants" to explain the special link of African Americans to African culture, Locke was a pioneer in challenging the biological definition of race that was so dominant in his time, by looking beneath surface physical features and skin color in order to offer instead a complex analysis of race as a deeper social construction. Moreover, by devoting much of his writing to the detailed criticism of particular works of literature, painting, and music, Locke was exemplary for not losing sight of the aesthetic surface, even when he plunged most deeply into its cultural underpinnings.

In chapter 8, I turn to two imposing figures of high modernism, T. S. Eliot and Theodor Adorno, who likewise combined the careful study of art's surface forms with a sustained critical probing of the social structures and ideologies that determine those forms and their meaning. I show how the delicate balance of this fruitful double focus can be seen in their re-

spective theories of aesthetic understanding, which are remarkably similar in structure. Both advocate a thorough experiential immersion in the artwork's surface qualities. But they then insist on a second level of cultural critique in order to achieve a deeper understanding of those immediately experienced effects by revealing the underlying ideological assumptions that enable those effects and the artistic forms that create them. Aesthetic analysis of form and experience can therefore emerge into a social and philosophical critique of ideology that still holds experienced formal surfaces somehow in focus. Although their respective political profiles as Anglican conservative and Marxian progressive suggest that Eliot and Adorno should have very different views of culture, I show that their cultural theories share a common core of principles and a common enemy—the ideology of bourgeois liberalism.

The final chapter in part 2 gives the book's dialectic of surface and depth a further turn. Having argued that our experience of the aesthetic surface calls for deeper inquiries into the cultural foundations that inform that experience, but that those cultural inquiries must not thereby lose sight of the lived experience and aesthetic surface (which conversely give those inquiries their prime motivation and justification), I show in chapter 9 how deeply entrenched cultural presumptions can actually blind us to dimensions of aesthetic surface that can be quite powerful. Philosophy's critical exposure of these deep prejudices can therefore redeem new dimensions of aesthetic surface that those prejudices have obscured. My case study for this argument is the tradition of aesthetic blindness to the visual dimension of the literary text. It involves a cultural history that extends from Plato, Hegel, and Shelley to Oscar Wilde, Roman Ingarden, and J. O. Urmson. The chapter closes with a brief analysis of two distinctively visual literary texts. This not only illustrates my argument in a more concrete way but also provides some actual attention to aesthetic surface. In advocating increased philosophical attention to surface so as to balance the reigning intellectualist preference for deepest hermeneutics, this book should provide at least some example of concrete aesthetic analysis. I wish there had been room to provide more.

Part 3 examines the efforts of some of the most important cultural theorists of the late twentieth century. As a practicing art critic, Arthur Danto surely attends to aesthetic surface, but his aesthetic theory tends to belittle it in order to celebrate art for having much more important philosophical depth. Chapter 10 examines Danto's forceful argument that traditional philosophical definitions of art (by highlighting aesthetic surface and pleasurable experience) have served to trivialize art and disenfranchise it from its deeper cognitive significance. I argue, however, that Danto's own insistence on boxing art into a rigid definition of essence (ironically symbolized by his preoccupation with Warhol's *Brillo Box*) is equally danger-

ous and disenfranchising. By defining works of art in terms of a transcendental metaphysical difference from real things, Danto may give them metaphysical depth, but he reinforces precisely the old divisions between art and real life that produced art's history of disenfranchisement and still continue to diminish its practical and political power. The chapter concludes by sketching the alternative of pragmatist aesthetics with its fuller integration of art and life.

Chapter 11 continues the exploration of pragmatist theories of culture by considering the important work of Joseph Margolis and Richard Rorty, who represent two very different styles of pragmatism and approaches to culture. If Margolis seems closer to the philosophical aims of C. S. Peirce and more interested in the deeper metaphysics of culture, Rorty seems more inspired by John Dewey and is extremely critical of all metaphysics, including Dewey's. Yet if Rorty's ironist aestheticism should encourage the appreciation of surface, his vehement critique of notions of experience, immediacy, and the nonlinguistic ultimately tends to dismiss the aesthetic *Schein* for a linguistic *Sein,* just as his literary criticism seems to reduce aesthetic value to moral usefulness. Both Margolis and Rorty have helped shape my pragmatism, so by critically contrasting their theories, I can clarify the elements that most distinguish my own pragmatist approach to culture: a revisionary activism, an insistence on the concepts of experience and pleasure, an appreciation of popular art and somatic disciplines, and a recognition of the value of immediacy (linguistic and nonlinguistic).

Many of these themes reemerge in chapter 12, where I consider the cultural philosophy of France's influential social theorist Pierre Bourdieu. Though often mistakenly linked by Anglophone intellectuals to French poststructuralism and postmodernism, Bourdieu protests this connection and prefers to align himself with themes and figures of Anglo-American philosophy. Chapter 13 shows how he not only shrewdly deploys crucial ideas of J. L. Austin, Wittgenstein, and Dewey concerning the sociocultural grounds of meaning, rules, and experience, but also renders these ideas more pragmatically potent and precise by bringing them into empirical sociological practice.

Bourdieu compellingly portrays the underlying social and cultural forces that frame our experience of art. Unfortunately, however, he remains too much the prisoner of his drive for deep sociological analysis. Dismissing the role of revisionary theory that could challenge (or even change to some extent) the sociocultural facts, he also rejects the formative power of aesthetic experience by simply reducing it to deeper social conditions and denying the validity of its surface immediacy. Bourdieu thus ultimately displays the unhappy imbalance of a social scientist's violent will to power, a relentless drive to unmask and neutralize the potent se-

ductions of aesthetic surface, a one-sided drive for deeper cultural prob-
ings that seems unwilling to let us return to dwell in the surface and im-
mediacy of aesthetic experience. In defining the aesthetic simply in terms
of the distinctive underlying social frame that demarcates art from the rest
of life, Bourdieu neglects the special contribution of what is framed, the
captivating surface qualities and immediacies of aesthetic experience.

The final chapter proposes a general definition of art as dramatization
that tries to combine the two perspectives whose fruitful dialectic the
book explores: experiential immediacy of surface and the deeper cultural
frame that structures the vivid immediacies of aesthetic experience. By an-
alyzing the concept of drama and tracing its etymological roots, we see
that dramatization has two different senses: On the one hand, it means a
formal staging or framing of action and experience that implies the medi-
ation of deeper social conventions that enable this formal staging and de-
marcate it from real action. But dramatizing also implies the intensifica-
tion of lived experience in which the action we witness so fully absorbs us
in its surface immediacy of vivid presence that our experience is felt as
more keenly real than as conventionally staged. In defining art as drama-
tization, I show how these two senses of dramatization work dialectically
together: how the underlying and mediating frame can intensify the expe-
rienced immediacy of action, but conversely how the sense of vivid expe-
rience or significant action justifies the act of framing.

In contrast to philosophy's typical projects of defining art, my theory of
art as dramatization does not purport to discover the immutable essence
of art or devise a verbal formula that perfectly covers what logicians call
"the extension" of art, that is, a formula that applies to all artworks and
only artworks. In my pragmatist view, definition of a historically evolving
concept like art can be useful without attempting to reveal the alleged
eternal essence of art and to achieve perfect coverage of its extension. Def-
initions, I argue, can be valuable in terms of enriching our understanding
and experience of art by highlighting dimensions of art that do not receive
enough attention, by connecting key features of art that are not suffi-
ciently connected, and by reconciling aspects of art and aesthetic experi-
ence that seem to be in disturbing conflict. In highlighting the different
aspects embraced by the notion of drama, my account of art as dramatiza-
tion also serves to reconcile the two competing orientations that dominate
and polarize aesthetic theory in recent centuries: naturalistic theories that
stress intense immediacy of experience versus historicist theories that de-
fine art in terms of social conventions that constitute the enabling frame
for art's existence and experience to unfold.

In tracing the debate between aesthetic naturalism and historicism,
chapter 13 confronts crucial insights of Emerson, Nietzsche, and Dewey
with those of Bourdieu and Danto in order to seek a higher synthesis that

will do better justice to both the natural energies and conventional practices of art by portraying their collaborative workings and productive tensions. It concludes the efforts of this book to illuminate the complex play of surface and depth, of immediacy and mediation, that constitutes the life of aesthetic experience and the captivating power of art.

Part I
Logics of Criticism

1.

On Analytic Aesthetics
From Empiricism to Metaphysics

I

Analytic philosophy has been the dominant twentieth-century philosophical tradition in the English-speaking world, and its dominance extends to the field of philosophical aesthetics.[1] In my student days at Jerusalem and Oxford in the 1970s, I was taught that any real progress in aesthetics would require working in the analytic tradition; and I was happy to comply. There is a more pluralistic mood today. But analytic aesthetics remains the most institutionally powerful approach in Anglo-American philosophy of art, though it still bears some of the chronic discomforts that seem to have always plagued it.

One such discomfort is the question of self-respect within the professional field of analytic philosophy, since there is a stubborn prejudice in mainstream analytic circles that aesthetics is only a marginal topic, if indeed a fully respectable one. Research in analytic aesthetics thus often takes the form of applying lessons from more central branches of analytic philosophy (like epistemology, metaphysics, or philosophy of language or mind). But there is almost never an influence in the opposite direction, where lessons learned from thinking about art are then applied to the preferred analytic areas, despite Nelson Goodman's claim that aesthetics can be a powerfully effective springboard for discovery in symbol theory and epistemology. The subordinate relation of aesthetics to other topics of analytic philosophy contrasts with its status in hermeneutics, phenomenology, poststructuralism, and pragmatism, where the study of aesthetic experience and interpretation is considered a crucial key to illuminating issues of metaphysics, meaning, knowledge, and mind. These nonanalytic traditions of aesthetics have also had much more impact on the creation and criticism of art, so even firm advocates of analysis have come to wonder whether there may be a stubborn problem of fit between the nature of analytic aesthetics and its subject matter.[2]

But what *is* the nature of analytic aesthetics? What are its preferred

goals, themes, and methods? How has this tradition developed and in which direction is it heading? A full answer would require no less than a book-length study, but this chapter provides a preliminary account of the field, while showing how analytic aesthetics effectively turned from surface to depth. As a valued and complex field, the exact meaning of analytic aesthetics is essentially contested. So there is difficulty not only in defining its nature but even in determining its scope.

Should its scope include all the aesthetic writings of twentieth-century analytic philosophers? Although this seems reasonable, some have argued that analytic aesthetics should be more narrowly construed. J. O. Urmson, an analyst who was very influential in the mid-twentieth century when analytic aesthetics first rose to dominance, argues that this field should exclude all projects of constructionist definition and conceptual reform, even when they are performed by eminent analytic philosophers of art. Anita Silvers, a prominent contemporary theorist, argues that the field of analytic aesthetics should be construed still more narrowly as a specific program (originating in the late 1940s and reaching full force by the late 1950s) that involved only *some* of the analytic philosophers who wrote on aesthetics (and, even of those, only some of their writings).[3] Urmson and Silvers want to identify a narrower, purer strain of what might be called classical analytic aesthetics.

Of course, the narrower the scope, the easier it will be to provide precise accounts and convincing generalizations about analytic aesthetics. But the broader definition of scope gives analytic aesthetics greater versatility, power, and range. Nelson Goodman's aesthetics certainly should be included, even if he engaged in reformatory definitions and pragmatic reconstruction of concepts—projects that were alien to the more descriptively neutral and commonsense approach that defines the classical analytic aesthetics (as exemplified by Morris Weitz, Arnold Isenberg, Urmson, and Frank Sibley). For Goodman's theories were every bit as influential in the field. Similarly, though Arthur Danto's aesthetics turned to a deeply speculative Hegelian historicism remote from the down-to-earth empiricism that characterized the classic strain of analytic aesthetics, his self-identification as analyst and his great influence on current analytic aestheticians guarantees him a central place in this field. Ludwig Wittgenstein's aesthetic views seem still more central, even though their first formulation predates what many regard as the real emergence of analytic aesthetics in the mid-twentieth century.

Does the aesthetics of any analytic philosopher then count as analytic aesthetics? The case of G. E. Moore puts this in question. By even the narrowest construal of philosophical analysis, Moore is an important, even paradigmatic, analytic philosopher. Along with Bertrand Russell and Gottlob Frege, he is considered to be one of the three main founders of an-

alytic philosophy, and his first and most famous book, *Principia Ethica,* provides detailed analysis of central aesthetic issues like organic unity, beauty, and the emotive and cognitive components in the appreciation of art and natural beauty.[4] But Moore was never really considered part of analytic aesthetics. Though he influenced Wittgenstein and inspired the fertile artistic minds of Bloomsbury (from E. M. Forster to Clive Bell and Virginia Woolf), Moore is virtually ignored in contemporary analytic aesthetics. Thus, when philosopher Arnold Isenberg argued (in the 1950s) for the need for analytic aesthetics, he falsely assumed that Moore paid no attention to aesthetics, lamenting that "none of the leaders of the analytic movement, such as Moore and Russell, have ventured into a field [i.e., aesthetics] that was not shunned by Bacon, Hobbes, Locke, Hume, or Kant."[5] Why was analytic aesthetics so blind and unreceptive to Moore's aesthetic theory? To answer, we need to see how Moore's views compare to key themes and orientations of analytic aesthetics.

II

1. As its name clearly testifies, analytic aesthetics is a consequence of the twentieth-century analytic approach to philosophy that emerged in England with Moore and Russell and was continued by Wittgenstein and others through the various phases of logical atomism, logical positivism, and ordinary-language analysis. Such philosophers and their disciples agreed with Russell's claim that analysis rather than the construction of philosophical systems is the major aim of philosophy.[6] However, there was considerable disagreement and uncertainty about what precisely should be analyzed: concepts, meanings, facts, or propositions? C. H. Langford's famous "paradox of analysis" raised the further question of how any formulated *analysans* could be perfectly accurate to its *analysandum* and still be informative rather than a mere tautology.[7] But confident in the general superiority of the analytic approach (with its apparent success in other areas of philosophy), analytic aestheticians dismissed these difficulties as ultimately resolvable and as not precluding objectivity as to what constitutes a good philosophical analysis in particular cases.

A further problem with the concept of analysis was its ambiguity. There seemed to be rather different and rival modes of analysis. The first mode involved reductively breaking down a concept, fact, or putative entity into the more basic components or properties that are its necessary and sufficient conditions. Such analysis was often pursued with the aim of metaphysical reductions (e.g., reducing objects into sense-data, or reducing "the average man" into a quotient of real men). However, another form of analysis was not aimed at reductive definition but simply at clarifying vague and problematic notions employed in some area of discourse.

Analysis in this mode became extremely influential through the later work of Wittgenstein and J. L. Austin. In this type of analysis, the aim is to distinguish the confusing complexities of a concept and provide a perspicuous overview of its different uses. This need not emerge in a univocal definition of the essential conditions of the concept, because it may not admit of a clear set of essential conditions that are both necessary and sufficient for its application. Since aesthetic concepts are among the vaguest and most contested, this second form of analysis long dominated analytic aesthetics. Indeed, analytic aesthetics first got firmly off the ground only after this form evolved from the reductivist approach.[8] Both procedures could rightly be called "analytic" in terms of their sharing not only a common genealogy but a common aim of descriptive clarification rather than critical reform.

This limitation of aim is not shared by a third analytic mode that likewise evolved out of first-generation analysis: the procedure of rational reconstruction made famous by Rudolf Carnap. As the influential debate between Carnap and P. F. Strawson makes clear, the very notion of analysis reveals a basic tension between the aim of precise definition through conceptual reconstruction and, on the other hand, the aim of providing a faithful clarification of our messy ordinary-language concepts without trying to replace them with more precise ones.[9] If clarificatory analysis reveals our aesthetic concepts as troublingly vague, why not proceed to make them better and more precise? Goodman takes this constructivist line in his definitions of musical and literary works of art, definitions that Urmson and others have criticized as a departure from analytic aesthetics as it should be understood.[10] But Urmson's own idea that analysis is confined to clarification without critical reconstruction seems to depart from Russell's initial view that analysis "consists in criticizing and clarifying notions," where we aim at "passing from those obvious, vague, ambiguous things that we feel quite sure of, to something precise, clear, definite."[11] In any case, an element of revisionary pragmatism in Goodman's aesthetics should not exclude it from the fold of analytic aesthetics. Whatever purist uniformity might be gained by excluding Goodman's influential work from analytic aesthetics is offset by impoverishment of the field.

2. If analytic aesthetics cannot be properly understood without the wider context of analytic methods and achievements first established in other branches of philosophy, we also need to grasp the background of early twentieth-century aesthetic theory against which analytic aesthetics first defined itself by sharp opposition. Aesthetics then was dominated by an idealism that stubbornly looked beyond the surface differences of artworks to find a profound explanatory essence or principle common to them all. In making an early argument for analytic aesthetics in 1948, W. B. Gallie complained that the "Idealist aestheticians" were so keen on

insisting that art's deep "essence" was a special form of "Spirit" equated with "Imaginative activity" that they tended to "exclude from the category of Art those [e.g., surface or material] features, ordinarily ascribed to works of art or to artistic creation or enjoyment, which cannot be comprised within this essence or equation."[12]

The most dominant theory was the Hegelian-inspired idealism of Benedetto Croce, with its distinction-demolishing essentialism. Asserting that all art is simply expression, Croce denied that there were any philosophically valid principles for classificatory distinctions (such as genre distinctions) that firmly identify different artworks as being of the same kind while distinguishing them from other kinds of artworks. All artworks are equally spiritual expression, and every expression is completely unique, so there is no point in paying serious attention to the different material and surface features of artworks, since these could not belong to the presumed common spiritual essence of art. Most analysts (like Gallie) were very critical of Croce, but they were even less sympathetic to the deep reductive essentialism of "Naturalist theories of art" that tried to explain all art in terms of some underlying natural cause, such as "soil and climate (with Taine), the needs of evolution (with Spencer), atrophied muscles (with Lombroso) and sexual repression (with Freud)" (*FPA*, 24).

The problem with all these theories, the early analysts argued, was their deep essentialism that obscured the important differences exhibited by art's various media, genres, and works. These differences and particularities seem crucial to what we appreciate in art; they are strikingly, purposefully present on the material, perceptual surface of artworks. So "if we are to understand art at all, we must begin from what we see or read . . . in different works of art" not simply presume a single deep essence whether spiritual or natural (*FPA*, 24). The early analysts even criticized the "significant form" theory of Clive Bell and Roger Fry for distracting us from the different empirical surface forms of artworks to the presumption of a mysterious metaphysical essence of significant form. Such an essentialist formalism lands us "in the depths of mysticism" while also implying that the representational and content features of artworks are not really crucial to their artistic identity and value.[13]

The vigorous burgeoning of analytic aesthetics in the mid-twentieth century was due not only to the perceived achievements of analytic philosophy but just as much to the perceived failures and confusingly woolly, speculative, a priori nature of Crocean idealism and other romantic essentialisms like R. G. Collingwood's expression theory or the Bell–Fry theory of "significant form."[14] However, if analytic aesthetics developed by challenging these essentialist romantic theories, it did not altogether rid itself of romantic tenets that can be traced (like analysis itself) back to Kant. These tenets include the uniqueness, gratuitousness, and autonomy of

artworks. Analysts could therefore still appreciate Coleridge, Croce, Collingwood, Bell, and Fry "as lovers of art" and genuine aestheticians, while rejecting their essentialisms. In contrast, the reductive essentialism of "Naturalistic theories of art" were condemned more strongly as diverting us from art's crucial aesthetic qualities and plunging us into nonaesthetic grounds (*FPA*, 24).

Thus, one feature that characterizes what I call early or classical analytic aesthetics is an empiricist respect for surface appearances that seem helpful in underlining art's variety and differences, in contrast to the presumption of seeing art as a deep uniform essence. In his influential paper "What Makes a Situation Aesthetic?" (1957), Urmson argued that aesthetics is specifically concerned "with the way the object in question looks or presents itself to the other senses," "with a thing's looking somehow without concern for whether it is really like that"; the aesthetic focus "is not even skin-deep." Morris Weitz's seminal critique of essentialism (in "The Role of Theory in Aesthetics," 1956) implores us to "look and see" the vast array of differences among artworks rather than presume a common essence to search for as a definition of art. Monroe Beardsley's landmark book *Aesthetics* (1958) shows his insistence on aesthetic surface by treating artworks purely in terms of their perceptual qualities, thus distinguishing between the perceptual aesthetic object and its material counterpart or vehicle, but also between the perceptual object and its mental effects on the artist or observer. The objects we study in aesthetics, Beardsley affirms, "are all, so to speak, objects *manqués*. There is something lacking in them that keeps them from being quite real, from achieving the full status of things—or, better, that prevents the question of reality from arising. They are complexes of qualities, surfaces." The same analytic focus on aesthetic surfaces can be found in Frank Sibley's influential study of aesthetic qualities.[15]

The history of analytic aesthetics since the mid-1960s can be read as a progressive turn away from the perceptual surface to deeper imperceptible depths. This turn was very fruitful, for there is certainly more to art than its surface display. And even this surface could be better understood by exploring beneath it to discover the kind of substructure or grounding primer that allows the surface qualities to shine forth with stability and helps shape their meaning. Turning from aesthetic surface to the imperceptible depths of art was also necessary to meet Weitz's compelling Wittgensteinian argument that if we just empirically "look and see," we will not find perceptual properties that are essential to all artworks and both common and peculiar to them. No set of perceptual properties seems both necessary and sufficient for being a work of art. No set of such properties seems exhibited by all things we consider artworks, especially after the revolutions of Dada, ready-mades, and conceptual art. Therefore, in the mid-1960s some analysts began to seek the essence of art by

looking beneath the aesthetic surface and beyond the perceptual qualities of artworks.

Arthur Danto helped initiate this turn from aesthetic perceptual properties by stressing art's imperceptible contextual features as the essential factor for an artwork: "what in the end makes the difference between a Brillo box and a work of art consisting of a Brillo box" is not a perceptual property "but a certain theory of art." Being an artwork "requires something the eye cannot descry—an atmosphere of artistic theory, a knowledge of the history of art: an artworld."[16] George Dickie then deployed the notion of artworld to propose an institutional definition of art that made the background conditions of the artworld and its agents more important for artwork status than any kind of perceptual properties the art object might have. Though Dickie's institutional theory had several flaws, it helped underline Danto's point that an object's status as an artwork depends crucially on the history and tradition of art as a cultural practice.[17] Indeed, a host of analytic philosophers (including Joseph Margolis, Richard Wollheim, Nicholas Wolterstorff, Jerrold Levinson, and Noël Carroll) have been insisting on this point since the mid-1970s. So in sharp contrast to the perceptual empiricism of Urmson, Weitz, Beardsley, Passmore, Gallie, and other classical representatives of analytic aesthetics, the dominant trend of analytic aesthetics at the dawn of the twenty-first century is to focus far beneath the varying surface properties of artworks and instead to concentrate once again (as Croce did) on the search for deep invariant commonalities constitutive of all art, sometimes even to return to the quest for art's metaphysical essence.

It is certainly instructive to look beneath the aesthetic surface. However, this change of focus courts a danger of aesthetic impoverishment if sight of the surface is then lost or dismissed as philosophically insignificant. Many analysts today exemplify a distinctly "anaesthetic" aesthetics, regarding notions like aesthetic qualities and aesthetic experience as largely marginal to the philosophy of art, if not altogether suspect. Danto exemplifies this trend when he claims that the connection between aesthetics and art is but a brief "historical contingency" remote from art's true essence and when he trivializes the aesthetic as narrowly confined to sensuous pleasure without meaning, so that "aesthetic delectation" becomes "the danger to be avoided." George Dickie's arguments against the very existence of the aesthetic attitude and aesthetic experience similarly downplay the notion of aesthetic surface so much as "to suggest the vacuousness of the term 'aesthetic,' " while Joseph Margolis's preoccupation with the deep cultural metaphysics of art is symptomatic of the same trend.[18] The dangers of this tendency are explored more fully in part 3.

3. The quest for clarity, especially through careful attention to the languages of art and criticism, was perhaps the most common feature of

early analytic aesthetics. Antiessentialism about art was also a very widely embraced doctrine among the analysts, and it helped distinguish them from traditional theorists who presumed that art must have an essence in order for "art" to be meaningful. Antiessentialism and the quest for clarity were clearly related. The murky confusion of traditional aesthetics was imputed to its assumption that the arts shared a common essence, which once discovered by the aesthetician could also serve as an absolute standard for aesthetic judgment. Noting that the various arts are very different and that their subsumption under our common concept of art was not effected until the eighteenth century,[19] the classical analysts argued that the essentialist presumption led traditional aesthetic theories to ignore, conflate, or homogenize obvious differences between the different arts or to speak of art in ambiguous terms so as to conceal all those differences behind a confusingly vague formula of essence.

Thus John Passmore (as also Stuart Hampshire, W. E. Kennick, Gallie, and Weitz) saw the woolly dreariness of aesthetics "as arising out of the attempt to impose a spurious unity on things, the spuriousness being reflected in the emptiness of the formulae [e.g., expression, representation, significant form, beauty] in which that unity is inscribed."[20] In the quest for more precise and meaningful theories, Passmore went so far as to suggest that "there is no aesthetics and yet there are principles of literary criticism, musical criticism, etc." and that general aesthetics should be abandoned for "an intensive special study of the separate arts, carried out with . . . much respect for real differences between the works of art themselves."[21] Such concern with the close study of the separate arts and their criticism was everywhere endorsed by analytic aesthetics and points to another important feature that distinguishes it from most traditional philosophy of art. This concern for the particularity of the different arts is still a positive presence in analytic aesthetics.[22]

There is, however, something paradoxical in the extreme antiessentialism of the early analysts. Stressing the particular uniqueness of artworks, this attitude was strikingly captured in Hampshire's claim that "when in Aesthetics one is travelling from the particular to the general, one is travelling in the wrong direction."[23] If this view is pushed to its logical conclusion, there is not much difference between such particularist antiessentialism and the Crocean essentialism that analysts so scorned. Both assume that uniqueness is an essential property of an artwork; Croce only gives the further explanation that such uniqueness follows from art's being expression, since what has been truly "expressed is not repeated."[24] Fortunately, most analysts implicitly realized that no matter how much we deny real essences, there must be some point and validity in generalizations about art and its criticism, even if they are best made about specific art forms or genres rather than about art as a whole. But issues of essen-

tialism and distortive generalizations also arise within a particular artistic genre like literature or even a subgenre like tragedy, as Morris Weitz cogently argued.

Although antiessentialism proved a very useful strategy against traditional aesthetics, its true meaning (like the meaning of "essence") remains problematic. Analytic antiessentialism seems most vulnerable when it protests against any general theory about art or art's subgenres as a violation of art's open character. This not only suggests that art has at least the essential character of not allowing definition, but more importantly seems to leave no space for the generalizations that we need to make in the criticism, history, and theory of art. Of course, art's "essentially" open character can be construed not as a permanent metaphysical essence but as a powerful historical tendency that seems likely to continue on the basis of past experience. In any case, the whole issue of essentialism needs more careful study of the relations between essence and definition. Would the fact that art has an essence imply that it is incapable of changing substantially, or even drastically, in character? Can essences be understood in a way that permits them to change? Must a valid definition be one of essence? Does a definition require that it be valid forever? Does a decent definition of art, even a definition in terms of necessary and sufficient conditions, really entail the existence of an unchangeable essence? Necessary and sufficient conditions for a concept can be changed (as when the minimum voting age is altered), and some notions of essences (such as those relating to entelechies in the Aristotelian sense) are certainly compatible with change.

In recent years, aestheticians have not been careful enough about the distinctions implied in these questions. I cannot go into all of them here, but let me at least distinguish three versions of antiessentialism in analytic aesthetics. The strongest version argues that art could not possibly have a defining essence because of its open, adventurous character. A milder, empirical version is that we simply cannot, at least for the moment, find such a defining essence. The most liberal and convincing version of antiessentialism is simply denying that there *must be* a defining, unchanging essence that is common and peculiar to all art in order for the concept of art to be meaningful. I call this logical antiessentialism because it denies that conceptual logic requires an unchanging essence for art. Almost all the early analysts seem to be antiessentialists in this minimal sense. Even someone like Beardsley, who ventured a definition of art (in terms of capacity to produce aesthetic experience of considerable magnitude), never presumed that art required some definable essence to guarantee the intelligibility of talk about art.[25]

Recent analytic aesthetics has changed dramatically in this respect. Its most famous advocate, Arthur Danto, insists "there is a kind of transhistorical essence in art, everywhere and always the same." "As an essential-

ist in philosophy," he continues, "I am committed to the view that art is eternally the same—that there are conditions necessary and sufficient for something to be an artwork, regardless of time and place. I do not see how one can do the philosophy of art—or philosophy *period* without to this extent being an essentialist." All artworks "must exemplify the identical essence" but "do not have to resemble one another" and can be "altogether open" in the properties or meanings they display.[26]

Danto never really delineates what art's putative essence really is. But this essence clearly serves the reassuring role of giving us the metaphysical security that although art seems increasingly volatile in its transformations, it always was, is, and will be the same thing. This underlying identity, he presumes, is ontologically implied in our use of the very same concept "art" to cover all its different manifestations (and their distinction from "mere real things"), and philosophy is committed by its very project to such metaphysical essences. Analytic aesthetics thus seems to have regressed to the pre-Wittgensteinian arguments of Clive Bell. Danto's position has grown exemplary for a younger wave of analytic aestheticians who seem similarly bent on finding a definition of art that will permanently capture its changing field of reference. Because such definitions narrowly aim at perfect coverage of art's extension rather than explaining how art functions or where its meaning and value rests, I have criticized them as mere "wrapper definitions."[27]

We can sum up the issue of essentialism by putting it in a wider context. In reverting from surface to depth, analytic aesthetics also underwent a curious reversal from being strongly empirical and antiessentialist to heralding metaphysically grounded essentialist definition as the inalienable goal of aesthetics. This reversal strikingly parallels a more general trend in Anglo-American analytic philosophy. As Hilary Putnam shows, this philosophy turned from a self-conception as vehemently "antimetaphysical during the positivist period [and] came to be the most proudly metaphysical movement on the world philosophical scene."[28]

4. Some metaphysical issues, however, have always been important for analytic aesthetics, even at the height of its antiessentialism. These were metaphysical questions of the ontological status and individuated identity of artworks. In what mode does a particular artwork exist (material, ideal, phenomenal, etc.), and how is it differentiated (e.g., in its instances, performances, copies, etc.) from other works? This concern about ontological status and work-identity derived from the movement's self-conception as metacriticism. Analytic aesthetics saw itself as fundamentally a second-order discipline engaged in the clarification and critical refinement of the concepts of art and art criticism. Since critical discourse in the artworld so often focused on particular artworks, the question arose as to what precisely those objects were and how they were to be individuated from each other.[29]

Analytic aesthetics neither made manifestoes about what art should be nor proposed new criteria about how art should be evaluated. It instead sought a more logical and systematic account of the principles of art and criticism as actually reflected in the practice of good critics. The fact that such practice was distinctly verbal perfectly suited analytic philosophy's special concern with language. It also neatly corresponded with analytic philosophy's primary concern and paradigm of a worthy first-order discipline—science. As science described nature, art criticism (understood widely to include art history and theory) described art. Correspondingly, what science was for analytic epistemology and logic, art criticism—the careful, systematic, and potentially even scientific study of the different arts—was for analytic aesthetics.

Without art criticism as a serious first-order cognitive discipline for analysts to clarify, logically sharpen, and ground, there would have been less impetus to refrain from traditional aesthetic preoccupations with the essence of beauty. The antiessentialism of classical analytic aesthetics and its sudden burst of vigor in the late 1940s and early 1950s can both be explained by the fact that art criticism, music criticism, and especially literary criticism were increasingly establishing themselves as serious and separate academic enterprises with scientific, or at least systematic, pretensions. This is also why analytic aesthetics burgeoned well after general analytic philosophy had already reached its prime. Second-order analytic method had to wait until it found an adequate aesthetic counterpart of science in academic criticism. Literary criticism seemed to represent the most developed of such "scientific" critical disciplines, and not surprisingly analytic aestheticians most frequently and closely concerned themselves with it. Consider Beardsley and Weitz, probably the two most influential figures in the 1950s and 1960s: Beardsley's most famous essay was coauthored with a literary critic (William Wimsatt), and Weitz was himself a scholar and practitioner of literary criticism.[30]

However, when postmodernism later challenged traditional ideas of meaning, objectivity, and the scientific study of texts, the field of contemporary literary criticism no longer presented analytic aesthetics with a confident paradigm of first-order scientific inquiry that it could be comfortable about analyzing and justifying. Here is another reason why analytic aesthetics in the past fifteen years has increasingly turned from empirical analysis of actual critical practice to a renewed quest for metaphysical foundations to define the objects and aims of criticism. This retreat into metaphysics conversely explains why practicing critics in literature and art have been much less interested in guidance from analytic aesthetics as compared to hermeneutics, deconstruction, poststructuralist genealogy, new historicism, and Frankfurt-school critical theory.

Although the perceived dissimilarities of science and art criticism

would eventually frustrate its grand metacritical program, classical analytic aesthetics was most prominently conceived as the philosophy of art criticism. Of course, an apparently larger project, "the philosophy of art and art criticism," was sometimes expressed. But since, in second-order fashion, art was to be studied through its criticism, philosophy of art effectively collapsed into the philosophy of art criticism. Hence Beardsley subtitled his *Aesthetics* as "Problems in the Philosophy of Criticism." There are serious limitations with the conception of aesthetics as metacriticism, because it seems essentially confined to art and to the critic's rather than also to the creator's point of view. The project of analytic metacriticism was also hampered by deep internal tensions regarding descriptive objectivity, normative justification, and critical reform. Before considering these tensions, let me note two other problematic consequences that followed from seeing aesthetics as the philosophy of criticism.

5. One consequence was obviously an overwhelming preoccupation with art rather than natural beauty. There was no first-order aesthetic discipline of nature criticism or environmental critique in the 1950s, though ecological hindsight certainly suggests we should have had one. Of course, after the powerful influence of Hegel, aestheticians rarely gave as much attention to nature as to art. But in classical analytic aesthetics, the bias toward art and neglect of nature is particularly pronounced. The point is too obvious to belabor, but one typical example is how Wollheim castigates Kant and Bullough for trying to understand the aesthetic attitude by means of examples from nature, when, for Wollheim as analyst, the only central, nonderivative case of having an aesthetic attitude is to regard an artwork "under the concept" of art.[31]

The overwhelming preference for art was further fueled by analytic philosophy's special concern with language. The linguistic turn in aesthetics is evident in the relentless titling of books and articles in the form "The Language(s) of Art (Criticism, Fiction, Painting, Poetry, Music, Metaphor, etc.)." Language obviously involves intention and mind. To study the languages of natural beauty might well have seemed naively animistic or more sinisterly theological to secular analysts.

The one-sided focus on art became increasingly damaging to the very idea of the aesthetic. Early analytic aesthetics devoted great efforts to defining the aesthetic and clearly distinguishing it from the nonaesthetic (e.g., in terms of a special aesthetic dimension, attitude, experience, judgment, or a logically distinct breed of concepts). But as these attempts proved problematic, cherished notions like the aesthetic attitude and aesthetic experience were exposed to savage critique, even to the point where their very meaning and existence were questioned.[32] Moreover, traditional ideas of the aesthetic seemed increasingly irrelevant with respect to developments in twentieth-century art that vigorously opposed that

tradition. Since the notion of "aesthetic" was etymologically and histori-
cally wedded to sensory perception and typically associated with the
pleasures of sensuous form, it hardly seemed reconcilable with the art of
Duchamp and later twentieth-century artists. For appreciation of such art
was more about concepts that require more than what the senses can dis-
cern, and such art often clearly strove against aesthetic notions like beauty
and disinterestedness.

This tension between art and the aesthetic was often deftly swept
under the carpet by ignoring natural beauty and tacitly identifying the
scope of aesthetics with art and its criticism. But Goodman and Danto,
probably the most influential analytic aestheticians of the 1980s and 1990s,
eventually denounced the traditional concept of the aesthetic as a mis-
leading repressive ideology that trivializes art as mere sensuous pleasure
with no essential cognitive dimension. Goodman's revisionary account of
the aesthetic is purely and explicitly in terms of the characteristic symbolic
functioning of the various languages of *art*, and aesthetic value is con-
strued simply as cognitive efficacy in the functioning of symbol systems
so characterized.[33]

6. A second consequence of construing analytic aesthetics as a sec-
ond-order discipline of metacriticism was a strong tendency to avoid
evaluative issues, generally by relegating them to the first-order level of
criticism itself. The philosopher of art's role was to analyze the evalua-
tive judgments of critics and to clarify and critically examine their sup-
porting reasons or premises. It was not the philosopher's job to contest
the critics' expert verdicts. She might try to extract and formulate some
evaluative standards from the critical practice she analyzed, but she was
not expected to offer original ones of her own. The interest in evaluation
also suffered because of academic criticism's own reluctance to evaluate.
Since it aspired (as a university-based discipline) to some sort of scien-
tific status, and since the then-reigning dogma held science to be value
neutral, academic criticism essentially confined itself to finding facts and
new interpretations. Leading critics like Northrop Frye could be
scathing in rejecting evaluation as "meaningless criticism" and "leisure-
class gossip."[34]

Despite some notable exceptions, analytic aesthetics gave far less atten-
tion to value than did traditional aesthetics.[35] Not only did it spend pro-
portionally more time on other topics (like interpretation, the definition of
art, representation, expression, fiction, and the ontological status and
identity of artworks), analytic aesthetics often seemed eager to skirt the
question of evaluation altogether as being too traditionally muddled and
fruitlessly intractable. This is starkly expressed in Wollheim's explicit re-
fusal to discuss the question in the first edition of his *Art and Its Objects*.[36]
It is still more bluntly affirmed in Goodman's continuing refrain that ex-

cessive concentration on the question of "excellence in art has been partly to blame for the lack of excellence in aesthetics."[37] Even those analysts who did discuss this topic typically insisted (against the view of Harold Osborne) that artistic evaluations could be accurately made and justified without relying on or appealing to aesthetic theory.[38]

Perhaps the most striking sign of shrinking engagement with evaluative issues is analytic aesthetics' distinctive attempt to identify and define a nonevaluative, merely "classificatory," sense of "art" that is distinct from the more characteristic evaluative or honorific sense of "art" as something that is at least prima facie valuable. Most analysts initially held with Weitz that the aesthetician's task was not to define art but to describe the logic of its concept. Gallie had earlier suggested that art's ineliminable evaluative dimension is precisely what makes it an essentially contested concept that resists definition. But Weitz argued that we could at least distinguish between a descriptive and evaluative use of the term "art."[39] Though Weitz held art undefinable in either its descriptive or evaluative sense, the conceptual wedge that he drove between the two senses led some analysts to think that they could factor out the so-called evaluative sense and concentrate philosophical efforts on understanding "art" in its purely descriptive or classificatory content. Here, they argued, definition might succeed, since there would be no debate about values to obstruct objective logical analysis.

We find precisely this move in Dickie's famous institutional definition of art, which defines an artwork only in the classificatory sense; to wit, as an artifact given the status of a candidate for appreciation by some agent acting on behalf of a social institution called the artworld.[40] But what real value or substance can such a definition have? As its proponents concede, the strictly classificatory judgment "this is art" has virtually no use. Moreover, the substantive aesthetic or evaluative issues that always motivated the quest for the definition of art (e.g., whether and how we should appreciate a particular artifact as a work of art) are never really faced by the institutional definition. They are merely deferred to the artworld and its evaluational decisions and definitions. Finally, the very notion of "candidate for appreciation" presupposes a background where art is evaluatively appreciated, and such evaluations take many more forms than mere ascriptions of beauty: there is rightness, precision, importance, originality, etc. Art and (the contest of) value cannot in a holistic sense be separated, which is not to say that particular works of art cannot be bad or valueless.[41]

Already in 1951, Passmore recognized that art could be theorized "as a social institution," but he rejected this approach as not really dealing with art's crucial aesthetic dimension.[42] By the time Dickie proposed his institutional definition of art, the power of the purely aesthetic approach for explaining art was much in question, so the central social dimension of art

could come clearer into view. Still, analytic philosophy's institutional definition of art seems paradoxically deficient, because it is a social definition of art that thoroughly abstracts from the thick social contexts, stakes, and battles of cultural legitimation that structure our judgments of artistic status. The social thus serves here as an abstract function without any rich and detailed explanatory power. In trying to define art in purely nonevaluative terms and in ignoring the more-than-aesthetic structures and struggles that shape the institutions of the artworld, analytic philosophy left out something important. The striving for aesthetic valorization expresses conflicts over larger social stakes in a very complex field of classes and individuals struggling for social legitimation and distinction. There are reasons beyond the artworld that make the artworld and "art" essentially contested concepts. Pierre Bourdieu has forcefully argued this point against analytic philosophy's neglect of the social forces that constitute the institutional structures of the artworld, even when analytic aesthetics advocates artworld theories in its institutional theory of art.[43]

7. There seems to be something analogous in the use of history by analytic aesthetics. Though analytic philosophy is generally ahistorical in its approach, analytic aesthetics has in some ways made history central to its enterprise. Prominent figures in the field have done considerable historical research in aesthetics,[44] but many more (such as Wittgenstein, Wollheim, Danto, and Margolis) have long emphasized the historicity of art and its appreciation. One of today's most popular approaches to the definition of art in analytic aesthetics is defining it in terms of history. Wollheim claims that "art is essentially historical"; Danto depicts the coming of "the end of art" as the development of art's self-conscious "understanding of its own historical essence." Extending the historical trend, Jerrold Levinson, for example, defines "an artwork" as anything "that has been seriously intended for regard-as-a-work-of-art, i.e., regard in any way pre-existing artworks are or were correctly regarded."[45]

Although recognizing that history somehow shapes the meaning of art, the historicist trend in analytic aesthetics lacks a sufficiently thick sense of history that could give a more substantive explanation of how history helps construct the realm of art and define its understanding. Analytic historicists for the most part use the idea of history much as the analytic social theories use the idea of art as a social institution. It functions more as an abstract function than a robust presence. Hence, when facing crucial aesthetic issues of whether and how we should treat an object as art, such historical definitions simply leave such decisions to art history or art criticism. Passing the buck in this way is logically legitimate and certainly in keeping with the analytic self-image as metacriticism. However, it raises grave questions as to what, if any, substantial contribution to artistic understanding such philosophical definitions really make. Ostensibly de-

signed to provide a robust standard for making decisions about art status, these "wrapper" definitions of art seem, in the end, to provide only a timidly abstract and flexible shorthand for decisions made elsewhere.

Another interesting feature of the historical trend in analytic aesthetics is its commitment to internalism in art history that parallels its internalist or autonomous view of the artworld. Analytic historicism has nothing to match the sort of grand genealogical approach that has been central in continental philosophy of art since Hegel and developed in different ways by Georg Lukács, Benjamin, Adorno, and Bourdieu. Danto's analytic historicism is avowedly Hegelian in inspiration but, as usual in analytic aesthetics, Danto treats art history as essentially autonomous and relatively isolated from history's wider social contexts, economic factors, and political struggles. The imperatives directing art's evolution are only those of "its own internal development."[46] Analytic aesthetics will seek to justify its internalist historical perspective as necessary for clarity of research and to respect the autonomy of art. Postmodern and Marxian critics will instead interpret and condemn this limiting perspective as an ideological reflection of the compartmentalization of culture and the myth of artistic autonomy that serve late-capitalist neoliberalism. Analysts can counter by insisting that any inquiry has the right and pragmatic need to circumscribe (in some way) its area of research in order to make explanatory progress. Pragmatism could mediate by suggesting that we judge the value of a given set of disciplinary limits by the explanatory fruits thereby engendered. This is a complex debate that must be introduced but not pursued here.

III

Having touched on some of the major themes of analytic aesthetics, we may return to consider the problem of G. E. Moore. Though neglected as an aesthetician, Moore had a powerful impact on aesthetics through three very different routes. First, his influence on Bloomsbury aesthetics was deep and wide-ranging, but it is most clear in the Bell–Fry theory of Significant Form, which reflects Moore's views on intuition of intrinsic value in terms of organic unity, as well as his views on language and unanalyzable concepts. Second, Moore influenced I. A. Richards by inciting him to disagreement, most significantly in Richard's seminal doctrine that full appreciation of literary works does not require belief in their truth. Moore, on the other hand, felt that, *ceteris paribus*, truth always added to the aesthetic value of an object, artistic or otherwise. Third, Wittgenstein also used his disagreements with Moore in order to develop his own seminal aesthetic views. In particular he argued against Moore's preoccupation with the subject-predicate form of aesthetic judgment (e.g., "This is beau-

tiful") and against Moore's traditional presumption that the single predicate of beauty contained the key to understanding aesthetics.[47] Moore's concentration on the notion of beauty departs sharply from the typical analytic perspective, though beauty is struggling to win its way back toward center stage in the discipline.[48]

Moore, however, certainly shared analytic aesthetics' quest for clarity and rigorous conceptual analysis through close attention to language and its ambiguities. In *Principia Ethica*, he claimed that beauty could be analyzed and defined in terms of the (unanalyzable) notion of the good, but he later put both beauty and goodness on the same level as basic (i.e., unanalyzable) forms of intrinsic value. Even when he thought that beauty could be analyzed and defined, Moore held that its definition (being based on undefinable goodness) could never generate any essential and formulable criterion of beauty.[49] To attempt such a universal criterion would be to commit what Moore called the naturalistic fallacy.

This particularist approach to aesthetic judgment was common to much work in analytic aesthetics, as was Moore's view of aesthetic value as being some sort of nonnatural and noninstrumental value, something intrinsically and ultimately good in itself. Sharing with analytic aesthetics the Kantian commitment to aesthetic autonomy and particularity of judgment, Moore takes these ideas to the extreme, exhibiting a resolute blindness to the wider sociohistorical contexts of art that was also characteristic of early analytic aesthetics. Moore argues that the aesthetic value of objects should be determined by the intuitive grasp of the individual observer, who must employ a "method of absolute isolation," introspectively assessing whether and how much value the perception of those objects would have "if they existed *by themselves*, in absolute isolation" and then moving on to determine "what comparative value seems to attach to the isolated existence of each."[50]

Moore's most marked differences with analytic aesthetics are three. First, his aesthetic interests were entirely devoted to the question of value, and he pursued it by narrow and single-minded concentration on what he regarded as the paradigmatic aesthetic value concept—the beautiful. In contrast, analytic aesthetics not only has paid less attention to value, but when it has, it has insisted on the wide variety of predicates in which our aesthetic evaluations are couched. Second, as opposed to all other prominent analysts, Moore gave pride of place to natural beauty rather than art. With what might seem a strong philosophical bias for reality coupled with extraordinary aesthetic naivete, Moore argues that "beauty in Nature should be held superior to an equally beautiful landscape (painting) or imagination" simply because the former is real, and thus beauty is further beautified by truth. Moore's preference for natural beauty is evident in the total disregard of art criticism in his aesthetics. That, however, was the

prime focus of analytic aesthetics, which conceived itself as the philosophy of criticism.

IV

If analytic aesthetics has thrived through its conception as metacriticism, this approach has not been without problems. Besides encouraging the comparative neglect of natural beauty, the role of metacriticism has tended to confine philosophy's understanding of the aesthetic to what criticism understood about art. This has inhibited the use of aesthetic inquiry to reach philosophical insights in fields like epistemology, philosophy of mind, and philosophy of language. It also has discouraged aesthetics from using its philosophical arsenal of tools and insights to formulate its own criticism of artworks. Nelson Goodman was vocal in making this complaint, which is much in the pragmatic spirit of John Dewey; and Arthur Danto's art criticism shows how philosophical theory can thoroughly inform one's practical criticism of art. As merely metacriticism, aesthetics seems essentially a handmaiden to criticism, thus ensuring its marginal place in analytic philosophy.

Finally, there were two problems of consistency intrinsic to the very project of clarifying the language and logic of criticism. The first tension was between the ideals of descriptive accuracy and critical reform, the second between the different language games or logics in critical practice. As a clarificatory second-order account of first-order critical practice, analytic aesthetics assumed the basic validity of that practice; it was something that the analyst qua analyst was not to challenge. The analyst's role was simply to elucidate the logical form of proper critical practice and perhaps formulate and sharpen it into clear principles which critics might use if they felt they had gone astray or were irresolvably deadlocked on a particular question. The job was to provide a clear map or picture of a very complex and vague terrain, intuitively familiar to critics who were its best explorers but had no skill in precise cartography. But if critical practice was confusingly vague and yet essentially acceptable, what should the analyst's job of clarification be? Should the analyst simply make that practice more clear to us by tracing all of its complex vagaries, or should she make the practice itself more clear by criticizing such ambiguities and recommending somewhat different and clearer concepts, standards, and procedures? Descriptive accuracy versus prescriptive clarity has always been the intractable dilemma of analytic aesthetics. As Wittgenstein pointedly put it, "won't it become a hopeless task to draw a sharp picture corresponding to the blurred one? . . . And this is the position you are in if you look for definitions corresponding to our concepts in aesthetics and ethics."[51]

It seems equally hopeless to recommend a definite reform to render

critical practice less ambiguous (as Beardsley did in his anti-intentional-ism and his three evaluative canons)[52] while pretending that this is simply the analytic discovery of what all good critics were really doing all along. Yet Beardsley's reformatory doctrines were probably the most influential theories for practicing critics both within and outside the analytic tradi-tion. Nelson Goodman was more outspoken in his analytic pragmatism and less committed to aesthetics as metacriticism, urging that analysis of antecedent practice and concepts should merely serve as a springboard for critically constructive efforts to improve or replace them. If recent crit-ical practice has taken some radical new paths that analytically trained theorists do not wish to accept as critical paradigms to which analysis as accurate second-order reflection must be faithful, then perhaps analysis needs a pragmatic supplement.

This need likewise emerges from a second source of tension in the metacritical program of analysis—the plurality of contested critical prac-tices. In accord with philosophy's traditional search for general, funda-mental, and unifying principles, much analytic effort was devoted to un-covering the underlying logic behind the complex variety of critical practices: for example, to reveal the basic logic of interpretation at work in the seemingly different interpretive practices of different critics. Analysts have sought to do this by close examination and accurate description of what good critics actually do when interpreting, but they have arrived at very different and inconsistent accounts of interpretive logic. In chapter 2, I argue that the reason for this divergence of analysis is that philosophers are analyzing different logics that they respectively take as paradigmatic and from which they generalize for all interpretation. Yet the idea that there must be one essential interpretive logic that underlies all good criti-cism remains the dominant dogma, a persistent vestige of essentialism that analytic aesthetics never seemed willing to shed. Perhaps the faith that there is such an essential logic to be discovered and then used to ground and regulate academic criticism was what motivated the whole project of analyzing interpretive logic. In any case, the logic of interpreta-tion is a crucial issue not only for aesthetics but for philosophy of lan-guage, culture, and epistemology. The next two chapters are devoted to its complexities.

2.

Logics of Interpretation
The Persistence of Pluralism

I

The logic of interpretation has long been one of the most important and controversial problems in analytic aesthetics. There are at least three distinguishable, though closely related, aspects of the problem. The first concerns the logical status of interpretive statements in our criticism of the arts. Do such statements express propositions with some sort of truth value or do they merely express decisions or recommendations? If the former, are these propositions really about the artwork itself or only about the critic's way of seeing it? Again, if interpretations do express propositions about the work itself, are they in principle determinable as true or false, or only at best as plausible or implausible?

Critics typically support their interpretations with reasons. The second aspect of interpretive logic concerns the logical role of these reasons. Do they function as real evidence logically supporting an interpretive conclusion, or only as rhetorical devices to persuade the reader to adopt the critic's experience of the work, or are they aids for focusing attention on some feature of the work, or for creating a desired perception in the reader? The third aspect, intimately connected with the second, concerns the general form or character of interpretive argument. If these arguments are indeed logical, is their logic typically inductive, deductive, or rather something entirely different?

In their attempt to determine the logic of interpretation, analytic philosophers of art offer very different views regarding these three aspects of the problem, often without distinguishing between them. For these philosophers, the attempt to determine the logic of interpretation is primarily an analytic or descriptive matter, not a normative or legislative one.[1] Their major aim is to analyze the logic that actually governs interpretation, not to recommend a logic that should be employed; they claim to describe what qualified critics actually do in interpreting, not to prescribe what they should do. Yet when we survey their analyses, we find a

perplexingly wide divergence of views. Aestheticians hotly debate which analysis of interpretive logic is the correct one, but seem to be getting no closer to resolving this issue.

The reason for this, I contend, is that the question itself is spurious. There is no one logic of interpretation, but rather many "logics" of interpretation. Different critics play different interpretive "games" with different sets of rules or "logics" implicit in the games they practice. These games reflect and serve different ends, and the diversity of the games and their variant logics is concealed by the fact that they are not explicitly formulated or demarcated and tend somewhat to overlap. The diversity of interpretive logics is further concealed by their sharing much the same terms (e.g., "the poem," "the right interpretation"), though they use the terms in different senses. Analyses of interpretive logic diverge because they are analyzing different logics. They take as their objects different interpretive games.

I shall substantiate this claim by briefly surveying some of the major theories on the logic of interpretation and pointing to the different critical games which they respectively describe. In demonstrating that critical interpretation is not a univocal concept, I also argue that the philosopher as mere analyst is not justified in rejecting interpretive games that do not fit his model on the grounds that they are not "true" interpretation or that they do not satisfy the "true" or "proper" ends of interpretation. For the true nature and ends of interpretation are essentially contested by critics, and thus to determine such questions is to legislate or recommend and not to analyze. Of course, there is nothing to stop philosophers from campaigning for their preferred critical practices. But then we are going beyond mere descriptive analysis toward pragmatic advocacy based on our assessment of the practical consequences of such practices for art and its understanding. If we deeply care about art and criticism, we seem impelled to go beyond descriptive neutrality. But even if we need a further pragmatic turn, this does not negate the value of analysis for clarifying our critical options and their comparative assets and liabilities.

Two final introductory remarks are in order. First, for reasons of brevity and simplicity, my examples of critical practice relate to literary arts. In any case, the logic of critical interpretation is most often discussed with respect to literary arts, perhaps because these arts, like their criticism, are clearly linguistic in nature. A second point is that philosophical analyses of critical interpretations can be usefully compared to the interpretations they analyze. As the critic interprets the meaning and import of the original artwork, so the aesthetician must interpret the interpreting critic's remarks. As the same work or line of poetry may be taken in a number of ways, so the same critical interpretation or remark may sometimes be taken or interpreted differently. As the interpreting critic may sometimes assert that a line has a meaning other than that intended by the author, so

the interpreting metacritic sometimes asserts that a critical remark has a logical status different from that intended by the critic. This analogy might suggest that if it seems impossible to reach a simple, final, and unchallengeable interpretation of a complex artwork, then there is also little likelihood of reaching a simple, final, and unchallengeable interpretation of interpretation.

II

What is the logical status of interpretive statements? The three major views on this issue may be characterized as descriptivism, prescriptivism, and performativism. To make our comparison of them more convenient, let us adopt the formula "W is I" as representing a typical interpretive statement (e.g., "*Measure for Measure* is allegorical," "*Hamlet* is a study of a vacillating, melancholy hero"); where "W" is a variable whose values are artworks, and "I" is a variable whose values are interpretive predicates about individual artworks. We can then portray and contrast these three interpretive positions by seeing how they differently analyze this formula. Of course, the formula is only a rough simplification of the language of critical interpretation; for interpretive statements are made not just about individual artworks *tout court* but about parts of artworks or groups of several artworks (an author's entire corpus, a genre, a period, a style). Moreover, the complex meanings that art criticism predicates of its object of interpretation may not always be adequately indicated by a single predicate variable like "I." Nevertheless, we can usefully deploy our formula for clarifying and contrasting the rival theories of the logic of interpretive statements.

1. *Descriptivism* treats interpretive statements as expressing propositions. But there are many brands of descriptivism which find very different propositions in the same typical interpretive statement. The subjectivist construes "W is I" as "W is I to me." Oscar Wilde and Walter Pater are among the most famous proponents of this theory of interpretation, and many critics practice in accord with it. These critics (who include Pater, C. A. Swinburne, and Arthur Symons) have been appropriately labeled impressionist critics, since their interpretive assertions concern their impressions of the artworks they interpret.[2] Here, if the critic is sincere, his interpretation will be true, but such truth may be aesthetically trivial in the sense that it is truth about the effect of the artwork on the critic and not about the work itself. The value of such interpretation is seen not in its literal truth but in the beauty and richness of experience it describes and affords its reader. An interpretation is evaluated in much the same way as the work it interprets is evaluated, and we thus should view (to borrow Wilde's phrase) "the critic as artist."

Subjectivism has its appeal. Conflicting interpretive statements about a work of literature and our critical tolerance of them are easily explained

by the subjectivist position, for certainly a work can be or mean different things to different people. However, not all interpreting critics accept to practice according to the subjectivist standard. Many critics rather claim or assume that their interpretive efforts are aimed at Mathew Arnold's nonsubjectivist goal, "to see the object as in itself it really is."[3]

Such an ideal is held by proponents of strong descriptivism, or absolutism, for whom "W is I" quite simply means "W is I." Interpretive statements are either true or false, and conflicting interpretations are incompatible and cannot be accepted. The interpreter either correctly describes the true meaning of the work or else he is not successful. However, in different versions of absolutism, the true meaning of the work may be identified as independent of the author's intention (as in Beardsley's theory) or it may be identified with authorial intention (for example, as E. D. Hirsch and others do).[4] Moreover, authorial intention may be identified with what is called the "actual intention" of the author (Hirsch, Iseminger, Carroll, Knapp, and Michaels) or with an ideal, hypothetical authorial intention, as in "our best projection of intent" or "best hypothetical attribution" of the author's intent (Levinson).[5]

Despite the philosophical skill of its respective advocates, the actual/hypothetical intention distinction strikes me as lacking in real substance, since the author's *actual* intention when writing the work can only be adduced, pragmatically speaking, in terms of a hypothesis about that intention (even if the author himself is making this hypothesis). As I explain more fully elsewhere, since intentions are always to some extent indeterminate, corrigible, and variously interpretable, we cannot simply invoke an author's intention in an artwork without involving an interpretive hypothesis as to what that intention is (in terms of scope, precision, etc.) or even which intention it is, because authors often revise their intentions during (or even after) the process of conceiving and composing their work.[6] Advocates of both actual and hypothetical intentionalism fail to counter such arguments.

Even if we concede that there are important differences between these various intentionalist theories, they all seem to share together with Beardsley's anti-intentionalism a strong commitment to strong descriptivism. For the strong descriptivist, we may never know with certainty that we have the true interpretation, but it is at least there to be known and makes all interpretations which differ from it false. This straightforward view (which seems akin to commonsense realism) is troubled by the fact that very different interpretations of the same work often strike one as acceptable and, in some sense, apt. Yet, by the absolutist doctrine, only one of them can be true, and the others must therefore be wrong or false.

Because of this problem, some philosophers of art have suggested a brand of weak descriptivism which abandons the notion of absolute truth and falsity for the logically weaker notions of plausibilty and adequacy.

For the weak descriptivist, "W is I" means " 'W is I' is (highly or most) plausible' " (Margolis) or " 'W is I' is (highly or most) adequate' " (Weitz).[7] Both Margolis and Weitz construe interpretive assertions as expressing explanatory hypotheses and not statements of fact. Both maintain, moreover, that the plausibility or adequacy of interpretations can be graded, albeit vaguely. Both also distinguish interpretation from description, the latter being statement of facts and the former the explanation of these facts. Yet their belief that there are such facts supporting and explained by an interpretation places them in the descriptivist camp.

Both strong and weak descriptivists can appeal to differing interpretive procedures in actual critical practice to support their metacritical models. Thus Margolis, in arguing for his relativist view that interpretations are logically weak and tolerate conflicting interpretations, appeals to the following remarks of a critic as "typical": "Too bare a summary cannot do justice to the cogency of Mr. Knox's proofs or to his valuable insights. His interpretations must be welcomed with thanks, provided we do not (as he would doubtless insist we should not) exclude other modes of interpretation."[8] Beardsley, the strong descriptivist, in attacking Margolis's position and in arguing for the "intolerability of incompatible interpretations," also brings examples of what he considers typical critical remarks to support his absolutist position. He cites, for example, Samuel Hynes, who affirms the incompatibility of Clark Emory's and Hugh Kenner's contrasting interpretations of Pound's *Cantos*: "Obviously, they cannot both be right; if the passage describes an earthly paradise, then it cannot be a perversion of nature."[9]

Is Margolis's or Beardsley's citation more typical? Surely we are not to determine this by mere statistics, but there seems to be no other way. Is it not clear that these diverse remarks, claimed to be typical, are indeed typical of variant interpretive practices? The logical status of interpretations is differently described because not all interpretations have or are meant to have the same logical status. Besides the logical plurality within the descriptivist position, there are two other general positions that claim to provide the logical model of all interpretation. But they too, I now argue, reflect, like descriptivism, only some of the many interpretive games critics play.

2. *Prescriptivism* regards interpretive statements not as expressing true or false propositions nor even adequate or inadequate hypotheses, but rather as expressing decisions or recommendations about how to regard an artwork. The prescriptivist analyzes "W is I" as "W should be seen as I" or "W is to be taken as I." A work of art may be seen in many different ways, taken to mean many different things. Witness the vast variety of different views that critics have taken of *Hamlet*. According to prescriptivism, the interpreting critic is recommending which manner of regard-

ing the work we should adopt, and his arguments to support his interpretation are attempts to get us to accept this recommendation and see the work as he does. First suggested in Wittgenstein's writings on aesthetics and the notion of aspect, prescriptivism was later affirmed by analytic philosophers like Charles Stevenson, Arnold Isenberg, and Virgil Aldrich.[10]

Stevenson, who gives the clearest and most cogent presentation of prescriptivism, argues that interpretive judgments are essentially expressions of "the critic's decision" on how the work of art should be observed and "quasi-imperative" recommendations that others should observe or regard the work similarly: "Having roughly familiarized himself with all the ways in which a work of art can be experienced, a critic must proceed to make a selection from among them—a decision about how he is to observe the work in the course of his subsequent appreciation" (*PHA*, 357). "It is the task of a critic not merely to dwell upon an aesthetic surface, but to make up his mind, and to help others make up their minds, which aesthetic surface is to be dwelt upon" (*PHA*, 380).

For Stevenson, "the critic's 'decision'—the channeling of his sensibilities in which he comes to accept certain ways of observing a work of art, when appreciating it, and to reject others" (*PHA*, 361)—introduces the normative or prescriptive character of interpretive judgments. This is because such decisions are based on and governed by factors that are not merely logical or cognitive. Conceding that critics often give their interpretive statements the air of objective description, Stevenson argues that behind this guise of objectivity, interpretive statements really function as prescriptions or quasi-imperative recommendations. Thus, for example, when the critic makes the interpretive assertion that a work is unified, he is implicitly, but essentially, recommending that we observe it in that way; and our acceptance of this judgment may be compared "with the overtly imperative expression, 'Yes, let's observe it in the way that makes it appear unified' " (*PHA*, 374).

The prescriptivist view of interpretation can explain our relative tolerance for a variety of interpretations and our sense of the challengeability and lack of finality of any one interpretation. It can do so simply by its view that there are many different ways of seeing the work and that an interpretation (i.e., the recommendation of one way) does not logically exclude other ways as false or unprofitable. Critics often debate which interpretation is better or worse, or even right or wrong; but right and wrong or proper and improper must not be confused here with true and false. For prescriptivism, the critic, in asserting that his interpretation is proper or right, is essentially asserting that the artwork *should* be taken or seen as he sees it rather than that it factually is what he describes it as.

The prescriptivist position purports to describe actual interpretive practice and can appeal to interpretive statements that clearly suggest the

prescriptivist view. Its claim that any interpretation a critic propounds is only one of many possible interpretations that a work may admit is strongly expressed by one interpreter of *Hamlet*, Francis Fergusson. Fergusson, who argues for his own myth-ritual interpretation of *Hamlet*, admits that the work can be seen differently from other points of view. Nor do differing interpretations logically exclude or rule one another out. "It is not necessary to rule out the Eliot-Robertson or the Joycean interpretation, merely because one accepts Mr. Dover Wilson's: on the contrary, the various critics should be taken as Jamesian 'reflectors,' each lighting a facet of the whole from his own peculiar angle."[11] All these other possible interpretations are nevertheless rejected by Fergusson. Even Weitz, who argues against the prescriptivist view of interpretation, admits that Fergusson's remarks and practice do suggest "the view that critical interpretations are neither true nor false, but invitations on the part of the critic to see the play or some aspect of it in the way the critic proposes in his particular interpretation" (*HP*, 102).

The second prescriptivist tenet—that the critic is essentially deciding and urging that of the many viable ways of seeing the work his way should be adopted, and that the interpretive statement is in this sense normative and quasi-imperative—gains support from many critical comments. Take the following remarks by the renowned English critic F. R. Leavis. In arguing against the established view of *Othello* as a noble hero cunningly undone by a greater villain whose mind and character are as intriguing and crucial as Othello's, Leavis surely seems to recommend in normative fashion a way of seeing the play. "We ought not in reading those scenes to be paying so much attention to the intrinsic personal qualities of Iago as to attribute to him tragic interest of this kind."[12] He continues to urge us in a quasi-imperative manner: "And it is plain that what we should see in Iago's prompt success is not so much Iago's diabolical intellect as Othello's readiness to respond."[13] It is possible to give a non-prescriptivist interpretation of these remarks, but nevertheless such remarks, as they stand here and also in their context, surely suit and support the prescriptivist model of interpretation and make it seem that prescriptivism, like descriptivism, is a proper account of some interpretive statements.

3. *Performativism* holds a different view of interpretive statements. They are neither descriptions nor quasi-imperative recommendations but rather performances. "W is I" is construed not as a statement but as a practical demonstration of W in I-fashion. The performativist likens critical interpretation to interpretive performance, which is not to say that the two are not distinguishable in important ways. The performativist point is that critical interpretation, like interpretive performance, is to some extent creative in the sense of helping to determine the qualities and meaning of

the work of art rather than merely revealing them. According to some versions of performativism, an artwork is a schematic object with various "gaps" of indeterminacy that are filled in by interpretation. If the text of *Hamlet* implies that Hamlet studied philosophy at Wittenberg, there is no determination at all of the kind of philosophy he studied and his attitude toward it. Such features and meanings are thus not simply there to be described by critics but depend partly on interpretation for their determination. The performativist denies that there is a clear description/interpretation dichotomy, much as many philosophers of science reject the observation/theory dichotomy, for both hold that "the facts" are themselves theory- or interpretation-dependent.

As the prescriptivist could explain the widely divergent interpretations of a given work of literature as recommendations to observe the work in different ways, so the performativist can explain this variety of critical interpretation as parallel to that of interpretive performances, none of which is final in the sense of ruling out all others. Moreover, as the prescriptivist may employ the normative terms of right and wrong, correlative to the descriptivist true and false, so the performativist also may characterize or grade interpretations as successful or unsuccessful, convincing or unconvincing.

In analytic aesthetics there is no extensive formulation of the performativist position, but two important analytic thinkers profess views that could be characterized as performativist. Richard Wollheim, for example, argues that critical interpretation, like interpretive performance, is ineliminable and never final, and he cites Paul Valéry's maxim: "A creator is one who makes others create."[14] Wollheim also argues against a clear fact/interpretation distinction in the arts, since what we choose to count as relevant facts often depend on our interpretation of them as such. For example, when we take it as a fact that Hamlet loved his father because he said so, we are simply interpreting his claims as true while rejecting other evidence in the play that implies a contrary, psychoanalytic reading.

Margaret Macdonald presents the most explicit performativist statement: "criticism and appraisal, too, are more like creation than like demonstration and proof,"[15] and "the task of the critic resembles those of the actor and executant rather than those of the scientist and logician" (*AL*, 127). She also denies the fact/interpretation dichotomy, since works of art "are not simple objects whose features can be presented for listing" (*AL*, 126). Interpretation, then, is creative and helps constitute its object. Indeed, it is ineliminable since the work itself is constituted by its interpretations—is what it is interpreted to be—and cannot exist apart from some interpretation:

> It is often said that a great artist is reinterpreted in every age and no doubt by some of these interpretations he would be much aston-

ished. Yet even the apparently bizarre interpretations are often illu-
minating. It seems to follow that interpretation is partly subjective
invention. . . . Certainly, the critic claims to be interpreting the
work, not supplying his own fancies. But the work is what it is in-
terpreted to be, though some interpretations may be rejected. There
seems to be no work apart from some interpretation. (*AL*, 126)

In more recent times, Arthur Danto has similarly insisted that artworks
cannot exist without interpretation, since it is only their interpretation as
art that can distinguish artworks (e.g., Andy Warhol's *Brillo Box*) from the
mere real things that are their perceptually identical material counter-
parts. But Danto limits such interpretation to the creative one of the origi-
nal artist's intention, so his theory of interpretation needs to be classified
with intentionalist descriptivism, not with performativism.[16] Of course,
many deconstructionist theorists affirm the performativist position by ar-
guing that all interpretation is a creative, performative misprision or
rewriting of the work, and cannot help but be. Likewise, the pragmatist
Stanley Fish claims: "Interpretation is not the art of construing but the art
of constructing. Interpreters do not decode poems; they make them."[17] But
since deconstructionist and pragmatist theories of interpretation are ex-
tensively treated in the next chapter, I concentrate here on more tradi-
tional theories and styles of criticism.

Even within the conservative confines of traditional Anglo-American
criticism, we find considerable support for performativism. Helen Gard-
ner tells us, for instance, that we must "allow a work to gather meaning
through the ages,"[18] and that consequently there can be no "final and in-
fallible interpretation."[19] Lionel Trilling expresses a similar view, regard-
ing a literary work as a kind of concrescence of various meanings it was
held to have over the ages, while Lascelles Abercrombie maintains "that
anything which may be found in that [work of] art, even if it is only the
modern reader who can find it there, may legitimately be taken as its
meaning."[20] These remarks are in the form of critical doctrine, but they are
deeply based on the influential success of creative critical practice; and
Gardner, for example, cites Samuel T. Coleridge and A. C. Bradley as re-
warding creative critics.

We can even find performativist elements in the practice of critics who
do not claim to be "creative" in this sense of determining the work rather
than revealing it. J. Dover Wilson in his interpretation of *Hamlet* argues for
certain textual emendations that would result in changing the work as it
exists in all of its early textual forms (e.g., substituting "sullied" for
"solid" or "sallied").[21] His interpretation also involves the insertion of
what he considers lost or omitted stage directions: for example, the "lost"
stage direction giving Hamlet an entry on the inner stage in II, 2, 158, en-

abling him to overhear Polonius and Claudius plotting the eavesdropping of his talk with Ophelia, and the "fact" that Claudius does not see the dumb-show because he is talking instead with Polonius or Gertrude. Moreover, it is noteworthy that the validity of Wilson's interpretations are challenged and defended in terms of the success of possible and actual performances embodying them (*HP*, 130).

The same sort of performative interpretation which seems more to determine than reveal or explain the alleged givens of a work may be seen in M. C. Bradbrook's interpretation of the last soliloquy of Doctor Faustus, where she argues against William Empson's reading.

> Ugly hell, gape not! Come not, Lucifer!
> I'll burn my books—Ah, Mephistopheles.
>
> The last is, of course, a scream (and so the reading proposed by Mr. Empson does not stand).[22]

However, its being a scream is not, of course, a fact in the text which is described or explained by interpretation, but is itself a product of interpretation. The test of such an interpretation would seem to be its success and appeal rather than its truth as description or explanation. Even if it is defended in terms of being consistent or true to the rest of the play, one still seems to be justifying a creative determination on the grounds of harmony rather than justifying a descriptive truth by evidence.

There is more than a grain of truth in performativism, but like descriptivism and prescriptivism it errs by generalization. A roughly faithful model of some interpretive statements will be a distorted theory of all interpretation, because interpretive statements often differ significantly in what they logically express or perform.

III

As we distinguished three theories of the logical status of interpretive statements, so there seem to be three, though not wholly parallel, theories on the role of reasons in interpretation. The first claims that the reasons a critic gives for his interpretation provide evidence that logically supports his interpretive hypothesis. Though the hypothesis may not be fully verified, it can at least be partially confirmed as probable, plausible, or adequate by the reasons given in support of it.

This view nicely complements the descriptivist position, so it is not surprising that Weitz, Margolis, Beardsley, and Hirsch adopt it. In certain interpretive undertakings, reasons clearly do have this role. Historically oriented (and especially author-oriented) interpretation certainly employs its reasons as confirming evidence. If one's interpretive hypothesis concerns

what the author intended by the poem (and for many critics this is the interpretive goal), then facts concerning the historical setting, the conventions and audience of the period, and the life and other writings of the author all may be introduced as evidence that helps to confirm or falsify the particular hypothesis. Stevenson, who rejects the view that reasons have this logical role of evidence, still admits that *if* one sees authorial meaning as the goal of interpretation, then one could regard reasons as functioning as evidence in an inductive argument, "each giving to an interpretive conclusion this or that sort of partial confirmation."[23] Thus, for at least one interpretive game (which Stevenson ultimately thinks is not worth playing) reasons have a logical role as evidence.

What then is Stevenson's view of the role of reasons in interpretation? Reasons relate to interpretive conclusions not in terms of strict logical evidence but more as causal explanations or motivational justifications. The interpretive judgment expresses the critic's decision to observe the work in a particular way; and his reasons for such a decision are not purely cognitive in nature, since in art appreciation one's aims are not purely cognitive. Besides, "like any psychological process, the critic's decision has a great many causes," among them "the critic's personal sensibilities."[24] Thus, the relation of critical reasons "to the quasi-imperative judgment they support (which is the same, in essentials, as the relation between knowledge and the decision knowledge guides) is causal rather than logical; hence they 'guide without constraining' " (*PHA*, 370).

Reasons function in this causal or motivational way in James Smith's allegorical interpretation of *Doctor Faustus*.

> Recognition of both these allegories, and that they are of complicated rather than simple type, is, I think, necessary to remove obstacles to the reader's enjoyment. For if it is not made, various absurdities arise which are incompatible with the reputation the play is felt to deserve.[25]

Smith here is deciding (and asking us) to adopt an allegorical interpretation in order not to diminish the enjoyment or appreciation of the play. Such a reason far more resembles a motive or cause for making an interpretive decision than a piece of evidence logically confirming a "scientific" hypothesis. When reasons for an interpretation are closely tied to such goals as increasing the reader's enjoyment, or making the work more impressive, they do play a causal and normative role, explaining the motives for a decision and recommending this decision on the basis of these motives.

What I call perceptualism is the third theory of the role of reason. According to the perceptualist, interpretive reasons have two different but

complementary tasks. First, they may function as verbal attempts to isolate elements in the critic's general perception of the work. They clarify and articulate the critic's interpretation to the critic himself in terms of further descriptions of aspects of that interpretation. Second, the critic may use these perception-focusing reasons as devices to clarify and convey his interpretation to his reader by inducing in the reader the desired view of the work. The interpreting critic is trying to get his reader to perceive the work in a certain way, and the reasons he gives for his interpretation work toward that end.

This view stems from Wittgenstein and has been endorsed by many analytic aestheticians (e.g., Aldrich, Isenberg, and Paul Ziff).[26] G. E. Moore describes Wittgenstein as claiming that reasons in aesthetics are "of the nature of further descriptions" that clarify and convince by providing examples and comparisons that focus perception. Such reasons "draw your attention to a thing" by "plac[ing] things side by side," and "by giving reasons of this sort, you make another person see what you see."[27]

Here the relation between reasons and interpretive conclusion is not logical. Nor is it causal in the sense that the reasons cause the critic's particular interpretation. Moreover, it is only the *giving* of these reasons (rather than the reasons themselves) that may be a cause of the reader's accepting the critic's interpretation; for following the given reasons may help the reader to focus on the work so that he sees it as the critic does. An example can explain this distinction. Suppose that in presenting an interpretation of a love poem as harsh and insincere, the critic cites the predominance of voiced plosives and the similarity of its imagery to some bawdy song. Neither the plosives nor the similarity are themselves what cause the reader to perceive the poem as harsh and insincere, but the act of citing these reasons may focus attention on the work in such a way that the perception of harshness and insincerity is induced.

Thus, the perceptualist sees the critic's use of reasons in justifying an interpretation not as logically confirming it by evidence, nor as recommending it through the motives which caused it, but simply as perceptually justifying it by creating in the reader the desired perception of the work. Reasons are but "hints and directions for focusing the attention in the very difficult art of exercising and cultivating the skill to perceive."[28] The meaning of the critic's reasons "is 'filled in', 'rounded out' or 'completed' by the act of perception," where the goal is "to induce a sameness of vision, of experienced content."[29] The interpreter's success is to get the reader to assent by bringing him to share the interpreter's perception or experience of the work.

Many critical arguments suit the perceptualist position. John Casey argues that Leavis's greatness as a critic stems in part from his use of such perceptualist reasoning.[30] Leavis is indeed a master of this technique, and

he seems aware that he uses it to induce sameness of vision or experienced content.

> I hoped, by putting in front of them . . . my own developed "coherence of response", to get them to agree (with, no doubt, critical qualifications) that the map, the essential order, of English poetry seen as a whole did, when they interrogated their experience, look like that to them also.[31]

An excellent example of how Leavis tries to induce such sameness of vision in the interpretation of a single work is in his study of *Othello* (mentioned above but far too complex to summarize here). His argument is structured around a series of excerpts from the text, where each passage is preceded by "focusing instructions" of what we are to look for and see in it, followed by further discussion to ensure that we see what we are meant to see.

Which of these three different theories of the role of reasons in interpretation should be crowned as the correct analysis? None seems entirely convincing, but each seems to have some element of truth. Is it not reasonable to suggest that there are at least three different roles or kinds of reasons in interpretation? There are reasons that function as evidence toward an interpretive conclusion, reasons that are essentially motives or causes in a decision to take and recommend a particular view of an artwork, and reasons (often in the form of further descriptions and comparisons) that function as devices to clarify and to induce a particular perception of a given work. The diversity of reasons seems to stem from a diversity of interpretive aims. Do we critics and readers want authorial intention, maximal enjoyment, or articulation and sharing of our own perception of the work?

Aestheticians often assume that this diversity of aims or functions is somehow misguided, that there must be only one proper aim, task, or object of interpretation. As Beardsley puts it, we must choose among the diversity of "possible interpretive tasks or inquiries . . . which of them is the proper function of the literary interpreter."[32] But there seem to be no grounds for this assumption, outside of the equally questionable assumption that criticism is or should be simple and uniform. Of course, in different contexts, there are always pragmatic grounds for choosing one task rather than another. But that is a different story involving the pluralities of contexts.

Philosophers who seek a simple, uniform analysis of interpretation (but also critics who are hostile to rival aims and methods) might condemn the practices that deviate from their favored mode as either nonaesthetic, hedonistically nonobjective, unsystematic, or boringly unimag-

inative. But one cannot legislate them out of existence. They are interpretive enterprises that are pursued, often fruitfully, by qualified critics, and an adequate analysis of the logic of interpretation cannot ignore them.

IV

The debate on interpretive logic is mostly focused on the two aspects considered above, but controversy can also arise concerning the general character or structure of interpretive argument. Is it essentially inductive, deductive, both, or neither? Some interpretive games are typically inductive, some have distinctly deductive elements, while others seem to present a logic of an entirely different sort. Historical critics who see as their goal the revelation of the author's intention present interpretive arguments that are essentially inductive in character and that point to a probabilistic conclusion. Data may be gathered from dictionary meanings, from the author's life and other works, and from the conventions and beliefs of the author's audience in order to suggest and confirm a hypothesis regarding the meaning the author intended in the work. Such an interpretive program may work within a general inductive framework, as even its opponents (like Stevenson) admit.

It is hard to find a theorist who explicitly claims that interpretive logic is deductive, though Harold Osborne firmly maintains that *evaluative* logic is. Weitz, however, does claim that all interpretations are essentially explanations in the form of deriving a specific interpretive hypothesis from a general hypothesis and a theory "about which category or combination of categories of explanation is most effective" (*HP*, 255). He also analyzes some interpretations that do exhibit a somewhat deductive character. For example, Caroline Spurgeon's interpretation of *Hamlet* may be schematically presented as deducing its conclusion from two premises: (1) In Shakespearean drama the imagery is central and conveys the meaning and (2) *Hamlet*'s imagery is predominantly that of disease and decay. Therefore, *Hamlet*'s meaning is that of man's condition of disease and decay. Of course, the premise that decay imagery is predominant in *Hamlet* needs to be justified inductively. But the argument seems to have a generally deductive framework.

Many compelling interpretive arguments seem neither inductive nor deductive nor a combination of the two. Such arguments frequently consist of a complex arrangement of focusing remarks, leading questions, and suggested answers which bring an often imaginary interlocutor to a particular desired conclusion. This type of argument might be called dialogical or dialectical (though not in the Hegelian sense); it can be found in philosophical writings as disparate as Plato's dialogues and Wittgenstein's *Investigations*. Some philosophers of art suggest that interpretive argument is essentially of this sort. Fine critics like Leavis confess that this

is what they actually do; putting their judgments "in the form: 'This is so, is it not?' " to invite "a collaborative exchange or commerce."[33]

Critics like Leavis are masters of such dialectical arguments of suggestion, question, and comparison; treating the reader as an interlocutor and constantly appealing to and compelling his assent. Take the following example from Leavis's interpretation of Blake's poem "Hear the Voice of the Bard":

> In spite of the semi-colon at the end of the second line we find ourselves asking whether it is the Holy Word or the Bard that is calling the "lapsed soul". There is clearly a reference to the voice of God in the Garden calling Adam, but is it God who is weeping in the evening dew? And is it God that might control the starry pole?—though it could hardly be the Soul (an interpretation permitted by punctuation and syntax) that might? And surely "fallen light" is Lucifer? . . . Looking back at the first stanza we can see how Blake uses the Christian theme and subdues it completely to his own unorthodox purpose. The opening line is Druid and pagan in suggestion (how utterly remote from Gray's Bard Blake is!) and "Present, Past, and Future" suggests Fates, Weirds, or Norns—suggests, in fact, anything but a distinctively Christian sense of Time and Destiny. . . . [34]

This sort of argument is neither deductive nor inductive, yet we cannot deny it is argument, indeed powerful argument. So just as we found no single logical status for interpretive statements and no single, uniform role of interpretive reasons, so there is no single general form of interpretive argument. Interpretive logic is a hotchpotch. There is more than one aspect to the analysis of the logic of interpretation, and even with respect to the same aspect there is more than one logic to be analyzed. Theoretical pluralism seems to be the only position that an analyst can honestly maintain in the face of the plurality of interpretive practice.

Similar conclusions emerge in an analysis of the logic of evaluation.[35] There too we detect the same three aspects for analysis and the same variety of philosophical positions with respect to each. Again, these different positions on evaluation reflect a plurality of logics in actual critical practice that in turn reflects a variety of evaluative aims.

V

We should be wary of attempts to deny and obscure interpretive variety by using notions whose ambiguity (by already including plurality) suggests a false unity. Thus, Weitz tries to unite the multiplicity of interpretive

practices under "only the one function of explanation." But even if all interpretive practice could be characterized as explanation, fundamental plurality would still remain. As Stuart Hampshire remarks (echoing Austin and Wittgenstein), "there are very many types of explanation."[36] Even the explanation of meaning admits different types of explanation, given the enormous ambiguity of the meaning of "meaning." Thus, the common claim of different interpretive enterprises to explain "the true meaning" of the work should not be regarded as assurance of the same interpretive aim or logic. And when in *Pragmatist Aesthetics* I suggested a different, wider general formula for interpretation—the idea of making sense—that would also cover interpretive practices not aimed primarily at truth, I made sure to insist that this formula must be pluralistically construed in terms of the "fundamental variety" of very different aims, strategies, and logics of sense-making.[37]

The logical pluralism which I maintain should be distinguished from a more limited cognitivist pluralism that recognizes merely a plurality of valid objects and methods of interpretation. According to that narrower pluralism, there are many approaches to the many aspects of an artwork with respect to which true (or truth-like) interpretive assertions can be made. There can be true interpretation of what the work meant to its author and true interpretation of what it means to the reader, true interpretation of its contemporary social meaning and true interpretation of its archetypal meaning. Thus, we can have differing and sometimes conflicting interpretive assertions that are true or plausible. Such a position of critical pluralism has been advocated by several analytic philosophers since Weitz and Margolis.[38]

I grant such plurality but go further by arguing that not all interpretations are assertions that aim to be true or plausible. Nor are all interpretations recommendations, nor are they all performances. Interpretive statements rather exhibit a plurality of logical status as well as a plurality of subject matter and viewpoint. Interpretation is not one game but a family of games; and as in other families, there are sibling rivalries where the value and even legitimacy of certain members of the family are bitterly contested. If each of these different games is coherently and successfully played, how can the philosopher as mere analyst crown only one as the logic of interpretation?

My talk of interpretive "games" relates, of course, to Wittgenstein's notion of language-games as the crucial basic phenomenon of practice from which we should philosophize. The term "game" must not be taken as implying that interpretation is simply a frivolously playful enterprise of "anything goes." For games themselves do not allow just anything. So when an astute and careful philosopher like Jerrold Levinson criticizes my

interpretive theory for being what he calls "ludic," he must mean something more than my notion of interpretive games.

In attacking my views in order to defend the theory of hypothetical authorial intentionalism, Levinson's main complaint seems to be that I justify the sort of performative interpretation that was made notorious by deconstruction but was already practiced in New Criticism. Such performativism accepts interpreters' interests and intentions as partly determining the meaning of an artwork and (at least in certain interpretive games or contexts) as being able to override the author's. Levinson claims that "this enfranchising of reader's intentions, purposes, or perspectives, unconstrained by the goal of hypothetically reconstructing the best authorial intention . . . gives all too much to readers, and threatens to undermine the motivations of authors for upholding their end of the implicit literary contract."[39]

There are many things that puzzle me in this critique. I shall put aside the troubling question of whether the vast variety of practices of writing and understanding literature are really governed by one kind of implicit contract, of what that contract exactly is, and whether it is simply a matter of only two different parties (author and readers) rather than a complex negotiation that equally involves editors, publishers, marketing publicists, booksellers, and so forth. I shall also put aside the problem of Levinson's presumably clear distinction between hypothetical authorial intentions and readers' intentions when he in fact defines the former in terms of the "notion of an appropriate reader."[40] I shall simply emphasize again what he and other critics of my interpretive theory (like Robert Stecker) are prone to forget: that my acceptance of certain performative interpretive games (where the interpreters' intentions may be able to outweigh those of the author) does not deny that there are other games where authorial intentions (however conceived) are clearly primary and ruling.[41]

Levinson, however, insists that the game of authorial intention must always be "primary."[42] But it does not follow from the fact of one logic being "primary" that other logics are reducible to or less important than that first logic. My pluralism is consistent with recognition of certain pragmatic priorities, but I cannot agree to intentionalism's primary status for interpretation without knowing more clearly what is meant by being primary. Does it mean being more important than other forms of interpretation or simply being more basic or primitive in level? We need, moreover, a real argument that explains why seeking the author's intention always must be primary, apart from the vague worry that sometimes using different ways of interpreting art might possibly undermine some vague, hypothetical contract.

Intentionalists like Hirsch have in fact provided an argument that authorial intention must always be primary in order to fix the reference

without which interpretation does not have an object to interpret. However, as I explain in chapter 3, there are other effective ways through which such reference can be established for purposes of critical communication, for instance in terms of consensus as to what counts as the text we are interpreting. So authorial intentionalism is not primary in the sense of being necessary for individuating the artwork as an object of criticism. I am more interested in stressing pluralism than primacy; but if I had to take a position with respect to primacy, I would claim that there is something both prior to and more basic and important than either the individual author's or the interpreter's intentions. These are the cultural traditions of writing and reading that prestructure both authorial and readerly intentions.

Does my pluralism entail that all interpretive games are equally valid or adequate? No. Assuming some interpretive aim (and we always do, no matter how vaguely and implicitly), certain methods or practices are clearly more adequate than others. But interpretive aims themselves cannot be reduced to a single logical kind.

One further argument against logical pluralism should be addressed: How can the logic of interpretation differ from game to game when a logic of interpretation must suit the ontological status of the object of interpretation, and surely the object of interpretation—the work of art—always has the same ontological status? Two responses are possible here. Assuming that artworks have an unchanging ontological status, one could argue that this ontology is precisely the kind that allows plural logics through the work's indeterminate gaps or its culturally open, historically constructed character. This strategy could even allow room for interpretations of authorial intentions. But there is also a more radical response: to affirm that an object of interpretation can change to some extent its ontological status. In other words, one could argue that because artworks are cultural objects whose ontological status is determined by the cultural practices through which they exist, the precise ontological status of an object of interpretation therefore depends to some extent on the kind of interpretive game we are playing with it.

If this seems shocking at first glance, we should recall that ready-mades are commonly claimed to have their ontology transformed from ordinary objects into artworks simply by the artworld's artistic interpretation of them. So why cannot ontological changes be likewise effected by framing an object in different cultural logics of interpretation? Related issues of work-identity can be treated in ways commensurate with such ontological and logical pluralism, by treating the identity of an artwork as a "gradable cluster concept."[43]

I shall not, however, pursue such issues further here. This is because I view the ontology and identity of cultural objects as merely the changing,

dependent precipitate of cultural practices. So attention is more usefully directed to studying those practices than to reconstructing the presumed ontology of the objects they structure and deploy. My arguments to justify this preference against Danto's and Margolis's metaphysical proclivities can be found in chapters 10 and 11.

3.

Croce on Interpretation
Deconstruction and Pragmatism

Benedetto Croce is a pivotal figure in modern aesthetics. He stands at the juncture of nineteenth- and twentieth-century thought, Janus-like, facing both. He looks back to Hegel and to nineteenth-century idealism, with its faith in the superior power of the imagination and its pre-Freudian trust in the integrity and identity of individual consciousness. On the other hand, Croce boldly looks forward to the major theme of twentieth-century philosophy in both analytic and continental traditions, namely, the linguistic turn. Long before Wittgenstein, Heidegger, and Gadamer, Croce had already advocated the fundamental and inalienable linguistic nature of our experience and knowledge of the world.

Little attention is given today to Croce's general philosophical views. He is most remembered for his aesthetic, which was exceedingly influential in the early twentieth century, because it expressed, in an admirably bold yet coherent philosophical form, the captivating spirit of the symbolist-aestheticist revolt against nineteenth-century positivism. Symbolism's enormous appeal stemmed from its attempt to protect a rich realm of spirituality—the mysterious glories of art—from the relentlessly encroaching and reductivist grasp of deterministic causal explanation that characterized the regnant positivism of the day. If positivism had undermined religious faith, then the defense of human spirituality on the artistic front became even more necessary and pressing. Nourished on the romantic ideas of art's spiritual genius, humanists did not want art reduced, as the positivist Hippolyte Taine proposed, to a mere causal product of *"race, milieu, et moment,"* where artistic masterpieces were seen as mechanically determined and "bound up with their causes as a physical phenomenon with its condition."[1]

In insisting that art could not be reduced to laws or causes, in defending the autonomy, primacy, and cognitive power of the creative intuition that generates art against the prevailing dogma that science was the only

worthy form of thought, and further in specifically attacking all existent varieties of aesthetic positivism (historical, naturalistic, and rhetorical-academic), Croce worked the visionary insights of the "art for art's sake" movement into a systematic gospel of the aesthetic, articulated in a respectably philosophical idiom. Humanists who were keen to champion art and defy the imperialistic claims of science were quick to hail Croce as the dominant twentieth-century aesthetician, a position he more or less maintained until his analytic critics rudely discredited and deposed him, as we saw in chapter 1.[2]

In this chapter, I examine Croce's treatment of an issue that is essential to any philosophy of art—the possibility and nature of valid interpretation. The problem with Croce is that his views on language and reality threaten to make this possibility an impossibility. Although he explicitly affirms that true interpretation and appreciation can be frequently achieved, there is a subversive subtext in his *Aesthetic*[3] that seems to imply that all interpretive readings are condemned to be misreadings because of philosophical arguments that today are associated with the theory and practice of Derridean deconstruction.

Croce's problem of interpretive validity is best understood in relation to Derrida, perhaps our closest contemporary analogue to Croce. Both Croce and Derrida have digested Hegel's historicism but refused its conceptualism and teleology of progress; both placed language at the center of their thought; and both rebelled against the reigning literary science of their respective days. For Croce this was positivist historical criticism, for Derrida it was structuralism. More significantly, Croce and Derrida share a number of important philosophical themes and strategies. Both insist that what we call reality is essentially a temporary and dynamically developing linguistic construct, "a provisional dynamic system developing through provisional and dynamic systematizations" in which there is no promise of an ultimate system.[4] Just as for Croce all the world "is nothing but intuition or aesthetic fact," and the aesthetic is essentially linguistic in the broad sense of expression; so for Derrida *"Il n'y a pas de hors-texte."* There cannot be "a reality . . . outside the text whose content could take place, could have taken place outside of language" and its changing "systematic play of differences."[5] For Croce and Derrida, language not only constitutes the world, but is an irrepressibly creative force which is constantly transforming itself. "Language," says Croce, "is perpetual creation" (*A*, 150); and Croce's continually creative, category-defying, linguistic intuition-expression clearly adumbrates Derrida's uncontainable disseminating *différance*, which "is incompatible with the static, synchronic, taxonomic, ahistoric motives in the concept of structure" and which "marks an irreducible and generative multiplicity."[6]

This points to a third important theme, which we could call antitaxonomism. Croce and Derrida insist that distinctions which we naturally

employ and take as valid have no ultimately unchallengeable rationale or justification. Such distinctions are inherently imperfect, wobbly, and conventional, since they lack any grounding in ontological essences or in transcendental rational justification outside the system of language. Derrida's deconstructive reversal and undermining of privileging binary oppositions are perhaps the hallmark of his thought, but Croce pointed the way toward this as well and was notorious in his day for his subversive challenge of criticism's rhetorical categories and of philosophy's traditional distinctions.[7]

In rebelling against the dominating yet philosophically problematic distinctions of the positivisms of their times, in their common revolt against what they see as oppressive closure, Croce and Derrida use the same strategy of insurrection. To defy the dominating discipline's authoritative strictures, they invoke a more potent and fundamental force, a supreme and subversively protean principle of creative generative freedom: intuition-expression for Croce, disseminating *différance* for Derrida. They then argue that the restrictive science's constitutive distinctions cannot be clearly and consistently drawn, and that the hierarchical order in these distinctions can be reversed. Croce undermines Taine's positivist distinction that privileges historical reality over art (and that presumes the latter is epiphenomenal to the former) by maintaining that historical reality is itself the product of aesthetic intuition and thus a form of art. This is a striking precedent for Derrida's deconstructive reversal of the philosophy/literature opposition, performed by treating philosophy as a form of writing.

In recognizing these deep affinities, we should not obscure important differences between Croce and Derrida. Croce's famous doctrine that intuition is expression deeply differs from Derrida's key notion of *différance* and seems painfully susceptible to Derridean deconstruction. Croce's equation that intuition is expression could be deconstructively construed as pathetically begging the question while graphically admitting (in the very formula of coupling the two concepts) the basic alterity of intuition and expression, signified and signifier, presence and trace. The equation of intuition and expression could also be deconstructed as a distortive longing for closure through the complete commensurability and union of signifier (expression) and signified (intuition). Derrida would stress the anxiety behind Croce's identification of intuition and expression, behind his assertion that "they are not two, but one"—an anxiety tellingly betrayed in Croce's remark that "he who separates intuition from expression never succeeds in reuniting them" (*A*, 8, 9). Less relentless than Derrida in questioning distinctions, Croce affirmed essential distinctions between practical and theoretical activity and between conceptual (or logical) thought and intuitive (or aesthetic) thought, even if he also argued that the conceptual must be based on the intuitive.

But the crucial difference for this chapter is that Croce firmly believed that interpretive truth could be achieved through the recovery or reproduction of original meaning, while Derrida fiercely challenges this possibility, evoking the paradoxical idea that texts are "unreadable"—that they admit of no correct understanding or valid interpretation. This important divergence is particularly intriguing against the background of their shared historicist view of language as protean and dynamically creative. How, one wonders, could Croce maintain his flexible, historicist openness to the constant change of meaning without abandoning his claim to interpretive knowledge and true understanding?

Croce's problem of interpretation still haunts contemporary aesthetics. Uncomfortable with absolutist theories that presume one metaphysically fixed meaning for every work, most theorists are even less comfortable with Derrida's interpretive skepticism. Croce's theory of interpretation therefore deserves our detailed consideration, not just for its historical interest but for our contemporary concerns.

II

According to Croce, to understand an artwork requires some identity of meaning or shared apprehension between artist and her interpreter. More specifically, this "identity" is achieved by the interpreter's "reproduction" of the artist's original intuition-expression, with which Croce identifies the work of art itself. If the artist aims to produce a successful intuition-expression, the aim of the interpreting critic is *"to reproduce it in oneself."* Thus, if we succeed in properly interpreting or appreciating Dante's *Divina Commedia,* "in that moment of contemplation and judgement our spirit is one with that of the poet, and in that moment we and he are one thing" (A, 118, 121).

Viewing criticism as a close spiritual communion between artist and interpreter, Croce not surprisingly asserts the essential identity of genius and taste, that which creates and that which judges. They represent the same intuitive-expressive capacity; their "only difference lies in the diversity of the circumstances" of its application: the former in "aesthetic production," the latter in "reproduction" (A, 120). Their divergence can only be a matter of context or quantity, because "to posit a substantial difference between genius and taste, between artistic production and reproduction, would render both communication and judgement alike inconceivable" (A, 121).

The premise of Croce's argument is that the products of a given activity can only be properly judged by that same activity or one essentially the same. If we accept this premise but deny that "genius and taste are . . . substantially *identical*" (A, 120), then interpretation and appreciation are indeed impossible. This argument does not threaten the possibility of interpretation, not only because we can recognize a continuum between taste and genius, criticism and creation, but more obviously because the

motivating premise of the argument is so dubious. Judging the winner of a race is surely altogether different from racing it, yet who would deny that such judgments are possible and valid?

The serious Derridean threat to Croce's idea of true interpretation concerns the impossibility of ever properly replicating or reproducing a particular intuition-expression because of the linguistic character of all intuition-expression and the essentially changing and contextual nature of language. For Croce, all thought, and hence all the intuitions that constitute both artworks and their reproductive criticism, are necessarily linguistic (in the wide sense that extends beyond the merely verbal). This is why he describes all art as intuition-*expression*; and since the very essence of language, for him, is its creativity and expressive structuring of experience, language is substantially the same as art. Hence he boldly declares, "*Philosophy of language and philosophy of art are the same thing*" (*A*, 142).

Treating art and criticism as language is not in itself problematic, but it becomes so if language is conceived as an irrepressibly creative and protean force; and this is clearly how Croce sees it: "Language is perpetual creation. What has been linguistically expressed is not repeated. . . . The ever-new impressions give rise to continuous changes of sound and meaning, that is, to ever-new expressions" (*A*, 150). If aesthetic intuitions are always linguistic and if language is continually changing, how could we ever succeed in adequately replicating the original intuition-expression with which the work is identified? But if exact replication is not possible, then for Croce true interpretive understanding is also impossible.

Committed to the validity of interpretation and too shrewd a philosopher not to see how it is thus threatened, Croce prudently makes an exceptional proviso to allay the danger. "What has been linguistically expressed is not repeated," says Croce (introducing the exception which I temporarily elided above), "save by reproduction of what has already been produced." Once this exception is granted, true interpretation seems possible. But why should we grant it? Given Croce's or Derrida's general view of the continuously creative and changing nature of language, how is such reproduction ever achieved?

The historical and mental context of the interpreter and the current state of language in which she is situated must be different in some respects from that in which the artist originally produced the work. And such contextual and linguistic differences would preclude the complete identity of author's and critic's intuition-expressions that Croce's model of interpretation requires. Even if author and critic both grasp what would ordinarily be called the very same words, these words are not really identical in meaning for author and critic. This is because such words will have not only different associations for different people but will have, at

various times and contexts, different systemic functional relations (syntagmatic and paradigmatic) with other elements in the open-ended changing linguistic system that determines meaning in structural terms. Even the author rereading her own work after some lapse of time will face the problem of the difference of context and language which the passage of time inevitably brings.

Croce seems to recognize such problems of context. Affirming that art's intuitions are "the aesthetic synthesis of impressions," he admits that such intuitions must vary because the constituent "impressions or contents [must] vary; every content differs from every other content, because nothing repeats itself in life" (*A*, 68). Croce infers from this "the impossibility of *translations*," since the translator's attempt at aesthetically capturing or "remolding" an original expression necessarily involves "mingling it with the personal impressions of the so-called translator," producing unavoidably a new, different intuition-expression (*A*, 68). However, the same problem surely arises with respect to interpretations, which (as Gadamer and others have noted) are like translations in the sense of rendering the meaning of one literary text in the words of another.[8] Surely the personal impressions of the interpreter are inevitably there, potently mingling with the text in her apprehension of it, just like the translator's are. The very same logic that brings Croce to the impossibility of translations also suggests the impossibility of interpretations, a conclusion he desperately wants to resist.

From such Crocean reasoning (but also from other arguments) deconstructionists have been quick to conclude that literary texts are in an important sense "unreadable." They argue that "all readings are [necessarily] misreadings," because the changing contextual nature of language and understanding does not allow the recovery of an unchanging determinate identity of meaning that is presumed necessary for true interpretation.[9] Thus Jonathan Culler, one of deconstruction's most influential exponents, maintains that the notions of "reading and understanding [claim to] preserve or reproduce a content or meaning, maintain its identity, while misunderstanding and misreading distort it; they produce or introduce a difference."[10] But on Crocean–Derridean premises, Culler then argues that this claim of reading is groundless. If language is always changing with context so that its understanding always involves some difference, then this makes absolute identity, preservation, or replication of meaning an impossibility. As Culler pithily puts it, "meaning is context-bound but context is boundless," "new contextual features . . . alter illocutionary force."[11] Since meaning can never be completely circumscribed contextually so as to permit perfect replication, true reading or interpretation is rendered impossible, and "all readings are misreadings."

This argument can be refuted. Even if its skeptical conclusion seems to follow validly from its two premises, at least one of these premises is dan-

gerously false. We may accept the Crocean–Derridean view of the continuously changing character of language, even though we should stress that much of this change is insignificant and occurs against a dominant background of some sort of continuity. However, the second premise—that understanding or interpretation is the recovery or reproduction of an identical object, "a content or meaning"—must be rejected as a very misleading, though very pervasive, philosophical picture that has long enthralled our thought.

As Wittgenstein tried to teach us, meaning is not a separate object or content but merely the correlate of understanding something. And understanding something is not a mirroring correspondence or reproduction of some fixed intentional object; it is fundamentally an ability to handle or respond to that thing in certain accepted ways that are consensually shared, endorsed, and inculcated by the community (forming part of the fabric of its form of life) but that are nonetheless flexible and open to divergent interpretation and emendation. We can thus defend validity of interpretation while eschewing the model of objectivity as correspondence to a permanently fixed object-meaning. Objectivity can instead be construed in terms of normative consensus within an interpretive community or tradition.[12] But that is not the interpretive model used by Croce, to whom we now return.

Croce bravely confronts the threat that changes of language and context could preclude the identical reproduction of an intuition-expression and hence the possibility of true interpretation. "When speaking of . . . [such] reproduction," he cautions:

> we said the reproduction takes place, *if all the other conditions remain equal*. Do they remain equal? Does the hypothesis correspond to reality? It would appear not. In order to reproduce an impression several times by means of a suitable physical stimulus it is necessary that this stimulus not be changed, and that the organism remain in the same psychical conditions as those in which was experienced the impression that it is desired to reproduce. Now it is a fact that the physical stimulus is continually changing, and in like manner the psychological conditions. (*A*, 123–24)

Croce notes the many ways that history can significantly alter our appreciation of an artwork by altering its material form (or, in literature, its text) and by modifying the interpretive conventions and psychological conditions of its reception. He refuses to seek refuge in the then-popular idea that artworks function like natural signs and therefore should be identically understood by all people, no matter what their historical, linguistic, or psychological contexts. Like today's more radical historicists, Croce boldly

declares, "Natural signs do not exist; because all are equally conventional, or, to speak with greater exactness, *historically conditioned*" (*A*, 125).

But if we grant the changes of material, historical, linguistic, and psychological contexts and their undeniable influence on our understanding of an artwork, then, Croce pointedly asks: "How are we to succeed in causing the expression to be reproduced by means of the physical object? How obtain the same effect, when the conditions are no longer the same? Would it not, rather, seem necessary to conclude that expressions cannot be reproduced, despite the physical instruments made for the purpose [that is, the material objects or texts in which artworks are embodied], and that what is called reproduction consists in ever new expressions?" (*A*, 125).

This is precisely the radical conclusion of deconstruction: every reading is necessarily a new misreading, somehow altering rather than identically reproducing the author's original meaning. In fact, deconstruction's critique of the "presence" of meaning and of the integrity and autonomy of the authoring "subject" could be used to challenge the very idea that the author has a unique, determinate, and definitive original meaning that she gives to the work.

To avoid the conclusion that reading necessarily alters and thus fails to reproduce meaning, to save the possibility of interpretation in his reproductive model, Croce must show that "the varieties of physical and psychical conditions" and the differences of linguistic and historical contexts are not "intrinsically insurmountable." He must insist that "we can replace ourselves in these conditions in which . . . [the work] was produced" and thereby reproduce or truly understand its intuition-expression (*A*, 125). But how can he maintain this?

III

One argument Croce employs is the analogy of understanding our past selves and our friends, which also involves understanding through different temporal or psychological contexts. If we were not able to "replace ourselves" into the conditions of our past selves and those of our acquaintances, Croce argues, then self-knowledge and social understanding (likewise assumed to rest on identity of experienced content) could never be achieved. "Individual life, which is communion with ourselves (with our past), and social life, which is communion with our like, would not otherwise be possible" (*A*, 125).

This argument begs the question in a "wishful thinking" way. According to Croce's presuppositions, understanding ourselves and others entails an ability to place ourselves imaginatively in the requisite conditions so as to achieve the requisite identical mental content. Then, hopefully assuming that we really have as a matter of fact such true understanding of

self and others, Croce concludes that we must have the capacity for this mental "replacing" and reproduction (*A*, 125–27). But this assumption of true understanding or communion is precisely what is at issue in the skeptical challenge from variety of context. The same challenge can be directed at the subject's own claims to understand her past self by identically reproducing its past mental contents despite significant changes of context. Surely Freudian and poststructuralist challenges have put the subject's unity and transparency seriously into question. But Croce has a nineteenth-century faith in the unity and integrity of individual consciousness. He also has an extremely romantic faith in the power of imagination, which serves as the *deus ex machina* for surmounting the variety of contexts and achieving the identical reproduction of mental content that, for him, defines understanding.

Croce is quite forthright about the importance of "the intuitive absoluteness of the imagination." "If the absoluteness of the imagination were removed, the life of the spirit would tremble to its foundations. One individual would no longer understand another, nor indeed his own self of a moment before, which is already another individual considered a moment after" (*A*, 122, 123). The imagination is here portrayed as some sort of transcendental, all-powerful force that can overcome the seemingly insurmountable differences of intuitive-expressive content that changing contexts clearly bring.

Croce, however, is careful to emphasize that the imagination does not work its miracles alone. It relies, first, on the efforts of artistic restoration (including the philological reconstruction of texts) to reproduce the work's material conditions; and second, on historical criticism, which serves "to reintegrate in us the psychological conditions which have changed in the course of history." It is only with the aid of restoration and historical research that imagination "revives the dead, completes the fragmentary, and enables us to see a work of art (a physical object) as its author saw it in the moment of production." "A condition of this historical labor toward true interpretation is tradition . . . where tradition is broken, interpretation is arrested" (*A*, 126).

The use of these tools may temper the extravagance of Croce's claim for imagination, especially if we forget that he sees history itself as a product of aesthetic intuition and aesthetic imagination (*A*, 26–30). But it does not relieve the mystery of how imagination can really surmount all differences to achieve an identity of intuited meaning with the artist's privileged, definitive intuition of the work. And no clue is given as to how we could ever know that such an identity is really achieved rather than falsely assumed—how we could measure our imagined reproduction with the original intuition itself.

To avoid such mysteries, Croce's best way to defend interpretive

knowledge as some sort of reproductive union with the author's meaning would be to adopt a radical pragmatist remedy. Blurring the distinction between finding and making, the pragmatist would assert that the imaginative reconstruction of the artist's intuition by the work's interpreters is all that really remains of the intuition that is to be united with or replicated. If Croce wants to identify the artwork with the artist's intuition-expression, then he should hold that there is, practically speaking, nothing more to understanding that artwork than our imaginative reconstruction of the artist's definitive intuition-expression through the aid of historical and restorative tools and interpretive traditions. This strategy would bring Croce's interpretive theory more in line with the Wittgensteinian consensual-practice account of meaning and understanding noted earlier.

The pragmatic point is that there is no "cash value" to the artist's intuition-expression, no possible way to grasp it and use it as a touchstone of correct interpretation, apart from some possible interpretive reconstruction of it. For whatever use we wish to make of the artist's original understanding of her creation, all we (or the artist) can ever have of it is an interpretive reconstruction of what it was, even if that reconstruction is based on the artist's own retrospective testimony. The unity of understanding that Croce requires of valid interpretation could then be construed and achieved as a fusion between the interpreter's point of view and the projected understanding of the artist as it is (continuously) reconstructed by the interpretive community in the course of the work's interpretive history. This gives another sense to Croce's notion of the absolute power of imagination: not a romantic transcendental potency to surmount all differences of contexts and mysteriously unite us with remote realities as they originally were, but an imminently pervasive power that is continuously making or refashioning the realities with which it deals.

Not only *could* Croce avail himself of this pragmatist strategy (which seems implicit in the nonskeptical theories of interpretation of Hans-Georg Gadamer and Stanley Fish),[13] he in fact seems committed to it by his view of historical reality and of literary history in particular. "History," says Croce, "is included in the universal concept of art," since it consists of "neither induction nor deduction" nor the presentation of general truths or concepts, but is rather a representational narrative of particulars, produced and understood only through the shaping and synthesizing agency of the imagination and memory. History, or "real imagination," is distinguished from the "pure imagination" of fiction by means of memory, but both rely on "probability" and "verisimilitude" to convince us of their validity (*A*, 27, 28).

This view that history is always a new intuitive-expression rather than the mirroring reproduction of old facts and perceptions is confirmed in Croce's account of art history. The historical facts themselves are "form-

less, incoherent, and meaningless" until they are shaped into a convincing and ordered narrative representation by the aesthetic intuition, thereby yielding a new expression. "Artistic and literary history is therefore *a historical work of art founded upon one or more works of art*" (*A*, 129, 131). Historians of art continuously reshape as they reconstruct the art of the past. "Purely historical historians do not and cannot exist . . . they will always add something of their own" (*A*, 134–35). The same must hold for all interpreters of past works, or for any reader the moment she tries to articulate her understanding of the text by writing another text.

We have, then, two possible ways to construe Croce's theory of interpretation. In the romantic construal, the interpreter truly reproduces in her own mind the author's original intuition as it was exactly experienced by the biological author and as it remains metaphysically fixed as an object of meaning expressed in the work. This reproductive union is alleged to be attainable through meticulous historical research of the author's life and times, through the restoration of the original artifact as it was originally produced, and most importantly through the absolute power of imagination to transport us mentally into the author's original conditions and intuition of the work.

On the other hand, the pragmatist construal requires neither metaphysically fixed mental objects of meaning as the goal of historical interpretive research nor any titanic leap of imagination to place us in the mind of the author. The author's creative intuition and the meaning of her work are instead construed not as psychic or semantic objects that are already fully and finally determined in an absolutely fixed historical past, but rather as relational notions that are shaped (and can be reshaped) by literary and historical understanding, which is essentially imaginative and creative, molding facts rather than mirroring them. On this view of history, which Croce surely shares, all historical facts and objects are in some sense "ideal" or historically constructed by the mind and human practices, rather than being simply brute realities. If this pragmatism seems more attractively consistent with Croce's account of history, other remarks in his *Aesthetic* suggest the romantic construal. Which, then, better represents Croce's real view of interpretation, and how should we decide what "his real view" means in this context?

One way to decide is by looking at Croce's actual interpretive practice. For Croce not only theorized but practiced literary criticism. Soon after his *Aesthetic*, he began to write critical essays on modern Italian literature, which were subsequently collected in his mammoth six-volume *La Letteratura della nuova Italia*. He later wrote sizeable individual studies of Goethe, Ariosto, Shakespeare, Corneille, and Dante, while also composing more general treatises on a variety of literatures: ancient and modern, Italian and other European, folk and high poetry.

Croce's critical practice accords strikingly more with the pragmatist account of his interpretive theory—and increasingly so as his criticism matured.[14] Even when interpreting an author to define and highlight her individuality, Croce does not treat the author as a "real" historical person, that is, as an empirical, biographical subject whose actual psychological conditions and circumstantial motives are to be reconstructed. Instead he sees the author as an "ideal" personality or persona, who is basically present in and constructed from her works as those works are interpreted by perceptive critics. Consider Croce's treatment of Shakespeare, whose distinctive poetic sentiment Croce defines as the "profound sense of life" in all its contradictions, tensions, and "strife in vital unity."[15]

Sharply distinguishing Shakespeare's biographical (or "practical") personality from his "poetical personality," Croce insists we must not confuse "the character and development of his life" with "the character and development of his art." Only the latter should be "the object of study for the critic and historian of art"; preoccupation with the former "often leads to delusion" and inspires scholarly "conjectures based upon air" that have no substantial bearing on the artwork. Asserting the "indifference of the poetical work towards biography" (*ASC*, 117, 129, 131), Croce traces the development of Shakespeare's art—proceeding from the dreamlike vagueness of the comedies of love and romance to the "hard reality of the historical plays" and finally "to the great tragedies, which are dream and reality and more than dream and reality" (*ASC*, 267). The developing series of Shakespearean intuitions that Croce reveals turns out to be altogether different from the actual chronological development of the Shakespearean corpus so praised by T. S. Eliot and others. It is instead "nothing less than the ideal development of Shakespeare's spirit, deduced from the very quality of the poetical works themselves, from the physiognomy of each and from their reciprocal relations" (*ASC*, 267).

Croce does not confront the worry that these reciprocal relations and perceived physiognomic qualities might be very different if the corpus were construed in its chronological order. For he imperiously rejects the actual or "real" chronology as unreal: "the ideal is the only truly real development, while the chronological is fictitious or arbitrary, and thus unreal; that is to say, in clear terms, it does not represent development, but simply a series or succession" (*ASC*, 268). Apart from its unconvincing bluster, Croce's remark fails to recognize that biography and chronological analysis are also history (involving imaginative reconstruction) and thus, by his own account of history, must be ideal as well.

Rejecting as "erroneous philology" the detailed historical study of Shakespeare's times and circumstances, Croce urges an "intrinsic" approach. The critic's interpretation should arise from a focused "examination of the works before him." Yet this scrutiny is not that of an innocent eye, since one already

begins with a constructed view of Shakespeare, "the synthetic or com-
pendius image . . . [he has in] the common patriarchy of culture." Croce's in-
terpretation of Shakespeare builds largely (though often polemically) on the
opinions of past critics; and he cites them almost as frequently as he does
Shakespeare's texts. His rejection of the biographical approach for deter-
mining the artist's intuition is so extreme as to insist "that it is necessary to
make an effort of abstraction, to forget biographical details concerning the
poets, in those cases where they abound, if we wish to enjoy their art, in
what it possesses of ideality, which is truth" (*ASC*, 119, 133, 138).[16]

Croce has clearly distanced himself from the romantic view of interpre-
tation that aims at exactly reconstructing an author's biographical circum-
stances so that we may then unite with her original intuition of the work
by some fantastic leap of the imagination. In rejecting such authorial in-
tentionalism, Croce even imputes its "useless labors" of philological and
historical scholarship to the romantic dream of perfect understanding
through unity with the author's actual lived experience or intuition of her
work. Such "hybrid biographical aesthetic" interpretation, he argues, "in
common with the philology of the nineteenth century in general, is un-
consciously dominated by romantic ideas of mystical and naturalistic
unity . . . These labors are animated with the hope of obtaining knowl-
edge of the poetry of Shakespeare in its full reality by means of the dis-
covery of the complete chronology, of biographical incidents, of allusions,
and of the origin of his themes" (*ASC*, 121). In contrast to authorial inten-
tionalism, Croce advocates a more intrinsic attention to the artistic text it-
self: "We do not know what were the intentions of Shakespeare and as
usual they matter little, because Shylock lives and speaks, himself ex-
plaining what he means" (*ASC*, 216).

Taken together, the sharp distinction between the poetic personality
and the biological author, the rejection of intentionalist interpretation for a
more intrinsic textualism, and the consequent devaluation of historical ex-
egesis in interpretation make Croce (despite his talk of authorial intuition)
look very much like a mid-twentieth-century New Critic. But this does
not preclude his looking like a pragmatist. For the New Critical argument
against intentionalism, especially as articulated by Wimsatt and Beards-
ley, was clearly and consciously pragmatic in its motivation. Not only is
the text far more available than the author's original intention, but con-
centration on the text is far more productive of aesthetic rewards.[17]

IV

The best way to counter the skeptical deconstructionist drift in Croce's
theory of interpretation is not by a romantic appeal to a mysterious, tran-
scendental imagination but instead by an earthy pragmatist refusal of the
rigid metaphysical contrast between the artwork's meaning in itself as

foundationally fixed and what it is reconstructed to be. One argument for this pragmatist strategy is that we have no way of getting hold of the work itself apart from some possible reconstruction of it. Although we can have an immediate experience of an artwork—that is, an experience prior to articulating an interpretation of it—we cannot erect such experience into a permanent criterion of work-identity or work-meaning. This is because the immediate experience itself is evanescent rather than permanent; and the moment we try to fix it through linguistic articulation we are already involved in reconstructive interpretation. Hence, we can never measure our understanding of the work against something permanently, independently, and determinately there—the work "as in itself it really is" or the author's original understanding of it—that we could know (and know we know) independently of our interpretive efforts to determine or reconstruct it through our interpretive imagination.

Identifying the work with what it is reconstructed or interpreted to be, however, makes it seem logically problematic to explain the possibility of error in a widely accepted, well-established interpretation. But without the possibility of error, how can there be a significant, substantive sense to validity in interpretation? Of course, the pragmatist can explain the error of a particular reader's interpretation in terms of its failing to comply with the reconstructed understanding of the work that is established in the given critical community. But what are we to say about this firmly entrenched and community-endorsed understanding with which the pragmatist here identifies the work and its meaning? Surely it must be possible for such an interpretation to be wrong, to require correction, if we want our calling it "right" to have any distinct sense, if we want "the right interpretation" to mean something other or more than "the currently established interpretation." Yet how can we allow for our accepted interpretation to be wrong if we refuse to admit the notion that the work itself exists apart from all interpretations and functions as the standard which can prove even accepted interpretations to be mistaken or inadequate?

The best pragmatist reply is to argue that the ever-present possibility that an established interpretation may prove wrong can also be explained pragmatically. In other words, we can explain it not by appealing to the possibility of finding the absolutely, exclusively, and permanently right interpretation, but rather by the simpler possibility of merely finding or forming a better interpretation, one that could prove more acceptable, convincing, or fruitful. Such evaluative predicates could, in turn, be construed in pragmatic terms rather than in terms of absolute permanent truth (e.g., "better" would not denote "closer to the single absolute truth of the ontologically fixed meaning of the work"). As long as the future is open, as long as interpretation continues, there is always the possibility of

encountering a more compelling interpretation that we think should oust the interpretation currently established as the valid (or most valid) one.

The reason we cannot identify the right interpretation with the currently accepted one is *not* that it is always an open question as to whether the latter truly mirrors or reproduces the foundationally fixed meaning of the work. The reason is rather because there is always a possibility of finding or devising an interpretation that is still more acceptable, more cogent and valid. And the notions of validity, cogency, and acceptability could be understood as a function of the considered, consensual endorsement of competent interpreters and their changing needs. These notions would also be construed as gradable, contestable terms of commendation that are continually open to reassessment. Pragmatism means fallibilism and the possibility of interpretive revision.[18]

V

Such pragmatist strategies provide a promising option between rigidly analytic and recklessly deconstructive accounts of interpretation. Analytic aesthetics often defends the objectivity of interpretation by construing it in terms of truth to an objective meaning that is metaphysically fixed in the artwork. Usually this objective "work-meaning" is identified with the intention of the artist (conceived as either actual or hypothetical); but sometimes it is instead identified independently in terms of the semantic features of the work itself, as Monroe Beardsley argues in his critique of "the intentional fallacy." In either case, interpretive truth is guaranteed by the presumed existence of a prior objective meaning that, in principle, is recoverable through systematic methods of interpretation, but that in actual practice allows for a variety of interpretations and so enables a productivity of readings that is important for the institution of academic criticism.[19]

Deconstruction, on the other hand, allows interpretive productivity by denying interpretive truth and rejecting any fixed objective meaning that a text could preserve for interpretation to recover. If linguistic meaning is not anchored in prior extralinguistic realities but is instead always the product of the systematic play of differences between the elements of language whose differential relations change with every change in context and every new use, then meaning is always changing. If "meaning is context-bound" but context is always changing, then meaning can never be perfectly preserved or replicated by an interpretation, which will always introduce its contextual difference. Hence, "all readings are misreadings," and interpretation, having lost the hope of truth, is unleashed to the unconstrained forces of uncentered "free play," where the very identity of the work seems threatened.[20]

The pragmatic approach acknowledges that language is dynamic and

changing but also that this change is not often very threatening to the identity and meaning of artwork because it occurs on a dominant background of continuity. More importantly, pragmatism rejects the idea that reading, understanding, and interpretation must be conceived as the recovery or reproduction of an identical semantic object, "a content or meaning." This misguided conception hypostasizes meaning as a distinct object rather than seeing it as something essentially relational and inextricable from human social practices, a point that deconstruction, in its wiser moments, does well to emphasize.[21]

Rather than reify meaning as an object, Wittgenstein explains it as the correlate of understanding. Understanding something is not the recapturing of a fixed semantic content but rather an ability to handle or respond to that thing in certain accepted ways. Though these ways of response are generally shared and endorsed by the community, they are nonetheless flexible and admit of some divergence and emendation. What counts as a proper response of understanding not only depends on the normative practices of the given society but also varies with respect to different contexts within that society and its subcultures. We should expect, for example, different responses with the ordinary, the literary, and the psychoanalytic understandings of an utterance. Understanding, as Wittgenstein remarked, means "knowing how to go on," how to project beyond past cases and previous forms of response. It involves, as Dewey noted, "a mode of interaction" between a responding agent and a structuring but flexible environment, an interaction through which both can be changed.[22]

Interpretive knowledge may be seen in this pragmatist fashion as a performed ability to respond to the work in ways conforming to the range of culturally appropriate response—either ways already accepted or ways capable of winning acceptance. On this account, our aim in interpretation is not to dig out and describe the objectified meaning already carefully buried in the text by its author, but rather to develop and transmit a meaningful response to the text. The project is not to describe the work's already given sense, but to make sense of the work. Although our sense-making activity is not enslaved to the task of mirroring fixed antecedent meaning, it is neither totally free nor condemned to arbitrary "misreading." For not only are we initially constrained by our cultural training to interpret artworks in certain ways that highlight their form, intensity, and meaningful reflection on life's problems, but we are powerfully impelled to continue this practice by the fear that so much beauty will be lost by interpreting them differently.

Our most established and respected practices of aesthetic interpretation seem governed by a twofold principle that could be called "coherent comprehensiveness of understanding." This principle aims at connec-

tively constituting a greater wealth of meaningful features into a more co-
herent whole, a coherent understanding that can extend beyond the limits
of the work itself and that can even be constructed on the interpretive in-
consistencies of the work by explaining them in a larger context.

However, from this general hermeneutic direction, no strict uniformity
of aims is implied, since there are a vast variety of socially entrenched,
aesthetically proven, yet mutually competing interpretive strategies for
making sense of texts, in other words, for rendering them coherent (even
in their occasional incoherence) to our understanding. The interpretation
sought by the textual critic piously reconstructing a text is hardly that of
the poststructuralist playfully deconstructing it. Contemporary criticism
is largely divided between reading with the text and reading against it.
Even within a single sense-making strategy (like authorial intention, to
the extent we can call it single), the precise aims and consequent stan-
dards of interpretive validity will vary with context, which always deter-
mines the whole in which understanding takes place. What is adequate
for a Sunday paper may not suffice for the seminar room or for academic
journals, whose standards are far from uniform.

Two other points contribute to the fundamental variety of interpretive
sense-making. First, not all interpretive responses are dominated by cog-
nitive purposes. The goal of enhanced aesthetic experience (as in creative
interpretive performance) can override the aim of trying to be "true" in a
nonaesthetic sense. Propositional truth, we philosophers need reminding,
is not the only worthy reason for reading and interpreting. Second, to
make sense of something is not always a matter of constructing an articu-
late propositional response at all. Some ways of responsive sense-making
can be so direct, immediate, and unthinking that they are better de-
scribed as simply reading or understanding rather than as interpreting;
they inhabit the vital and changing realm I have long described as "be-
neath interpretation."[23]

My pragmatist account of interpretation as sense-making should now
face the strongest argument for positing objectified meanings as the target
of reading and interpretation: Without some fixed meaning-object with
which to identify an artwork, there is no adequate way to individuate or
refer to the work as a common object of understanding. Hence, there could
be no possibility of fruitful critical dialogue concerning the work and how
it should be understood. Surely to understand a literary work (or anything)
must be to understand something, but without a fixed work-meaning there
would be no common meaningful object for readers and critics to under-
stand. If the text's identity as a meaningful object is only a product of ef-
forts to make sense, then as its readers make sense of it differently, would it
not then degenerate into different works? How can we continue to identify

it as the same work? Are we not obliged, then, to posit a fixed independent meaning to constitute the artwork's identity in order to secure the identity of reference that seems necessary for critical discussion of the work?

Pragmatism resists this argument of metaphysical coercion by distinguishing the logical issue of referential identification from the substantive issue of the nature, properties, or meaning of what has been identified. Although we may allow our interpretations (or experiences) of a text to differ, we must ensure the reidentification of the same text among this difference in order to talk about "the" text (and "its" different interpretations) at all. But such bare logical identity of reference does not entail that what is identified on different occasions is substantially the same. For practical purposes of discourse, we can agree that we are talking about the same thing, although differing radically as to what the substantive nature of that thing is—whether the airborne object in question is a bird, a kite, or a model plane. Agreement about referential identity can be secured by agreeing about a basic number of identifying descriptions, or it can be (and most often is) simply assumed without explicit discussion in accordance with our deeply entrenched cultural habits, for instance, our established practices of individuating artworks.

In distinguishing between substantive and referential identity, we can similarly distinguish between change *in* the object interpreted and a complete change *of* the object interpreted; the former need not (but can, if sufficiently extreme) involve the latter. A new interpretation or authorial revision can make a poem new without making it an altogether different poem in the referential sense of individuation.

For pragmatism, interpretation and inquiry are always rendering some sort of change in what they study; but if there are sufficient background continuities through these changes, we continue to identify the object of inquiry as the same object. Such objects are not totally fixed, but they are relatively stable; and the degree and nature of the desired stabilities depend on our (changing) purposes of individuation. Artworks are cultural entities that are constituted and reconstituted as individual objects by the practices and traditions of the cultures that they serve. Their individuation and identity (referential and substantive) rest on no fixed semantic ontology beyond such practices; they are as open to change as these practices are.

Recognizing this, we can easily explain how the work's substantive identity or meaning can change significantly over time although the work has already been "completed" by its author and although we continue to identify it as the same work. We could also stop agonizing over the question of whether or not, given such change, it really *is* the same work. For we would no longer assume that the question must have a single, clear,

and definite answer for all contexts (as it must if we assume that the work exists as a fixed, determinate, and independent object of meaning).

Instead, my pragmatist account sees the meaning of an artwork as a continuous and often contested construction of the efforts to determine its understanding and interpretation; that is, of efforts to determine how and what the work will be taken to be, which amounts, pragmatically speaking, to how and what it actually is. Such efforts to determine the work's understanding are often said to begin with the creative artist. But we should not forget that entrenched artistic and linguistic traditions are already determining the artist's efforts. And once those efforts are completed, the intentions that will continue to shape the work's understanding extend far beyond the artist's authorial control.

4.

Wittgenstein and Critical Reasoning

Wittgenstein is generally recognized as the analytic philosopher who did most to transform aesthetics from what was once described as woolly dreariness.[1] This is striking when we recall that despite Wittgenstein's great interest in the arts (especially in music),[2] aesthetics can hardly be considered among the prime areas of his philosophical writing—in contrast to logic, epistemology, ontology, philosophy of language and mind. He never wrote a book or even an article on aesthetics, and his views on the subject must be culled from scattered remarks in his general philosophical works, together with the accounts and transcriptions of some rather informal lectures on aesthetics given to small and select audiences at Cambridge.[3]

Still more striking is the fact that Wittgenstein's revolution in aesthetics does not seem to be constituted by any positively articulated theory of art, beauty, or aesthetic value. Wittgenstein's rather loosely organized remarks on aesthetics do not suggest that he was very interested in proposing any systematic theory. Moreover, we have his notorious assertion that the philosopher must eschew the propounding of any theory whatever: "And we may not advance any kind of theory" (*PI*, 109). Wittgenstein is probably most famous in aesthetics for providing the ammunition, fired by Morris Weitz and others,[4] for exploding all theories of art that aim at essentialist definitions. He is therefore sometimes seen as the devil's advocate of all theorizing in aesthetics. But it is unfair to present Wittgenstein's contribution to aesthetics only in such negative terms—as supplying the metatheory that invalidates all theory. Wittgenstein's ideas have also been central to theory construction in aesthetics; for example, his notion of "seeing-as" has figured significantly in theories of representation and theories of the aesthetic attitude.[5]

This chapter examines an area of aesthetic theory in which Wittgenstein's influence has been especially positive and powerful: the nature of critical reasoning. Around this issue some of his most important aesthetic views may be focused. Moreover, Wittgenstein's remarks on critical rea-

soning are comparatively detailed and come close to constituting a sub-
stantial theory. Certainly many aestheticians find one there. After tracing
three important themes of Wittgenstein's aesthetics that required him to
seek a new account of critical reasoning, I examine the theory he allegedly
provided. I then conclude by arguing that this would-be theory seems in-
consistent with the very doctrines that engendered it, and that if Wittgen-
stein really held such a theory, he has ironically fallen victim to the very
dangers against which he fervently warned us.

II

1. The first Wittgensteinian theme to consider is *the radical indeterminacy
of aesthetic concepts.* This familiar theme is an elaboration in aesthetics of
Wittgenstein's general doctrine of the indeterminacy and open texture of
ordinary concepts. Although ordinary concepts have blurred edges and
vague and flexible boundaries, and lack determinate essences, Wittgen-
stein argues that they are nonetheless usable, adequate, and legitimate.
Wittgenstein indeed suggests that a concept's vagueness and flexibility
can often make it more useful (*PI,* 71).[6] His exemplary discussion of such
indeterminacy with respect to the concept of game (*PI,* 66–71) is surely too
famous to warrant quotation here.

However, Wittgenstein goes on to assert that it is especially wrong-
headed to seek precise boundaries and exact definitions for the particu-
larly blurred concepts of aesthetics (and ethics), since such precise defini-
tion cannot by its very nature be faithful to the vagueness of the concept it
is supposed to represent: "won't it become a hopeless task to draw a sharp
picture corresponding to the blurred one? . . . And this is the position you
are in if you look for definitions corresponding to our concepts in aesthet-
ics or ethics" (*PI,* 77).

How does this doctrine of the radical indeterminacy of aesthetic con-
cepts constitute a revolution in aesthetic theory with respect to critical rea-
soning? To begin to answer this question, we should distinguish two
different kinds of aesthetic concepts. The first category could be called
artistic concepts or genre concepts (in a somewhat extended sense of
genre). It covers not only familiar genre concepts (such as "tragedy,"
"comedy," "epic," "symphony," or "sonnet") but also artistic style and pe-
riod concepts (such as "gothic," "mannerist," "baroque," or "cubist") and
even the concept of art itself, the mother of all genre concepts. In contrast
to such artistic concepts, we find another kind of aesthetic concept that
cuts across genre, period, and style distinctions. Sometimes called "aes-
thetic predicates," these concepts include such terms as "vivid," "deli-
cate," "unified," "balanced," "elegant," "discordant," "awkward," "life-
less," and of course the paradigmatic binary opposites, "beautiful" and
"ugly."[7] These concepts are also distinguished from the first by their char-

acteristic evaluative coloring. For all our love of the novel and the Gothic, the description of a work as a Gothic novel has very little evaluative import compared to its description as vivid and unified, not to mention beautiful.

But genre concepts also function in evaluation. Indeed, one of criticism's oldest and most widely used forms of evaluative argument is criticism in terms of the defining essence or rules of genre. Dating back to Aristotle, the argument is of a deductive form, premised on the definition of the given genre. The necessary elements or properties that define the genre (for example, those of Aristotle's definition of tragedy) also define what is required for a paradigmatic or excellent example of the genre and thus become necessary and sufficient criteria that define success or excellence in the genre. The underlying idea here, as R. G. Collingwood later articulated it, is that "the definition of any given kind of thing is also the definition of a good thing of that kind."[8] Hence, if a good exemplar of tragedy requires properties P1–Pn, and if work W achieves these properties, then it would follow that work W is a good tragedy.

Morris Weitz has explained how this model of evaluative argument underlies much of the evaluation of Shakespearean tragedy, especially in Samuel Johnson and Samuel Taylor Coleridge, and I have shown how this sort of argument is used even when there is uncertainty about ascribing genre.[9] Joseph Addison, for example, waives the controversial question of whether *Paradise Lost* is an epic poem, arguing that "it will be sufficient to its perfection" if it satisfies "the rules of epic poetry" and has all "the beauties which are essential to that kind of writing."[10] Demonstrating that *Paradise Lost* has all the properties or "beauties" required by Aristotle's definition of the epic, Addison can then conclude that whether or not we choose to call it epic poetry, it is certainly good poetry.

Because so much evaluative argument in criticism has been presumed to have this deductive form, relying ultimately on the definition of genre concepts, the correct definition of such concepts (including that of art itself) has naturally been assumed to be of vital importance. This explains the endless debate over the proper definition of artistic genres and of art itself. For depending on which definition of the relevant genre is embraced as the proper one, many works would be upgraded as being more congruent with the definition, while others would be downgraded as departing from it (or at least could no longer justify their value by appeal to genre).

If the definition of genre concepts supplies ultimate premises for deductive evaluative argument, then the proper definition of such concepts as poetry, tragedy, and art should be a crucial goal for aesthetics. The assumption was always that there must be a determinate defining essence for each genre concept; otherwise how could we use and understand our genre terms? By showing that our concepts need not have clear, fixed, and

definite essences in order to be usable and adequate, and by further insisting that aesthetic concepts are especially vague and flexible and thus inherently resistant and unsuitable to essentialist definition, Wittgenstein shattered this assumption. He thereby undermined the promise of deductive argument based on essentialist genre definitions, thus deflating the critical urgency of finding such definitions.

When Wittgenstein's doctrine of the indeterminacy of aesthetic concepts was first applied to art in the mid-1950s, there was a tremendous loss of interest in traditional attempts to define art and its genre concepts. Not until the late 1960s was there any notable new attempt. But that attempt—George Dickie's institutional definition of art (inspired by Arthur Danto's notion of "the artworld")—differs sharply from pre-Wittgensteinian definitions of art because it recognizes that there is no inherent essence in the surface properties of artworks. Instead, art is defined in terms of factors that lie beneath the aesthetic surface: the background of artworld institutions, art history, and social practices in which objects are framed to make them artworks.[11] But explaining artistic (and aesthetic) concepts in terms of the deeper background of our historically evolving cultural practices and "forms of life" is also a clearly Wittgensteinian idea, as we soon shall see.

Wittgenstein's theme of the radical indeterminacy of aesthetic concepts likewise provided an antidote to philosophy's compulsion to define concepts like beauty and sublimity. Definitions of beauty (like definitions of art and its genre concepts) were often sought to serve as criteria for evaluation, because such definition was thought to provide the categorical, universal premise in a deductive argument justifying particular judgments of aesthetic value. If beauty is defined as constituted by property B, then whatever has B is beautiful; and thus, if a particular artwork or natural phenomenon possesses B, we can conclude that it is beautiful. But definitions of beauty have been no more successful than definitions of art; for beauty too is a concept whose content, borders, and application are not only vague, flexible, and contextual, but are essentially contested by its many users.

Wittgenstein realized this. He held "definitely that there is nothing in common in our different uses of the word 'beautiful,' saying that we use it 'in a hundred different games'—that, e.g., the beauty of a face is something different from the beauty of a chair or a flower or the binding of a book" (*PP*, 313). Thus, by challenging the assumption that concepts need clear boundaries and common essences to be functional, and by pointing to the apparent lack of these features in the concept of beauty, Wittgenstein destroyed the faith that there must be an essential definition of beauty which could serve as a touchstone for critical evaluation and as an ultimate justificatory premise for evaluative argument. Definitions of beauty thus fell out of vogue, but another account of critical reasoning would have to be offered.

2. A second Wittgensteinian theme that changed the field of aesthetics and generated a new account of critical reasoning is the *logical plurality of critical discourse*. This theme has two aspects: (1) recognition of the logical variety of critical statements and (2) recognition of the plurality of critical frameworks. Both ideas are salient in Wittgenstein's 1938 lectures on aesthetics, and the first seems to be a straightforward application in aesthetics of his famous doctrine that language performs a variety of logically different tasks. Language is not a monolithic instrument, but more of a toolbox. The functions of words and sentences are at least as different as the functions of different tools. "Think of the tools in a tool-box: there is a hammer, pliers, a saw, a screw-driver, a rule, a glue-pot, glue, nails, and screws.—The functions of words are as diverse as the functions of these objects" (*PI*, 11).

A major source of errors in philosophy, Wittgenstein argues, is the assimilation of the many different functions of diverse words into one single paradigmatic type. We tend to concentrate philosophical attention on a single word (or type of word) as representing the essence of all the key terms of a certain area of inquiry. We thus assume that by determining the meaning of this word we can essentially resolve the entire area of inquiry. This error can be found in traditional aesthetics' preoccupation with the predicate "beautiful." As we noted earlier, intense concentration was directed at defining the beautiful, because it was assumed to provide the key to all our questions of critical evaluation.

Wittgenstein, however, argues that this approach is very wrong. In the first place, if we look at our evaluative judgments in criticism, we find that we hardly use the word "beautiful" at all, but more often words like "right" and "wrong." Indeed, we use a variety of kinds of predicates and expressions.

> It is remarkable that in real life, when aesthetic judgements are
> made, aesthetic adjectives such as "beautiful," "fine," etc., play
> hardly any role at all. Are aesthetic adjectives used in a musical crit-
> icism? You say: "Look at this transition," or . . . "The passage here is
> incoherent." Or you say, in a poetical criticism, . . . "His use of im-
> ages is precise." The words you use are more akin to "right" and
> "correct" (as these words are used in ordinary speech) than to
> "beautiful" and "lovely." (*LA*, 3)

Second, not only are there different kinds of critical predicates, but often the very same critical predicate can be used in logically different ways. Though "beautiful" and "lovely" are most often used as interjections and expressions of approval, they can also be used descriptively. We can describe the *character* (as opposed to the value) of a picture as beauti-

ful or lovely. We might even describe certain artworks that border on kitsch as too beautiful or too lovely. Here these aesthetic predicates are surely functioning very differently than from their typical use as mere expressions of approval in such familiar interjections as "How beautiful!" or "Lovely."

Third, whatever words we use in evaluating art, the main thing that gives meaning to our judgments is not the words themselves but the complex cultural background and critical context—the occasions, activities, and settings in which these words are used. To understand what an aesthetic judgment means, we need to be "concentrating, not on the words 'good' or 'beautiful,' which are entirely uncharacteristic, . . . but on the occasions on which they are said—on the enormously complicated situation in which the aesthetic expression has a place, in which the expression itself has almost a negligible place" (*LA*, 2). "In order to get clear about aesthetic words you have to describe ways of living" (*LA*, 11). Thus, not only are there many different terms of judgment in criticism with logically different functions, but even the very same term can have different functions, and hence the significance of an aesthetic judgment is not really in words uttered but more in the cultural and critical context in which it appears, in its role in our "ways of living" with art.

This raises the second aspect of critical pluralism: there exists in our culture a variety of critical contexts or frameworks that often have different aims. Recognizing that a note is wrong is not like recognizing that a symphonic movement is triumphant; appreciating the right length of a sonnet (or of a dress) is something very different from appreciating the sublimity of a tragedy. Turning from evaluation to interpretation, we find the same diversity. The literal explanation of a religious poem is something very different from a psychoanalytical interpretation of it. As Wittgenstein says, "The games played . . . are utterly different. The explanations could in a sense be contradictory and yet both be correct" (*LA*, 23).

3. Plurality abounds not only synchronically but diachronically. Different periods produce different cultures, and thus the aesthetic judgments of, say, the Middle Ages would be very different in meaning from those of today, even if the very same words were used. As Wittgenstein insists:

> The words we call expressions of aesthetic judgement play a very complicated role, but a very definite role, in what we call a culture of a period. To describe their use or to describe what you mean by a cultured taste, you have to describe a culture. What we now call a cultured taste perhaps didn't exist in the Middle Ages. An entirely different game is played in different ages. (*LA*, 8)

This historical pluralism or contextualism directly involves us in the third Wittgensteinian doctrine that helped transform contemporary analytic aesthetics with respect to critical reasoning: the *historicity of art and art-appreciation*. As the previous quotation makes clear, Wittgenstein regarded the notions of beauty, art, and aesthetic appreciation not as ontologically necessary and unchanging elements that are altogether independent of human history and social change. Instead, they are products of human culture and history that could have been otherwise (e.g., could have had different standards, used different media, etc.) and that tend to change as society changes, even if sometimes only imperceptibly. Our aesthetic concepts are inextricably bound up in our forms of life, in ways of living which change over history through social, technical, and theoretical developments.

In this aspect of his aesthetics, Wittgenstein paved the way for the historical, social, and institutional theories of art that dominated contemporary analytic aesthetics in the work of Wollheim, Danto, and Dickie and that still exercise a strong presence in Wolterstorff, Carroll, Levinson, and others.[12] Yet Wittgenstein's approach remains superior because his recognition of social context and history is more inclusive than these others. He goes beyond their reliance on mere "artworld" or art historical notions by emphasizing how the artworld is itself embedded in a larger cultural world and network of nonartistic practices. Moreover, Wittgenstein highlights art's social and historical dimension and its plurality of practices without feeling compelled to wrap all this plurality up into a single definition of art. Such "wrapper definitions," I argue, provide verbal formulas that merely cover or contain art's pluralities but have little explanatory value of their own to improve our understanding and appreciation of art, for they simply refer the substantive questions back to the messy contested pluralities of art history and the controversies of our critical present.[13]

How have these second and third Wittgensteinian themes helped change aesthetic theory with respect to critical reasoning? Recognition that critical judgments employ a vast variety of predicates besides the allegedly paradigmatic "beautiful" has diminished our compulsion to define beauty, while directing attention to other predicates that function at least as frequently in evaluative judgment and argument: "unified," "expressive," "balanced," or "true." Similarly, recognition of the importance of the sociocultural context of critical judgment has also directed attention to the institutional and performative character of critical evaluation. When a film festival jury declares a film prize-winning, it is not just offering an evaluative opinion but creating an evaluative fact.[14] Moreover, realizing that the meaning of an aesthetic predicate is not some fixed autonomous essence, but instead changes significantly according to culture

and context, has made the prospect of deriving our evaluative judgments deductively from firm unchanging definitions of such predicates seem deeply misguided, since such predicates seem to have no firmly fixed meaning to be defined. The old hope to establish critical reasoning on a firm and certain deductive model was thus immeasurably dimmed, if not virtually extinguished.

Finally, the flexibility and historical change of aesthetic concepts can be taken still further to question the adequacy of inductive or probabilistic arguments in criticism. If the meaning of an aesthetic predicate changes in different critical, cultural, or historical contexts, then how can we use its past applications to justify its present one? An entirely different game may be played with the expression; it may have changed its meaning and become inapplicable. If the meaning of unity changes from context to context, age to age, the fact that poems lacking property P were formerly correctly described as disunified gives little confidence that whatever now lacks this property will also be lacking in unity. We may be in a new context, a new game. The creative artist with his new poem may have added a new dimension to the notion of poetic unity. It is not surprising that Wittgenstein vehemently condemns statistical explanations in aesthetics. One does not demonstrate the unity of a symphony by the evidence that fifty million Frenchmen cannot be wrong. Wittgenstein's scornful attack on the idea that aesthetic reasons could be reduced to inductive, statistical explanation gave a crushing blow to the hope (of I. A. Richards and others) of transforming aesthetics in the direction of a psychological science.[15]

III

If Wittgenstein's doctrines of the radical indeterminacy of aesthetic concepts and the logical plurality and essential historicity of aesthetic judgment challenge the credibility of deductive and inductive models of critical reasoning, then what account of critical reasoning does Wittgenstein himself offer? Surely this cultured Viennese devotee of the arts did not wish to conclude that critical evaluation was altogether barren of reasoning, even if his early writings did consign aesthetics to the realm of *das Mystische*.[16] Wittgenstein's lectures on aesthetics do in fact suggest an intriguingly original and influential account of the nature of critical reasoning. G. E. Moore recounts these remarks as follows:

> *Reasons*, he said, in Aesthetics are "of the nature of further descriptions": e.g., you can make a person see what Brahms was driving at by showing him lots of different pieces by Brahms, or by comparing him with a contemporary author; and that all Aesthetics does is "to draw your attention to a thing," to "place things side by side."

He said that if, by giving "reasons" of this sort, you make another person "see what you see" but it still doesn't appeal to him, that is "an end" of the discussion. (*PP*, 315)

As I argued in chapter 2, Wittgenstein's view of critical reasoning may be characterized as perceptualist rather than logical or causal. In other words, the critic's reasons are regarded not as logically justifying his judgment in terms of principles or evidence in a deductive or inductive argument; nor as causally explaining or recommending it in terms of the motives or causes that engendered it. Instead, the critic's reasons function as devices for focusing the reader's perception in such a way that she will see the work as the critic does. Perception is the proof. The critic, both in interpretation and in evaluation, is trying to get her reader to perceive the work in a certain way, and the reasons she gives are devices to induce in the reader the desired perception of the work.

Moreover, as I explained in chapter 2, it is only the giving of these reasons and not the reasons themselves that are seen as bringing the reader to accept the critic's judgment; for following the reasons given may help the reader to focus on the work so that she sees it as the critic does. This perceptualist account of critical reasoning has been very popular among analytic thinkers, and certainly much good criticism suits this perceptualist model of reasoning.[17] It also gains support from our frequent experience of the inadequacy of reading criticism without having the work of art perceptually before us.

Wittgenstein presents critical reasoning not only as essentially perceptual in nature but also as neither deductive nor inductive in form. Critical arguments are instead described as having a complex, open, and flexibly structured form, which consists of comparisons, associations, leading questions, and focusing instructions that are directed at an often hypothetical interlocutor, the reader. I called this form of argument "dialectic"; John Wisdom called it "rhetoric."[18] Both terms have unfortunate associations. But whatever we call such argument, the main question is how its validity is to be assessed.

Wittgenstein's apparent answer is an extremely simple and pragmatic one: validity is success—success in inducing the desired perception of the work, if not also the desired critical verdict. He held that "aesthetic discussions were like discussions in a court of law," where the goal and criterion of success is "that in the end what you say will 'appeal to the judge' " (*PP*, 315). Elsewhere, Wittgenstein suggests that the criterion for adequacy of argument and correctness of explanation is acceptance or satisfaction. "The answer in these cases is the one that satisfied you" (*LA*, 18). "That explanation is the right one which clicks" and is accepted by one's interlocutor; "if he didn't agree, this wouldn't be the explanation" (*LA*, 19, 21).

Much critical argument indeed has this dialectical, rhetorically persuasive form and is evaluated not by principles of deductive or inductive va-

lidity but rather by its power in convincing or satisfying its readers. What is more significant is that Wittgenstein does not present this form of reasoning as an inferior, degenerate form of thinking which reflects, as it were, the inherent irrationality of aesthetics itself. He regards it as a perfectly legitimate style of reasoning that is not at all limited to the domain of aesthetics. It is found in the law courts, in philosophy, and even in some areas of science. Wittgenstein confessed that much of his own philosophical argumentation is nothing more than persuading his audience or readers to see a particular phenomenon in a particular way, much as the critic tries to persuade his readers to see an artwork in a particular way. "What I'm doing is *also* persuasion. If someone says 'There is not a difference,' and I say 'There is a difference,' I am persuading; I am saying I don't want you to look at it like that" (*LA*, 27). Affirming that such persuasion is also present in science, Wittgenstein suggests it underlies our firm and ready acceptance of the theories of Darwin and Freud, even when the grounds for their doctrines were, in strictly logical terms of confirmation, "extremely thin." We have been largely persuaded by the peculiar attraction of looking at things the way these theories present them (*LA*, 26–27).

Wittgenstein's account of critical reasoning as perceptualist and rhetorically persuasive—as basically different in kind from deductive and inductive logic and causal explanation and thus free from their standards of validity—has had great value for critical theory. So has his insistence that criticism shares this character with other types of reasoning (e.g., legal and philosophical) whose rationality and validity are not questioned. These Wittgensteinian views helped free criticism from the need to seek justification and legitimacy by aping (inductive or deductive) science through the construction of the kind of systematic frameworks suggested by Northrop Frye or through Roman Jakobson's subsumption of criticism into an established science like structural linguistics.[19] Moreover, by releasing critical reasoning from bondage to deductive or inductive models, Wittgenstein liberated critics from the frustrating search for definitions on which to base deductive proof and from the often-tedious accumulation of confirmatory data demanded by strict inductive argument. The critic is thus free to get on with his critical practice without needing to provide the logical underpinnings and justification for that practice and without having to change it to meet some extrinsic logical standard. The only apparent requirement is to be convincing. This emancipatory yet quiescent achievement seems perfectly in keeping with Wittgenstein's conception of the role of philosophy. "Philosophy . . . leaves everything as it is" (*PI*, 124).

IV

Wittgenstein's account of critical reasoning, with its apparent philosophical legitimization of critical laissez-faire and persuasion, should appeal to today's sense of criticism's diversity of styles and methods. Some might

object, however, that precisely this radical libertarianism makes Wittgenstein's account unacceptable as a theory of critical reasoning. Would it not render such reasoning too free and unprincipled to be considered an acceptable form of reasoning at all? Does not the very notion of a rational form of argument require some constraints on the manner of reasoning, on the way it may be conducted? For if successful persuasion were indeed the sole constraint on reasoning, then there would be no way of distinguishing the illocutionary act of reasoning from the perlocutionary act of persuading.

On many occasions (in aesthetics and elsewhere), although a given argument does not convince us to change our view, we still recognize the argument as plausible, reasonable, or legitimate and will assess it as superior to other (perhaps frivolous or incoherent) arguments that might be advanced for the same conclusion of which the given reasonable argument failed to convince us. In other words, we seem able to assess the reasonableness of a piece of critical reasoning apart from its success in perceptually convincing us of its conclusion. This suggests that our notion of critical reasoning is governed by some basic constraints of legitimacy—however vague, liberal, and flexible these constraints may be. We could clarify this point by imagining ways in which a critic might succeed in getting an interlocutor to see something his way but which would not be regarded as constituting good or even legitimate arguments for his view: for example, hypnosis, bribery, threats, or suggestion through drugs. To put it more generally, we want to allow for cases where persuasion is achieved, but not by legitimate critical methods of argument.

There is a problem, then, in the extreme libertarian view that anything is valid in critical reasoning if it evokes assent through persuasion. I believe this difficulty may be avoided by arguing that Wittgenstein's apparent acceptance of total freedom is only apparent and not real. First, though Wittgenstein may suggest that satisfaction or successful persuasion is a criterion of an *adequate* critical argument (or a correct aesthetic explanation), he never explicitly maintains that satisfaction or success is the only constraint on the *legitimacy* of a critical argument. In other words, we could maintain that simply to qualify as a legitimate critical argument certain constraints must be observed, and only then would satisfaction or successful persuasion entail *adequacy* of argument. We could put this another way by reading such constraints into the very notion of a critical argument's actually satisfying or persuading. Satisfaction, then, would not simply be mere assent, but assent under certain constraints or acceptable means.

Wittgenstein's remarks not only allow the possibility of constraints on how perceptual persuasion should be achieved; they also give a definite indication as to how these constraints or requirements should be conceived. We should understand them as the diverse, vague, flexible, and

largely unformulated rules and principles that govern the various language-games and procedures that are entrenched in our forms of living with art. Critical arguments of perceptual persuasion involve a great number of different conventional procedures that are shared by those competent in aesthetic appreciation within the given culture. Wittgenstein, characteristically, does not try to enumerate or classify these methods of perceptual persuasion, although Frank Sibley later distinguishes seven.[20] But Wittgenstein does indicate by his examples that such perceptual reasons fall centrally in the domain of conventional critical practices that T. S. Eliot classified under the two general principles of comparison and analysis.[21]

Critical reasoning is thus limited by the language-games which constitute our aesthetic forms of life. The freedom that Wittgenstein allows the critic is only within these limits. However, this is not to say that critical reasoning is fixedly limited to any particular given boundaries, for that would be to assume that our critical language-games or forms of life are fixed and cannot be modified or supplemented. This, by Wittgenstein's own historicist account, is patently wrong. Our forms of aesthetic appreciation and argument can change (and have changed) with time.

However, Wittgenstein's recognition of the flexible, historicist, and conventional character of critical reasoning should not be construed as an aesthetic subjectivism where reasons are given but cannot "establish conclusions" since their coercive power rests only on conventional practices that are contingent, arbitrary, and have no further metaphysical grounding.[22] The contingency of conventions, as we shall see in chapter 6, need not mean they are arbitrary or subjective in a cognitively vitiating sense. Conventions typically involve intersubjective collaborative consensus, and they reach down into our most important practices or forms of life. Our conventional practices do not require justification through metaphysical principles but are instead justified by appeal to deeper conventions and the basic needs they serve, which are also partly shaped by convention. For Wittgenstein, conventions constitute not only the bedrock of our language but also the human world of experience that language informs. As he remarks in *The Blue Book*: "Here we strike rock bottom, that is we have come down to conventions."[23] So in speaking of critical reasoning as constrained by the conventions of our aesthetic language-games and forms of life, we are committed neither to radical anomie nor to arbitrary, superficial subjectivism.

Wittgenstein's position must address a more surprising problem: essentialism. His account of critical reasoning as perceptual and persuasive has been adopted by many analytic aestheticians and transformed into a theory of what all critical reasoning essentially is or should be. The theory, in other words, not only maintains that (good) critical reasoning *need not* be deductive or inductive in form and that critical reasons *need not* func-

tion as general principles or as evidence logically supporting a critical judgment; it more radically asserts that *no* effective criticism can be inductive or deductive in character. Critical reasoning can be nothing else than perceptual persuasion.

Stuart Hampshire thus opposes the idea of any "general principles" in critical reasoning and insists that the critic's role is only "to direct attention"; "the point is to bring people to see these features, and not simply to lead them to say: 'that's good.' " Again, as with Wittgenstein, the criterion of success is getting someone to see: "if one has been brought to see what there is to be seen in the object, the purpose of discussion is achieved."[24] Margaret Macdonald likewise asserts that reasoning about critical judgments is "unlike . . . deductive and inductive inference" and that "to justify such a verdict is not to give general criteria as 'reasons' but to . . . 'show' the value."[25] For her, as for Frank Sibley, the critic's reasons serve as "a kind of key to grasping or seeing," where the goal is to get "his audience to see what he sees."[26] In a similar vein, Arnold Isenberg rejects deductive and inductive justifications of critical judgments and maintains that the critic's reasons not only function perceptually but that their very meaning is perceptual in character: "the critic's *meaning* is 'filled in,' 'rounded out,' or 'completed' by the act of perception," which is necessary for the simple understanding of the reason he cites. Isenberg likewise affirms that the true goal of critical reasoning is "to induce a sameness of vision, of experienced content," which "may or may not be followed by agreement . . . in identical value judgements."[27]

Wittgenstein's argument that critical reasoning can be perceptually persuasive (rather than necessarily logical in an inductive or deductive sense) has thus evolved into a theory asserting that all valid critical reasoning is of this perceptually persuasive kind and that deductive and inductive models of critical reasoning are not only wrong (in not accurately reflecting critical practice) but fundamentally wrongheaded. Though the first view is clearly correct, the second seems dubious. Yet it is very natural and dangerously easy to slide from one view to the other.[28] If one is insisting that critical arguments need not be deductively or inductively logical but can be (and often are) perceptually persuasive, one is naturally preoccupied with the presence and merit of this latter form of criticism, and thus one is apt to ignore the claims and even existence of other kinds of critical reasoning. One falls victim to what Wittgenstein diagnosed as "a main cause of philosophical disease—a one-sided diet: one nourishes one's thinking with only one kind of example" (*PI*, 593).

We may never know whether Wittgenstein himself held the more extreme doctrine that *all* critical reasoning is or should be of a perceptually persuasive kind, for we have only transcriptions and reports of his remarks on this subject. Moore's account of Wittgenstein's lectures does

imply that Wittgenstein maintained this radical doctrine; for Moore writes: "*all* that Aesthetics does is 'to draw your attention to a thing' " (my emphasis) rather than something less universal like "what aesthetics often or usually does is to draw your attention to a thing." Still, I am reluctant to attribute this essentialist theory of critical reasoning to Wittgenstein out of respect for what he says elsewhere in aesthetics and in philosophy in general. "It is difficult not to exaggerate in philosophy," Wittgenstein writes.[29] So perhaps if he used the essentialist-sounding language that Moore cites, he is just exaggerating to make his point of the prevalence and importance of perceptualist reasoning.

Whether or not Wittgenstein really held such a theory, it seems not only wrong but also radically inconsistent with the three themes that engendered his perceptual-persuasive account of critical reasoning. Those themes clearly point to an uncompromising critical pluralism. First, aesthetic concepts cannot be precisely and exhaustively defined because they have different uses and are governed by flexible and changing conditions of application. Second, the diverse expressions used in criticism are made to perform a variety of logically different roles and indeed may change their roles and meaning in different contexts. Third, the whole notion of critical appreciation depends on our complex forms of life that can change over time. So if at a particular time and context critical concepts are applied in a particular way (or critical judgments are made and justified in a particular way), this does not mean they always will or should be applied, made, or justified in these particular ways.

If we take this pluralism seriously, we cannot simply rule out deductive and inductive models of critical reasoning as intrinsically illegitimate. We cannot conclude from contemporary criticism's confusion and lack of faith in general principles and definitions that deductive argument from general principles or shared definitions is never possible in criticism nor could ever have been successfully practiced, since such principles or definitions can never be formulated or agreed upon. Even if they are unattainable today, they may not have been so in the past and may not be so again in the future. In Aristotle's age, there could have been a shared definition of tragedy. In Samuel Johnson's time, there were general principles of criticism that were commonly held and firmly established.[30] We cannot simply deny this on the basis of today's state of criticism.

What justification can we have for asserting with Morris Weitz that although certain critics claim to be and seem to be arguing deductively from general principles and definitions, they cannot really be doing so since "critical evaluation . . . cannot be true (or false) deductive argument," there being no satisfactory definitions or irresistibly conclusive standards on which to base such argument?[31] For even if the definitions and standards on which critics have based their deductions seem wrong to us (in

fact even if they are and were wrong), this cannot negate the fact that their arguments were deductive and indeed deductively valid. To claim that critical reasoning never was nor could be deductive is to deny that different critical games can be played at different times, yet that is precisely what Wittgenstein labored to affirm. The same considerations hold against ruling out the possibility of inductive critical reasoning, and we can point to critics of the past who seem to reason inductively.[32]

Moreover, even in contemporary criticism, if we consider the variety of differently functioning predicates it employs, we will reject the theory that all effective critical reasoning can only be in the form of perceptual persuasion. Criticism ascribes predicates like "important" and "original" that can be justified inductively through confirmatory evidence. As the critic Graham Hough maintains:

> It is not really open to anyone to say "Yes, Dante's works exist, but they are not of any importance." This is contradicted by a large body of indisputable evidence. And it would be a very strange position to hold that Dante's fame and influence were no evidence of literary merit.[33]

Not only ascription of merit but also ascription of importance can constitute critical evaluation. (And we saw in chapter 2 how interpretive criticism deploys inductive arguments in critical games of determining authorial intention, where reasons can function as evidence rather than as perceptual devices.)

To conclude, despite the value of Wittgenstein's perceptualist account of aesthetic argument, it would be wrong to embrace this account as the essence of all critical reasoning. If we heed Wittgenstein's general injunction against presuming shared essences but instead "look and see" how critics actually reason, then we find that some critical reasons do not operate perceptually, but instead function logically as evidence or causally as motives. We shall also see that some critical arguments are structured deductively or inductively rather than being merely rhetorical, dialectical persuasion.

Each of us may have a preference for one style of critical reasoning. But this should not blind us from recognizing the plurality of critical methods and aims that are successfully practiced, even if we do not share them. "Criticism," like "art" and "literature," is an essentially contested concept that involves a whole *family* of games. As in other families, there are rivalries where the value and even legitimacy of certain members are bitterly contested. The philosopher cannot award the sole birthright by mere logical analysis, for there seem to be rival logics governed by different aims. Having identified and analyzed the various critical games, the philoso-

pher (as disinterested analyst) must let them justify themselves, as they have justified and must justify themselves, in terms of actual critical practice, in our forms of life that concern art. Having distinguished between the different species, the neutral analyst must rely on the survival of the fittest. But that is why analysis needs the supplement of a pragmatic turn involving advocacy.[34]

Part II
Logics of Culture

5.

Of the Scandal of Taste
Social Privilege as Nature in the Aesthetics of Hume and Kant

I

The classic aesthetic theories of Hume and Kant that have largely structured modern aesthetics cannot be properly understood without understanding a central dimension and dilemma of which they themselves were not properly aware and which their theories instinctively tried to avoid or minimize, if not suppress. This dimension is the social-class context of aesthetic judgment. By introducing social distinctions and prejudice, it threatens the idea of a natural uniformity of feeling on which the Humean and Kantian theories essentially are based. This social dimension, I argue, lurks pervasively in the subtext of these theories, beneath their more explicit arguments; and it constitutes the unacknowledged structural core of their problematic.

Hume's influential essay "Of the Standard of Taste" and Kant's more seminal and more substantial *Critique of Judgement* make reference to society and culture and to their role in promoting the proper exercise of taste.[1] But neither philosopher adequately confronts the ways that aesthetic judgment and standards of taste seem grounded in social conditioning and class distinction. Instead, in their attempts to justify a normative and universal standard for aesthetic judgment, the problem of the social dimension of taste is swept under the carpet of some reassuring notion of natural uniformity of feeling, essentially free from social determination and class distinction.

For Hume, this natural, universal basis for the standard of taste is found in "the common sentiments of human nature." Certain objects just "are naturally fitted to excite agreeable sentiments" of beauty in normal human beings. Such objects are "naturally calculated to give pleasure," just as certain properties of objects will always excite standard perceptions of colors, unless there is some obstruction to, disease of, or temporary malfunctioning in the faculty of taste or organ of sense (*ST*, 237–39). Hume is sometimes ready to admit that in actual fact these aberrations are

very common so that precious "few are qualified to give judgement on any work of art, or establish their own sentiment as the standard of beauty." Yet he still maintains in theory that "the general principles of taste are uniform in human nature." And this foundational community of sentiment both justifies and is justified by the alleged fact that certain works have been "universally found to please in all countries and in all ages." The standard of taste is thus recommended as a universal and natural one, ultimately free from social difference and determination; any distortions of taste imposed by social pressure and prejudice "will yield at last to the force of nature and just sentiment" (*ST*, 236, 246–47, 249).

Kant employs the same strategy of natural foundational uniformity, though characteristically with greater complexity and with much more emphasis on the commonality of human *cognition* rather than mere sentiment. The pure aesthetic judgment, for Kant, is determined by the "autonomy of the Subject," with no constraints of conformity to concept. But it nevertheless can base its claim to necessary and universal assent on the natural "subjective universality" involved in the dispositional powers of cognition shared by all human beings, "that subjective factor which we may presuppose in all men (as requisite for possible experience generally)" (*CJ*, 135, 146). Though Kant, like Hume, accords "culture" some role in developing and communicating taste, the standard of taste is not determined by society at all. "Rather must such a standard be sought in the element of mere nature in the Subject" (*CJ*, 212). "Rather is it in human nature that its foundations are laid, and, in fact in that which . . . we may expect everyone to possess and may require of him" (*CJ*, 116).

If taste is not socially and historically determined, then a culture's entrenched aesthetic judgments—the verdicts of taste that have so far dominated it—are accorded the status of natural and necessary facts rather than seen as the contingent and alterable product of social dynamics and history. Taste that departs from such a standard is thus not merely different but diseased or unnatural. Historically privileged subjective preferences (essentially those of historically socially privileged subjects) are reified into an ahistorical essentialist standard, a necessary standard for all subjects and all times. This might be cynically described as "the scandal of taste" perpetrated by the Enlightenment's founding fathers of modern aesthetics and smugly perpetuated by their followers.

Aesthetic theory is sometimes criticized as a "bourgeois" attempt to disguise socially conditioned determinations of taste as naturally or ontologically grounded values, and thus to justify them as somehow objectively proper or necessary, thereby perpetuating their dominance and the privileged dominion of the class which determines and sustains them. Such global claims seem too grandiose to be true.[2] However, a close reading of Hume's and Kant's efforts to establish aesthetic norms will show

that they cannot succeed without appealing to social privilege in an essential way, thereby undermining their project of a universal, naturally grounded, class-free aesthetics.

II

"Of the Standard of Taste," Hume's most influential aesthetic statement, has won more praise for its thorough diagnosis of the problems of finding such a standard than for the success of the actual solution Hume proposes.[3] Hume's project is to establish a decisive objective standard for the clearly subjective judgment of taste, which as a judgment of sentiment rather than "fact" admits of no factually existent "true and decisive standard." His strategy is to link judgments of taste to judgments which *do* have such a determinate standard "in real existence and matter of fact" (*ST*, 248); and his principal device to effect the linkage is the notion of the good critic. The standard of taste or proper aesthetic sentiment regarding a work of art is determined by the consensus of sentiment of the good critics regarding that work, but the questions of who these critics are and what qualities they require are, for Hume, "questions of fact, not of sentiment" (ibid.). Hume sometimes seems to suggest that the objectivity of aesthetic judgments may be based on "rules of composition," "rules of art," "rules of beauty," or "principles of taste [that are] universal," so that we should be able to convince someone that our aesthetic judgment is correct "when we show him an avowed principle of art" that bears on the case at hand (*ST*, 235–36, 240, 241, 246).

However, not only are these "general rules of art" never specified by Hume, they are explicitly held to be "founded only on experience and on the observation of the common sentiments of human nature" (*ST*, 237). They represent no independent foundation of factual objectivity outside of human sentiment and are nothing but the expression of "general observations, concerning what has been universally found to please in all countries and in all ages" (*ST*, 236). In our search for an authoritative standard of taste through impersonal rules of art, we are simply thrust back to our human sensibility as critics, of which these rules are merely a derivative expression. There seems to be ultimately no authority except human consensus. But is the consensus of human sentiment as to what pleases really as universal in all cultures and ages (and social groups within a given culture and age) as Hume would like to, but cannot fully, believe? He himself is too aware of the actual diversity of taste, and too committed to the need for ordered convergence of taste in "civilized society," to countenance any absolute "principle of the natural equality of tastes" in all people, places, and points of time (*ST*, 233, 235). This is the impasse which requires Hume to introduce the notion of "a true judge" or good critic in order to salvage a workable standard of taste.

The five requisite qualities Hume lists for good critics are "*delicacy* of

imagination" (essentially a matter of perceptual acuity and sensibility to fine discriminations), "practice" in appreciating good works of art, experience in their comparison and proper relative assessment, a "mind free from all prejudice," and "good sense" (*ST*, 239–46).[4] The standard criticism of Hume's theory is that it is circular. It defines good taste and art by appeal to good critics, but the good critics are in turn ultimately defined in terms of (their experience with and reaction to) good art. However, as Peter Kivy has cogently argued, the final two qualities, and perhaps also the first, can be defined so as to escape circularity. Kivy instead criticizes Hume's solution for involving an interminable or at least unresolvable regressive debate as to who has the requisite delicacy, good sense, and lack of prejudice, and as to what precisely these critical prerequisites involve.

In challenging Kivy's complaint, Noël Carroll rightly remarks that the regressive debate need not be vitiatingly endless, since within an ordered society there could (perhaps even must) be sufficient agreement as to the nature of good sense and lack of prejudice, even if this agreement cannot resolve clearly and decisively all differences of aesthetic taste (and even if such agreement ultimately rests on repressive force). But Carroll goes on to offer his own complaint against Hume's theory. To wit, its reliance on the notion of good critics "is redundant," since the five qualities specially ascribed to the good critics should be seen as "applying to anyone" at all. If I have the five qualities on my own, Carroll continues, "then what reason should I have to consult a group of critics? I could argue for the worth of the work of art on the basis of my own good sense, my own delicacy of taste, my own practice, my own use of comparisons, and my own lack of prejudice." Carroll realizes that the idea that everyone can be "a critic such that everyone can consult themselves about their assessments seems antithetical to Hume's purposes." Carroll is right about this, but wrong in assuming these purposes are primarily epistemological and ontological, that they are ultimately aimed at grounding judgments of aesthetic values in objectively external facts outside any "intersubjectively shared" human sentiment, in some "external, empirically discoverable . . . objective standard" or "entity."[5] Who more than Hume insisted that values and attitudes could not be adequately grounded on or justified by facts?

Hume's primary aim was normative stability rather than epistemological certainly or ontological grounding; and all he needed for this was an "intersubjectively shared" socially objective standard. His deep purpose (that he perhaps never fully fathomed) was social stability under the aegis of the increasingly ascendant bourgeoisie and its liberal ideology. In introducing the notion of the group of good critics (which Carroll mistakenly regards as "extraneous, excess theoretical baggage")[6] and in consigning to *their* consensus the standard of taste and culture, Hume was trying not only to affirm the hegemony of the liberal culture of his day but to resolve

one of the most fundamental and difficult problems of liberal ideology. The problem is one of affirming the individual's freedom, autonomy, and protection in the private realm (and what could seem more private, free, and autonomous than taste?) but reconciling this with the contrasting need for some objective authoritative notion of right—something commanding conformity to a more than personal norm and thus involving some negation of personal freedom—so as to insure that individual freedom and autonomy would not degenerate into chaos and anomie.[7]

This tension is already implicitly announced in the title of Hume's essay: a standard (something social, constraining) of taste (which seems essentially personal and free). In the context of this tension between freedom and normative authority, Hume's idea of the consensus of good critics is far from excess baggage but rather his most crucial tool for mediating between the free assent of personal feeling and conformity to an extrapersonal norm. The key premise underlying Hume's strategy is that despite the divergence and controversy over individual judgments of taste, there is uniformity of sentiment (hence freely achieved consensus) as to who the critics are who should set the standard according to which personal taste should then conform (within, of course, a certain permissible range of variation).

The ineliminable role of the consensus ("the joint verdict," *ST*, 247) of good critics in mediating the tension between individual freedom and social conformity can be appreciated better against the background of two related oppositions that pervade and perplex Hume's essay. The first is the natural versus the cultural or learned; the second opposes uniformity of feeling and judgment to the distinctive superiority of judgment of those who, in a breach of uniformity or a conflict of judgment, will carry the authority to set the standard for consensus.

Hume's liberal aim is to avoid the Scylla of suppressing subjective freedom of sentiment that seems crucial to taste by imposing external, rigid laws of taste. But he also wants to escape the Charybdis of total freedom, a chaotic free-for-all that would threaten the consensus of feeling that was deemed necessary for holding a society, even a liberal society, together. This fear of social chaos through cultural anomie was surely not an idle worry in a society like Hume's eighteenth-century Britain, rampant with social change, riven with increasingly complex socioeconomic divisions, and apparently lacking any sufficiently powerful overarching principle or structure of unity to ensure cohesion. As Paul Guyer pointedly puts it, not only had the feudal order and its unifying ideology been destroyed and discredited, but "political unity could not readily be found in the crown, which was shared by three forcibly united nations and which had sat for a century upon Scottish, Dutch, then German heads, or in a parliament for which only a few were franchised to vote; and perhaps above all, the sec-

tarian struggles of the previous century had shattered the role of religion as a common source of culture."[8]

How, then, to establish an authoritative standard for consensus that will not be seen as an unjustified imposition on the individual's freedom as subject? The most satisfying answer would be some form of aesthetic realism: the standard of taste is conformity to real properties of aesthetic value ontologically grounded in the objects judged, so that conformity of our appreciative sentiments to this standard is justified by the rational project of conforming our judgment to the true nature of things.[9] Hume, however, rejects any such realism, insisting that "Beauty is no quality in things themselves: it exists merely in the mind which contemplates them. . . . To seek the real beauty, or real deformity, is as fruitless an inquiry as to pretend to ascertain the real sweet or real bitter" (*ST*, 234–35).

Rather than realism, Hume's solution is an empirical naturalism: the consensus and standard is naturally there, but is based on nothing more than the "experience" of our natural aesthetic reactions, in other words, the "general observations concerning what has been universally found to please in all countries and in all ages" (*ST*, 236). If the standard of taste is constituted by a natural conformity of sentiment, the standard would be legitimated as commanding assent without unjustifiably imposing it coercively on an individual's sentiments. The dilemma of liberalism would be resolved. Unfortunately, things are not so simple. For the idea of naturalism of taste suggests that as tastes naturally conform they should also be naturally equal. Yet, although Hume would like to admit "the principle of the natural equality of taste" on "occasions where the objects seem near equality," he emphatically asserts that this principle is and must be "totally forgot" when we are faced with judgments sharply out of line with the "natural" consensus—for example in what he (now apparently wrongly) regards as the "palpable absurdity" of comparing the genius of Bunyan and Addison (*ST*, 235).

The problem is that the evidence for the naturalness of the standard of taste is in uniformity of sentiment, but such uniformity is not sufficiently evident to make the case for naturalism compelling. If taste is natural but divergent, then in order to save the standard of taste and its naturalness, some judgments of taste must be argued to be more natural than others. This is precisely Hume's strategy. Deviant judgments are explained in terms of distortive diseases or obstructions of the natural mechanism of aesthetic perception. Hume likens deviance in aesthetic taste to the aberrational deviances in sensory perception induced by "fever" or "jaundice," which involve "some apparent defect or imperfections in the organ" of perception (*ST*, 238, 249). If not unnatural through disease, then divergent taste is unnatural in being distortively mediated by some social veil. Hume enumerates authority, prejudice, envy, and jealousy among such distortions. But he also insists that if we have "the sound state of the

organ" of perception, then "when these obstructions are removed, the beauties, which are naturally fitted to excite agreeable sentiments, immediately display their energy," and, with time, "prejudices . . . yield at last to the force of nature" (*ST,* 238, 249).

Hume here expresses the Enlightenment's case that if only we could see things naturally (free from disease and cultural prejudice), we would all see them aright; and true uniformity of sentiment on matters of taste would indeed obtain. However, in sharp contrast to this naturalism, when we look at whom Hume regards as the good critic or "true judge," it is obviously not a healthy innocent or *homme sauvage*, but someone who is thoroughly educated, socially trained, and culturally conditioned. What is the requisite practice, comparison, and good sense of Hume's good critic, if not the achievement and exercise of dispositions (socially acquired and refined) to react to the right objects in the culturally appropriate way or to think in ways that society regards as reasonable?

The same may even be said for the requirement of "delicacy of imagination," with its skill in discriminating "minute qualities" (*ST,* 250). Once we abandon the notion of an objectively innocent eye, we must recognize that not only the surface aesthetic properties we think relevant to discriminate in an object, but also the degree of minuteness of discrimination desired, are not simply ontologically fixed in the nature of things. They are instead a product of a social practice, a way of living with art which informs or prestructures our aesthetic response in certain normative ways. (One could, for instance, be *too* delicate, too sensitive to unintended, negligible differences in minute qualities and thus miss the aesthetic perception of the unity of a work that should be perceived.) Thus Hume's good critic, in effect, turns out to be someone not *without* prejudices but simply with the *right* prejudices, namely those unquestionably assumed as right (hence regarded as natural or necessary truth rather than prejudice) by the entrenched culture.

With respect to this requirement of lack of prejudice, Hume's argument becomes so confused that his masquerade of naturalism ends up relying on the presumption that good taste requires a culturally acquired attitude that only the socially advantaged can properly exercise. In plying his naturalistic line, Hume begins by claiming that the critic "must preserve his mind free from all prejudice, and allow nothing to enter into his consideration but the very object which is submitted to his examination" (*ST,* 244). But this clearly contradicts his demand that good criticism requires the application of practice, good sense, and comparison, all of which take us beyond the object presently perceived to preconceptions of how such objects *should* be perceived and assessed. Such preconceptions are socially formed and are culturally variant rather than given naturally and immutably to humankind in general. Good sense and practice in the refine-

ments of art seem inextricably bound with good breeding in society, and certainly were especially so in Hume's day, when access to artworks was extremely limited.

Hume himself seems to recognize the role of variant cultural prejudices when he tells us that in assessing a work of "a different age or nation" the critic "must place himself in the same situation as the [original] audience" (*ST*, 244–45). But then he immediately tries to conflate this projective placing with lack of prejudice by likening it to the act of "considering myself as a man in general, forget[ting] . . . my individual being and my peculiar circumstances. A person influenced by prejudice, complies not with this condition; but obstinately maintains his natural position, without placing himself in the point of view which the performance supposes" (*ST*, 245).

Hume's notion of unprejudiced naturalism has become deeply confused here. First, the critic's imaginative "placing" is not the exclusion of prejudice but the temporary adoption of different prejudices, those of the work's author or original audience. Moreover, that such a self-forgetting projective attitude should be adopted is not at all a natural inclination but a culturally acquired prejudice, which apparently requires a level of learning and socioeconomic ease that only the higher classes of Hume's time could enjoy. As he later remarks: "A man of learning and reflection can make allowance for these peculiarities of manners; but a common audience can never divest themselves so far of their usual ideas and sentiments" (*ST*, 251). Hume thus ends up here by identifying man's "natural position" with a prejudiced one, in sharp conflict with his general valorization of the natural as opposed to prejudice and ultimately overcoming it.

In short, although recognizing that taste involves much more than natural gifts, Hume never faces up to the fact that this gravely undermines his appeal to a natural standard of taste through the common natural constitution of humankind, through "general principles . . . uniform in human nature." Hume's standard is culturally rather than naturally set; as such, it reflects not the natural free sentiment of the individual but the social authority of those who set the standard.[10] And only the socioeconomically privileged can set the standard of taste, since only they have the access to the right objects and the time and education necessary to render their perceptions and judgments of taste ever more refined. As Hume's contemporary, Lord Kames, bluntly asserted: "those who depend for food on bodily labor are totally devoid of taste. . . . The exclusion of classes so many and numerous reduces within a narrow compass those who are qualified to be judges in the fine arts."[11] Moreover, to maintain their distinction as having more refined taste, the privileged will ensure that the standard is always something beyond the natural reach and pleasure of the vulgar; for how else could they assert their superiority of taste? Hence, there is a social explanation for the fact, noted by Hume, that "a person fa-

miliarized with superior beauties" cannot appreciate the beauty of vulgar ballads though they be not wholly without beauty (*ST*, 244).

It is not surprising that a bourgeois liberal like Hume locates the social authority for taste neither in birth nor title, but in the authority of talent, sense, education, and industriousness of practice. Nor does he locate taste in the authority of an *individual* (a master critic potentate) but in the cooperative consensus of a group of superior minds. No longer would aesthetic taste be determined by the individual tyranny of patron king, nobleman, or bishop, but by the collective tyranny of the educated burghers. Their superiority in such matters is, however, presented by Hume as a recognized fact; for they are "acknowledged by universal sentiment to have a preference above others" (*ST*, 248). But if a fact, it is a sociocultural, not a natural, fact; and since it is based on the social consensus of their superiority, on "universal sentiment" of their "preference above others," Hume is clearly wrong to treat it simply as a question "of fact, not of sentiment" (*ST*, 248).

Although Hume's naturalism relies on distinguishing the sociocultural from the natural, he fails to maintain this distinction consistently. He shrewdly blurs it so that historically entrenched standards that were determined and sustained by privileged social classes can be presented as belonging to the natural.[12] The idea of a group of good critics, whose superiority is universally respected and who in principle span the length of history and are thus not specifically confined to a particular nation or explicitly defined by one particular class, is crucial in making their consensual verdict seem almost a natural product of human sensibility at its best, and thus a naturally legitimate authoritative standard of taste to which we should freely conform. But we should not forget that this group, despite its apparent multinational, transhistorical, and transcultural composition, is hardly representative of culturally unprivileged populations or of unprivileged cultures. Hume's group of good critics, far from a pancultural consensus, is as much an expression of distinction as uniformity.

As with the natural/cultural tension, Hume tries to smooth over this second tension of uniformity versus distinction through the crucial notion of the consensual community of good critics. Uniformity of sentiment is Hume's essential evidence that the standard of taste is natural, that is, based on "the common sentiments of human nature." Hence, despite his initial recognition of the enormous "variety of taste" (*ST*, 231), Hume repeatedly insists on the presence of a substantial uniformity of taste. He claims it is expressed in "rules . . . concerning what has been universally found to please in all countries and in all ages," "models and principles" based on "universal experience" and "established by the uniform consent and experience of nations and ages."[13] It is obvious, however, even to Hume, that no such universal uniformity of sentiment regarding works of

art really exists. If it did, then we would not need to seek a standard of taste, let alone ponder whether we can find one; for we would already have one simply in our uniform consensus.

However, given the absence of total uniformity, how is the standard to be determined so as not to represent a coercive, illegitimate imposition on individual freedom, an ideal dear to Hume's liberalism? A radically democratic answer might be majoritarianism, but such a standard is obviously too unwieldy and demotic for Hume's eighteenth-century bourgeois mind. Asserting "that the taste of all individuals is not upon an equal footing," Hume must instead base his standard on the consensus of a narrower group of cultural distinction: those "rare" "men of delicate taste . . . distinguished in society, by the soundness of their understanding and the superiority of their faculties above the rest of mankind" (*ST*, 248–49).

Thus the uniformity of consensus of taste that Hume both appeals to and seeks is not truly universal uniformity; it does not embrace the less-educated majorities "in all countries and in all ages." To secure a consensus on the verdict of taste, not all are eligible to serve on the jury, only those whose social station and training already ensure that a reasonable degree of consensus will be achieved, indeed that it is already given. Uniformity of taste comes to mean the uniformity of taste of those who are socially nurtured to have taste, and this is already largely determined by prevailing structures of social privilege.[14]

Yet Hume still argues that this narrow and privileged group of critics can adequately represent a truly universal standard of taste, expressing real universality of sentiment and consensus. For this group is "acknowledged by universal sentiment to have preference above others" in matters of taste. Hume implies that this universal consensus of deference to the privileged few is freely felt and willingly given, because it is not visibly coerced. So conceived, this group of critics solves Hume's liberalist paradox of authority and personal freedom. Personal freedom of sentiment is preserved as expressed in the free decision to submit one's taste to the authoritative standard set by those recognized as superior, here the artistic elite. If Hume's strategy resonates well with today's deference to the consensus of experts, it even more strikingly parallels the political system in the Britain of his day: representative democracy with only a partial enfranchisement of the electorate.

But how free, really, is this acknowledgment of critical deference? It seems almost obligated by the prevailing socioeconomic inequalities and the hierarchical structures of culture, especially high culture, which seems largely constituted by its distinction from the low or common. Individuals lacking the preparatory education, leisure, access, and sociocultural conditioning necessary for appreciating works of high art have little hope of challenging or achieving the superior taste of the privileged, especially

when the modes of proper appreciation can always be changed to ensure the perpetual possibility of distinguishing tastefully refined from vulgar appreciation of a given artwork. The socially unprivileged cannot help but concede the superiority of others in a game of taste so structured as to disqualify or brutally handicap them from the outset, particularly when the "essential" superiority of others is reinforced in so many matters outside the realm of taste.

III

Art's obvious linkage with culture and connoisseurship should make the prospect of founding a universally valid, class-free aesthetic on the grounds of our common human nature seem much more promising if pursued with respect to nature rather than art. So it is not surprising that Kant's universalist aesthetic gave pride of place to natural beauty. Not only does judgment of an artwork fail to qualify as a "pure aesthetic judgement" or "pure judgement of taste," but art itself, unless "brought into combination with moral ideas," "renders the soul dull . . . and the mind dissatisfied with itself and ill-humoured." In contrast, "the beauties of nature," besides providing the paradigm case of pure aesthetic judgment, are "the most beneficial" in affording pure aesthetic pleasure which cannot dull or distress the soul, but only uplift it. Regarding beauty as a symbol of morality, Kant finds natural beauty superior to art in its freedom from human frivolity and corruption, making it an unadulterable beauty whose moral content is unassailable (*CJ*, 191).

Kant's explicit reason for denying the aesthetic purity of judgments of art is that they necessarily involve essential reference to concepts, at the very least the concept of art (if not also the concepts that artworks represent). In contrast, the pure aesthetic judgment is held to be free from any conceptual constraints on the pleasure we take in an object, free from any reference to conceptual knowledge of what the object should be. This exclusion of conceptual knowledge is also a handy device for excluding from taste all the social differences expressed in the possession or lack of such knowledge. In the same section where Kant unfavorably contrasts art to natural beauty, he describes art's pleasure as dependent not only on aesthetic form but "at the same time culture" (*CJ*, 190–91). However, if Kant's pure aesthetic of natural beauty seems better poised than Hume's aesthetic to make the case for a naturally grounded standard of taste, Kant's project exhibits the same frustrating problematic as Hume's, implicitly but necessarily incorporating the idea of social privilege on which it both relies and founders.

Facing the obvious divergence of judgments of taste, Kant strives to establish a standard of aesthetic judgment that can claim the universal and necessary assent of humankind without relying on any coercive structure that is foreign to and repressively imposed on human nature and its

proper freedom. As with Hume, the normative aesthetic judgment or standard of taste must be reconciled with the "autonomy of the Subject" that Kant insists is of the very essence of taste.[15] The conflicting needs of personal freedom and more-than-personal authoritative standards for conformity and consensus is a dialectical tension that lurks pervasively in the subtext of Kant's *Critique* and eventually surfaces in the text itself.

This tension between freedom and authoritative standards or law is manifested in Kant's central aesthetic notion of the "free play of the cognitive faculties" (specifically the faculties of imagination and understanding) that provides the pleasure on which positive aesthetic judgment is based. But such free play is not entirely free. Freedom of imagination is limited by the constraints of "the general conformity to law of the understanding"; its "free play of the powers of representation . . . [is] subject, however, to the condition that there is nothing for understanding to take exception to" (*CJ*, 86, 88). Kant tries to safeguard freedom by affirming that the law of understanding to which freedom is subjected is not "a definite law" that can be formulated in concepts. But this only makes the issue more enigmatic. Likewise, the freedom/law tension is not resolved but only reformulated by Kant's notion that imagination's "free conformity to law of the understanding" is "only a conformity to law without a law" (*CJ*, 86). Unless that conformity is understood as a mere nonnormative accidental coincidence, the notion seems to make little sense, like following a rule where none exists.[16]

The tension between imaginative freedom and the law of understanding to which it must (yet paradoxically *must freely*) submit presents a mental microcosm of the real sociopolitical drama of taste played out between the free individual and the social authority that lays down the law of taste. The deeply political character of the problem of taste is effectively suppressed under the weight of Kant's transcendental aesthetic naturalism that locates taste in the supersensible stratum of human nature. But it finally emerges (albeit in a rather muted and indirect manner) in the Appendix to the "Critique of Aesthetic Judgement."[17] Here Kant's discussion of taste is led from the freedom of the imagination in its very conformity to law to the political "problem of bringing freedom (and therefore equality also) into a union with constraining force (more that of respect and dutiful submission than of fear)." Kant identifies this problem with the tension between "the more cultured and ruder sections of the community," the former representing "law-directed constraint," the latter "free nature" (*CJ*, 226–27).

The good taste of ancient times is hailed as "a happy union" of compromise between the two, "that mean between higher culture and the modest worth of nature, that forms for taste also, as a sense common to all mankind, that true standard which no universal rules can supply." But at

the same time Kant underlines the need for taste to have a "sound preparatory education" and "the culture of moral feeling and moral ideas," while claiming that as humankind progresses the force of "nature will ever recede farther into the background" in determining taste. Here Kant comes closest to recognizing that taste not only requires culture but seems based on cultural difference that can only sustain its claim to refinement by its distinction from the more "natural" character and preferences of the "ruder sections of the community" (*CJ*, 226–27).

Of course, Kant's explicit position is quite the opposite—a naturalism whose standard of taste is one to which all humans by their very nature should freely agree. But is his naturalistic solution really adequate? Like Hume, Kant rejects the idea that beauty is a real inherent property of things, a property independent of human perception and pleasure. He therefore cannot appeal to beauty as an ontological ground that justifies a true judgment of taste as objective and thus legitimates the demand for conformity of variant judgments to it. "The judgement of taste . . . denotes nothing in the object, but is a feeling [of pleasure or displeasure] which the Subject has of itself and of the manner in which it is affected by the representation" (*CJ*, 41–42). Nor can Kant legitimate the demand for universal uniformity of aesthetic judgments by appeal to the objectivity of concepts which inform aesthetic judgments, because he emphatically asserts that these judgments are made "apart from concepts." Their claimed "universality" or "validity for all men" thus "cannot spring from concepts," which may define perfection but not beauty. Kant's commitment to subjective autonomy means that the universal validity of an aesthetic standard cannot be seen as illegitimately imposed, so he must ground it on "a claim to subjective universality" in human nature (*CJ*, 50–51).

The source of the universal standard of taste, Kant thus maintains, lies deep in every subject and is something to which each subject should therefore freely or naturally conform.

> Rather must such a standard be sought in the element of mere nature in the Subject, which cannot be comprehended under rules or concepts, that is to say, the supersensible substrate of all the Subject's faculties (unattainable by any concept of understanding). . . . Thus alone is it possible for a subjective and yet universally valid principle a priori to lie at the basis of that finality [of taste, making "a warranted claim to being bound to please everyone"] for which no objective principle can be prescribed. (*CJ*, 212–13)

If taste's standard is found in human nature, it is found only in some abstract "supersensible substrate" of such nature, "unattainable" by our understanding. As such, can we truly say that the standard is indeed found

or understood at all? Kant seems to posit its grounding yet "supersensible substrate" as a transcendental article of faith. His aesthetic naturalism thus falls back awkwardly into a supersensible supernaturalism.

However, Kant does offer a clearer criterion for determining which judgment of pleasure should count as representing the standard, as constituting a true judgment of taste to which all should conform. In principle, any person's judgment should reflect the standard, but only provided that the judgment is "pure," in other words, made under the proper "conditions" (*CJ*, 147). The first and most crucial of these is disinterestedness. (Other conditions, such as that the judgment is not based on concepts and that it concerns pure form rather than practical purposes seem clearly related to disinterestedness.) Kant claims that "Everyone must allow that a judgement on the beautiful which is tinged with the slightest interest is very partial and not a pure judgement of taste." Disinterestedness he defines as "indifference" to (or not being "concerned" for) "the real existence of the object" judged, but also as freedom from want, since "all interest presupposes a want, or calls one forth" (*CJ*, 43, 49).[18]

But who, then, can afford to be disinterested? Who can take the time and trouble to peruse things closely with exclusive regard to their form and no regard at all to their instrumentality in satisfying one's wants and needs? Only those who have the conditions of ease and leisure to do so, those whose essential wants and needs are most adequately satisfied, those who have culturally acquired the rather unnatural aesthetic attitude of detachment from need, of consideration of form over substance. In short, only the socially and culturally privileged can meet Kant's conditions of pure aesthetic judgment and can set the standard of taste; and they can do so only so long as they refuse to question the privilege of this attitude of detachment, which allows them to take implicit pleasure in their sociocultural superiority by taking pleasure in ways unavailable to others.

In introducing the notion of disinterestedness by distinguishing it from various interested reactions, Kant employs imagined examples that unwittingly underscore the link of taste with sociocultural privilege. Those who fail to adopt the aesthetic attitude to a palace are the "Iroquois *sachem* who said nothing in Paris pleased him better than the eating-houses," "a *Rousseau*" who demonstrates concern for the underprivileged by protesting "against the vanity of the great who spend the sweat of the people on such superfluous things," and someone "on an uninhabited island, without hope of ever again coming among men," totally deprived of society and thus deprived of any means of asserting his social distinction through his judgment of taste (*CJ*, 43).

The purely disinterested aesthetic attitude that Kant recommends seems less a natural than a peculiar cultural acquisition, presupposing special social conditions. Its claim to be natural and free from both "preju-

dice" and "subjective personal conditions of . . . judgement" and therefore to reflect *"a universal standpoint"* (*CJ*, 152–53) seems a shrewd philosophical strategy to disguise its character as a culturally privileged prejudice. Given the empirical diversity of taste, Kant can posit its natural and necessary universality only in a supersensible substrate; and he argues, transcendentally, that this substrate must exist, since without it we could not properly explain the judgment of taste's presumption to universal and necessary assent. But this presumptive claim can be otherwise explained by social facts. If even so-called "pure" judgments of taste express sociocultural superiority, then they should expect and demand assent.

Kant's prime candidate for pure aesthetic appreciation is the appreciation of nature. But even that appreciation turns out to be more culturally acquired. Not only do we need a certain distance of security from the "terrifying" ravages of nature to appreciate its sublimity; Kant further asserts that the sublime cannot be appreciated without culture's "development of moral ideas." Hence, "culture is requisite for the judgement upon the sublime in nature (more than for that upon the beautiful)" (*CJ*, 115–16). Even the appreciation of "the beauty in nature is not in fact common" or natural to uncultured taste. "It is peculiar to those whose habits of thought are already trained to the good or else are eminently susceptible of such training" (*CJ*, 160). Only those who have been culturally trained to disregard nature's emotional and sensual charms can instead confine themselves to the beauty of pure form; to do otherwise, for Kant, is to display a taste reflective of "barbarism."[19] But who can obtain this training by freely turning away from the easy delights of nature's charm to seek the more difficult appreciation of its purely formal beauty? Only those who are already endowed with a life rich enough in ease and easy delights, and who therefore can take the trouble for more refined pleasures.

Kant and Hume would like to see these pleasures of refinement as guaranteed to all humankind by their natural endowment, if only we had the time and education to reach the needed level of refinement. This is the liberal dream of culture that still captivates most humanists and is reinforced by the analogy with objectivity in science. Mathematical and scientific knowledge cannot be achieved without some measure of leisure and distance from life's urgent necessities, but that does not render it an expression of class preference, does not preclude its being universally valid and in principle shareable by all. If this is so for science, can it not hold as well for aesthetics?

The analogy cannot work for Hume or Kant, since they claim that aesthetic value (unlike scientific or mathematical validity) is neither a real property of objects nor rests on the rationality of concepts but instead depends essentially on the pleasure of subjects. If we give up aesthetic realism and conceptualism, if we seek to ground aesthetic value in the free re-

sponse of socially situated subjects that are differently socially situated, then there is no fixed yardstick or positive essence of good taste to provide free, universal convergence. The standard of taste will thus be continuously contested in the complex social field of culture; if established judgments of taste gain power by being already culturally entrenched, they will also need to continue to prove themselves in experience and criticism. As human subjects, our aesthetic judgments rely on a variety of shifting factors including new media, changing forms of cultural dissemination and mediation, social interests, attitudes, and relations, along with our enduring desire for pleasures of sense, meaning, and form. We should expect the field of taste to have diversity and critical contestation, since our judgments of taste, like other valuations, are contextual in nature, and the contexts of taste are often very different. Between the one-sided quest for a uniform standard of taste and a critical nihilism that rejects all judgments of better and worse, we need to recognize the value of diversity as well as agreement in taste.[20]

IV

I conclude that the Humean and Kantian projects of grounding a standard of aesthetic value in universal human nature not only fail but conversely demonstrate the deeply social dimension of taste and its linkage to political issues of order and hierarchy. We cannot erect a universal standard of taste for evaluating artworks on the basis of a pure aesthetic naturalism, because the aesthetic, despite its dimension of immediacy, is a deeply cultural concept and because the whole idea of a clear dichotomy between the natural and cultural is extremely problematic.[21] Before exploring this complex distinction in the next chapter, I should close the present chapter with a word of caution.

In criticizing the aesthetic naturalism of Hume and Kant, we see that taste and fine art are shaped by social forces and are stubbornly linked in our culture with social distinction. Should we then exclude naturalist elements from aesthetic theory by viewing art and the aesthetic as institutional constructions of our cultural history, but not the expression of natural needs and energies? Should we also conclude that the whole aesthetic enterprise (including our cherished artistic heritage) is simply a product and mechanism of sociocultural privilege and repression?

Such inferences are dangerously wrong. With respect to naturalism, we need to distinguish between the claims that there are natural roots or features of aesthetic experience and the claim that natural principles or uniformities can establish a true standard for aesthetic judgment. Denying the latter does not preclude the former. We also need to realize that the natural and the aesthetic are complex concepts that can be construed and deployed very differently from the way Kant understood them. In chapter

7, for example, I explore how the pragmatist theories of Alain Locke and John Dewey develop a notion of the aesthetic that invokes art's natural roots and social functions, while rejecting the Kantian purism of disinterestedness, conceptlessness, and formalist purposelessness.

In the same way, to reject art and the aesthetic as invariably a tool of class privilege and cultural oppression fails to recognize the complexities of art's relations to society, as well as the complexities of social privilege (where even highbrow artists and their intellectual audience, though culturally elite, are themselves subject to domination from more powerful centers of power and social privilege). Art can also serve as an instrument of social liberation and transformation. This was Alain Locke's central strategy of cultural politics in *The New Negro*. T. S. Eliot and T. W. Adorno likewise made strong claims for the emancipatory power of art. Providing not only explicit criticisms of society, art also offers implicit critique through its harmonious unities and its examples of foreign social worlds and different ways of life that can help us realize how our own socially entrenched practices are neither necessary nor ideal. Despite its frequent service to the dominant socioeconomic order, art still can represent values that are not simply reducible to the values of economic profit. Finally, there is the hope that popular art, if recognized as genuine art, could help overcome the long-standing identification of aesthetic taste with class privilege. These claims need more elaboration than this chapter has space to provide. I return to them in chapters 7 and 8, where I discuss the views of Locke, Eliot, and Adorno.

6.

Convention
Variations on the Nature/Culture Theme

The distinguished Harvard philosopher Hilary Putnam has argued that "a deep examination of the notion of convention is one of the great contributions of analytic philosophy" and that "two great analytic philosophers have reached the conclusion that convention is a relatively superficial thing. It rests upon facts about us that are Natural and not Conventional." Putnam, who shares this low estimate of convention, claims Ludwig Wittgenstein as one of two analytic "greats" who rejected the importance of convention, the other being Willard Van Orman Quine.[1] We can begin our study of convention by questioning this point about Wittgenstein.

Certainly Wittgenstein, with his central notion of language-games and his emphasis on shared social usage and practices rather than natural essences, could easily be characterized as underlining the pervasive importance of the conventional rather than the natural. In *Philosophical Investigations*, he maintains that all language "is founded on convention"; and in *The Blue Book*, rather than regarding conventions as relatively superficial, Wittgenstein describes them as most fundamental, the bedrock not only of language but also of the understanding and knowledge that language informs. "Here we strike rock-bottom, that is we have come down to conventions."[2]

Ironically, Stanley Cavell, whom Putnam enlists to support the superficiality of convention, maintains (and in the very same chapter of *The Claim of Reason* cited by Putnam) that "Wittgenstein's discovery, or rediscovery, is the depth of convention in human life."[3] Cavell moreover recognizes that convention is central not only to Wittgenstein but also to another great analytic philosopher whom Putnam fails to mention, J. L. Austin. In his *How to Do Things with Words*, Austin defined his seminal notion of the illocutionary speech act as "a conventional act: an act done as conforming to a convention." "But," he later added in casual qualification, "it is difficult to say where conventions begin and end."[4] This incidental after-

thought has more than a grain of truth and could serve as the motto, if not the moral, of my chapter.

It might be objected, in Putnam's defense, that the kind of conventions emphasized by Wittgenstein and Austin are very different from those celebrated by Rudolf Carnap and criticized by Quine, and that these latter are the kind of convention that Putnam seems to have foremost in mind. However, such an objection only proves that convention is a far more complex and intricate theme in analytic philosophy (and a far more important notion) than Putnam's account would suggest. My aim in this chapter is to probe deeper into the confusing complexity of our notion of convention. It may be quixotic to expect a crystal clear account of this notion, but by exploring its complexity we can better understand why philosophers have frequently made such puzzling and conflicting assertions regarding convention and the conventional. Such exploratory analysis may help explain how philosophers (like Bertrand Russell and Quine) can deny the platitude that language is conventional, and why others like David Lewis can maintain that while language *is* conventional, fashion is not. But it also may help explain why Putnam, undoubtedly familiar with the central conventionalist aspects of Wittgenstein's philosophy, can nonetheless claim him to be asserting the superficiality of convention.

II

An initial approach to examining our concept of convention would be to consult the dictionary. The *Shorter Oxford English Dictionary* lists nine different meanings for the entry "convention" alone, besides additional meanings for derivative terms such as "conventional," "conventionality," and so forth.[5] If we try to look for a core or underlying meaning by going back to the word's sources and original sense, we learn that it already existed in Middle English, having been adopted from the French word of the same spelling and ultimately from the Latin word "convention" meaning "meeting or covenant." Its original Middle English meaning, which it still maintains today, is "an agreement or covenant between parties." Etymology thus presents conventions as explicit agreements contracted between parties who need to formulate and establish them, and perhaps also, by extension, as shared practices ultimately based on and expressing such agreements. This is surely one important sense of convention, and perhaps the clearest conventions are of this sort.

However, confining convention to this sense does not do justice to the concept's wider role. Conceived as requiring explicit formal agreement, convention would seem too superficial to serve as the basis for language. Thus Russell (long before Quine) brought the classic argument against the conventionality of language: "We can hardly suppose a parliament of hitherto speechless elders meeting together and agreeing to call a cow a

cow and a wolf a wolf. The association of words with their meanings must have grown up by some natural process, though at present the nature of the process is unknown."[6]

The apparent cogency of this line of argument against the conventionality of language has prompted David Lewis's important theory of convention which, as Quine aptly puts it, "undertakes to render the notion of convention independent of any fact or fiction of convening."[7] Lewis's analysis of convention, which is based on the mathematical theory of coordination games, is examined below. But before turning to game theory, we can examine the concept through more traditional forms of semantic analysis.

One of the most important principles of semantics is that of contrast and opposition. Words and sentences do not get their meaning in isolation, but instead derive their meaning from their relationships with other words and sentences in the same language system. Among the most basic and important of these relationships is opposition or contrast.[8] One could even argue that opposition is the fundamental principle of semantic information theory, since the semantic content of a proposition can be defined simply as the set of state descriptions it opposes or contradicts and thus excludes. Certainly, structuralist semantic field theorists as well as independent linguists like C. K. Ogden have recognized the essential role of opposition in determining the meaning of words.[9] The idea that what a word means can be essentially a function of what it opposes is also salient in Austin's discussion of what he calls "trouser words" such as the philosophically problematic words "real," "proper," and "free." Such a word "takes whatever sense it has from the contrast with its opposite" which, so to speak, wears the semantic trousers.[10]

Whether or not "conventional" is a trouser word, can we at least determine a definite and satisfactory sense of the conventional by means of its standard (or, if you will, conventional, or, for that matter, natural) opposite—the natural? Caution is required here, since the natural/conventional contrast is not an unproblematic one of simple contradiction, as we see by the interchangeability of these terms in the parenthesis of the preceding sentence. Moreover, it seems hard to define the conventional by its contrast to the natural, for the meaning of the natural seems even more elusively vague and variable. Indeed, one could probably make a better case for "natural" being a trouser word having "conventional" as one if its sense-giving opposites, along with such terms as "artificial." The natural/conventional opposition might be likened to an odd couple where no one seems to wear the trousers. But this opposition is too central to philosophical discussion to be thus jokingly dismissed without further examination.

Consider, then, the regularities of human life and behavior that we regard as natural. We might roughly distinguish at least two different categories, or levels, of naturalness. First, we find those most stark and primal natural activities that concern only the bare necessities of life, dictated en-

tirely by what seems essential to the uncultivated human constitution. As T. S. Eliot's Sweeney describes it: "Birth, and copulation, and death. That's all the facts when you come to brass tacks."[11]

We may wish to add a few other basic facts or activities, such as breathing, eating, excreting, and some form of locomotion; but the general idea is clear. The natural is identified with what is radically fundamental and necessary, as opposed to the conventional which is nonnecessary or "arbitrary" (in a very wide sense of "arbitrary," meaning that it could be or could have been otherwise). With this conception of the natural, and given the progressive improvements in biotechnology, it would follow that sexual copulation (perhaps even sexual reproduction in general) should no longer be classified as a natural act, but only a conventional one, since we have biotechnological alternatives for reproduction. Michel Foucault and his disciples have, of course, provided very different (essentially genealogical) arguments to affirm that sex is not a natural phenomenon but a socially constructed concept. Despite the power of these arguments and the possible alternatives to traditional sexual reproduction, it still sounds odd (even unnatural) to speak of copulation as a nonnatural activity. This is because we also have another, higher-level notion of naturalness that goes beyond the absolute minimal necessities of life. Far greater claims have been cogently made for human nature.

We commonly take as natural all sorts of activities that seem to have evolved in an informal fashion from basic human needs and proclivities. Living together in social groups and thus conforming to social norms, speaking a natural language (called "natural" despite its alleged conventionality) are typically regarded as perfectly natural activities, whose nonperformance would seem unnatural. Yet such natural activities also involve, in a very fundamental and necessary way, certain features which we characterize as conventional. For instance, many consider it natural to get married, though marriage clearly seems to require convention and can be described as conventional vis-à-vis mere sexual cohabitation. Or we may consider it natural to greet or congratulate a friend, yet these actions, even when performed nonverbally, are constituted by convention.[12]

In short, a great deal of the fabric of our behavior is constituted by practices and customs that go beyond stark natural necessity, could have been otherwise, and thus may be called conventional. But such conventional behavior has become so deeply entrenched, so intrinsic to what Wittgenstein calls our "forms of life," that unless we are philosophers, we consider it natural. These conventional activities become, as the idiom aptly puts it, "second nature." This more expansive conception of the natural to include not only primal but also second nature seems to be what lies behind Putnam's claim that convention is something relatively superficial

and insignificant. For Putnam indeed suggests that we take the natural to include all of "what we do *naturally* (either by virtue or our constitutions or by virtue of the particular cultural traditions that have become part of our makeup)" (*CTP*, 4). Since this would include all the practices, customs, and habits that have become second nature (that is, are done as a matter of course), then those regularities of behavior which still remain to be characterized as not natural but instead conventional must be very few and superficial.

Indeed, even Putnam's own example of the superficiality and arbitrariness of convention—driving on the right rather than the left—in a highly motorized culture where this practice has been long and deeply entrenched could very well be described as something done naturally "by virtue of the particular cultural traditions that have become part of our makeup" or second nature. Moreover, when such tradition is reinforced by an infrastructure of road systems and mechanized car-parks based on right-side driving, then this way of driving is not only second nature but also is nonarbitrary and "not up for questioning—given our constitutions and forms of life." Hence it would not meet Putnam's own standard of what can "intelligibly be described as 'conventional' " (*CTP*, 5–6). Thus, Putnam's account of the natural/conventional distinction problematically seems to deny the conventionality of its own paradigm of convention, allowing it to be characterized as natural and perhaps even unquestionable given our specific cultural forms of life.

Something is obviously wrong here, not only with Putnam's theory but ultimately, I think, with the whole idea of any neat and firm divide between the natural and conventional.[13] First of all, we must acknowledge that just as primal nature is a vaguely demarcated abstraction, second nature (as we have characterized it with Putnam) is a very mixed bag, covering things that range from virtually primal necessity to what seems quite arbitrary and equally characterizable as conventional. In other words, there are habits and customs that seem to evolve much more directly from our most basic physiological needs and proclivities and seem to have no acceptable alternative. But there are also other things we do "naturally" (i.e., as a matter of course) simply because they have been ingrained by habit or conditioning; yet they are also arbitrary in the sense that an adequate alternative seems to be available.

It may be impossible to draw a definite line dividing these levels of second nature, just as there is a problem in demarcating the primally natural. But surely there are clear differences in degree of naturalness (versus conventionality) that can be made evident by examples. For instance, wearing clothes does not seem to belong to the primally natural, but it is clearly a nonarbitrary development of our natural desire for warmth and protection; and it is so deeply entrenched that we are loath to regard it as

mere convention, though in certain instances we may wish to. However, although in certain populations it may be second nature for men to wear caps or neckties and for married women to wear a ring on a particular finger, we have no hesitancy in characterizing these second-nature practices as arbitrary and mere convention. Similarly, we see clear differences between sexual cohabitation, marriage, and the traditional church wedding with respect to the degree of naturalness versus conventionality. We recognize this, even if we are unsure about classifying marriage as natural or as conventional (for it is often called either and could be called both), and even if some might hold, following Putnam's account, that, in many social contexts, getting married in church would be an unquestionable act of second nature and so might as well be called natural rather than conventional.

Having indicated some of the complexity of usage regarding the natural/conventional distinction, let me try to draw some conclusions concerning this opposition. First, in the terminology of traditional logic, "natural" and "conventional" are not contradictory predicates but at most (and perhaps not even absolute) contraries. That is, the negation of one does not entail the affirmation of the other. But (at most) the affirmation of one would entail the negation of the other.

In the terminology of contemporary linguistics, a very similar distinction is made between nongradable and gradable opposites.[14] Gradable opposites (e.g., "hot" and "cold," "friendly" and "unfriendly") are like contraries in that the predication of one entails the negation of the other. In contrast, nongradable opposites (e.g., "male" and "female," "married" and "unmarried") function like contradictories in that if they are in principle applicable to an object, not only does predication of one entail negation of the other but also the negation of one entails predication of the other. "Natural" and "conventional" are clearly more like gradable than nongradable opposites. For denying that something (e.g., self-mutilation) is natural certainly does not entail that it is conventional; and its nonconventionality certainly does not entail its being natural. Indeed, if there is any problem about characterizing "natural" and "conventional" as gradable opposites, it is that we have seen that predication of one does not always seem strictly to entail total negation of the other. We may wish to affirm that greeting a friend is a natural act without denying that it is a conventional one. Certainly affirmation of naturalness in the sense of second nature does not seem inconsistent with some measure of conventionality.

This points to another conclusion connected with the gradability of the natural/conventional opposition, namely that the distinction between natural and conventional is not absolute or fixed but essentially relative, variable, and context-dependent. This is probably because gradable op-

posites, as Edward Sapir points out, always involve grading or compari-
son with respect to a variable standard that is often only implicit.[15] Char-
acterizing some practice as conventional rather than natural thus depends
on the implicit standard of naturalness we adopt as a standard of com-
parison; and this may vary significantly from context to context because
of the extremely wide-ranging variability of the notion of the natural. As
I. A. Richards remarks, "*Nature* is evidently as variable a word as can be
used . . . And what is 'natural' to one culture is strange and artificial to
another."[16]

We have seen that many practices we call natural (since they are sec-
ond nature to us) nonetheless require conventions and may instead, by a
stricter, more primal standard of natural, be described as conventional
rather than natural. If we conceive a gradable scale of naturalness to
conventionality, the line between the natural and the conventional
would be drawn at different places according to our changing contexts
and aims of comparison. In most contexts it makes no sense to question
the naturalness of speaking a language, wearing clothes, and caring for
our children. But if we wish to point out that these practices are never-
theless not necessary, inevitable, or primal, we shall describe them as
conventional.

Even at the poles of this hypothetical scale of opposition there seems
little room for fixity or absoluteness, unless we make the questionable as-
sumption that nature or at least human nature is immutably and noncon-
ventionally given. One could press this point further by arguing that
whatever one conceives as natural is in part determined by one's conven-
tions of representing nature. Hence, our sense of the natural itself seems in
part a construct of convention. But no matter how we regard the poles of
this gradable opposition, it is clear that for most of the semantic field they
embrace, the natural/conventional distinction is variable and relative to
context. A regularity of behavior or practice is characterized as natural
rather than conventional when we want to assert that it is more basic, en-
trenched, or inalienable than other practices. It is characterized as conven-
tional when we wish to say that it is somehow less necessary and funda-
mental, or more arbitrary and dispensable, than other activities we
(perhaps only implicitly) have in mind.

We can conclude our discussion of the natural/conventional opposi-
tion by agreeing with the letter, though not the spirit, of Putnam's claim
that "convention is a relatively superficial thing." We must heavily under-
score the word "relatively"; for many conventions, as we have seen, go
very deep and are indispensable to the forms of life we typically take as
natural, and such conventions are only superficial relative to some other
thing taken as more basic. Convention perhaps always implies something
more primal or basic on which it is based and which it serves, but that

does not mean it is not itself fundamental and indispensable to life as we know it and wish to live it.

III

Our etymological and "contrastive" analyses of "convention" and "conventional" may leave us unsatisfied, because they provide a concept of convention that is either excessively restricted to explicit agreement (and thus requiring the positing of mythical convenings) or, on the other hand, a concept that is uncomfortably flexible and unclear in its contrast to natural practices and regularities of behavior. Consider, then, David Lewis's logically rigorous explication of convention, which aims to free the notion of convention from any need of convening and explicit agreement. His theory is based on the theory of coordination games, that is, games in which the interests of the players or agents coincide and the aim is to reach a mutually desirable course of interdependent action or "coordination equilibrium." Such games or problems of coordination are contrasted to games of conflict (like the *prisoner's dilemma*), where there is a dominant conflict of interests between the agents (*CPS*, 34).[17]

The basic intuition behind Lewis's theory is that the agreement or conformity of behavior that constitutes convention can readily arise in coordination-problem situations and without any explicit agreement, simply through the agency of rationally held "concordant mutual expectations" (*CTP*, 34). (Indeed, explicit agreement can be seen as merely one way of establishing these expectations.) Suppose that we first met at a certain café and that we forget to fix the venue of our next meeting. We may both go to the café for the subsequent meeting and succeed in meeting because of our mutual expectation to find each other there. Moreover, the success of this conformity of action in realizing our shared interest in meeting will reinforce our mutual expectations of meeting in that café when we next forget to fix the place of meeting. And this in turn will make us both go to that café and again achieve our desired meeting, which in turn will further reinforce our mutual expectations to find each other there when we do not fix otherwise; and so on and so forth until a convention of meeting has been established without any explicit agreement. Lewis elaborates this notion of a self-perpetuating system of common interests, mutual expectations, and conformity into the following "final definition" of convention:

> A regularity *R* in the behavior of members of a population *P* when they are agents in a recurrent situation *S* is a *convention* if and only if it is true that, and it is common knowledge in *P* that, in almost any instance of *S* among members of *P*,

(1) almost everyone conforms to R;

(2) almost everyone expects almost everyone else to conform to R;

(3) almost everyone has approximately the same preferences regarding all possible combinations of actions;

(4) almost everyone would prefer that any one more conform to R, on condition that almost everyone conform to R;

(5) almost everyone would prefer that any one more conform to R', where R' is some possible regularity in the behavior of members of P in S, such that almost no one in almost any instance of S among members of P could conform both to R' and to R. (*CPS*, 78)[18]

One of the merits of Lewis's theory, apart from its rendering convention independent of explicit agreement and prior convening, is its clarification of the sense of arbitrariness and relatively superficial character of convention that we noted earlier. The arbitrariness of a convention is explained (in condition 5) as the fact that an alternative regularity of behavior (R') in the same recurrent situation would, if generally conformed to, be just as satisfactory and would be preferable to R, which then (by definition) would no longer be generally conformed to. Thus, the preference or inclination to conform to a convention is only conditional on such conformity and in this sense is arbitrary rather than naturally necessary. Preference for R is wholly conditional on conformity to R, and there is no rational reason (that is, it is arbitrary) to prefer conformity to R over conformity to R'; for either conformity will satisfy the shared interests or preferences of the given population. In most populations either left-side or right-side driving, provided that only one is conformed to, will satisfactorily serve the population's shared desire for smooth and safe traffic. The choice of convention is thus arbitrary.

Lewis's definition also explains the sense in which convention is *relatively* superficial: there is always something more basic, some interest or desire (here traffic efficiency), that the convention is meant to serve. His definition has the advantage of being broadly formulated to allow conventions to serve any preference or interest of the population involving interdependent action.

Despite its many merits, Lewis's theory of convention is not entirely successful in realizing its aim to be "an analysis of our common, established concept of convention" (*CPS*, 3).[19] This is because certain practices that we typically describe as conventional are firmly excluded by his definition. Lewis must concede that things like practices of fair play, promise-keeping, and other (often implicit) rules of social morality, as well as more trivial things like fashion, cannot be conventions by his theory; yet obviously common usage generally treats them as such (*CPS*, 46, 88–96, 103).

There are still more striking exceptions to his theory. Consider conventions or rules of war (and note, by the way, that the standard opposite of conventional warfare is not "natural" but "nuclear," "chemical," or "biological"). They cannot be conventions for Lewis, since they are motivated by conflict, not by identity of interest. For different reasons, nor could the institution of marriage and the practice of serving white wine with fish. Exploring such exceptions can reveal the problematic limitations of his theory of convention.

Two main features (essentially embodied in Lewis's last three conditions) seem to produce the problematic exclusions. The first is his restriction of convention to coordination problems or situations where coincidence of interest overwhelmingly predominates, as condition three stipulates.[20] For example, in the recurrent situation of driving we all prefer that everyone, including ourselves, drive on the same side. But many conventions deal with situations where there is considerable conflict of interest. With conventions of war, the belligerents certainly do not share "approximately the same preferences regarding all possible combinations of actions." Each side would prefer that it (but not its enemy) would use some horribly destructive weapon (say, poison gas) over mutual abstention from such use, since its one-sided use would insure victory. The convention to abstain is a compromise agreement based on conflict and fear of retaliation rather than on predominant community of interest. However, this fact does not make the convention less serviceable or important; nor does it require that it be an explicitly formulated agreement reached through an act of convening, in other words, a formal covenant or a treaty rather than a tacit convention.

Similarly, in the world of fashion, being "in" requires that some be "out" without wanting to be; and since the situation of fashion thus contains a substantial conflict of interest, such regularities of dress are explicitly denied conventional status by Lewis's theory. Restricting convention only to the limited situations where Lewis's third condition of near identity of interests holds is to demarcate a concept far narrower than our established concept of convention, and one depleted of some important applications.[21]

This problematic limitation appears again in connection with Lewis's fourth condition, which is closely related to the demand that conventions deal only with coordinating action between agents whose preferences exceedingly coincide to the extent that each prefers everyone, including herself, to conform to the convention. According to Lewis's account of this condition, if we merely prefer that all others conform to a certain practice but would prefer not to conform ourselves (even if we do in the end conform, say, for fear of sanction), then this practice could not be a convention. For example, suppose that in a shared apartment all residents conform to an informal agreement to limit hot-water showers and conver-

sations on the apartment's only telephone to about five minutes. Each perhaps would prefer that others conform while he himself not conform, if he could go undetected. Such agreed conformities, common in community life, could not count as conventions for Lewis, though surely we think of them as informal conventions regulating social morality. Much of what we call conventional morality, conventions of morality, and more general social conventions are conventions of this sort, involving some conflict of interests. Yet such apparent conventions are excluded from the concept of convention defined by Lewis, which, despite his hope to the contrary, seems quite different from "our common, established concept of convention."

So far our critique has focused on the problematic limitations of confining convention to conditions of near perfect or very predominant conformity of interest. The other major way that Lewis narrows the concept of convention relates to his explication of convention's arbitrariness, which is enunciated in his fifth condition but which derives in any case from his view of conventions as solutions to coordination problems. Simply put, the arbitrariness of a convention is the existence of a satisfactory alternative. In other words, for a regularity of behavior to qualify as a convention, there must be a similarly satisfactory alternative regularity that could have been the relevant convention instead. If no such alternative exists, the regularity would be, for Lewis, nonarbitrary and hence not conventional (since this regularity, one might say, would be "naturally" dictated by desire or reason). Lewis further holds that convention requires not only the availability of a satisfactory alternative but also that this availability be commonly known or at least readily recognized (*CPS*, 58–68).[22]

Thus, if we know of no equally satisfactory alternative to marriage or to having white wine with fish, these regularities of social behavior typically regarded as conventional cannot, by Lewis's theory, be conventions. In some societies, marriage may be the only adequate solution (or, in the terminology of game theory, "coordination equilibrium") for achieving the shared interest of social stability in sexual and social reproduction. While in the case of food-drink harmonies, practices that may seem to have equally acceptable alternatives are denied conventionality because they involve what Lewis calls "an unconditional preference," that is, one not entirely dependent on conformity, even if originally induced by a desire to conform (*CPS*, 119). Thus, even if we originally adopted the practice of having white wine with fish because everyone else did, if we continued to prefer it when others have switched to red wine or beer, this practice should not be described as conventional.

Lewis's interpretation of the requirement of arbitrariness has the unsavory result of denying the conventionality of any custom, habit, or tradition that we would prefer to continue though others give it up. That

means one cannot, by definition, hold on stubbornly to a convention, since the mere desire to do so would deny its being a convention. Similarly, Lewis's theory makes it seem logically impossible to be enslaved or blinded by convention. According to Lewis, for something to be a convention, there must be knowledge of its dispensability through the availability of a satisfactory alternative; and the knowledge entailed is not simply our wiser retrospective knowledge, but the knowledge of participants of the convention while they adhere to it.

What Lewis renders a conceptual impossibility is in fact a commonplace of our notion of convention.[23] We often speak of a society's conventions as being blindly assumed by its population (though perhaps not by us) to have no known satisfactory alternative. In traditional societies, it was a firm convention that a woman's place was in the home, while the viability of the feminist alternative could hardly be conceived, let alone be common knowledge. Similarly, neoclassical conventions of drama were seen by their adherents as indispensable. But for Lewis, paradoxically, they can be conventions only when there is the awareness of alternatives that could easily result in their abandonment.

For all its rigorous narrowing of the concept of convention, Lewis's definition seems very vague in its psychologistic relativism. Since a convention requires awareness of alternatives and a readiness to change to that alternative conformity, the issue of whether or not something is a convention becomes a problematic question of group psychology. As Lewis is forced to admit, "what is not conventional among narrow-minded and inflexible people . . . may be conventional among more adaptable people" (*CPS*, 75). Indeed, for people who are unimaginative and rigid in their ways, who cannot accept or conceive of doing things differently, there can be no conventions. Even something as paradigmatically conventional as right-side rather than left-side driving will not qualify as convention if we are stubbornly inflexible or chauvinistic about our driving habits. For Lewis, then, conventionality requires not only a regularity of behavior that could just as well be otherwise, but also a mental attitude to that behavior, an awareness of its arbitrariness.

Thus conceived, conventions cannot help but seem relatively unimportant and superficial, since by definition any convention has a commonly known satisfactory alternative for which we would readily abandon it if others did. All convention becomes what might be called "mere" or "purely arbitrary" convention. Hence Lewis thinks it is senseless to speak of nonarbitrary versus arbitrary conventions, just as "it is redundant to speak of an arbitrary convention" (*CPS*, 70).

To sum up, Lewis fails to realize his aim of providing "an analysis of our common, established concept of convention" (*CPS*, 3). Apart from the problem of psychological relativism, his theory defines a concept far nar-

rower than our common, established concept of convention, which *does* include conformities of behavior in situations with conflict of interest as well as conformities lacking the extreme arbitrariness that Lewis requires. Contrary to Lewis, convention's conformity or agreement in behavior can be on a background of predominant disagreement or conflict of interests; and it can be a behavioral choice where no alternative is known to be satisfactory.

IV

Given the difficulties we have encountered, should we conclude that the whole project of providing a clear and uniform analysis of "our common, established concept of convention" is doomed from the outset, since this concept is simply too complex, vague, and variable in use to allow this? Certainly our common, established concept of convention is not a perfectly univocal one, but rather has a few different, though related, meanings, as even a glance at the dictionary might reveal. There seem to be a number of importantly different kinds of conventions, even if we exclude from this variety the many sorts of assembly commonly denoted by this name. Artificial conventions are explicitly stipulated, agreed upon, and sanctioned; yet other conventions are regularities of practice or usage that have more "naturally" evolved and may never have been explicitly formulated or explicitly agreed upon. Some may not even admit of such formulation and agreement (*CPS*, 86–87). Moreover, among these naturally evolved conventions (and perhaps also among those artificially or formally introduced), an important distinction may be made between those having a similarly satisfactory alternative and those lacking one, or at least a commonly known one. There also seems to be an important distinction in kind between conventions of coordination and those of conflict.

Nonetheless, the deep philosophical yearning for unity inspires the hope of finding some underlying core of conventionality that is common and necessary to all these different things we call conventions and is more important than the differences between them. So consider the following proposal. Whether artificially or naturally induced, whether in situations of coincidence or conflict of interest, whether having or lacking a commonly known satisfactory alternative, a convention is always a general conformity of social behavior or usage that is somehow arbitrary rather than necessary.

This last-ditch attempt remains problematic. First, it is questionable whether a convention always entails general conformity to itself in the relevant population. It hardly seems contradictory to speak of a convention that is more often violated than observed, or a convention that fails to catch on when introduced and is thus never really accepted. Conventions of war, disarmament, and dress may be of this sort. Obviously, those con-

ventions that have evolved and established themselves through general conformity rather than explicit stipulation must at some time have been generally observed. But we must remember that conventions are not all of this kind, nor indeed of any one kind.

The error of assimilating all conventions to one privileged type is largely responsible for the many strange and unconvincing assertions of philosophers concerning convention, some of which we noted earlier. Russell and Quine, for instance, deny the platitude that language is conventional, since they construe convention as limited to explicit agreement, typically through convening. Likewise Putnam is led to the questionable view that convention is always a relatively superficial thing (and to the equally unconvincing view that Wittgenstein thought so) by his taking as convention only "artificial," "planned," and "arbitrary" conventions which cannot in any way be described as something "we do naturally." Finally, Lewis is obliged to deny the conventionality of conventions of war, fashion, and social morality not because he limits convention to the artificial, planned, and explicitly agreed upon, but because he rather assimilates all convention to those which serve problems of coordination and are thus by definition arbitrary in Lewis's sense of this notion.

This raises a second problem with defining convention as a general conformity of social behavior or usage that is arbitrary: the nature of arbitrariness. Conventions are very frequently described as arbitrary, and in many contexts (for instance, the characterization of the linguistic sign) the terms "conventional" and "arbitrary" seem to be used interchangeably as virtually synonymous.[24] But can we say that all conventions must be arbitrary? Certainly we have seen that not all are arbitrary by Lewis's standard of arbitrariness. Nor can we say that all are arbitrary in the sense of being the product of mere chance, whim, or unjustified prejudice or personal preference. What sort of arbitrariness could be shared by all the things we call conventions? At most, we can say that all are arbitrary in the sense of being contingent and not inevitable, that is, not a matter of stark, natural necessity. In other words, we could always do without a given convention, even if doing without it would mean doing very poorly. However, this sense of "arbitrary" seems a misleading philosophical usage that appears to be based on an equivocal slide from the meaning of "arbitrary" as mere chance to the importantly different meaning of being contingent or not necessary. This equivocal shuffle is perhaps facilitated through the mediating notion of the accidental, which seems to overlap with the meanings of both contingency and random chance.

In any case, equating the conventional with the arbitrary seems just as problematic as regarding the conventional and the natural as incompatible opposites. There is a real danger of implicitly moving from the presumption that all convention is arbitrary in the minimal sense of contingency to

the more radical inference that conventions are always arbitrary in the sense of being without justification; based on accident, unreasoned prejudice, or preference; and having an equally satisfactory alternative. For instance, it is tempting to take the premise that our representation of the world is based on linguistic convention and thus is arbitrary (in at least the minimal sense) and then slide to the conclusion that that representation (or even the represented world) is but an arbitrary construct—a product of unjustified prejudice, unreasoned preference, and pure randomness.

Certain constructivist philosophies do not seem entirely immune from such temptations. Similarly, in the humbler field of interpreting poetry, we speak of the meaning of a poem being governed by our readerly conventions of seeking in it unity and coherence and a significant attitude toward the world of human experience.[25] These conventions of poetic meaning may be arbitrary in that there is no clear necessity or inevitability in treating texts this way. However, they certainly do not seem to be the arbitrary product of unjustified prejudice, chance, or whim, having equally satisfactory alternatives. It is hardly clear whether we could really have poetry without these conventions, which indeed seem to derive from and answer to basic human needs for order and significance that we might even describe as natural needs.

So even if all conventions may be described as somehow arbitrary and nonnatural, they differ greatly in the manner and degree of arbitrariness and nonnaturalness. We must therefore be very careful about what we infer from the fact that some cultural practice, principle, or standard involves or is based on convention. When we speak about conventions and the conventional, we should try to be aware of which variety of convention we have in mind and also of the variety of convention that should be kept in mind. In recognizing the productively structuring power of art's cultural conventions, we need not exclude the formative natural sources of art. The next chapter considers how pragmatist aesthetics brings nature to bear in navigating the contested fields of art and culture and in challenging some of their problematic conventions and social prejudices.

7.

From Natural Roots to Cultural Radicalism
Pragmatist Aesthetics in Alain Locke and John Dewey

I

In the pragmatic tradition of Ralph Waldo Emerson, William James, and John Dewey, Alain Locke affirms philosophy as an expression of the individual's personality, an intellectual response to the problems one faces in the project of living. "All philosophies, it seems to me, are in ultimate derivation philosophies of life and not of abstract, disembodied 'objective' reality; products of time, place, and situation, and thus systems of timed history rather than timeless eternity."[1] Recognizing that even one's most impersonal philosophical efforts "may merely be the lineaments of a personality," Locke confessed, "I project my personal history into its inevitable rationalization as cultural pluralism and value relativism" (*PAL*, 17).

Such honest critical self-reflection is exemplary in philosophy. It inspires me to preface my philosophical commentary on Locke by an embarrassing confession of my own personal history with regard to him. Though Locke's work should have long ago been known to me, and though it could have been extremely helpful to my initial studies of pragmatism and hip-hop culture, it was only after the publication of those studies in *Pragmatist Aesthetics* (1992) that his name began to be mentioned to me as someone whose work I ought to read.[2] My joy in discovering him was as deep as my shame for having overlooked him. In developing pragmatist ideas to defend the value of popular art, I celebrated Dewey's more famous theories as my guiding exemplar. I never noticed Locke's pragmatist aesthetics, which not only anteceded but could well have influenced (through the mediation of Albert C. Barnes) Dewey's prime aesthetic statement, *Art as Experience* (1934). Locke's work, moreover, was far more relevant to my special concern with legitimating popular art forms like rap. There is an appalling irony here that indicates just

how heavily the deck is still stacked against black culture: my very at-
tempt to provide a philosophical legitimation of the African American art
of hip hop unknowingly reinforced a shameful neglect of African Ameri-
can philosophy.[3]

This sad testimony further shows that philosophy is also always more
than one's personality. My ignorance was largely the product of the ways
a philosopher's range of ideas and sources depends on the institutional
field in which one philosophizes. It does not follow that one's philosophy
is so rigidly determined that one's ideas and arguments can never lead to
changes in how we think and in the shape of the philosophical field. One
of the goals of this chapter is a reshaping of pragmatist aesthetics to rec-
ognize Alain Locke's important place in that field. In a fine collection of
Locke's philosophical writings, *The Philosophy of Alain Locke*, Leonard Har-
ris described Locke's philosophy as "radical pragmatism" (*PAL*, 17), but
did not treat his aesthetics. In this chapter, I want to present Locke as a
prophet of pragmatist aesthetics by sketching twelve themes that demon-
strate this rich direction of his thought and by systematically comparing
his views to Dewey's. In doing so, I probe further into the complex dialec-
tic of the natural and the social-political that constitutes the life of art and
culture.

II

Expressing its Darwinian and Emersonian heritage, pragmatist aesthetics
insists on art's deep roots in the natural world, in the elemental desires,
needs, and rhythms of the human organism interacting with that world.
As Dewey put it in 1934, "Underneath the rhythm of every art and every
work of art there lies . . . the basic pattern of relations of the live creature
to his environment"; so that "naturalism in the broadest and deepest
sense of nature is a necessity of all great art."[4]

Almost a decade before, Alain Locke's *The New Negro* had stressed the
same need for art to sustain its bond to nature's vital forms and basic en-
ergies, even while urging art's development toward ever higher levels of
spirituality and culture. Locke could thus hail the African American
artist's special advantage in having a more "vital common background,"
a closer link to the "instinctive" (*NN*, 47). If tenor Roland Hayes is a better
performer of spirituals than talented whites like David Guion, "it is more
than a question of musicianship, it is a question of feeling instinctively
qualities put there by instinct" (*NN*, 207). This is not because of some-
thing biological in black genes, but, Locke claims, because of the Negro's[5]
closer link to nature's rhythms which constitutes part of his "original
artistic endowment."[6]

Modern art needs the vitality of the African American, Locke argues,
because the vital, natural aesthetic energies of European culture have

largely dissipated into "a marked decadence and sterility . . . due to gen-
erations of the inbreeding of style and idiom," where art worked merely
from its own past models while forgetting nature (*NN*, 254–59). "Art can-
not disdain the gift of . . . a return to nature, not by way of the forced and
worn formula of romanticism, but through the closeness of an imagina-
tion that has never broken kinship with nature. Art must accept such gifts,
and revaluate the giver"—in other words, the African-rooted artist who
has preserved his bond with nature (*NN*, 52). Nor does this naturalism
preclude the highest flights of spirituality, as the Negro spiritual makes
clear. Though derived "from the 'shout' and the rhythmic elements of the
sensuous dance, in their finished form and basic emotional affect all of
these elements [of the spiritual] were completely sublimated in the sincere
intensities of religious seriousness" (*NN*, 201).

III

As naturalism is not art's only end, nor is it art's sole formative factor.
Pragmatist aesthetics recognizes that history and its changing social con-
ditions are likewise formative. Even art's most distinctively individual ex-
pressions are also the expressive product of communal life in a given his-
torical society. No less than works of philosophy, artworks, Locke insists,
are "products of time, place, and situation, and thus systems of timed his-
tory rather than timeless eternity." If the Negro spirituals seem classics of
"compelling universality" and "immortality," it is because they "have out-
lived the particular generation and the peculiar conditions which pro-
duced them" by expressing something that can be shared by succeeding
historical ages (*NN*, 199). As "each generation . . . will have its own
creed," so each will have to create its own art through the changing social
conditions and historical formations that structure aesthetic expression
(*NN*, 11).

Today's social constructivists too often present nature and history as
incompatible polarities; but pragmatism, suspicious of such dichotomies,
realizes that nature has a history, while history works in and with nature.
The closer link to nature that Locke sees as distinguishing Negro art is not
a purely natural or biological affair but the product of the difference be-
tween Negro and European history. Similarly, Locke identifies the Harlem
Renaissance flowering of "the New Negro" as the product of historical
forces. First, there were improved material conditions for these newer
generations of African Americans, along with some relaxing of "the
tyranny of social intimidation." Then there was the "shifting of the Negro
population" to the northern cities, which put this new constituency in
close contact with the most advanced technologies and most modern
forms of life and cultural expression. Finally, there were the world-wide

trends of national and ethnic pride: "Europe seething in a dozen centers with emergent nationalities, Palestine full of a renascent Judaism" (*NN*, ix, 4–5). All of this, Locke argues, encouraged the expression of Negro "race pride" as an avant-garde cultural expression.

The particular *genius loci* of Harlem was also socially explained. Harlem was not merely "the largest Negro community in the world, but the first concentration in history of so many diverse elements of Negro life." Such concentrated diversity of background, talent, and professional activity provided the most creative interaction for cultural flourishing and thus made Harlem the New Negro's cultural "race capital" (*NN*, 6–7). Acutely sensitive to the issues of race and culture, Locke believed that full social legitimation would not be granted to African Americans until their specific cultural contribution was respected, so he touted the distinctive cultural merit and potential of the New Negro. Locke would agree with John Dewey that a culture's popular artworks are "signs of a unified collective life" (*AE*, 87), but he seems more appreciative than Dewey of the value of ethnic diversity in the unities of art and culture.

IV

The value of such interactive brewing of diversity is central to pragmatist aesthetics as I understand it. Against traditional aesthetics of purist segregation and compartmental isolation, pragmatism urges an aesthetics of "the mix" that became so popularly salient in fusion and in hip hop. Locke expresses this aesthetic preference in his multiculturalist advocacy of not simply "unity in diversity" but "unity through diversity" (*PAL*, 134–35). More generally, the pragmatist orientation toward *mélange* is expressed in its treatment of distinctions as flexible tools for changing purposes rather than as fixed dichotomies. Thus Dewey insists on the continuity between the different arts, on their mixture of elements, and on the definition of aesthetic experience not by any specially unique "aesthetic" dimension but rather by "a greater inclusiveness" and a closer, more zestful integration of all the different elements of ordinary experience (*AE*, 259; cf. *PA*, 12–17).

Locke makes similar points about the continuity and fusion of the different arts in advocating "The Ethics of Culture" (*PAL*, 181–82). *The New Negro* further invokes the pragmatist aesthetic of "the mix" not only to explain how the concentration of "dissimilar elements into a common area of contact and interaction" has resulted in the aesthetic creativity of Harlem life, but also to advocate the American Negro's great artistic promise as someone who can better mix the "original artistic endowment" of Africa with the "more complex patterns and substance" of American life (*NN*, 256–57). The musical greatness of Negro spirituals is

similarly explained as the product of a perfect mix of "distinctiveness of the melodic, harmonic, and rhythmic elements in this music," in which we can "separate or even over-stress" no one element without losing the genre's "finer effects." "It is the fusion, and that only, that is finely characteristic" (*NN*, 206).

Locke evinces his commitment to an aesthetic of diversified mixing in many more ways than can be treated in this chapter. Let me just note three important examples. First, though *The New Negro* is largely devoted to building "race pride" and insisting on "a racial idiom" for African American artists (*NN*, 11, 13, 262), Locke is clearly not an exclusionary racialist of the separatist or essentialist type. Viewing race itself as a "composite" product of cultural fusion, he thinks race relations for the African American can only be improved through greater contact and interaction (*PAL*, 192–95, *NN*, 8–11). Advocating "free-trade in culture" and "the principle of cultural reciprocity," he insists that "cultural goods, once evolved, are no longer the exclusive property of the race or people that originated them. They belong to all who can use them; and belong most to those who can use them best" (*PAL*, 206).

Second, though Locke advocates a distinctive African American aesthetic, white artists can be recognized as welcome contributors to its artistic mix, and even sometimes hailed as being useful teachers for African American artists in the portrayal of black African or African American subjects. Noting "the fine collaboration of white American artists" (e.g., Eugene O'Neill) in advancing African American literature (by their "bringing of the materials of Negro life out of the shambles of conventional polemics, cheap romance and journalism," *NN*, 49), Locke further praises European painters, especially the Belgian Auguste Mambour, for developing a "technique of the Negro subject [that] has reached the dignity and skill of virtuoso treatment and a distinctive style" that was still well in advance of African American artists:

> The work of these European artists should even now be the inspiration and guide-posts of a younger school of American Negro artists. They have too long been the victims of the academy tradition and shared the conventional blindness of the Caucasian eye with respect to the racial material at their disposal. (*NN*, 264)

Locke thus chooses the African American portraits and designs of Norwegian artist Winold Reiss to constitute the illustrations of *The New Negro*—exemplifying yet another aspect of Locke's aesthetic of the mix.

For *The New Negro* is not just a mixture of voices (his and the many authors he anthologizes (including white authors like Albert C. Barnes and

M. J. Herskovits), it is also a composite of high and popular art forms and an amalgam of artistic genres: essay, fiction, poetry, drama, portraiture, decorative art, photos of African sculpture, and even musical scores. Sometimes the mix of visual, musical, and literary art can even be found within the very same critical essay.

V

A major theme of pragmatist aesthetics is the practical value of art, even of so-called pure art. Respective of art's formal values, pragmatism nonetheless insists that art is always more than its well-formed objects; it is a purposive activity and needs to be understood also in terms of its moral and social functions. Locke admirably exemplifies this pragmatist balance of surface form and instrumentality. Analyzing the formal richness of genres like the spiritual, he urges African American artists to break through tired forms and stereotypes through formal invention inspired by the exquisite formalist discipline of African plastic art. But Locke puts at least equal emphasis on the deeper practical functions of even "pure art values" (*NN*, 52).

Foremost among these functions is art's use for the "self-expression" and "self-determination" of both the individual and her ethnic group. "And so the social promise of our recent art is as great as the artistic. It has brought with it, first of all, that wholesome, welcome virtue of finding beauty in oneself" (*NN*, ix, xi, 52). Along with "the motives of self-expression and spiritual development" and "the old and still unfinished task of making material headway," Locke advocates the contribution of African American artists as the privileged means for the full social acceptance of African Americans in American life. "The especially cultural recognition they win should in turn prove the key to the revaluation of the Negro which must precede or accompany any further betterment of race relationships" (*NN*, 15).

Recognizing that art is a practical, purposive form of activity, Locke criticizes the great African American thinker W. E. B. Du Bois for interpreting spirituals by mere mood or emotional theme. Instead, Locke argues, we must "relate these songs to the folk activities that they motivated" and their specific "type of folk use" in "the communal life" they served (*NN*, 205). For this reason, though welcoming the prestige acquired in bringing spirituals to the concert hall, Locke warns how they can be misunderstood when transplanted from their original congregational usage and turned into entertainment. "We should always remember that they are essentially congregational, not theatrical, just as they are essentially a choral not a solo form" (*NN*, 202). In short, Locke applies the pragmatist lesson that art is a practice defined by its uses as well as its experience.

VI

For pragmatist aesthetics, art's highest and most general use is the improvement of life. This is the underlying theme of Locke's cultural agenda of aesthetic activism. By providing the joys of beauty, self-expression, and self-respect through perceiving beauty in oneself; by providing cultural recognition, material rewards, and spiritual development (through art's exacting discipline)[7] for oneself and one's group; and finally by providing also "poetry of sturdy social protest, and fiction of calm, dispassionate social analysis," art can make the Negro's life increasingly better, turning "the brands and wounds of social persecution . . . [into] the proud stigmata of spiritual immunity and moral victory." Moreover, by combining critical realism and utopian imagination, art can supply "an emancipating vision to America" as a whole (*NN*, 52–53). As Locke later writes, "Our espousal of art thus becomes no mere idle acceptance of 'art for art's sake' or cultivation of the last decadences of the over-civilized, but rather a deep realization of the fundamental purpose of art and of its function as a tap root of vigorous, flourishing living."[8]

In advocating art's utility for life, Locke highlights the blending unity of the arts in this service, while expressing the ancient pragmatic idea that "life itself is an art, perhaps the finest of fine arts—because it is the composite blend of them all." Not only the formalized elite fine arts belong in this mix. The "amateur arts of personal expression—conversation and manners . . . are as important as the fine arts; in my judgement, they are their foundation." In the same pragmatist spirit of dissolving dualities, the audience's "refined consumption" of art is brought on par with artistic production as equally crucial for creating the aesthetic mix that makes art and life richest. Only "with the products of the fine arts translating themselves back into personal refinement and cultivated sensibilities, culture realizes itself in the full sense, performs its full educative function and becomes a part of the vital art of living" (*PAL*, 181–83).

VII

Pragmatist aesthetics views art as at least equal to science in improving life by improving the quality of experience. Although very respectful of science and aware of its deep aesthetic features and affinities to art, pragmatism warns against what Locke describes as scientism's "fanatical cult of fact." Human life is lived more in felt experience than in the impersonal facts of science, and art's experience is typically more rich, vivid, and affectively powerful than that of science (*PAL*, 36–37, 53; *AE*, 33, 90–91; *PA*, 11–12). The dominantly experiential and affective quality of value is a crucial point of Locke's technical philosophy. Values are most basically "emotional," formed and sensed "directly through feeling":

the value-mode establishes for itself, directly through feeling, a qualitative category, which, as discriminated by its appropriate feeling-quality, constitutes an emotionally mediated form of experience.

Values thus should be understood "primarily in terms of feeling or attitude," not in terms of objective predicates and judgments of impersonal reality; "the feeling-quality, irrespective of content, makes a value of a given kind" (*PAL*, 38–40).

The consequences of such affective axiology for cultural politics are manifest in *The New Negro*. While welcoming "objective and scientific appraisal" and recognizing that true social recognition is better served by "the new scientific rather than the old sentimental interest" in African American life, Locke nonetheless advocates art as the better tool for achieving the Negro's full "cultural recognition" and "revaluation" (*NN*, 8, 11, 15). African Americans will be more highly valued when people (of all ethnicities) feel better about them; and powerful artworks by and about African Americans are far more able to render this change of affect than the dry statistics of social science, however important and useful Locke knew them to be.[9]

VIII

In recognizing art's social potential to express and change attitudes, pragmatist aesthetics advocates a distinctively democratic view of art. Though often used for antidemocratic ends, art is best put in the service of democracy. This means renouncing the narrow identification of art with elite fine arts as sharply distinguished from forms of popular culture. If a healthy democracy needs the productive understanding that comes from a free and richly interactive contact between its different groups, then a democratic aesthetic needs the same sort of open exchange and mutual recognition between different forms of artistic expression. Though pragmatist aesthetics insists on the crucial role of distinguishing good from inferior artworks, it refuses to see this distinction as marking a rigid barrier between the canonized high art of culture sophisticates and the expressive forms favored by more common folk. Arguing genealogically, pragmatism challenges this barrier by insisting that today's high art classics derive from popular art and were often formerly disparaged as mass entertainment.

In *Pragmatist Aesthetics*, I made this case for democratic pluralism by drawing largely on Dewey. But Alain Locke anticipated Dewey's critique of the hierarchy and compartmentalization of the fine arts. Locke laments that "art has run to classes, cliques and coteries," losing its "vital common background" in shared popular experience (*NN*, 47). Although deeply ap-

preciative of high art and extremely wary and critical of corrupting com-
mercialization in the world of popular culture, he nonetheless defends the
value of popular and folk art traditions, suggesting that the path to new
greatness in classical music may lie through the development of popular
music, especially "the most consistently developing genius [of] Duke
Ellington" and his creative jazz tradition (*CTAL*, 113).

Locke has a complex position on jazz, the outlines of which can be
grasped in his "Toward a Critique of Negro Music" (*CTAL*, 109–15).[10] He
critically notes that to attain its potential, jazz must be "intellectualized"
so as to "completely break through the shell of folk provincialism as
only the spirituals have as yet done, and completely lift itself from the
plane of cheap popular music." "Jazz must be definitely rid of its
shoddy superficiality and its repetitious vulgar gymnastics. Further, it
must be concentrated nearer to the Negro idioms from which it has been
derived" so as to guard against commercialist dilution by cheap oppor-
tunistic imitators in the music industry (*CTAL*, 112–13). Yet despite such
critique, Locke affirms the promise of jazz (through the likes of Elling-
ton) to reach the highest peaks of musical achievement. "The titanic
originality of the great Negro orchestras has only to be intellectualized
to conquer Parnassus or raise an Olympus of its own" (*CTAL*, 113).

In his critical affirmation of jazz, Locke exemplifies the pragmatist po-
sition on popular culture that I call *meliorism*: popular art needs attentive
criticism because it needs considerable improvement, but it also rewards
attentive criticism because it has great aesthetic and social potential,
which it realizes in its best works. There are, however, two ways to con-
ceive of such meliorism: pluralistically or through a basic underlying hier-
archy. One can argue for artistic difference without domination, where
popular genres of music can be valued for their own aesthetic value with-
out needing to be justified only by their approximation or contribution to
more elite musical forms. That is the meliorism I favor, which can prize
music for its dance value and not just its concert value in terms of formal
criteria of classical music.

Locke's melioristic position may be different. Sometimes he seems to
value vernacular styles less for the joys and qualities they provide than for
their potential to evolve into the established "high" genres of art and the
"universal" language of modernism. Locke praises Duke Ellington's jazz
by portraying it as moving beyond vernacular jazz traditions toward clas-
sical, symphonic forms: Ellington "is the pioneer of super-jazz and the
person most likely to create the classical jazz towards which so many are
striving" (*CTAL*, 113). If Locke really views the classical and modernist
high art tradition as the ultimate apex and criterion for aesthetic value (as

Tommy Lott suggests), then this would be a significant limitation to Locke's cultural pluralism.[11]

Yet Locke's major thrust is certainly to undermine the barrier between high art and popular or folk culture. With great skill, he links Negro spirituals to the complex simplicity of medieval art. He deftly notes "the folk song origins of the very tradition which is classic in European music," and he insists that the art of spirituals can be rightly appreciated on both the simpler popular level of "emotional intuition" and the more erudite level of musical "technical values" (*NN,* 200, 209). Applying pragmatism's aesthetic of the productive mix, Locke advocates not a mere purist preservation of African American folk music but its integration into new forms, including classical orchestral forms. He likewise argues that elements of African folk art (such as disciplined control, abstract decorative forms, and stylization) have inspired the high art tradition of European visual arts and thus should be better integrated into the efforts of contemporary African American artists (*NN,* 258–67).[12]

The political motives of Locke's aesthetics are also more widely democratic. He brings us the art of "the New Negro" not simply to promote the cultural recognition of his people but to advance "a new democracy in American culture" (*NN,* 9), because true democracy cannot tolerate cultural disrespect toward any ethnic group in society. Pragmatic meliorism insists that democracy and race must not be used as excuses for accepting lower aesthetic standards to justify "vulgarity" and "sub-mediocrity" in the arts (*PAL,* 180),[13] but it recognizes that democracy, like art and culture, is best served by open exchange between different ways of thought and diverse ethnic voices. African American expression therefore must be fully integrated as a well-respected, interactive part of American culture.

> Democracy itself is obstructed and stagnated to the extent that any of its channels are closed. Indeed they cannot be selectively closed. So the choice is not between one way for the Negro and another for the rest, but between American institutions frustrated on the one hand and American ideals progressively fulfilled and realized on the other. (*NN,* 12)

Locke's advocacy of race pride and a racial idiom for African American art is not to serve an exclusionary racist separatism: "The racialism of the Negro is no limitation or reservation with respect to American life; it is only a constructive effort to build the obstructions in the stream of his progress into an efficient dam of social energy and power." And "this

forced attempt to build his Americanism on race values" cannot succeed "except through the fullest sharing of American culture and institutions" (*NN*, 12). In short, far from an Afrocentric purism or essentialism, Locke's policy is rather a proudly mixed African American culture that can contribute more fully to the flowering manifold of American civilization as a whole.

IX

Locke's complex handling of this issue of race exemplifies his pragmatist recognition that concepts are practical tools whose use depends on context. An intensely careful student of the difficulties of defining race, Locke recognized it as one of the "most inevitable but at the same time most unsatisfactory concepts" (*PAL*, 188). Disguised as a biological, scientifically objective concept for the explanation of culture, race typically functions more as a classificational strategy to privilege certain cultures and social groups over others. Appreciating the critical scientific motive to dismiss race as merely a fictional construction on what is really only a "culture-type" that is best "explained in terms of social and historical causes" (*PAL*, 192), Locke still more strongly grasps the pragmatic insight that race remains a concept of entrenched social, political, and cultural power. If it has been (and will continue to be) wielded to damage populations like Africans and African Americans, race must not be dismissed as mere fantasy but instead redeployed to rehabilitate its past victims.[14]

Hence Locke's *The New Negro* repeatedly touts "race pride," "race genius," and the "race-gift," even though his more technical writings of the same period inveigh against "the fallacy of the block conception of race as applied to the Negro peoples" (*NN*, 11, 47, 199; *PAL*, 169). On the strict scientific or philosophical level, Locke attacks the idea of defining race in terms of blood and genetics and defines it instead as essentially cultural and "in terms of social and historical causes."[15] But this hardly prevents him (in more popular and politically engaged texts like *The New Negro*) from affirming, in block, the American Negroes' closer racial link to African culture by being "blood descendants" of African "forefathers," even when their "cultural patterns" are so very different from the African, displaying "a curious reversal of emotional temper and attitude" (*NN*, 254, 256).

This apparent duality of discourse might seem like a pragmatism of shifty opportunism and duplicitous double standards, but it is not. Close reading reveals that, for Locke, the blood link functions not on the biological level but instead as a social symbol of connection that provides special "cultural inspiration" through "a sense of direct cultural kinship" far greater than that of Europeans who come to African art only "through the channels of an exotic curiosity and interest" (*NN*, 256). Locke's ability to sustain such subtle philosophical nuances in even his most popular writ-

ings—deploying his concepts flexibly (aware of their mutablity and ambi-
guity) but still with careful consistency—demonstrates his great philo-
sophical skill and pragmatic intelligence.

X

In his abundant writings in aesthetics, Locke does not struggle over for-
mal definitions of art and beauty; nor does he formulate systematic theo-
ries of criticism. This would be surprising were he not, as I claim, a dis-
tinctly pragmatist aesthetician. For pragmatism, the prime aim of
aesthetics is not to supply definitions and ontological truths about the arts
and their values. It is instead to realize, enhance, and deepen those values
in actual experience by improving the arts and our aesthetic appreciation
of them.

Proud as he is of the artistic achievements of African Americans,
Locke's aim is not merely to document them through descriptive truth nor
simply to preserve them through a fetishist conservation. The primary
goal is rather to improve and develop African American artistic creation
and thereby also enrich American and world culture. Locke stresses the
tradition of "spirituals, ragtime, and jazz" as "one continuous sequence of
Negro music" that will continue to develop and enrich American music.[16]
He therefore argues with respect to spirituals: "We cannot accept the atti-
tude that would merely preserve this music, but must cultivate that which
would also develop it. Equally with treasuring and appreciating it as
music of the past, we must nurture and welcome its contribution to the
music of to-morrow" (*NN*, 210).

This forward-looking practical perspective is typical of pragmatism.
And with an interpretive leap, we can even understand Locke's advocacy
of past music's contribution to tomorrow's as somehow prefiguring the
kind of aesthetic mix that is the hallmark of rap music today. Rap's signa-
ture technique is the appropriative sampling of past music (especially re-
spected older works of African American music) in order to make some-
thing excitingly new, something that affirms the value of the tradition's
past works by transformatively recycling its elements so as to move that
tradition in new ways and forms.[17]

Locke's aims for artistic development are not narrowly racial. The goal
is "to evolve from the racial substance something technically distinctive,
something that as an idiom of style may become a contribution to the gen-
eral resources of art" (*NN*, 51). As African sculpture has done this for the
plastic arts through its inspiration of cubism (notably in Picasso's *Les
Demoiselles d'Avignon*), similar contributions come from the African Amer-
ican musical tradition. Its genres of spirituals, blues, jazz, rock, and rap
have all been fruitfully adopted by artists of very different ethnicities.

XI

Linked to Locke's pragmatist goal of artistic development is his firm faith that such development is eminently possible, already on the wings, and apt to be realized by "a new generation" of young artists and writers, who hold the key to the future "not because of years only, but because . . . [they share] a new aesthetic and a new philosophy of life" (*NN*, 49).

> The Younger Generation comes, bringing its gifts. . . . Youth speaks, and the voice of the New Negro is heard. . . . What stirs inarticu- lately in the masses is already vocal upon the lips of the talented few, and the future listens, however the present may shut its ears. Here we have Negro youth, with arresting visions and vibrant prophecies; forecasting in the mirror of art what we must see and recognize in the streets of reality tomorrow. (*NN*, 47)

Here again, Locke's views foreshadow the artistic renderings and prophe- cies of street realities that have kept rap music not only high in the charts but in the headlines of politics and crime. Unfortunately it is not the best rap music that gets the most attention.

I see Locke's upbeat respect for youth as expressive of pragmatism's es- sentially forward-looking and hopeful orientation. Though eschewing naïve optimism, pragmatism's commitment to meliorism harbors the hope that intelligent action can produce significant improvements. Critics thus chide pragmatism as a juvenile philosophy for its hopes of reforming the world. Like Dewey, Locke not only respected the potential and imagi- nation of youth, but he consecrated enormous theoretical and practical ef- forts in reforming education so as to bring out the best of youth's promise and even to extend its limits by furthering adult education. Writing ar- ticles on educational reform that ranged from elementary schooling to col- lege and continuing adult studies, Locke chaired the Howard University philosophy department from 1917 to 1925 and again from 1928 to 1954. One of the founders of Associates in Negro Folk Education (an organiza- tion that published educational materials), he later was elected president of the American Association for Adult Education.[18] If youth is character- ized by openness to developmental growth, it cannot be limited to chronological measurement. By stimulating grown minds and bodies to new ideas and disciplines, adult education (including somatic education) can keep us flexibly open to growth and in this sense dynamically young.

XII

If pragmatist aesthetics aims at improving both art and experience through developments inspired by youth's new forms and energies, it will

be ardently advocatory rather than dispassionately neutral. Locke's work on the Harlem Renaissance and other African American artistic achievements clearly displays such aesthetics of engagement. More generally, Locke affirms "a pragmatically functional type of philosophy, to serve as a guide to life and living" rather than to serve merely truth for truth's sake or for "what Dewey calls 'busy work for a few professionals' " (*PAL*, 155).[19] This pragmatically partisan posture, I am often told, is false to philosophy's ideal of disinterested objectivity. The counter arguments I tend to offer are already implied in Locke's critique of scientism and his view of philosophy as a tool of life.

Philosophy's greatest achievements, as a careful study of its history will show, usually have been motivated by something more than the merely disinterested goal of truth for truth's sake. Moreover, the rigid philosophical posture of lofty disinterestedness too often disguises the narrow interests of a professionalized philosophical conservatism that is either happy to reinforce the status quo by canonizing it as "objective fact" or is simply too timid to risk dirtying its hands in the messy struggle over the shaping of culture. The fetishism of disinterested neutrality obscures the fact that philosophy's ultimate aim is to benefit human life, not simply to articulate truth.

An engaged pragmatism surely risks errors through its zeal; but fallibilism is part of pragmatism's experimental message. Errors can be corrected in the future and sometimes even justified retrospectively by their strategic function. As Leonard Harris notes, Alain Locke's particular enthusiasms led him in *The New Negro* to exaggerate the primitivism and emotional spirituality in African and African American culture. He also erred in placing the hopes of African American progress too narrowly on the role of urban African American cultural elites. But because of the writings of Richard Wright and others, Locke later reached a greater recognition of "the mass Negro." He also eventually realized that his own urban and elite vision of "the New Negro," through which he aimed to displace old negative stereotypes, had simply been a helpful "counter-stereotype" rather than "the whole truth" or essence of the Negro (*PAL*, 7, 205–10). Certainly, the abiding aesthetic richness of more traditional, working class, and rural African American images has been stunningly demonstrated in the fiction of Toni Morrison and Alice Walker.

XIII

If pragmatist aesthetics aims at improving the arts, one effective way to do so is by improving the conditions of their creation and reception, conditions that are not merely material but also social and cultural.[20] A crucial

factor in improving such conditions is increased respect for the cultural traditions that produce our artworks; and here the pragmatic style of aesthetic advocacy can play a major role. And if value, as Locke argues, is basically experiential and affective, then the only way to gain a deep respect for a cultural tradition is through a deep, affective experience of its representative works.

This is precisely Locke's strategy in *The New Negro* (and in other critical presentations of African American art and literature that he edited).[21] Esteem for the African American cultural tradition (its achievement *and* potential), will best be gained by putting a contemporary sample of its excellent artistic fruits on display, so that people can really *feel* its value in their own aesthetic experience. Moreover, to ensure the best experience of these artworks, Locke's *The New Negro* frames them with careful practical criticism and theoretical essays that provide useful tools of focus for readers approaching the presented artworks, critical tools that constitute in themselves validating symbols of cultural respect for such art. Nor should we forget that the selection and structuring of an anthology like *The New Negro* is itself a work of practical criticism.

Combining advocatory theory with detailed practical criticism is the best method for pragmatist aesthetics as I conceive it. Dewey is very disappointing in this regard. Deploring popular art's lack of recognition, Dewey notes that it suffers from getting no validating "literary attention" or "theoretical discussion" to remedy this lack of respect (*AE,* 191). But Dewey makes no attempt to provide such literary attention through practical criticism, nor does he bring specific theoretical arguments in defense of popular arts. Moreover, his passing reference to popular art (such as movies, jazz, and comics) ends by associating them with "the cheap and vulgar" to which the frustrated "esthetic hunger" of the masses is directed (*AE,* 11–12). Without concentrated aesthetic attention to the popular arts, how can these arts escape their image as cheap and vulgar. And why does Dewey not provide this attention, since they surely seem to need it?

Dewey's only apparent answer is that if art is redefined as aesthetic experience, then simply experiencing popular art aesthetically will render it legitimate as art. Nothing but aesthetic experience is needed for legitimation, and criticism is simply a means to bring the reader to have the relevant experience, an "auxiliary" device to make the experience of the work "enlarged and quickened" (*AE,* 328). This suggests that if we had the right experiences, then we would not need criticism at all, neither for understanding nor for legitimation. The power of the experience would be enough.

However, legitimation is social and justificatory, and thus requires means of consensus-formation that are not as immediate as the aesthetic

experience on which Dewey so deeply relied. Criticism is needed not simply to sharpen perception but to provide the social preconditions and practices necessary for proper appreciation. If popular arts are not thought worthy of serious aesthetic attention, they are not likely to afford the fullest aesthetic experience. One way to establish their worthiness is to show that they can reward serious critical attention if we actually provide such attention. Moreover, since the tools of aesthetic criticism are already invested with great social status, it transmits a measure of that status to the objects toward which it is directed.[22]

Of course, even the combined forces of aesthetic experience, aesthetic criticism, and theoretical argument are not in themselves enough to win full legitimation for an unacknowledged art, especially one that emerges from a culturally marginalized or socially stigmatized source. Concrete social reforms may be needed; but such reforms, Locke cogently argues, can in turn be aided by aesthetic arguments. In any case, compared to Dewey, Locke's tireless and influential efforts of practical criticism (in both high and popular arts) present a far better exemplar of pragmatic activism in aesthetics, even if Locke's taste, like Dewey's, may not always be as radically progressive and as pluralistic as today's pragmatism might recommend.

In Dewey's defense, we should recognize the difficulty of combining rigorous philosophical argument with the concrete analysis of particular artworks. Locke's labors in practical criticism made him pause from technical philosophical writing. After receiving his doctoral degree in 1918, he did not publish a philosophical article until 1935. I confess my own imbalance toward pure philosophical argument in this book. *Surface and Depth* is regrettably poor with respect to practical criticism, much poorer than my earlier books, *Pragmatist Aesthetics* and *Performing Live*. However in chapter 9, I do introduce some concrete aesthetic analysis in order to argue for a dimension of aesthetic surface that theory too often obscures. Before reaching that discussion, the next chapter explores two theorists who share Locke's skill in combining acute studies of aesthetic surface with probing analyses of art's sociocultural depths: T. S. Eliot and T. W. Adorno.

8.

Eliot and Adorno on the Critique of Culture

I

Although far better known as a poet and literary critic, T. S. Eliot devoted a great deal of writing to social theory and cultural criticism. A master of formal techniques of poetic surface, Eliot realized that their innovation and impact depend on deeper conditions of culture and society that frame the experience of both writing and reading poetry. A cannily pragmatic poet, Eliot used his literary criticism to help create the taste for the kind of poetry he wanted to write. His social and cultural criticism likewise promoted the kind of cultural background favorable to his literary projects.

But Eliot's interest in social theory and criticism went far beyond his personal literary agenda. He had a profoundly abiding concern with the conditions of Western culture and political society that compelled him to speak out forcefully and propose radical measures. This concern for social theory and cultural criticism links Eliot to the English tradition of Matthew Arnold, John Ruskin, and Walter Pater. Rejecting, however, their humanistic religion of progressive culture and aesthetic fulfillment, Eliot presented a more conservative brand of cultural theory.[1] It seems today especially right-wing because of Eliot's explicit commitments to the conservative institutions of Anglicanism, royalty, and the Tory Party.

This extremely conservative image has made it more difficult for contemporary progressives to value Eliot's achievements and to deploy his ideas productively.[2] If it has tarnished his literary reception, this outspoken conservatism poses a far greater obstacle to the appreciation of his cultural theory. Here it is impossible to bracket out political, social, and religious questions as marginal, for they are at the core of the theory and criticism of culture.[3] Eliot mourned the modern disintegration of a unified European culture united under Christianity, and he sought to shore up and revitalize Western civilization through a return to dogmatic religion that was largely moribund in intellectual society. Moreover, he vehemently rebuked our dominant liberal ideology of optimistic progress

through ideals of individual fulfillment that were already well established in his day and continue to thrive in ours. Is Eliot's cultural criticism then too conservative to be helpful for progressive theory?

This chapter argues the paradox that precisely because Eliot is "too conservative," his views converge with more progressive contemporary perspectives on culture. If conservatism is the desire to preserve the status quo, then Eliot is less a conservative than a reactionary, who is as scornfully dissatisfied with the social status quo as any radical revolutionary. Eliot's arguments against the dominant bourgeois liberal ideology of his day, which remains the prevailing ideology of our own, could therefore provide support and resources for more progressive cultural critique. This way of appropriating conservative ideas for progressive thinking is proposed by the radical cultural critic T. W. Adorno, whose powerful influence on contemporary critical theory now far exceeds Eliot's. In a brief epigram from *Minima Moralia*, Adorno writes: "Not least among the tasks now confronting thought is that of placing all the reactionary arguments against Western culture in the service of progressive enlightenment."[4]

By placing Eliot's cultural critique alongside Adorno's, I hope to shed light on some of the deeper philosophical, social, and political ideologies that frame our cultural world and structure our experience of art. I also hope to show how very relevant Eliot's thought remains, even when his operative recommendations sound so repellent and outdated to our progressive, secular ears. The critique of contemporary culture and its liberal ideology are be developed through three interrelated areas of ascending specificity: (1) the fundamental philosophical presuppositions (of ontology, epistemology, and the relation of self and society) that help sustain liberalism; (2) the broad cultural discontents and dangers of liberal individualism; (3) and finally the specific role of art in our culture and in the critique of culture.

II

Probably the most fundamental premise of liberal ideology is its privileging of the individual subject. This bias toward the subject as the ultimate source and authority of truth can be traced back to the father of modern philosophy—René Descartes, whom Eliot condemned (in his Clark Lectures) for originating "the disintegration of the intellect" of Western civilization by diverting "human inquiry from ontology to psychology."[5] Descartes' innovative idea was that what one most surely knows is not the objects of the world but one's ideas or representations of those objects, and that therefore to study the world one must first and foremost study the contents and faculties of one's own mind. Eliot blamed this doctrine

for having undermined our sense of a shared external world and thus shattered the *"sensus communis"* that helped unify our culture and make its art more powerful.

With the loss of the shared human world, "mankind suddenly retires into its several skulls"; the individual becomes the center of truth and reality, and thus ontology is superseded by what Eliot calls the "pseudo-science" of epistemology based on psychology. This subject-centered revolution is seen by Eliot as more radically momentous than Immanuel Kant's later "Copernican revolution" in philosophy, since Descartes "gave rise to the whole pseudo-science of epistemology which has haunted the . . . last three hundred years" of Western philosophy, including Kant. Eliot further notes that John Locke (a founding father of political liberalism) played a central role in reinforcing this subject-centered epistemological bias, with its representational theory of knowledge.

Critique of the Cartesian-inspired and liberal-supported interiorization of thought and subjectivization of authority resounds throughout Eliot's critical corpus. One striking example is his sarcastic diatribe against Middleton Murry's faith in the "Inner Voice" of the individual as superior to the shared principles of tradition or to any "spiritual authority outside the individual" (*SE*, 26–29). In denouncing the Inner Voice, Eliot pointedly gives it the name "Whiggery," a synonym for liberalism. In his doctoral dissertation in philosophy, Eliot argues that the inner/outer dichotomy that is basic to the Cartesian-liberal project of interiority cannot be sustained in any strict or principled philosophical sense: "the distinction between inner and outer, which makes the epistemologist's capital, cannot stand."[6] So when Eliot employs the distinction for the pragmatic purpose of polemics against Murry's Inner Voice, he construes it in a deconstructive manner. "If you find that you have to imagine it as outside, then it is outside" (*SE*, 26–27). This definition of the outside paradoxically relies on the inner voice of one's imagination, thus undermining the firmness of the inner/outer distinction.

As the Cartesian world picture locates the center of thought and meaning in individual consciousness of subjectivity, so it contrastingly regards the external world as mere mechanical extension devoid of thought and purpose. This "disenchantment of the world"[7] and the privatization of spirituality has made us feel increasingly alien in our natural and social world and thus ever more contemptuously manipulative and destructive of it. It has even made us feel alien in our own bodies, since our senses and feelings are identified with the materiality of sensory organs. To claim that the only conceivable meanings and values are those projected from the desires of individual psyches is to promote a vision of society torn by the war of subjective wills struggling to assert their private valuations. It fails

to explain the presence and power of community, where individuals are formed by a common ethos and shared set of values.

Eliot's critique of Cartesian interiority—the privatization of thought and the subjectivization of knowledge and authority—is shared by most of the powerful currents in twentieth-century philosophy. The pragmatism of C. S. Peirce, G. H. Mead, and John Dewey, the ontological hermeneutics of Heidegger and Gadamer, the embodied phenomenological existentialism of Maurice Merleau-Ponty, the critical theory of Adorno and Jürgen Habermas, and the historicist analytic philosophy of the later Wittgenstein all insist that social structures and historical contexts crucially shape our experience and ground our thought. They argue that our being in the world and with others is always presupposed in any thinking that we do. For any individual to think a thought in any language, she must exist in some linguistic, social community and inhabit some purposive form of life. These themes lie at the core of Eliot's mature theory of tradition. Tradition is lived and living social history, and it provides simultaneously a temporal-genetic and structural matrix of meaning.[8]

As theorized by the mature Eliot, tradition is not the narrowly aesthetic and transcendent set of artistic monuments (described in his early essay "Tradition and the Individual Talent") that only the elite can attain through a "great labour" of "consciousness" (*SE*, 14, 17). Tradition is instead that full-bodied and immanent matrix in which we move and which we have grasped or imbibed largely unconsciously, but which prestructures our activity, experience, and understanding of the world.

> What I mean by tradition involves all those habitual actions, habits and customs, from the most significant religious rite to our conventional way of greeting a stranger, which represent the blood kinship of "the same people living in the same place." . . . I hold—in summing up—that a *tradition* is rather a way of feeling and acting which characterizes a group throughout generations; and that it must largely be, or that many of the elements in it must be unconscious.[9]

Eliot says essentially the same thing about culture (his later term to describe tradition). Culture is not limited to high culture, which Eliot describes as simply more specialized and "more conscious culture," but includes the entire spectrum of the community's activities and can only be adequately defined or understood "in the pattern of the society as a whole" (*NDC*, 23, 48). He takes admirable care to situate and explain the realm of individual culture in the larger anthropological framework of a society's culture as a whole, insisting that we cannot understand the former without the latter.

Since culture forms the basic structural matrix of our experience, it is not something that can be wholly grasped and consciously controlled.

"Culture can never be wholly conscious—there is always more to it than we are conscious of; and it cannot be planned because it is also the unconscious background of all our planning," including "the unconscious assumptions upon which we conduct the whole of our lives."[10] Culture is a socially generated and historical framework that structures our most private thoughts and gives them a language without which they could not be articulated or thought. It therefore shows the folly of the isolated Cartesian *cogito*.

The Cartesian premise of knowing the world by first examining individual consciousness and by relying on the subject's reason and capacity for clear and distinct ideas is complemented by the Cartesian scientific ideal of objectivity. True knowledge means knowing the world as it really is in itself, unbiased by any particular human perspective on it, with the goal of attaining a perfect God's-eye view of the world free from human prejudice and distortion. The whole method of Cartesian doubt and cognitive recovery is based on a clear separation between things as we may see them (our ideas in our mind) and things as they really are (which our ideas can either accurately or inaccurately represent). For Descartes, as for Galileo and much of modern science, the true world is not the world of situated, sensory experiences but rather what can be measured and explained by mathematical laws revealed by universal reason. This picture of representational epistemology makes the ideal of human knowledge a mirroring correspondence to reality in which the sociohistorical and physiological contexts of human perception are transcended so as to present things with a perfectly pure objectivity. What cannot detach itself from the personal context and be covered by mathematical law is relegated from the realm of knowledge.

As a young poet-critic, Eliot deployed this prevailing scientific epistemology to provide authority for his judgments—advocating, even for poetry, "a pure contemplation from which all the accidents of personal emotion are removed; thus we aim to see the object as it really is."[11] But he soon saw the implausibility of this rigid correspondence model of knowledge and therefore insisted that our understanding must always be conditioned and limited by our concrete historical situation.[12] "We are all limited, by circumstances if not by capacities," "limited by the limitations of particular men in particular places and at particular times."[13] Hence "pure poetry [is] a phantom," " 'pure' artistic appreciation" free from the sociohistorical context and attitudes of the reader is an equally "illusory" "abstraction" or "figment" (*SE*, 271; *TUP*, 98, 99). There is no perspectiveless knowledge. To criticize, "one must criticize from some point of view" (*SE*, 114); "we have to see literature through our own temperament in order to see it at all, though our vision is always partial and our judgement is always prejudiced."[14]

Rather than lamenting that all our thinking is sociohistorically condi-

tioned and thus rests on cognitive prejudices, Eliot (like Gadamer) recognizes that such prejudices provide the necessary directedness to the world and social context in which we must cope. Tradition and practical intelligence have the role of factoring out the fruitful from the baneful prejudices and applying them wisely to changing circumstances. Rather than the pure gaze and ideal of correspondence posited by the ideology of science, Eliot chose a model of objectivity as shared belief, a model of consensus that is implicit in his notion of tradition and his ideal of the "common pursuit of true judgement" (*SE*, 25). This view of objectivity as constituted by solidarity and consensus reflects Eliot's debt to the community-centered pragmatism of C. S. Peirce and Josiah Royce but anticipates the consensus-oriented theories of Gadamer, Habermas, and neopragmatism.

Eliot's goal of consensus led him initially toward a dangerous cultural integrism that courted antisemitism, but his quest for solidarity was later wisely tempered by an insistence on the tolerance of difference. For both ethical and aesthetic reasons, our cultural need for some underlying unity should not drive us to an oppressive uniformity.[15] Eliot thus endorsed another progressive theme of contemporary cultural theory—the multicultural respect for the Other. In *Notes towards the Definition of Culture*, Eliot defends the importance of weaker regional cultures and third world cultures (which he terms "satellite" cultures) against the totalizing hegemony of Western cultural imperialism. He was extremely worried (as were Adorno and Pierre Bourdieu) of top-down technocratic efforts toward the homogenization of culture advocated in the name of world unity, but which will more likely result in an oppressive uniformity. Eliot thought the ideology of science and technology exercised a homogenizing effect similar to that of the globalizing pressure of economics.

If there are no absolute perspectives, then, Eliot argued, even science works within a sociohistorical context of which it is often unaware. Bravely critical of the dangers of technology when it was less fashionable to be so (well before the horrors of Hiroshima), Eliot warned of our unhealthy "exaggerated devotion to 'science' " and affirmed its need to be guided by wisdom.[16] Recognizing that science is not free from ideology and can itself be an ideology that obscures the real, Eliot warned that "practitioners of both political and economic science in the very effort to be scientific, to limit precisely, that is, the field of their activity, make assumptions which they are not only not entitled to make, but which they are not always conscious of making."[17] None of us, not even the hard-nosed scientist, "could get on for one moment without believing *anything* except the 'hows' of science."[18]

The very pursuit of science cannot exclusively rely on verified scientific knowledge and method, for any scientific theory or hypothesis needs to be interpreted into real-world or laboratory conditions in order to be

tested and confirmed; and the determining of such conditions and assessment of confirmational testing require more than is given by the theory or by strict scientific method. Philosophers of science like Hilary Putnam and Michael Polanyi therefore contend that even the most exact science "typically depends on unformalized practical knowledge," on tacit socially acquired skills and sentiments, and that the scientist must *"rely on his human wisdom."*[19]

Less concerned with science than with the society and liberal ideology that looked to it for all the answers, Eliot felt that the uncritical liberal faith in science and in individual preferences was dangerously misleading. We cannot simply accept the contingent, unexamined hopes of all individuals as equally valid and then rely on science (whether political, psychological, or technological) as a means to adjust them to a satisfactory equilibrium. Since many of those unquestioned hopes are the irrational product of misinformation and manipulation, social theory must be critical and deal with values. It must face "the question: what is the good life?" and achieve some measure of ethical wisdom before it moves on to social engineering. "A really satisfactory working philosophy of social action, as distinct from devices for getting ourselves out of a hole at the moment, requires not merely science but wisdom"; and "wisdom, including political wisdom, can neither be abstracted to a science nor reduced to a dodge" (*EAM*, 115, 116, 118).

Eliot condemns our culture's sharp division of political and social theory from ethical thought and practice, a division that is reinforced in our educational institutions where scientific "objective" facts are rigidly separated from human values and emotions, which are considered to be utterly and irremediably subjective or private.

> The modern world separates the intellect and the emotions. What can be reduced to a science, in its narrow conception of 'science,' . . . a limited and technical material, it respects; the rest may be a waste of uncontrolled behavior and immature emotion. (*EAM*, 117)

Instead, Eliot urges "that the classical conception of wisdom be restored," an Aristotelian *phronesis* that is more than the cold, technical instrumental reason of "means-end" rationality (which Adorno vehemently critiques). This wisdom is rather an intelligence directed at both means and ends, both act and feeling. It involves the development of character, the education and discipline of the emotions. For without such ethical development—"a moral conversion" involving "the discipline and training of emotion"—the knowledge of social truths and mastery of techniques of social engineering cannot achieve true social regeneration. Such emotional discipline, Eliot thought, was so difficult for the modern mind that it was "only obtainable through dogmatic religion" (*EAM*, 130; *RH*, 110).

This was his pragmatic justification for rejecting secular liberalism and adopting a religious perspective that offered a definite, time-tested vision of the good life and a solid, reinforcing community and practice for its pursuit. The rejoinder of today's secular pragmatist is that dogmatic religion has been too dead for too many people for too long to make it truly effective for ethical and social regeneration. We need a more living, compelling myth to guide us or we need to make do without any grounding faith at all as we attempt to forge a better society and way of life.

If liberal individualism has so deeply fragmented our sense of community that we need some communal myth to bind us together in a spirit of social and individual regeneration, then Marxism, as Eliot recognized, was well-positioned to provide the needed binding of narrative myth and utopian vision. "The great merit of Communism is the same as one merit of the Catholic Church, that there is something in it which minds on every level can grasp. . . . Communism has what is now called a 'myth,' " one that can appeal both to the intellectual and to common folk.[20] After the fall of the Soviet empire, communism strikes most of us as no more a real option than dogmatic Catholicism. For better or worse, neoliberalism now enjoys an almost uncontested global dominance.

If neoliberalism's most powerful myth is that of individual freedom and fulfillment, its most trusted method is that of instrumental, cost-accounting reason. Eliot and Adorno remain skeptical of the substance of this freedom and the adequacy of this method. They advocate a more substantive rationality or wisdom that goes beyond mere instrumentality to deal with values, ends, and feelings. "Intelligence," writes Adorno, "is a moral category. The separation of feeling and understanding . . . hypostasizes the dismemberment of man into functions. . . . It is rather for philosophy to seek, in the opposition of feeling and understanding, their—precisely moral—unity" (*MM*, 197–98).[21] These remarks echo Eliot's complaint against the modern separation of intellect from emotions and values that he captured in his famous notion of the dissociation of sensibility.

When Eliot first launched this theme in "The Metaphysical Poets" (1921), he wrote: "In the seventeenth century a dissociation of sensibility set in, from which we have never recovered," a dissociation of thought from feeling. If poets like Donne and Herbert could still "feel their thought as immediately as the odour of a rose" while expressing their feeling with lucid intellect, later poets could not fuse thought and feeling together; "they thought and felt by fits, unbalanced" (*SE*, 287–88). Descartes was *the* philosopher of the seventeenth century whom Eliot later blamed for originating the split. Besides condemning the unreliability the senses, Descartes equated human identity with thought. The *cogito* by which he proves his existence is also how he defines himself in "Meditation II" as essentially "a thinking thing"; and in "Meditation VI," he

more explicitly argues for the radical dualism of mind and body, where human identity is identified with (since inconceivable without) mind, while the body is regarded as a contingent, misleading, though closely connected appendage. The result of this bifurcation of the intellect from the bodily senses is that feelings and emotions, because of their association with the body, get relegated to inferior and irrational status; while rationality becomes wholly disembodied and equated with only the abstractly logical and mathematical.

However, Cartesian dualism is not the only source of the modern dissociation of sensibility. Our individualism and functional division of labor are also factors. Four centuries of increasingly individualist liberal ideology, Eliot argues, has erased our sense of communal wholeness, "our natural collective consciousness . . . and unconscious values" (CS, 49–50). Society has become deeply fragmented into very poorly integrated functions and groups. The Cartesian division of thinking mind and bodily machine has been reified into a society of privileged managerial thinkers and contrasted mass of laborers who are treated as the unthinking machines to which they are compelled to assimilate their rhythms and psychic energies.

Even on the individual level, the complex functional division of modern life makes it difficult to maintain a satisfying integrated sense of self. How does one unify the very different rhythms and demands of being an impersonally efficient check-out cashier at Wal-Mart, a patiently caring lover and mother, and a Ph.D. student of literature struggling to find a route to material security free from alienated labor? Eliot recognizes the intimate link between the dissociation of individual sensibility and the deep schisms of our world, between the fragmentation of self and society.

> I believe that at the present time the problem of the unification of the world and the problem of the unification of the individual, are in the end, one and the same problem; and that the solution of one is the solution of the other. Analytical psychology . . . can do little except produce monsters; for it is attempting to produce unified individuals in a world without unity; the social, political, and economic sciences can do little, for they are attempting to produce the great society with an aggregation of human beings who are not units but merely bundles of incoherent impulses and beliefs. (RH, 108)

Making the same connection between personal and social fragmentation, Adorno also sees this dissociation of sensibility issuing in lifeless thought and empty sentimentality.

> The assumption that thought profits from the decay of the emotions, or even that it remains unaffected, is itself an expression of

the process of stupefaction. The social division of labor recoils on man. . . . The faculties, having developed through interaction, atrophy once they are severed from each other. . . . The socialization of mind keeps mind boxed in . . . as long as society is itself imprisoned. (*MM*, 122)

One of the trivial triumphs of philistinism derives from the futile exercise of sorting out feeling and knowing. . . . This perspective is a distorted reflex of . . . the division of labor, a trend which has left its imprint even in subjectivity. . . . Modes of response which we subsume under the concept of feeling turn into enclaves of futile sentimentality as soon as they lose their relation to thinking. . . . The deadly dichotomization of emotion and thought is a historical result that can be undone.[22]

To speak, as Eliot and Adorno do, of the fragmentation of the self and its divided sensibility as "a historical result" is to recognize the self as a social product, which they sadly portray as the weak and withered fruit of liberal individualism. The next section examines this critique.

III

Liberal individualism sees itself as a victory of human emancipation and autonomy that promises more happiness for more people by promoting their freedom to pursue it in whatever form they see fit. Certainly great progress has been made by the liberal revolution in freeing individuals from the yoke of feudalism, aristocracy, and ecclesiastical institutions. But critics like Adorno and Eliot argue that such gains of individual freedom have also resulted in serious losses. As current studies continue to show, the greater freedoms Americans enjoy are not making us any happier, and some even suggest (as Eliot did) that religion might be a needed remedy.[23] Eliot's critique of liberalism, however, does not logically rely on religious faith. He argues that liberalism is tortured by contradictions and fails to provide what it promises.

The first point is that liberal individualism's promise of happiness has proven illusory. The dissolving of traditional societal bonds in order to promote the private pursuit of individual happiness has issued in a world of haplessly lonely and unrewarded pleasure-seekers. The painful isolation and fragmentation of modern individualist society echoes with plaintive power in Eliot's verse, which so often portrays lonely, alienated individuals who are desperately unhappy and desperately seeking to achieve real community in a social world that neither provides it nor seems to allow it. When they are not figures of isolation, they are members of arbitrary lumpen aggregates rather than of truly integrated groups. Thus, we find in Eliot's work a solitary whore in a lunar nightscape ("Rhapsody on

a Windy Night"), a lonely aging socialite starving for friendship ("Portrait of a Lady"), an exotic collection of rootless cosmopolitans inhabiting the same house ("Gerontion"), a bunch of old hags "gathering fuel in vacant lots" ("Preludes"), and "a crowd" flowing over London Bridge (*The Wasteland*). Even the social groups and relations that his verse depicts are portrayed as artificial, elusive, or illusory: the mechanically peripatetic women "talking of Michelangelo" in "Prufrock," or the tawdry and meaningless coupling of the lonely typist and "the young man carbuncular" in *The Wasteland*, or the failed effort of intimacy between the young man and older woman in "Portrait of a Lady."

Eliot's prose likewise attacks liberalism for "destroying traditional social habits of the people, by dissolving their natural collective consciousness into individual constituents" (*CS*, 49). This loss of collective habits of feeling, action, and thinking is expressed not only in the individual's lonely alienation and the environing social and political fragmentation. It provokes a loss of common meanings that renders language too hollow and vague for good literature, which, to achieve classic status, requires both "a common style" of language and "a community of taste" (*OPP*, 57).

Liberalism's promise of happiness has failed, Eliot argues, because most individuals are neither intelligent enough nor sufficiently self-critical to know what is good for them and to distinguish between what they want or think they want and what will really make them happy. Liberalism's doctrine that every individual can and should determine his own values and goals too often amounts to "licensing the opinion of the most foolish" (*CS*, 49), with dire results for those foolish individuals and for society at large. Eliot explicitly addresses the "liberal-minded" faith

> that if everybody says what he likes and does what he likes, things will somehow, by some automatic compensation and adjustment, come right in the end. "Let everything be tried," they say, "and if it is a mistake, then we shall learn by experience." (*EAM*, 106)

The problem Eliot sees in this argument is that we are finite; our time for experiment is limited; our memory of past experience is fallible and fading; and our willingness "to learn from the experience of . . . elders" and past generations is increasingly diminishing (*EAM*, 106). Life is not a controlled laboratory, and a bad experiment can be fatal. Liberalism not only errs "in assuming that a majority of natural and unregenerate men is likely to want the right things" (*EAM*, 134), but it wrongly presumes that modern individuals are really independent in their thinking and that truth will emerge from an evolutionary struggle of their autonomous thinking. "These liberals are convinced that only by what is called unrestrained individualism will truth ever emerge. Ideas, views of life, they

think, issue distinct from the independent heads, and in consequence of their knocking violently against each other, the fittest survive, and truth rises triumphant" (*EAM*, 106–7).

The problem, claims Eliot, is not so much "that the world of separate individuals is undesirable; it is simply that this world does not exist." Modern life has become so pervasively programmed by technocratic bureaucracy and the mass-media formation of public opinion that the individual is relentlessly assimilated into "a mass movement." The public is "so helplessly exposed to the influences of its own time . . . : [that] it is more difficult today to be an individual than it ever was before" (*EAM*, 107–8).[24] The ideology of liberal individualism masks the conformist mentality of our society, a mask that Eliot critiques with biting irony by identifying the special "inner voice" of our individuality with the gang sentiment of a soccer mob. "The possessors of the inner voice ride ten in a compartment to a football match at Swansea, listening to the inner voice, which breathes the eternal message of vanity, fear, and lust" (*SE*, 27). Adorno offers an even pithier attack on the pretensions of liberal individualism: "In many people it is already an impertinence to say 'I' " (*MM*, 50).

What is responsible for undermining real individualism and independent thought? Eliot and Adorno blame liberalism's excesses of unrestrained industrialized capitalism, with its ideal of "materialistic efficiency" and "mass suggestion" through advertising. For Eliot, "the tendency of unlimited industrialism is to create bodies of men and women—of all classes—detached from tradition, alienated from religion, and susceptible to mass suggestion: in other words, a mob. And a mob will be no less a mob if it is well fed, well clothed, well housed, and well disciplined" (*CS*, 53).

Eliot's complaint against "regimentation and conformity, . . . puritanism of a hygienic morality in the interest of efficiency; uniformity of opinion through propaganda" (which includes advertising and any art that "flatters the official doctrines of the time," *CS*, 54–55) anticipates Adorno's claim that today's individual owes her identity "to the forms of political economy, particularly to those of the urban market. . . . The individual mirrors in his individuation the preordained social laws of exploitation, however mediated" (*MM*, 148).[25]

Although Adorno admits "reactionary criticism's . . . insight into the decay of individuality and the crisis of society," he chides reactionaries for blaming the intrinsic weakness of the individual rather than the destructive, fragmenting idolatry of individualism. Eliot, however, can in no way be accused of failing "to criticize the social *principium individuationis*" (*MM*, 148–49). He recognizes as much as Adorno that the individual self is a social construct, "the result of the social division of the social process" (*MM*, 153). Already in his doctoral thesis, Eliot asserted that the self and its most pri-

vate thoughts could only be defined, identified, and articulated in terms of a common social world constituting a "community of meaning" that is "ultimately practical" in purpose. "I only know myself in contrast to a world" and to other selves or "finite centres" who collaborate to construct it.[26]

No less than Marxist materialists, Eliot recognized that just as the self is molded by society, so "society [itself] is very deeply affected morally and spiritually by material conditions, even by a machinery which it has constructed" (*EAM*, 133–34). The material conditions fostered by liberalism tend to weaken traditional social bonds and securities. Hence, in Adorno's words, the liberal man's pursuit of freedom from these communal bonds "only robs him of the strength for freedom" (*MM*, 149).[27] The social links of family, region, community, and culture provide the individual with a substantive and differentiated identity so that a person is not simply reduced to an integer of mass marketing and political regimentation. Deprived of those social modes of self-definition, one's values are more easily manipulated by what advertising proclaims as valuable. The individual is dissolved into a market-programmed conformism of thought and action.

Fear of this homogenization of society made Eliot think that a traditional class society might be better than liberalism's fragmentation of society, which also has its own elites and vicious inequalities. But such a return to traditional class society seems futile; it is neither possible nor desirable, given the democratic desires of most of our population. Pragmatists like myself therefore urge the Deweyan option of reconstructing liberalism to avoid its one-sided, myopic emphasis on individualism by equally emphasizing the value of community and the deep dependence of the self on society.[28] For Eliot and Adorno, however, there remains an aesthetic remedy to foster social and individual regeneration that we should now consider.

IV

Eliot's criticism of liberalism seeks to instill a greater appreciation of community not only in the present but with our past, a repository of values beyond those marketed by contemporary liberal thought. Art provides a precious tool for criticizing present assumptions and social relations, partly by portraying past alternatives. Through its shared imaginative experience, art helps connect us to each other and to a history that can provide a critical touchstone for judging the present. Although often maligned as a narrow formalist, Eliot emphasizes what Adorno calls "the social essence of art" (*AT*, 20, 320). Insisting that major developments in art and criticism are largely "due to elements which enter from the outside," most especially "social changes" (*TUP*, 21, 127), Eliot recognizes with Adorno that social influences and contents are sedimented in art and can be read from its very form.[29]

The process through which the forms of art express the sedimentation of social forces and meanings is neither instantaneous nor fully self-conscious, if the expression is deep, genuine, and original; since society itself, even in frenzied modern times, does not change in such an immediate and conscious way. Hence Eliot and Adorno combine their praise of originality with a penetrating critique of modern culture's worship of the superficially new. Eliot's most famous essay, "Tradition and the Individual Talent," affirms the creative resources of tradition as more productive than the willful, attention-seeking quest for individualist innovation. And this theme runs throughout his work. Far from opposing artistic innovation, Eliot simply opposes the search of novelty for its own sake, which issues in shallow, artificial newness. Though he condemns the modern cult of artistic individuality (most viciously in *After Strange Gods*) and denies mere "novelty as a sufficient criterion of excellence" (*TCC*, 152), Eliot welcomes "the new (the really new) work of art," recognizing that if "it would not be new, . . . [it] would not therefore be a work of art" (*SE*, 15). He likewise affirms the need for "revolutionary theories" to supply "the violent stimulus of novelty" when a tradition becomes crustily complacent (*TCC*, 184), since he realizes that we must not "associate tradition with the unmovable; for the word itself implies movement. Tradition cannot mean standing still."[30]

Eliot links the modern idolatry of artistic individuality to the social decay inflicted by liberalism's cult of individual freedom. The individual, including the artist, could once see herself defined and integrated through meaningful social relations. Now, having lost a strong social sense of themselves and of their public, artists are driven to fashion and assert some "particularist" individuality to call attention to their work and seek recognition in the global, impersonal market of symbolic goods.[31] Loss of traditional social community, which involves community with the past, likewise compels the artist to seek the kind of immediate novelty that confines her to "the ephemeral" of the present. For "the novelty of anything that is merely new produces only momentary shock: the same work will not produce the same shock twice, but must be followed by something newer" (*TCC*, 152).

Adorno also links our worship of the superficially new to liberalism's dissolution of communal society and its consequent disintegration of the self. But he highlights more than Eliot the industrial and economic machinery that drives this frantic quest for novelty that simply produces the disguised and unsatisfying repetition of the old.

> The cult of the new . . . is a rebellion against the fact that there is no longer anything new. The never changing quality of machine-produced goods . . . converts everything encountered into what al-

ways was, a fortuitous specimen of a species, the *doppel-gänger* of a model. . . . The new, sought for its own sake, a kind of laboratory product, petrified into a conceptual scheme, becomes in its sudden apparition a compulsive return of the old, not unlike that in traumatic neuroses. . . . The decomposition of the subject is consummated in his self-abandonment to an ever-changing sameness. (*MM*, 235–38)

Contemporary art's quest for individualistic novelty, Adorno claims, is less the expression of deep originality than the product of the cold relentless logic of consumer capitalism.

The phenomenon of novelty is a historical product. In its original economic setting, novelty is that characteristic of consumer goods through which they are supposed to set themselves off from the self-same aggregate supply, stimulating consumer decisions subject to the needs of capital. As soon as . . . capital stops offering something new, it is going to lose ground in the competitive struggle. Art has appropriated this economic strategy. (*AT*, 31)

This strategy, Adorno argues, is especially flagrant in what he calls "the culture industry" of popular entertainment, whose overwhelming commercialism has undermined art's posture of relative autonomy.

However, for all their recognition that art was vulnerable to the corruptions of our socioeconomic world, Eliot and Adorno still defend art as an indispensable source of wisdom and an invaluable tool for emancipatory critique and spiritual regeneration, because it embodies crucial values beyond the pervasive logic of materialist profit and efficiency.[32] Though "commercial literature will continue to flourish and to pander," the true artist will not lower her standards simply to suit the public's tastes, even when, like Eliot, she hopes to reach a very wide audience. If art's critical role involves challenging our common taste and presumptions, then, Eliot argues, there is justification for an artistic or intellectual elite in terms of "their labour in developing human sensibility, their labour in developing new forms of expression and new critical views of life and society."[33] Adorno defends the same stance of superior difference: "The elitist segregation of the avant-garde is not art's fault but society's. The unconscious aesthetic standards of the masses are precisely those society needs in order to perpetuate itself and its hold on the masses" (*AT*, 360). But Adorno, I think, goes too far here. The value of a cultural elite can be defended without such false global condemnations of popular aesthetic tastes and genres, condemnations that fail to see how popular forms of

mass-media art have significant power of opposition to societal standards and presumptions.[34]

Whether elite or popular, art's fictional worlds have critical value in presenting an alternative to realities that we are trained to see as inevitable. Works of past ages and foreign cultures show that different worlds with different social values and assumptions are not only possible to conceive but were actually lived. Eliot thus insists that "we make the effort to enter those worlds of poetry in which we are alien so that we can achieve a better critical understanding of our own" (*RH*, 602).

Art challenges our prevailing ideology in two other ways. First, in a society dominated by ideals of material profit and means-end rationality, art's deep sense of play and noninstrumental purposiveness represent a striking and challenging alternative. Both Eliot and Adorno follow Friedrich Schiller in emphasizing art's ludic character. Eliot's claim that "poetry is not a career, but a mug's game," "a superior amusement" (*TUP*, 154)[35] finds an echo in Adorno's affirmation that play "is a necessary ingredient of art . . . [through which] art is able to atone for its illusory character." "What lifts art above the context of immediate economic praxis and purposive behavior is the moment of play" (*AT*, 57, 437).

But play does not entail art's failure to serve important social functions. Indeed, one valuable social function is to be an implicit critique of society's relentless functionalism. For this reason, both Eliot and Adorno deplored art as propaganda when it seemed too narrowly and programmatically political. Adorno expresses this point in his typically outspoken way: "What is social about art is not its political stance, but its immanent dynamic in opposition to society. . . . If any social function can be ascribed to art at all, it is the function to have no function." By being different from the "ungodly reality" of universal instrumentalism and profit-seeking, art negatively suggests the possibility of a more positive alternative (*AT*, 322). "To instrumentalize art [by giving it a particular function] is to undercut the opposition art mounts against instrumentalism." "In actuality, art's role in a totally functional world is precisely its afunctionality" (*AT*, 442).

This should not be seen as a compelling refutation of pragmatist aesthetics, which also appreciates art's function of implicit critique of narrow instrumentalism. In asserting art's functionality, my pragmatism agrees that art has no narrow, single, specific task to perform. However, rather than concluding that art is purely intrinsic, purposeless, disinterested value, pragmatist aesthetics construes art's functionality and value not in terms of any specialized, particular service, but in satisfying us in a more global way through a variety of ends. High among those ends is the enhancing of our immediate experience, whose stimulation helps us, of course, to realize other purposes as well.

Another way that art presents a useful contrast to our social world is in

its noncoercive unity in variety. In the polyphonic harmony of a poem or musical work, the individual words and notes seem joined together in the whole without thereby losing their specific value and identity. This provides an implicit critique of the failure of our social union and a model of what ideal society could be. For Eliot, "it is a function of all art to give us some perception of an order in life, by imposing an order upon it." And he repeatedly employs art's classic definition of formal beauty—"variety in unity," "the ideal pattern of unity in diversity"—to convey his sense of what the ideal society or culture would be (*OPP,* 86; *NDC,* 120, 81).

Adorno agrees that art's fictional order is much more harmonious, tolerant, and integrated than the deeply divisive classes and institutionalized compartments that modern society imposes. But he is also aware that art's order, however close to the ideal of nonrepressive union, cannot be wholly nonrepressive. As a product of social life, art—even in its surface form—inevitably bears the deeper background traces of social repression and regimentation that are part of our civilization.

> Form is the non-repressive synthesis of diffuse particulars; it preserves them in their diffuse, divergent, and contradictory condition. . . . This goes to show that form is the anti-barbaric dimension of art. Form ensures that art both shares in the process of civilization and criticizes it by its sheer existence. [Yet in imposing form on the flow of life and on natural materials, we can see] how repression is carried from reality into artworks . . . ; it makes incisions in the living in order to endow it with language, but disfigures it in the process. The myth of Procrustes tells a chapter of the primal history of art. (*AT,* 207–8)[36]

To sum up, though art may be a promising source of truth and progress, its cognitive and social value remains vulnerable to falsehood, folly, and regression. Whatever wisdom we can gain through works of art cannot be simply imbibed or read off from them. Art's immersion of its audience in fiction may promote an impotent escapism of fantasy rather than real critical enlightenment. How then is art's claim to truth and wisdom to be redeemed? On answer would be by combining attentive immersion in art's surface and immediate experience together with a deeper critical look at the wider background that lies beneath that captivating surface and experience.

Eliot and Adorno argue that art needs deeper ideological criticism for its real truth to emerge, yet that criticism must first be based on a full experience of a work's imaginative surface and the alternative assumptions and world-view it purveys. They therefore advocate a remarkably similar two-stage theory of reading. In the first stage, we project ourselves into

the work and surrender ourselves to the author's vision, "when we try to understand the rules of his own game, adopt his own point of view" (*OPP*, 145). For unless we at least provisionally surrender ourselves to the world of the artwork, we shall be unable to get deeply involved in the work and thus fail to understand it fully enough to appreciate the power of its alternative vision. This primary process of imaginative self-surrender and self-projection into the work is what Adorno describes as the stage of imminent interpretive experience, or *"Verstehen"* (*AT*, 177, 477). But proper understanding requires going further to "another stage of self-consciousness," a stage of deeper critical reflection in which we detach ourselves from the work we have entered and accepted, in order to examine it "by outside standards" involving the wider contexts of our cultural tradition and social world (*EAM*, 103–5; *OPP*, 145).

This two-stage theory of reading can provide a cogent answer to the long-debated question of whether literature purveys valuable truth or misleading illusion. The cognitive value of a literary work depends not simply on itself but on how well its reader performs both stages of the reading process. As Eliot puts it:

> It is simply not true that works of fiction, prose or verse, . . . *directly* extend our knowledge of life. . . . Knowledge of life obtained through fiction is only possible by another stage of self-consciousness. . . . So far as we are taken up with the happenings in any novel in the same way in which we are taken up with what happens under our own eyes, we are acquiring as much falsehood as truth. But when we are developed enough to say: "This is the view of life of a person who was a good observer within his limits . . . so what I am looking at is the world as seen by a particular mind"—then we are in a position to gain something from reading fiction . . . but these authors are only really helping us when we can see, and allow for, their differences from ourselves. (*EAM*, 103–4)

Adorno urges the same double perspective. On the one hand, to understand an artwork, one "must enter into the work" and "give . . . himself over to the work" (*AT*, 346, 387). But the second stage is equally necessary:

> A wholly immanent understanding of works of art is a false and deficient mode of understanding because it is under art's spell. . . . This demand [for understanding] can be fulfilled only by a twofold approach: specific [immanent] experience joined to . . . [critical] theory. . . . The states of affairs discovered by immanent analysis have to be transcended in the direction of second reflection and emphatic criticism, which try to get at the truth content of the work. . . .

Those who have only an inside view of art do not understand it, whereas those who see art only from the outside tend to falsify it for lack of affinity with it. (*AT*, 177, 179, 477, 479)

Through this two-stage theory of reading, Eliot explains the dangerous power of artistic entertainment consumed merely for pleasure. Our light "pleasure reading" wields a surprisingly potent influence on our beliefs and attitudes, because with such reading we typically do not trouble ourselves with the second, critical stage; for we know we are reading only for pleasure, not for cognitive or ethical enrichment. However, since any enjoyment or understanding of an artwork requires a first stage of imaginatively accepting and assimilating its vision, the omission of subsequent critical reflection will leave the attitudes or beliefs expressed in the work dangerously active—unconsciously and uncritically—in the mind of the reader. Hence, it is "the literature that we read for 'amusement' or 'purely for pleasure' that may have the greatest and least suspected influence upon us . . . [since it is] read in this attitude of 'purely for pleasure,' of pure passivity." And since mass-media popular art is most readily consumed in that uncritical pleasure-seeking attitude, it "can have the easiest and most insidious influence upon us" and thus "requires to be scrutinized most closely" (*EAM*, 105). This, I should stress, does not mean rejecting the pleasures of popular art but instead testing and deepening them with greater understanding through more extensive critical analysis.

For Eliot and Adorno, aesthetics thus implies a crucial dimension of cultural critique, exposing and critically examining the deeper ideologies that inform our arts (high and low) and that shape our experience of their aesthetic surface and meaning. If Eliot's Christian execution of this task seems awkwardly heavy-handed and outdated, if Adorno's elitist Marxism seems similarly problematic, our disagreement should not be about the relevance of ideological critique to art criticism, but only about the particular ideals we use as critical touchstones and pursue as cultural ends. Eliot and Adorno did not themselves agree on ideology, even if they shared the critique of bourgeois liberalism's ideology of individualism, instrumental reason, and programmed production and consumption of the superficially new.

In their dissatisfaction with the social and personal malaise of our world, Eliot and Adorno still speak to us as contemporaries. In perceptively tracing many of our problems to the excesses of late-capitalist liberalism, they even speak as acute diagnosticians. If Eliot's reactionary Christian royalism and Adorno's ascetic Eurocentrism seem so implausible and unsavory compared to today's progressive hopes for a secular, multicultural regeneration of society, we should at least respect and learn from

their exemplary attitude of constant self-critical reflection. We, too, must continuously question how plausible and concretely desirable our often nebulous goals of radical social and cultural reform really are, no matter how firmly and doggedly we continue to desire and fight for them.

9.

Deep Theory and Surface Blindness
On the Aesthetic Visibility of Print

Littera scripta manet

HORACE

I

Surfaces are generally thought to be the most apparent or visible of things. One central dictionary meaning of "surface" is "outward appearance," and the word's etymology suggests being on the face. What could be more visible than what is on one's face, what more easily perceived than surfaces? The ways of perception, however, are not so simple. One cannot in fact see the surface of one's own face without some reflecting device; we cannot see what is on other faces if they are wearing a veil or if we are trained to look away. Socially ingrained habits and cultural beliefs thus often conceal the surface from us. We usually do not notice the surface of our glass windows because we are looking through them; nor do we notice the particular color and size of the pixels on our computer screen as we look at them to grasp the images they constitute. This chapter examines a case in which deep cultural presumptions promote an aesthetic blindness to surface, a failure to see the aesthetic importance of the visual face of literature.

Neglect of the visual or graphic in the literary text is one of the sad and surprising phenomena of Western aesthetics. Though oral or auditory qualities have always been held to be aesthetically central to literature (especially to poetry), the role of the written or printed—in short, the visual—has generally been regarded as aesthetically irrelevant, as merely a technical means of recording, preserving, and presenting the literary work. Such a view might seem plausible for ancient and pre-Gutenberg cultures, where, according to literary historical dogma, literature was more often uttered than inscribed, more heard than read, and was typically preserved through oral tradition. Scholarship has shown, however, that the majority of historical evidence points to the contrary: that most of

our literature has been appreciated and preserved through written manu-
scripts, and that the visual aspects of the manuscript (e.g., calligraphic
style and format) were greatly appreciated aesthetically.[1] Indeed, the vi-
sual aspects were considered so important that the first printing presses
were designed to imitate as closely as possible the visual properties of the
aesthetically finest and most admired manuscripts, rather than merely to
print efficiently the same letters.[2]

Even if we continue to question the central aesthetic status of the written
text in pre-Gutenberg literary cultures, the invention and development of
printing undoubtedly established the visual text as a standard end-product
of literary art and a typical object of literary appreciation. Literature may
have originated as an essentially oral art, but with the invention of writing,
printing, and the consequent growth of literacy, the literary artist acquired
a medium through which she could reach a much larger audience and con-
vey a far longer and more complex message than could be adequately vo-
calized or conveyed in a standard oral performance. The literary artist now
writes more to be read than to be heard; the written text has largely sup-
planted the oral performance, and we find more asides to "the reader of
this story" or "the reader of these lines" than to "the hearer of this tale."[3]

Once the inscribed text was firmly established as a standard, if not the
predominant, end-product of literary art, the literary artist could be ex-
pected to exploit the rich aesthetic possibilities offered by the inscribed
medium. Prominent among these possibilities are, of course, visual ef-
fects.[4] This tendency in literature toward accepting and aesthetically ex-
ploiting the visual medium of the text received considerable impetus in
the twentieth century, not only with the *Calligrammes* of Apollinaire and
the typographical devices of e. e. cummings, but also through the rise
(since about 1950) of the whole movement of Concrete Poetry which is
dedicated to the visuality of the text.

Despite these developments in literary art, literary theorists too often
remain blind to the importance of the visual, thereby affirming the tradi-
tional view that poetry is sound and sense but not sight, that the visual as-
pect of the literary work does not form a part of the work's identity and
aesthetic make-up, and that to appreciate a literary work's visual aspect is
to appreciate the work as graphic art, not literature. Though critics like
T. S. Eliot and F. R. Leavis emphasized the visual in poetry, what they re-
ferred to was the importance of vivid images that the reader must visual-
ize in her mind, not what she can simply see on paper. The dismissive
view of textual visuality is shared by a host of modern theorists from a
wide variety of schools and approaches; though they more often affirm it
than carefully argue for it. Here is a sample of the consensus on this view.

First, among continental aestheticians we find Benedetto Croce treating
the written text as merely a sign for producing certain sounds. Roman In-

garden takes a similar view, denying the written symbols of the text a place in any of the four strata that for him constitute the literary work. They are thus not part of the work, but are merely symbols prescribing the sounds (to be actualized physically or mentally) which constitute its first stratum. Mikel Dufrenne still more sharply denies the aesthetic relevance of writing, while maintaining the essentiality of the oral: "l'écriture n'est qu'un moyen . . . pour la vraie langue qui est la langue orale"; "la poésie est une voix . . . pas un être écrit."[5]

In analytic aesthetics, we find Monroe Beardsley maintaining that since words are "meaningful sounds," they and the literary works they constitute "present two aspects for study": "the sound-aspect" and "the meaning-aspect."[6] Beardsley strangely ignores that words consist of letters as well as morphemes and phonemes; hence they and the literary works they constitute have a visual aspect as well. J. O. Urmson is more outspoken in rejecting the significance of the visual in literature, boldly asserting that "literature is essentially an oral art," "the written word being primarily a score for the performer."[7] So entrenched is the view that textual visuality is aesthetically irrelevant that even theorists like René Wellek and Austin Warren, who begin by noticing its artistic uses, end up blindly echoing Ingarden and tradition by denying a visual stratum to the literary work and equating its sensuality or physicality with its sound.[8]

Why is so questionable a view still so powerfully entrenched? Why are aestheticians so often blind to the visual in literature? My aim in this chapter is to explain this blindness but not to justify it. Instead, I argue that not only the facts of actual literary practice but more general aesthetic considerations should urge us to grant real aesthetic relevance to the visual aspect of the text. After establishing this relevance in principle, I then examine some concrete cases of its use and conclude by suggesting a provisional theory as to when the aesthetic relevance of textual visuality is particularly significant.

II

There are numerous reasons why aestheticians have ignored the visuality of the text, but I shall concentrate on three that seem most significant. The first two concern influences of major philosophical traditions (that of Plato and romantic idealism); the third involves a more general influence—cultural conservatism. One of the few modern philosophers to recognize and celebrate the written nature of literature, Jacques Derrida rightly points to Plato's influence on the primacy of the oral over the written in Western thought. Derrida further connects this preference of the oral to a general bias of Western culture toward "a metaphysics of presence" that locates both reality and truth in that which is immediately present to consciousness, a bias which also finds expression in the Cartesian *cogito* being taken as the most indubitable reality.[9] For our present pur-

poses, it seems best to consider Plato's condemnation of writing in a more specifically aesthetic framework by comparing it to his general condemnation of art, which it resembles in some significant respects.

Plato's *Republic* denounces the mimetic arts on several counts: for their corrupting moral, educational, and political influences in undermining religion and morality with tales of the gods' misdeeds, and in stirring up violent, dangerous emotions that threaten character and the rule of reason, and thus also social and political stability. He also condemns mimetic art for its epistemological inadequacy, since it fails to give real knowledge but only verisimilitude, and for its ontological inferiority in being two removes from the truly real, an imitation of an imitation. However, Plato's notorious denunciation of art strikingly refrains from condemning art aesthetically, that is, from an aesthetic point of view. Similarly, if we look at his condemnation of writing in *The Phaedrus* (274b–278c), we find no censure of it on *aesthetic* grounds.

Plato condemns writing because of its harmful educational and moral effects. It makes the mind weak, because it undermines the cultivation of memory. It fills men with an empty conceit of their own wisdom, which without memory is shallow and unabiding. Written discourse is further censured as epistemologically inadequate, since, orphaned from the voice of its author who could explain or define it, it cannot speak to answer interrogators and is helplessly exposed to misinterpretation. Finally, the written word is metaphysically inferior, a lifeless image of oral communication and, as it were, two removes from "the word of thought graven in the mind."

In contrast, *Phaedrus* suggests an aesthetic justification of writing, which is endorsed for literature's aesthetic purposes of "noble recreation" (276). Plato held literature vastly inferior to philosophy, but not because it is written rather than spoken; for he tells us that "neither poetry nor prose, spoken or written, is of any great value" unless instructive. So Plato's condemnation of writing was not really a condemnation of the written aspect of literary *art*. Only a misinterpretation of *Phaedrus* would support the rejection of textual visuality in the art of literature. But such misinterpretation is common enough, since it is reinforced by Plato's critique of writing as adequate for philosophy. Long after Plato, many philosophers (myself included) continue to affirm this Socratic idea that philosophy is more importantly a form of life than simply a form of writing.[10]

The second tradition that helped foster the disregard for literature's written or visual aspect might be termed "romantic idealism." This tradition championed the primacy of spirit and imagination against the fetters of materiality. Like Platonism, it found value not in surface appearances but in deep spiritual truth. Unlike Plato, romantic idealism insisted that art was a crucial means to reach the noble truth of spirit. The verbal, con-

ceptual medium of literature made it particularly apt for this cognitive role, but the concrete material dimension of the inscribed text was contrastingly neglected as essentially alien and antithetical to literature's spiritual, ideal, and imaginative nature. This romantic rejection of literary visuality is exemplified in the two rather dissimilar figures of Percy Bysshe Shelley and Friedrich Hegel.

Like several other romantics, Shelley conceives the idea of poetry in quite general terms as "the expression of imagination," and therefore present in all the arts (and indeed connate with the origin of man).[11] But he does reserve a special, imperial place for poetry in the restricted sense of literary art. For Shelley, literature is inherently superior to the other arts because its medium—language—is more transparent and is closest to and a more direct expression of the imagination, "whose throne is within the invisible nature of man."

> Language . . . is a more direct representation . . . and is susceptible of more various and delicate combinations than colour, form, or motion, and is more plastic and obedient to control of [the imagination]. . . . For language is arbitrarily produced by imagination, and has relations to thought alone; but all other materials, instruments, and conditions of art have relations among each other, which limit and interpose between conception and expression. The former is as a mirror which reflects, the latter as a cloud which enfeebles, the light of which both are mediums of communication. (*S*, 125–26)

The superiority of literature is thus based on the invisible transparency and spiritual purity of language, which is claimed to relate to thought alone and thus to be unconstrained by the material relations which limit expression in all other artistic media. However, Shelley, whose poetic practice has frequently been censured for relying excessively on sound, cannot refrain from incorporating sound into the essence of poetry and ends up asserting that relations of sound are "connected" and "indispensable" to the poetic "relations of thoughts" (*S*, 126–27). He thus "corrupts" the spiritual purity of poetry and the logical consistency of his theory of poetry's supremacy as a totally transparent and direct expression of imagination in a medium relating to thought alone.

With Hegel, a systematic philosopher and not a practicing poet, the romantic view of poetry as the pure expression of spirit is carried to its logical conclusion. Poetry is "the most spiritual" form of art; it is the direct representation of the imagination and spirit itself, free from external sensuous material. Not only is the visual of literature dismissed as irrelevant, so is the oral. Ideas are all that is essential to poetry. "To express these it uses sound indeed, but only as a sign in itself without value or content.

The sound, therefore, may just as well be a mere letter, since the audible, like the visible, has sunk into being a mere indication of spirit. Poetry is the universal art of the spirit which has become free in itself and which is not tied down for its realization to external sensuous material."[12]

Hegel's theory shows that the romantic identification of poetry with pure expression of imagination and spirit can give no real support for the view that sound is essential to poetry while the visual aspect is irrelevant. If poetry is purely spiritual, immaterial, and nonsensuous, then both the sight and the sound of a poem are irrelevant; for both are material or sensuous. One might be tempted to think that sounds are more spiritual than sights, since it is more difficult to draw their material borders or precise location, and since physics typically describes them as waves or vibrations of air. So conceived, sounds may be invisible, but this in no way implies that they are immaterial, nonsensuous, or spiritual. To make such an inference is to reveal an unscientific and outdated metaphysical outlook that borders on the primitive. Below, I explain how conservatism and antiquarian attitudes play a further role in the conscious neglect and rejection of visuality in literary art.

If the Platonic condemnation of writing and the Hegelian view of poetry as pure expression of spirit have contributed to literary theory's stubborn rejection of textual visuality, they nonetheless hardly seem sufficient cause for such rejection. Philosophers have found other reasons for regarding literary art as essentially oral and thus denying the aesthetic relevance of textual visuality. J. O. Urmson, for example, argues that in order to give literature its proper place in the established classification of performing versus nonperforming arts, we must regard it as essentially an oral art.[13] He claims that we should logically group literature with the performing arts of music, drama, and dance. Like literature, these are temporal arts whose works have a problematic multiple identity and cannot be identified, as a painting or sculpture typically can be, with a particular material object (or, in the case of some multiple works of plastic art, with a very limited group of such objects defined by the same required history of production). But if we regard literature as a performing art, then we must regard some performance as essential to it; and the only one it has comparable to performance in the other arts is *oral* performance. Urmson therefore concludes that literary art is essentially oral and that its written aspect is consequently an aesthetically irrelevant technical tool for oral performance.

In an earlier critique of Urmson's theory, I stressed the dangers of deriving conclusions about the essence of literature (if there is one) from the desire to maintain a general classificatory theory of the arts.[14] I also noted that in order to group literature with the performing arts, one need not affirm that it essentially requires oral performance (real or imagined). It is enough to show that literary works can be and sometimes are performed

by executant artists in ways that the works of nonperforming arts simply cannot. But to strengthen his view that literature is essentially oral, Urmson also employs an altogether different argument. He claims that in ancient times, at the birth of literary art, literature was generally performed orally rather than read, and that up until modern times poetry readings and even prose readings remained quite common. This argument reflects a deep attitude of aesthetic conservatism that has been the most powerful influence in sustaining the view that literature's oral properties are aesthetically important, while its textual visual properties cannot be aesthetically significant.

The force of aesthetic conservatism is great and perhaps useful to balance the force of aesthetic innovation. We tend to look back in wondering admiration on the literary achievements of the past and try to emulate them. Probably more than any other period, ancient Greece has provided the defining paradigm of what literature is or should be. Literary theorists are thus drawn to regard literature as it was in its glorious formative days; and if that means disregarding the visuality of the text, so much the worse for the visuality of the modern verse which employs it.

This conservative attitude is vividly expressed by Oscar Wilde, who complained already in 1890 about the growing, and to his mind unjustified, role of textual visuality, and who shrewdly discerned the technological and social factors contributing to it.

> Since the introduction of printing, and the fatal development of the habit of reading amongst the middle and lower classes of this country, there has been a tendency in literature to appeal more and more to the eye, and less and less to the ear, which is really the sense which, from the standpoint of pure art, it should always seek to please, and by whose canons of pleasure it should abide always. . . . We, in fact, have made writing a definite mode of composition, and have treated it as a form of elaborate design. The Greeks, upon the other hand, regarded writing simply as a method of chronicling. Their test was always the spoken word in its musical and metrical relations. The voice was the medium, and the ear the critic.[15]

Despite its rhetorical and psychological power, once this conservative case against visuality is explicitly articulated, we see its logical weakness. The mere alleged fact that textual visuality was aesthetically insignificant in ancient Greece (and there is clear evidence, to the contrary, that it was already aesthetically employed in Hellenistic pattern poetry) does not entail that it is still aesthetically insignificant. Still less does this entail that visual aspects of the text *cannot* be in principle aesthetically relevant to the work of literature qua literature. To assume that textual visuality is not

and cannot be aesthetically significant to literary art simply because it was not so originally is to fall victim to the genetic fallacy on a grand scale. Literature, as Wilde complained, just is not exactly what it used to be, nor is there any logical constraint that it should be.

However, Wilde's remarks also hint at another reason against accepting the visual: that accepting the aesthetic relevance of another aspect of literature (namely, the visual) will damage the aesthetic purity and hence aesthetic value of literary art. The next section therefore brings arguments to resist this charge of aesthetically damaging impurity and to show that we should grant aesthetic relevance to the visual aspect of the text. These arguments concern our most basic aesthetic interests and the basic nature of aesthetic symbols.

III

The notion of aesthetic purity is suspiciously ambiguous and vague. Though often taken as utter homogeneity or lack of mixture of elements, it can also be construed as perfect fusion or unification of elements into an organic whole. Even if we limit ourselves to the first conception, ambiguity abounds. For the purity can be abstinence from different sorts of mixture: that of sensual aspects (say, mixing the visual, audible, and tactile), that of quality within one aspect (say, unmixed rather than mixed colors), or that of aesthetic dimension (say, pure form rather than form with representation). From which mixtures must art abstain? The purists are not very clear about this, and abstinence from all would make a terribly dull work of art. Even Plato, Kant, and Hegel had trouble maintaining that there could be any beauty in pure color, and there is no doubt that such beauty is inferior to the mixtures and combinations of colors and forms we find in nature and art. The demand for "elemental" purity stems from the aesthetic requirement of unity, but unity is only one side of the classic formula for beauty, the other being diversity or richness, which of course is quite contrary to this first conception of purity.

It is only the second conception of purity whose violation in disunity, disorder, or discord implies an aesthetic flaw. Admission of the visual aspect makes literary art less pure in the first sense, mixing another aspect to those of sound and meaning. But this does not necessarily create impurity in the second sense, because there is no reason why the mixture cannot be harmonious and unified. The success of writing indicates its compatibility with sound and meaning, and surely we are not to deny in principle that the visual can be aesthetically united with the audible. Think what such a denial would entail for drama, dance, and opera. Furthermore, to argue that acceptance of the visual aspect corrupts the artistic purity of literature seems to imply, by parity of reasoning, that the semantic aspect of poetry likewise corrupts poetry's purity of sound, and hence should also be dis-

missed from aesthetic consideration. Such purist arguments of exclusionary either/or must be rejected. We hear sound and meaning together; just as we can simultaneously perceive the surface colors and represented figures of a painting. More generally, we should be wary of the presumption that we must always and finally choose between surface and depth. If patient, we can usually pay attention to both; and, as they are conceptually independent, it is hard to get the full appreciation of one without some sense of the other.

In short, only a confusion of the two notions of purity could condemn the visual as an aesthetically damaging impurity in literary art. Moreover, the general demand for aesthetic purity strikes me as overrated, an overcompensating safeguard for unity and for the autonomy of art against threats of moral and religious encroachment. What seems aesthetically more important is the notion of unified richness or complexity, that is, that the unity effected in a work of art should be one that embraces not uniformity but diversity, a rich manifold of content. Dewey and Croce thus characterize the aesthetic by the inclusiveness or richness which is unified in experience or expression.

Structuralist semioticians likewise affirm complex richness as central to the very nature of the aesthetic sign. Jan Mukarovsky regards the aesthetic sign as designating not a specific narrow meaning but rather making "a global reference to reality," signifying "the total context of so-called social phenomena." Similarly, Roland Barthes maintains that what distinguishes the literary text from ordinary linguistic discourse is its plurality of meaning—"its multiple systems of sense" or "galaxy of signifiers." Such ideas of semiotic richness have their counterparts in Anglo-American theories of literary language, for example in William Empson's notion of the language of ambiguity or Monroe Beardsley's notion of "semantical thickness."[16] Nelson Goodman provides an especially rigorous account of the semiotic richness of aesthetic signs, affirming that their "density," "exemplificationality," "repleteness," and "multiple and complex reference" are symptoms that best define the aesthetic.[17]

Goodman's idea of repleteness is particularly important for acceptance of the visual aspect as aesthetically part of the literary sign. According to Goodman, a symbol is more replete the more aspects of it are relevant or constitutive of its semiotic role. He illustrates repleteness by contrasting the symbolism of drawing with the less replete (and consequently less aesthetic) symbolism of diagram. The black on white design of an electrocardiogram may be identical to that of a Hokusai drawing of Mount Fujiyama. What makes the difference between diagram and drawing is that in the former there are fewer aspects of the symbols that are relevant.

> The only relevant features of the diagram are the ordinate and ab-
> scissa of each of the points the center of the line passes through.
> . . . For the sketch, this is not true. Any thickening or thinning of
> the line, its color, its contrast with the background, its size, even
> the qualities of the paper—none of these is ruled out, none can be
> ignored.[18]

The bearing of this on textual visuality seems direct and significant. By accepting the visual aspect as part of the literary sign, we are making the literary sign more replete, more aesthetic. To deny the visual aspect is to deplete the aesthetic potentiality of the literary work, to treat it less aesthetically; in much the same way as denying the aesthetic relevance of color, size, or tactile qualities would deplete the aesthetic possibilities of painting.

Although the exact nature of the aesthetic sign remains variously described and hotly contested, there is general agreement that it is characterized by richness, fullness, and complexity rather than narrowness, attenuation, and uniformity. And this would recommend including the visual aspect of literature, which affords an added dimension to sound and sense, as part of the literary sign. The general aesthetic desire for greater richness provides in itself reason for accepting the visual aspect of the text as aesthetically part of the work and not a mere external technicality.

Western aesthetics should overcome its traditional blindness and recognize the visual aspect of the literary artwork. Theory would then be more faithful both to the actual practice of creative writers who utilize the visual and to the lived experience of readers who encounter and appreciate it. This should also have valuable consequences for aesthetic education, because theoretical recognition of the visual would encourage the reader to pay more attention to the visual side of the literary work and thus possibly lead her to perceive new features, aspects, or meanings that would enrich her understanding and appreciation of the work.

IV

Having established that the text's visual aspect should in principle be regarded as aesthetically relevant, we might ask more precisely: When is it actually or especially significant? Even ardent exponents of textual visuality would not pretend that the visual is of major aesthetic importance in all literary works. Can we give a general theory as to when textual visuality is aesthetically important, or are we confined to a purely particularist approach of case by case analysis? A definitive answer would require more discussion than this chapter permits, but let me conclude by briefly suggesting a general theory that seems worthy of consideration.

I suggest that aesthetic significance obtains when the visual is visible or, to make this sound even more tautological, when the visible is visible. No tautology is, in fact, intended here, but rather a play on the two meanings of "visible." "Visible" can simply mean "able to be seen," and in this sense the visual aspect of the text, when presented, is visible to anyone with normal sight. However, "visible" can also mean "conspicuous," "apparent," or "strikingly manifest to the sight." In this sense we could speak of, say, midgets as being more visible in our society than normal-sized people. Though in the first sense of "visible" they are no more visible (perhaps even less so), midgets are much more noticeable or visible in the second sense; they stand out and command attention. Textual visuality might be considered aesthetically important when and to the degree that it is visible in this sense of being conspicuous, notable, or calling attention to itself.

What then makes a text (or part of one) visible or conspicuous? I doubt the answer can be found in any single or simple group of intrinsic nonrelational visual properties of text (such as ink of a certain color or type of a certain shape) that are independently grasped as conspicuous by some hypothetical "innocent eye" of the reader. The visibility of the visual text seems instead dependent on textual patterns and conventions and on deviations from them. Since textual patterns and conventions may vary to some extent from context to context, the visibility of textual visuality seems fundamentally context-dependent. For example, though italicized words ordinarily seem more visible than those in ordinary type, in a (con)text composed of italicized characters, a word or line in ordinary type will stand out and be more conspicuous. Deviation from textual norms (whether these be general printing conventions or merely the norms or patterns of the particular text) seems central to the visibility of textual visuality.

There are many deviatory devices for attaining this visibility or foregrounding of the visual: peculiarities of line length and spacing, unusual or irregular color of ink, deviations in case, size, and shape of characters, unconventional use of punctuation marks, and so forth. Some of these devices are effectively employed to make the significant visuality of Lewis Carroll's "Tale of a Mouse" and e. e. cummings's "l(a" (from his *95 Poems*) so distinctly visible.[19]

Carroll's poem, sometimes mistaken for a trivial visual pun, uses irregularities in the length and horizontal placing of lines on the page but also a deviatory, steadily diminishing size of character in order to shape a pleasing image of a mouse's tail. In the book's larger narrative, Alice's mistaking the mouse's *tale* for the mouse's *tail* and the resultant quarrel reinforce Carroll's important theme of the fragile nature of linguistic communication by showing how easily it breaks down through reliance solely on its oral medium—where homonyms like "tale" and "tail" abound. The

Fury said to
a mouse, That
he met in the
house, "Let
us both go
to law: *I*
will prose-
cute *you*.
Come, I'll
take no de-
nial: We
must have
a trial;
For really
this morn-
ing I've
nothing
to do."
Said the
mouse to
the cur,
"Such a
trial, dear
sir, With
no jury
or judge,
would
be wast-
ing our
breath."
"I'll be
judge,
I'll be
jury,"
said
cun-
ning
old
Fury:
"I'll
try
the
whole
cause,
and
con-
demn
you to
death."

visual presentation of the word "tale" would have prevented Alice's misunderstanding, and the ingenious visual presentation of the tale as a tail ironically exemplifies the presence and importance of the visual medium of language. Even taken in isolation, the poem gains richness from its visible visuality. Its steadily diminishing size of characters evokes the small print and minutia of legal proceedings which nevertheless have grave consequences; and the mouse's condemnation to death (the end of the tale) is mirrored in the end of the tail and also in the virtually annihilating diminution of the type.

The poem by cummings is visually simpler but just as rich in the effects of its visuality.

l(a

le
af
fa

ll

s)
one
l

iness

It does not deviate in size of type or in the horizontal placing of the lines. It gets its visibility both through the extreme brevity of line length (at one point only one character), in which not only single words but single syllables are divided into two or more lines, and also through an unconventional (but regular) pattern of vertical line spacing. Punctuation is also deviant, the only punctuation being the highly unusual use of parentheses to place an entire sentence within a single syllable, the first syllable of the word "loneliness." The effects of the poem's visuality are numerous and rich. The falling of a leaf to which loneliness is compared is not only visually represented by the sharp vertical fall of the poem, but we feel it empathetically in our reading of the poem. Moreover, the parentheses makes the metaphorical connection all the more powerful by graphically incorporating the vehicle into the tenor. The connection between loneliness and selfhood is also powerfully evoked through emphasis on the visual identity of the letter "l" and the numeral one in many type faces. We are visually shown that "loneliness" consists literally of "l," "one," "l," and "iness" (I-ness).

Having suggested that the foregrounded visibility of textual visuality is largely dependent on conventions of textual format, I have used two poems to show how such visibility can be achieved through certain deviations from the visual conventions of normal writing and printing. The exploration and application of other devices of this sort provide a promisingly fruitful field for both creative artists and literary scholars. The range of these visual devices has been enormously enhanced through the technological development of computerized production of texts, whose screen visuality seems to offer options (like moving, streaming texts) that neither writing nor print seemed able to supply.

On the other hand, the visibility of literature's visuality is also dependent on conventions of reading rather than writing, and thus can be increased through changes in our reading habits in appreciating literature. A habit of attention to the visual surface of the text will make that visuality much more visible. These two different views on visibility (as deviating from conventions of textual formatting or from habits of reading) can be seen as complementary rather than mutually exclusive. Affirming both these views while challenging the deep traditional theoretical obstacles to taking textual visuality as aesthetically relevant, this chapter concludes by encouraging both authors and readers to take greater advantage of literature's rich visual potential of surface. To do so will only deepen our appreciation of this art.

Part III
Contemporary Reconstructions

10.

Art in a Box
Danto

Art emerged in ancient times from myth, magic, and religion, and it has long sustained its compelling power through its sacred aura. Like cultic objects of worship, artworks wax an entrancing spell over us. Though contrasted to ordinary real things, their vivid experiential power provides a heightened sense of the real and suggests deeper realities than those conveyed by common sense and science. Since the late nineteenth century, thinkers as different as Matthew Arnold and Oscar Wilde have predicted that art would supplant traditional religion as the locus of the holy in our increasingly secular society. Such prophecies have largely been realized. In twentieth-century Western culture, artworks have become the closest thing we have to sacred texts, and art almost seems a form of religion with its priestly class of creative artists purveying the new gospel and of interpretive critics who explain it.

Despite millennial rumblings, this sacralization of art as something almost otherworldly still prevails. Art is worshiped as something beyond material life and praxis, its miraculous relics (however profane they strive to be) are enshrined in temple-like museums which we dutifully visit for spiritual edification as we once frequented churches. This religion of art was in fact shaped by centuries of philosophical ideology aimed at disempowering art by consigning it to an unreal, purposeless world of imagination. Such religion is the enemy of pragmatism's quest to integrate art and life, a quest exemplified in the very ideal of practicing philosophy as an art of living.[1] As the religion of art grows weaker and more corrupt, its temples are overrun by pharisees of connoisseurship and mercenary speculation. Amidst the hype of new revelations and the din of trading, some prophetic voices of transformation can be heard. One of them is Arthur Danto's.

I begin in this religious context not simply to highlight this chapter's major target—the spiritualizing ideology that compartmentalizes art as a

transcendental realm divorced from ordinary reality, but also because my central character, Arthur Danto, has called himself a prophet.[2] He is obviously too Nietzschean to be a Jesus, much too urbane to play John the Baptist, and far too upbeat to make an Isaiah or a Jeremiah. So, in developing my arguments, I shall treat Danto as Moses, that is, as a prophet of revolt against what he calls "The Philosophical Disenfranchisement of Art."

As Moses reminded the Hebrews of their unjust disenfranchisement by Pharaoh, so Danto reminds us of art's subjugation by philosophy. As Moses was abandoned as a Hebrew baby and then adopted to become an Egyptian prince, so Danto began as an artist who then found a foster home in the king discipline of philosophy, and for many years did not reveal himself as a philosopher of art. This insider status was very important; for Moses and Danto could challenge the enslaving authority because they were in a sense part of it. Danto could reason with the Pharaoh of philosophy not only because he could speak the right language but because, like Moses, he was granted an audience and the power to be heard in that Pharaoh's court.

Interestingly, both Moses and Danto had to wander from the royal court to get the inspiration to reclaim their original heritage and challenge its cruel oppressor. Moses fled to the wilderness, Danto simply wandered down from Columbia University's Philosophy Hall to the artistic wilds of the Stable Gallery on East 74th Street. In these strange and stressing landscapes, each was transfixed by a single image which perplexed and fascinated, and which converted them back to their respective original faiths. For Moses it was the burning bush which transfigured him into a prophet of the Hebrew nation; for Danto it was the *Brillo Box* which inspired "the philosophical intoxication" and "insight" on which he would construct a philosophy of art (*TC*, vi–vii).

To extend this already extravagant conceit still further, note that for both Moses and Danto the miraculous aspect of the image was essentially the same—nonconsumption. Burning bushes and Brillo boxes were certainly commonplace sights. The transfiguring wonder was that they were not consumed: neither for Moses in the fiery biblical sense of consumption, nor for Danto in our coolly commercial sense of being bought or used as "mere real things" rather than contemplated as art.

However, the most important analogy between Moses and Danto is their imperfect success as emancipators. Moses led the Hebrews out of Egyptian bondage but did not deliver them into the Promised Land, which he himself could not enter though he was allowed to glimpse it darkly from the distant heights of Mount Nebo where he was soon to be buried. For Moses had too much of the Egyptian prince and the Hebrew slave mentality to handle the messy and violent nitty-gritty of introducing his people into pagan Canaan. That required a rude *inculte* like Joshua who trafficked with spies, whores, and trumpets.

Danto occupies a similar position. Having led aestheticians to an emancipatory awareness of the philosophical disenfranchisement of art, he has left its reenfranchisement far too incomplete. His theories remain too enslaved by traditional philosophical ideology, too compartmentalized and otherworldly, too dominated by ideals of deep theoretical truth. A more earthy, pragmatist approach is needed to restore to art its power of praxis and revive our appreciation of its aesthetic surface and sensory pleasures. Before confronting Danto with critique, I should present the ground we share: the genealogical critique of art's philosophical subjugation.

II

Philosophy arose in ancient Athens by aggressively defining itself in contrast to art as the highest pursuit—providing not only superior wisdom but the noblest and most intense joys of contemplation. With Socrates and Plato, philosophy was born of a struggle for intellectual supremacy fought against the rhetoricians or sophists on the one hand and the artists on the other. Philosophy's battle was especially directed against the poets, since poetry best captured the sacred wisdom of tradition and lacked the banausic character of plastic art.

Just as philosophy employed the argumentative strategies of rhetoric, so it took some of its epistemological and metaphysical (and perhaps even ethical) orientations from art. The ideal of knowledge as detached contemplation of reality rather than active interaction and reconstruction of it reflects the attitude of a spectator at a drama or an observer of a finely finished work of plastic art. Similarly, philosophy's idea that reality ultimately consists of well-defined and stable *forms* that are rationally and harmoniously ordered and the contemplation of which provides sublime pleasure suggests a preoccupation with fine artworks whose clear shapes and contours and whose enduring and intelligible harmonies set them above the flux of ordinary experience and make them seem more vivid, permanent, and compelling—in a sense more *real* than ordinary empirical reality. Finally, the founding images of the philosophical life—either as Socrates' death-defying heroism or as the ascending quest toward the Form of Beauty and the engendering of beautiful creations that Plato describes in *The Symposium*—seem to be modeled either on the heroes already portrayed in Greek art or on the vision of the artist's life as devoted to the quest for beauty.

To establish its own autonomy and privilege, philosophy had to define art in more negative terms. With keen dialectical ingenuity and imperiousness, Plato transformed philosophy's epistemological, metaphysical, and ethical imitation of art into a depreciative definition of art as imitation or *mimesis*.[3] As Danto shrewdly remarks, this definition "gives us less a theory than a powerful disabling metaphor for impotency" (*PD*, 6).

Plato thus defined art not to promote its practice or enhance its appreciative understanding, but rather to deprecate, confine, and control it—even to the extent of censorship and banishment. His inaugurating definition left such a formative influence on the field that, even when philosophers felt increasingly free of his condemnatory agenda, they remained confined within its disenfranchising logic that neutralizes art from any serious role in cognition or praxis and insures its inferiority to philosophy. We see this already in Aristotle's defense of art. In asserting that tragedy imitates the universal and thus provides a "more philosophical" truth than history, Aristotle simply reinforces the imitation theory and the hegemony of philosophy.

Danto identifies "two stages to the platonic attack": first, an "effort to trivialize art by treating it as fit only for pleasure" (and inimical to true knowledge or right action) because of its essential sensual dimension and concern with appearance; and second, an effort to "rationalize" art as an inferior, "uncouth" form of philosophy, alienated from recognition of itself as striving for philosophical truth (*PD*, xiv–xv, 70). These two strategies were strongly reinforced in modern philosophy through Kant's notion of the aesthetic as a disinterested realm concerned with mere appearances with no regard to their reality or practical function, and later through Hegel's theory of art as a more childish stage of Spirit (*Geist*), a stage that had to be superseded on Spirit's way to philosophical maturity.

Danto's emancipatory efforts on behalf of art "seek a reenfranchisement against both moves." He counters the first by insisting that interpretive thought is essential or constitutive of the artwork while "aesthetic consideration" is not. To counter the second move, Danto provides a historical narrative in which art can no longer be seen as struggling to arrive at philosophy because, having itself evolved into philosophy of art, it has already arrived there and in that sense art has ended its historical quest (*PD*, xv). However, this narrative (which is essentially Hegel's story of the end of art) seems only to reinforce art's subordination to philosophy by affirming that art has reached its end in becoming more philosophical and is incapable of further progress.

III

Before reviewing Danto's theories in greater detail, I want to consider a third strategy in the platonic attack that Danto ignores. Less explicit and strident, it is all the more insidiously potent. This strategy is the whole fundamental enterprise of trying to define art compartmentally as a special category of objects or activities that is separated from ordinary "real" life. While Plato's definition of art as *mimesis* categorized art both in the sense of delimiting compartmentalization (so as to nullify its influential connection with life) and in the original Greek sense of "categorization" as

accusation, subsequent philosophy dropped the explicit accusation but has persisted in the habit of compartmentalized definition which in effect sustains, however unwittingly, art's praxical disenfranchisement and neutralization. The very project of traditional philosophical definition means putting art in a box, confining it and marking it off from the rest of life.

Once Plato's sequestering initiative had taken root and art's separate status had been firmly reinforced through modernity's differentiation of cultural spheres, philosophy no longer needed to urge art's compartmentalization but could merely sustain or affirm it by reflective definition. Given the presumption that art is a distinct domain of objects that must be clearly individuated from other domains, the traditional exercise of definition is to find a verbal formula that will fit all and only those objects that would be called works of art according to the accepted understanding of that domain.

We can challenge any proposed definition of this sort by showing counterexamples that its verbal formula would either wrongly cover or fail to cover and so would either wrongly include or exclude from the domain of art. The definition is thus shown to be either too wide or too narrow; its motivating ideal is perfect coverage, and it might well be called the wrapper model of theory. For like the better food wraps, such theories of art transparently present, contain, and conserve their object—our understanding of art. They aim to preserve rather than transform art's practice and experience. Like the condom, another form of elastic transparent wrapper that promises to be as ubiquitous and as advertised as food wraps (and which the French aptly designate *préservatif*), these theories aim to preserve art from contamination by its exciting yet impure enveloping environment while at the same time preserving that environment from art's potential to create new life.

Danto has inspired at least two such wrapper theories, but endorses only one as his own. His "discovery" of the artworld (as that which makes Andy Warhol's wooden Brillo boxes art, but not their ordinary carton counterparts) provided the inspiration for the institutional theory of art proposed by George Dickie. That theory defines an artwork as simply any "artifact upon which some person or persons acting on behalf of a certain social institution (the artworld) has conferred the status of candidate for appreciation."[4] Though the institutional theory defines "work of art" in terms of necessary and sufficient conditions, the definition is purely procedural. All substantive issues are left to the artworld. By stressing this social context through which art is generated and provided with properties not directly exhibited to the senses (properties that distinguish between Warhol's *Brillo Box* and its visually almost identical counterparts), the institutional theory can explain how art can have a definitional essence without its objects sharing a core of exhibited aesthetic properties. The

theory can cover anything that an artwork will present, even if it presents nothing. But the institutional theory's breadth of coverage is matched by its explanatory poverty. It provides no real account of the structure and content of the artworld or of the constraints on its agents, let alone an account of the relationship of the artworld to the wider sociocultural and politico-economic world in which it is embedded.

In rejecting the institutional theory, Danto locates its explanatory weakness primarily in its historical emptiness. Ignoring Heinrich Wölfflin's insight that not everything is possible at every time, the institutional theory leaves everything magically to the power of artworld agents without considering the historical constraints that structure the artworld and thus inform and limit its agents' actions. Thus, even if this theory can explain how Warhol's *Brillo Box* could be proposed for art status, it cannot explain why this work should be so accepted but an indistinguishable one rejected, or even why this work itself would not have been accepted had Warhol produced it in fin-de-siècle Paris or quattrocento Florence.

The explanation, Danto argues, depends on the history and theory of art. The status of artwork must involve more than just being conferred "appreciational candidacy" by an artworld agent. A museum curator might offer us a beautiful flower at an exhibit's opening without making that flower a work of art, even if it is indistinguishable from an actual artwork of a real flower (entitled *Living Beauty*) currently exhibited there. For Danto, any object successfully claiming to be art must bear a distinct interpretation as a particular artwork (the artwork flower, for example, as an artistic comment on the moribund character of still life and of museum art in general). As "nothing is an artwork without an interpretation that constitutes it as such" (*TC*, 135), so for the requisite interpretations to be possible, certain structures and contexts in art history and art theory must obtain.

Thus, the *Brillo Box* as a work of art required an interpretation to that effect, both creatively by Warhol and responsively by his audience; and the artworld "required a certain historical development" to make that interpretation possible (*TC*, 208). Objects are artworks if they are so interpreted by the artworld; and since the artworld is but an abstraction from the artistic, critical, historiographical, and theoretical practices that constitute art's history, art is essentially a complex historical practice and must be defined as such.

Although far superior to the institutional theory, Danto's aesthetics is still governed by the same wrapper model of definition and ideal of perfect coverage. We see this in its motivating concern and criterion that "any definition of art must compass the Brillo boxes" of Warhol but not cover their ordinary counterparts (*TC*, vii).[5] Indeed, Danto's astonishingly acute preoccupation with this particular icon of "art in a box" may well be the

expression of his philosophical compulsion for art's definitional contain-
ment compounded by his contradictory repulsion from the disenfran-
chisement of art that such compartmental containment created and still
sustains.

Obsessions, Freud tells us, emerge from such contradictory impulses,
and the *Brillo Box* could provide a stunningly powerful image of artistic
freedom that is nonetheless boxed in. Given Danto's conflictual alle-
giances to philosophical definition and to art, it is not surprising that he
should be haunted by this artwork, and even reasonable that he has inter-
preted it, as I shall suggest, incorrectly.

Before pursuing such controversies of interpretation, we should note
how Danto's definitional drive and sensitivity to history neatly converge
with his controversial Hegelian view that art has reached its end. Confess-
ing "the philosophical aspiration of the ages, a definition which will not
be threatened by historical overthrow," Danto ingeniously defines art in
terms of its own history, while arguing that that history, in an important
sense, is now over. Twentieth-century art, pursued as a progressive in-
quiry into art's essence, has evolved into the philosophy of art and, hav-
ing reached the philosophical "understanding of its own historical
essence," has reached its end (*PD*, 204, 209). Art continues to be produced,
but its history of progressive self-definition is over. Lacking a clear goal
for progress, posthistorical art gropes in what Danto sees as the "do what
you damned please" pluralism of postmodernity, where "it does not mat-
ter what you do" (*PD*, 114–15).

However, art's historical definition hardly depends on this "end of art"
thesis. One could argue that the basic openness of history guarantees that
art's definition by history can accommodate whatever new artistic devel-
opments future history will bring. For any such development would, by
definition, belong to the continuing history of art, as told by future histor-
ical narrative. Thus, even aestheticians who do not share Danto's apoca-
lyptic vision still agree that art is a complex sociocultural practice essen-
tially defined by its (continuing) history.[6]

This historical definition of art may be the best wrapper theory we can
get. In faithfully representing our established concept of art and how art's
objects are identified, related, and collectively distinguished, it best real-
izes the dual goals of traditional philosophical definition: accurate reflec-
tion and compartmental differentiation. It also betrays how questionable
and gainless these goals may be. For what does such a definition do for us?

In defining art as a practice defined by art-historical narrative, all sub-
stantive decisions as to what counts as art are left to the internal decisions
of the artworld as recorded by art history. Philosophy of art collapses back
into art history; so the actual, momentous issue of what art *is* or *should be*
gets reduced to a second-hand account of what art *has been* up to the pres-

ent. If it merely reflects how art is already understood, philosophy of art condemns itself to the same reductive definition with which it condemned art. It is essentially an imitation of an imitation: the representation of art history's representation of art. What purpose does such representation serve apart from appeasing the old philosophical urge for theory as mirroring reflection of the real, an aim which has outlived the transcendental metaphysics of fixity which once gave it meaning?

The theoretical ideal of reflection originally had a point when reality was conceived in terms of fixed, necessary essences lying beyond ordinary empirical understanding; because an adequate representation of this permanent real would always remain valid and effective as a criterion for assessing ordinary understanding and practice. But if our realities are the empirical and changing contingencies of art's career, the reflective model seems pointless. For here, theory's representation neither penetrates beyond changing phenomena nor can sustain their changes. Instead, it must run a hopeless race of perpetual narrative revision, holding the mirror of reflective theory up to the changing nature of art by representing its history.[7]

But art's mutable history need not be represented, it can also be made; and Danto's move to practical criticism (as art critic for *The Nation*) shows his recognition that art needs more active care than mere philosophical mirroring provides. Art history can be made not only by the work of artists and critics, but also through the intervention of theorists, whose views have traditionally been central to the creative and critical context in which artists, critics, and art historians function. Consider, for example, how Aristotle's *Poetics* dominated centuries of dramatists and critics, or how Kantian ideas of aesthetic imagination and judgment helped shape romantic poetry and justify modernist formalism.

If art seems to have lost direction in today's postmodern confusion, there is need and opportunity for revisionary reorientation through more activist theory. Pragmatist aesthetics, in pursuing this role, eschews not only mirroring, historical definition but indeed the whole philosophical project that seeks to define art by isolating it from life and opposing it to praxis.

Defining art merely in terms of its established history is dangerous because it endorses the constricting and exclusionary tendencies of that history. If the notion of art once included a wide variety of skills and crafts that improved life's praxis, it is today reserved for the practice of fine art as compartmentally constituted by the artworld. This shrinking isolation of art into fine art both reflects and reinforces a vicious division in modern society between practical labor (deemed to be intrinsically disagreeable) and aesthetic experience (held to be enjoyable but functionless), a division that too often manifests itself in painfully unaesthetic industry and uselessly irrelevant fine art.

Art's historical impoverishment goes beyond its modern reduction to the practice of fine art. Our concept of fine art itself tends toward progressive narrowing and elitist specialization, particularly when it is defined in terms of its recent history. Fine art, as historically defined by standard art-historical narrative, has come to mean fine art that makes art history, while this in turn means that art gets essentially confined to the tradition of high art and its epoch-making avant-garde. Defined by what Danto calls "historical imperatives," where artistic "success consisted in producing an accepted innovation," art's progress, at least since modernism, has meant progressive alienation from the appreciative experience of most people (*PD*, 108–9).

Without denying the value of high art and its avant-garde, we need to challenge the exclusionary presumption that this tradition exhausts the realm of legitimate art. Yet the presumption seems irresistible when art is defined in terms of art history, which, as practiced in the artworld, is the history of high art through its progressive, epoch-making transformations (even though many of these were inspired and fueled by more popular culture). Such historical definition boxes art into an impoverishing narrowness, a virtual coffin, if Danto is right that our high art tradition has reached its end. His 1986 prognosis that "the institutions of the art-world—galleries, collectors, exhibitions, journalism—which are predicated upon history and hence marking what is new, will bit by bit wither away" (*PD*, 115) seemed to be coming true in the increasing waves of gallery closures and artworld hardships of the 1990s. Art could hardly have a future, if "without the artworld there is no art" (*TC*, 125).[8]

For pragmatist aesthetics, however, this crisis can be greeted as a necessary step toward a revitalized reintegration of art into life. The end of its compartmentalized history and the weakening of its compartmentalizing institutions, as even Danto notes, should "return art to human ends" and "abiding human needs" (*PD*, xv, 115). If art can outlast its compartmentalized history, then we must recognize a notion of art not narrowly defined by that history. Pragmatist aesthetics is heretical not simply in breaking with standard historical definitions of art but in flouting the whole philosophical tradition of defining art as a separate domain, sequestered from and opposed to reality and practical life. This tradition remains so strong in Danto that although he inveighs against philosophy's disenfranchising definitions, he ultimately encourages them by his presumption that art must have a distinct essence that demands and justifies an essentialist definition, whether this be what he calls art's "own historical essence" or some still deeper metaphysical essence that he later suggests is "extrahistorical" (*PD*, 204; *ATE*, 187).[9]

To effect a fuller reenfranchisement, at least three radical steps must be taken beyond Danto's prophetic path. First, the art/reality opposition must be challenged so that the concept of art can be widened to incorpo-

rate more dimensions of real life and more forms of cultural expression. But emphasizing art's reality is not to reject aesthetic surface as mere appearance. Appearances are experientially real, even when what they suggest is fictional. Second, our notion of the aesthetic must be enlarged beyond the merely formal and sensory to embrace both the cognitive and the practical. Third, we must extend the notion of philosophy beyond its preoccupation with reflective definition, that is, beyond pure theory and the pursuit of truth for truth's sake. A brief sketch of these three strategies completes this chapter's critique of Danto and the compartmentalization of art and philosophy.

IV

1. I begin with the art/reality dichotomy, which Danto, like all of us, inherits from Plato. Though an unquestioned dogma, the "gap between art and life" (*TC*, 13) is, in an obvious way, quite simply false. Art is undeniably real; it exists concretely and vividly in our world, constituting, for some of us, a central, irreplaceable part of our lives. Of course, we can always distinguish between a real object and its artistic representation, but this does not entail that the representation is either unreal or intrinsically deceptive. Similarly, though we can usefully contrast appearance to reality in some linguistic contexts, the fact that an aesthetic surface is an appearance does not entail that it is illusory, trivial, or devoid of meaning. Appearances can be instructive, significant, and efficacious.

The presumed schism between art and reality served not only to deny art's cognitive value but also to isolate its practice from practical life and sociopolitical action by dismissing it as intrinsically impractical through its contrast to the real. Thus art came to be quarantined in an aesthetic domain essentially defined after Kant by utter disinterestedness, "complete indifference" to "the real existence" of things.[10] This view not only belies the efforts of artists who seek to change the world by transforming our attitudes. It also encourages the practice and reception of art as something essentially purposeless and gratuitous. Ignoring art's wide-ranging cognitive and social potential, it has inspired the perversions of the artist as antisocial dreamer and the true aesthete as frivolous wastrel.

Philosophy's separation of art from life has also eviscerated aesthetic experience by repudiating its connection to bodily energies and appetites and by defining its delight in contrast to the sensual pleasures of living. With Kant's determination that true aesthetic pleasure should be sharply distinguished from sensory satisfaction, reinforced by Hegel's privileging of ideality and immateriality, modern aesthetics put the experience of art on a path of disembodied spiritualization, where full-blooded and widely shared appreciative enjoyment is refined away into anemic and almost ascetic contemplative devotion.

This idealist aesthetic tradition, which Danto also inherits, maintains Plato's gap between art and life while inverting its ontological valorization. Rather than being ontologically demeaned vis-à-vis ordinary real things like beds or grapes, the artwork, for Danto, is given an ontological promotion, while real objects, which may even be "like it in every obvious respect, . . . remain in an ontologically degraded category" (*TC*, 5). Artworks are thus not simply unreal; they instead partake of a higher ontological status than ordinary reality, one requiring a special mental act of artistic interpretation. "The distinction between art and reality is absolute," Danto declares, linking this claim to Hegel's elevation of art to the realm of Absolute Spirit while real objects merely form "the Prose of the World."[11] Art's role is to "express the deepest thoughts" and convey "the kind of meaning that religion was capable of providing" (*MF*, x; *ATE*, 188).

This romantic theology of art seems a vestige of our otherworldly religious culture. Having lost faith in its traditional transcendental object—God—intellectual culture has redirected its devotional energy into art as the expression of divine genius and superior spiritual reality. Since "we cannot believe in transcendent beings," we displace religious feelings that we once had toward them and the beauties of nature they were thought to have created and instead invest those feelings in artworks. Mark Rothko's canvases are thus described in terms of "supernatural meanings," "presenting a high truth of metaphysics or theology" (*MF*, 337–38). Works of art, like miraculous acts of God, transfigure the commonplace and require special interpretation, while ordinary mundane realities do not.

However, things that require interpretation can be interpreted wrongly, so let us return to Moses and Danto and see whether the transfiguring miracles they witnessed could not be given more down-to-earth, less otherworldly meanings. That sturdy burning bush which was not consumed, which did not billow up in smoke to the heavens but remained full and rooted in the earth, was taken by Moses as the sign of a transcendental, immaterial God, one to be sought in the heavens, approached by scaling Mount Sinai, and worshipped by obeying his ascetic, spiritual law.

Had Moses been less of a romantic transcendentalist, he could well have interpreted the miracle in a more materialist and worldly fashion, saying: "Look to the earth and the life it brings forth, not even fire will completely consume it or exhaust its life-giving fruit. The earth and its living gifts are holy and need to be worshiped by working the land—*la'avod et ha'aretz*—the very same Hebrew words which also mean 'to worship the land.' Do not try to elevate yourselves too high above the land and above other earthly people, but obtain your own land to work and worship rather than slaving on Pharaoh's." Had Moses been more like Karl Marx (or the Zionist Ehad Ha'am), we might have had this alternative interpretation of the miraculous message of the burning bush, an interpretation

which might well have been better, if not also truer, for the haughty Hebrews. God only knows.

Yet if Moses could have misinterpreted God, it is conceivable that Danto might have misconstrued Warhol, and in the same spiritualizing fashion. Danto takes the *Brillo Box* as showing that art is essentially and ontologically different from ordinary real things, even when they are perceptually indistinguishable. In order to be art, such things must be interpreted as art, which means recognizing that they can no longer be seen as the things they were in the real world; indeed, they are no longer part of the real world but rather spiritualized into the superior artworld. But is it not plausible that Warhol's *Brillo Box* is instead claiming that the idea of art as a transcendental realm of higher spiritual value is a pathetically fraudulent myth that has outlived its use and even its credibility?

Here the message is that the romance of theological art is dead and that the only living art of today is not in the museum but in the products, designs, and entertainments of everyday living: Campbell's Soup and Coca Cola, Elvis and Marilyn, Superman and Howdy-Doody. By this construal, real Brillo boxes do not need to be interpreted as art to become art, they already are art—attractive, expressive exemplars of graphic design. (Warhol, of course, began as a graphic artist, and the original Brillo box design was the graphic art achievement of a modernist painter turned commercial artist, Steve Harvey.) Warhol's message, according to my interpretation, is that the hoary separation of art from life can no longer be honestly maintained. Art needs to overcome its old-fashioned transcendental theology and absorb itself into the real world, a world effectively made and remade through human artistry, be it technological, commercial, or conceptual. As Warhol wrote in expounding his philosophy, "making money is art and working is art and good business is the best art." He was proud that his "art had gone into the stream of commerce, out into the real world. It was very heady to be able to look and see our movie out there in the real world on a marquee instead of in there in the art world."[12]

Whatever we make of Warhol, we should recognize that both art and life have clearly suffered from the ideology of the ontological gap between them. If art, in pursuing its purist path, has lost its ancient existential power[13] and its vital connection with the experience and active interests of most people, life has lost the sense of its own artistry and potential for beauty. The idea of art as a separate realm distinguished by its freedom, imagination, and pleasure has as its underlying correlative the dismal assumption that ordinary reality must be one of joyless, unimaginative coercion. By thus compartmentalizing art and the aesthetic as something essentially different from reality, only to be enjoyed when we take a break from reality, the most hideous and oppressive institutions and practices of our society get legitimated and more deeply entrenched as inevitably real.

They are erected as necessities to which art and beauty, by the reality principle, must be subordinated. The art/reality dichotomy must be overcome so that art takes on more life, while reality is rendered more aesthetic.

One strategy is to develop those arts of living whose aesthetic potential has been philosophically ignored but is widely (though often not wisely) deployed in today's multitudes of lifestyles. Such arts are evident in the stylizations of popular culture. They include arts of external shaping and adornment (such as bodybuilding, cosmetics, and fashion) but also the much neglected but more enriching somatic arts of inner awareness (like meditation, yoga, and the Feldenkrais Method). If we may speak of a comprehensive art of living that integrates other arts and attempts through critical and creative work on the self to shape a life of richly satisfying beauty, then philosophy could aspire to be this art.[14]

2. As a second step toward reenfranchising art, we should broaden the traditional concept of the aesthetic, which Danto correctly condemns as another philosophical tool for dismissing art's cognitive power and political potential. Our dominant Kantian aesthetic tradition defines the aesthetic attitude as divorced from purpose. "So art is systematically neutered, removed from the domain of use, . . . from the world of needs and interests" (*PD*, 10). Boxed into a rarefied, cloistered space of formal beauty, art is not only isolated from knowledge and praxis, but trivialized as "fit only for pleasure" (*PD*, xiv). Arguing that "aesthetical considerations . . . have no essential application to . . . art produced from the late 1960s on," Danto concludes that the whole "connection between art and aesthetics is a matter of historical contingency, and not part of the essence of art" (*ATE*, 25).

Echoing Marcel Duchamp and Barnett Newman, Danto further repudiates the aesthetic as "a danger" from which art must escape (*PD*, 13) and insists instead on art's interpretive (that is, semantic or cognitive) dimension. But his rejection of the aesthetic cannot be justified by the need to defend art's cognitive value against aesthetic pleasure, because Kant in fact defined aesthetic pleasure by its distinctive cognitive character as contrasted to what he regarded as more trivial sensual pleasures. More generally, there is no tension between cognition and aesthetic pleasure. Pleasure both results from the cognition of aesthetic objects and is what in turn inspires us to seek to know them still better.

If the aesthetic seems dangerous to Danto, this is because it is closely associated with surface appearances, while Danto, in Hegelian fashion, sees the essential function of art as the expression of deep truths. In complaining against art that serves "the ends of pleasure and entertainment," Hegel insists that art can only be free "when it has taken its place in the same sphere with religion and philosophy, and has become simply a mode of revealing to consciousness and bringing to utterance the Divine

Nature, the deepest interests of humanity and the most comprehensive truths of the mind." Here is the prefiguration of Danto's romantic theology of art. Art can achieve its freedom only by forsaking the pleasures of aesthetic surface in order to devote itself to the servitude of profound truth. Likewise, art cannot satisfy "spiritual wants" in its own right by its more direct aesthetic meanings; it requires "the science of art," or philosophy, to give its meanings "genuine truth and life."[15]

Is this repudiation of the aesthetic really feasible or worthwhile? What would art be without aesthetic surface? Andy Warhol himself flies in the face of both Danto and Hegel by insisting that his art is very much about surface appearances and their power. "If you want to know all about Andy Warhol, just look at the surface: of my paintings and films and me, and there I am."[16] Danto is willing to concede that art can hardly escape the aesthetic by mere willful ugliness, for that too is an aesthetic term. Beauty, moreover, is resurfacing as a theme in today's artworld.[17] To try to escape into the alternative Hegelian view—where art seeks not beauty but philosophy—leads art inescapably back to its philosophical subjugation and the end of art in its achievement of philosophical self-consciousness. The notions of aesthetics and art are by now so deeply connected, and the very term "aesthetic" is so laden with blue-chip cultural capital, that radically severing art from its connection to the aesthetic seems a futile operation that would further discourage our aesthetic appreciation of the surface qualities of art.

Pragmatism's alternative is not to escape the aesthetic but to reconceive it in broader, more practical terms than the prevailing Kantian conception recognizes and with more respect for surface than Hegel or Danto would allow. This broader conception (embracing the sensually somatic as well as the cognitive and practical) can already be found in Nietzsche and Dewey. More crucially, outside the discourse of philosophy, aesthetics is surely free from such disempowering Kantian constraints. Madison Avenue and Capitol Hill have long been aware of the practical power of beauty as well as the power/knowledge involved in its definition and production. Oppositional artists have likewise recognized that political art can be most effective when aesthetically most powerful.

3. A third strategy for the philosophical reenfranchisement of art is the broadening of philosophy beyond its traditional obsession with classificatory definitions and mirroring truth. Danto once again is the prophet who condemns the old philosophical manacles that disempower art, but remains too enslaved by them to really break art and philosophy free. He shows how philosophy's definitions of art are "penitentiary architectures" of disenfranchisement; their "power to classify is the power to dominate" (*PD*, 12). Yet he cannot resist affirming "the philosophical aspi-

ration of the ages, a definition which will not be threatened by historical overthrow" (*PD*, 209).

Philosophy's disempowering definition of art is ultimately a disempowering definition of philosophy itself. If art is but a weakened substitute or childish version of philosophy, if art can make nothing happen since it is merely a representation or symbol of meaning, what then does that say for the power of philosophy? If art, as Plato thought, is but an imitation of an imitation of the real, then philosophy is only slightly better in that it represents the real at only one remove. It still is disempowered from creating the truth by transforming reality instead of merely mirroring it. In curing art of its philosophical disenfranchisement, Danto hints, we might even "cure philosophy of a paralysis it began its long history by infecting its great enemy [i.e., art] with"—the paralysis of only mirroring realities rather than creating them, discovering and reflecting the truth rather than making or improving it (*PD*, 17).

Although prophesying the cure, Danto refuses to take it and remains locked in the paralyzing bounds of a philosophical ideology fixated only on reflecting the truth. In his philosophy, "when the truth is found, there is nothing further to do" (*PD*, 210), no role of changing, challenging, or bettering it; no role of incorporating it into one's practical art of living and the aesthetic reconstruction of self and society. Philosophy remains as compartmentalized and ineffectual as art.

In reconceiving art and the aesthetic, pragmatism also rethinks the role and limits of philosophy. No longer content with analyzing realities and concepts, it seeks to improve them. But does not such theoretical activism mean abandoning philosophy altogether by forsaking its traditional project and self-image as the wholly disinterested pursuit of truth? In *Practicing Philosophy*, I present a more practical tradition of philosophy in which the ideals of enriching experience, illuminating meanings, and improving life has primacy, and where truth is valued as instrumental to these ends. As experience and meaning are wider notions than truth, so philosophy's aims should go beyond the search for truth.

Moreover, as Danto's own argument reveals, philosophy's most powerful achievements were not always, if ever, really governed by the goal of revealing truth for truth's sake. Certainly Plato's theory cannot be seen as disinterestedly representing the nature of art. It was clearly a politically motivated response to the pressing problem of whose intellectual leadership (art's ancient wisdom or philosophy's new rationality) should guide Athenian society at a time of troubled change, political dissension, and military defeat. Though Plato's disenfranchising aims were the very opposite of the reenfranchising pragmatism I recommend, the engaged and activist role of philosophy remains the same.

If art and aesthetic experience are crucial forms of human flourishing, then philosophy betrays its role if it merely looks on neutrally without joining the struggle to extend their breadth and power.[18] If this requires bringing art out of its box, we should also be wary of the dangers of its liberation, dangers of commercializing corruption and political abuse of which T. W. Adorno and Walter Benjamin shrewdly cautioned. These worries should not make us abandon the integration of art and life, but rather spur us to a more vigilant critique of our diverse arts and their role in the comprehensive art of living.

11.

Pragmatism and Culture
Margolis and Rorty

I

Pragmatist philosophy celebrates the idea of culture. Recognizing that culture is both an essential value and the ineliminable matrix of human life, pragmatism further insists that philosophy itself is the product of culture, changing with cultural change. Philosophy's methods, aims, and problems reflect those of the culture that shapes it. Even its concepts of truth, knowledge, identity, and meaning get their concrete significance from the roles they play in a culture's language-games. As these games are complex, contested, and historically changing, so the concepts of philosophy are characteristically contested and difficult to define. Like other rich philosophical traditions, pragmatism presents no monolithic school but a variety of related approaches. This chapter contrasts two different pragmatist approaches to culture. We can call one the descriptive-metaphysical approach, while the other can be characterized as the reconstructive-narrative or genealogical-poetic approach.

The first is particularly concerned with the ontology of culture, with second-order, metaphysical questions of logical legitimation or adequacy: questions about the sort of objects on which cultural discourse must be grounded so that the coherence of cultural discourse can be ensured through conditions of change. This approach can be seen as largely Kantian in character, because it is a quest for the conditions of possibility of coherent discourse. The second approach is less concerned with the metaphysical and logical grounding of our cultural discourse than with employing and revising this discourse to address concrete problems and to overcome obstacles that block the road of inquiry. More Hegelian than Kantian, it legitimates (and challenges), not by transcendental arguments of "conditions of possibility" but by composing polemical narratives and advocatory depictions; in other words, by elaborating critical genealogies of our concepts and by suggesting new ways of thinking and talking about cultural phenomena.

The first approach has its source in C. S. Peirce and is most fully and cogently developed in the work of Joseph Margolis. (Hilary Putnam also exemplifies this style of pragmatism, but his work is much less focused on cultural issues.) The second approach, inspired by John Dewey, is represented in rather different ways by Richard Rorty's advocacy of new vocabularies and by my own narrative-polemics for popular art and nondiscursive somatic understanding. John Stuhr very aptly characterizes and defends this Deweyan approach as "genealogical pragmatism."[1] Must pragmatism choose between these two general approaches to philosophy of culture, or can they be reconciled so that they might even complement each other? If such reconciliation is possible, it is because the two approaches share some of pragmatism's major themes.

II

As both Dewey and Peirce remarked, pragmatism is inspired by Darwin's idea of evolution. The world, including the world of human thought, develops over time, and such development is contingent rather than necessary. The universe is not only plastic but variant, the product of chance probabilities. Human thought and action are evolutionary responses to the world, and they play a central part in reshaping that world. The very concept of reality, Peirce famously urged, is a social product implying a community of inquirers focused on the same object of inquiry. William James similarly insisted that the very concepts with which we experience the world reflect humanity's past valuations or interpretations of experience and that the trace of the human is everywhere. In Willard Quine's more contemporary formulation, reality is a blend of fact and convention, and these cannot be factored out into their pure separate components. Finally, there is pragmatism's strong fallibilism and antifoundationalism. No representation or alleged fact enjoys apodictic incorrigible certainty; any belief is open to revision by further inquiry; and no cognitive act enjoys absolute privilege. Besides the permanent possibility of error, there is the possibility that conceptual change will render a past belief irrelevant and even incoherent.

In the technical vocabulary of Margolis, these various themes are described as variance, flux, contingency, the lack of cognitive transparency and privilege, and the socially constructed nature of human culture, including human selves. In one of his major works, he formulates them in the following five doctrines:

1. Reality is cognitively *intransparent*: that is, all discourse about the world is mediated by our conceptual schemes [and no single perception or scheme can claim apodictic privilege or necessity].
2. The structure of reality and the structure of human thought are inex-

tricably *symbiotized*: that is, there is no principled means by which to decide correctly what the "mind" contributes to what we take to be the world's real structure or what the "brute" world contributes.

3. Thinking has a history, is *historicized*: that is, all the supposed fixities, invariances, necessities, universalities of thinking and world . . . are contingent artifacts of the historical existence of different societies . . . [and are] under the constraint of changeable history.

4. The structure of our thinking is *preformed* and self-modifying: that is, tacitly formed by antecedent enculturing processes that we cannot entirely fathom, though by participating in these same processes (as we must) we alter them. . . .

5. The phenomena and entities of human culture are *socially constituted* or *constructed,* have no "natures," . . . are only histories: that is, persons and selves, artworks, artifacts, texts, actions, institutions, societies, words and sentences and the like cannot be characterized as falling under "natural kinds" . . . having assignably fixed essences or [being explainable] by reference merely to . . . physical things. (*I*, 2–3, 7)

These doctrines may seem radical, but they find support from various quarters outside pragmatism. Kant already argued for intransparency and symbiosis, though insisting on the fixity and necessity of a certain conceptual scheme and of the noumenal world. Varieties of historicism and sociological theory (e.g., nonessentialist Marxisms and the theories of Pierre Bourdieu) provide support for doctrines three and five, while thesis four is central to the wide range of hermeneutic philosophies that have embraced the interpretive turn. More generally, the acute time consciousness that has grown from the birth of modernity to the breathless confusion of postmodern transformations has made us (and not merely us philosophers) particularly aware of change, flux, and the constructed, artifactual character of ourselves and what we often call natural.

Although the general worldview emerging from the conjunction of these pragmatist doctrines is, of course, more radical than its individual components, this vision is far from unfamiliar, particularly in poststructuralist thought. The question is whether it can successfully answer the dominant philosophical critique that in giving up ontologically fixed objects and unchanging essences one abandons the possibility of coherent discourse and thus of real knowledge.

The pragmatist defense of flux therefore concentrates not on adducing the presence of change but on combating the deeply entrenched philosophical view that at least some independent, invariant objects and essences are necessary to ground discourse and thus guarantee the possibility of truth and knowledge, which themselves depend on discourse.

Because this traditional view seeks foundations in an invariant, autonomous reality apart from human practices, let me call it invariant realism. Such realism can, of course, allow for change; otherwise it would be implausible. It merely insists that something (some form of foundational atoms, as it were) remains invariant. Such realism has always dominated philosophical thinking, and its abandonment has usually been taken to entail a vitiating skepticism. Both forms of pragmatism—the descriptive-metaphysics of Margolis and the reconstructive-genealogical approach I favor—challenge the argument that invariant realism deserves its dominance because it is conceptually necessary for the very possibility of coherent discourse and knowledge.

In challenging invariant realism, pragmatism deploys at least three central strategies. The first is shared by the descriptive and reconstructive approaches, while the two others are more closely linked to reconstruction. The shared strategy challenges invariant realism's claim that coherent discourse and knowledge are impossible without invariant objects to serve as the shared objects of discourse and truth. Invariant realism's argument is that without fixed objects to ground our referential discourse, there is no way to reidentify anything as the same thing, and thus there is no way of establishing reference that is stable enough to sustain discourse on a common object. But without the possibility of a common object of discourse, an object that can be reidentified (hence sustained) for more than one utterance, the very notions of discourse and shared knowledge are rendered impossible. The concluding step of this transcendental argument is that because coherent discourse and knowledge are indeed achieved, then it follows that there must be some invariant objects.

Margolis's central strategy in *Interpretation: Radical but Not Unruly* is to challenge this argument by showing how pragmatist philosophies of the flux can allow for reidentification of particular objects without presuming their fixity. There is no need, he argues, to prove that variance exists. Since change is surely evident and history seems open to further change, the burden of proof rests on those who insist invariance is necessary for coherent discourse.

Margolis's key maneuver is to show how we can individuate and reidentify an object as the same object without denying that that object has in fact changed radically and without appealing to a core of essential properties that always remain stable throughout all the changes of the object. His crucial tactic is to distinguish the referential fixity of an object—that is, the fixity necessary for establishing it as an object of discourse—from the substantive fixity of that which is thereby discursively identified or referred to. "The referential (grammatical) fixity of a text is a matter quite distinct from the substantive fixity of what may be thus fixed." Although "nothing could be referentially fixed that did not exhibit a certain

stability of nature," stability is different from complete invariance and the nature and range of the existent or needed stability can be left wide open (*I*, 34). Margolis makes a related distinction regarding the oneness that is traditionally required of an object. To speak of an object, all that is needed is grammatical unity or "unicity," not real substantive unity of that which is individuated and reidentified through such minimal unicity (*I*, 33). In this way, we can say of a particular object that it lacks substantive unity, yet we still can regard it as constituting a single object through its unicity.

Reconstructive pragmatism employs the same strategy of distinguishing between logico-referential issues and substantive ones. In arguing against the need "to posit a fixed independent meaning as the work's identity in order to guarantee identity of reference for its critical discussion," I write in *Pragmatist Aesthetics:*

> The key is to distinguish the logical issue of referential identification from the substantive issue of the nature, properties, or meaning of what has been identified. Certainly, however much we allow our interpretations of a work to differ, we must allow for the reidentification of the same work in order to talk about "the" work (and indeed "its" different reception) at all. The ordinary referential and predicative functions of discourse simply require this bare logico-grammatical identity of individuation. But such identity does not entail that what is identified on different occasions is completely or even substantially the same. For practical purpose of discourse, we can agree that we are talking about the same thing while differing radically as to what the substantive nature of that thing is, whether it's a bird, a plane, or indeed Superman.[2]

But how, one might persist, is this referential identity ever achieved and sustained, if it cannot rely on a fixed substantive identity? Margolis and I give the same answer. A culture's linguistic practices of individuation and identification can supply enough propositional and behavioral agreement to allow us to focus on or to frame a common (even if vaguely specified) object without committing us to the precise substantive content of that object. To quote again from *Pragmatist Aesthetics*, "Agreement about referential identity can be secured by agreeing on a certain minimum number of identifying descriptions, or it can be (and most often is) simple assumed by our deeply entrenched cultural habits of individuation" (*PA*, 94). As Margolis puts it, "What ensures the success of discourse . . . are the collective resources of a natural-language community's habits of life" (*I*, 75). In short, Margolis and I regard artworks, texts, and even human selves as cultural entities that are constituted and identified as the individuals they are by the social and linguistic practices of the cul-

ture they serve. Their identities thus can change as these practices change, but given the stability of our linguistic practices, such cultural artifacts can be "relatively stable" (*I*, 45; *PA*, 94).

III

What then is the difference between Margolis's descriptive-metaphysical pragmatism and the reconstructive-poetic pragmatism I favor? Part of the difference is the latter's advocacy of two other strategies for challenging the necessity of invariance. One of these reconstructive strategies is genealogical narrative that undermines the claim of invariance by explaining the historical motives that generate its power. The other strategy is the creation of new linguistic means, new vocabularies or ways of talking, which by the very fact of their variance yet coherence challenge the doctrine of invariance. These strategies can overlap a good bit, since the genealogical-reconstructive narratives often deploy new vocabularies and constitute new ways of talking.

There is also a further difference between Margolis's vision of philosophy of culture and my own. Margolis has a deep and abiding concern with ontologizing the cultural and linguistic practices that allow individuation and reference. He is intent on claiming that "some form of cultural realism would be required" to ground our linguistic practices and to give them a logical coherence or rigor (*I*, 25). He is preoccupied with providing a *metaphysics* of cultural objects, for determining the precise mode of being of the referents of cultural discourse. Although he opposes fixity in the identity of such objects, he is profoundly concerned with fixing their precise ontological status and with sharply distinguishing the status of these cultural referents from that of natural objects. Although he insists that cultural objects have no natural nature but only histories (i.e., they are not natural kinds), he gives them a metaphysical nature as "Intentional objects."

Cultural objects, he insists, are special entities that "differ from natural objects essentially in possessing Intentional properties"; and though as yet unrealized, his aim is "a full account of the ontology of artworks or cultural phenomena in general" (*I*, 46). The apparent motive for this concern for the metaphysics of cultural referents is that cultural discourse would be incoherent without the positing of entities to which such discourse refers and without an account of the metaphysical nature of such entities.

Reconstructive pragmatism, as I see it, is hardly interested in these metaphysical questions. It embraces the idea that our reality is plastic and contingent and largely structured by human discourse and action. But it sees no point in trying to ground cultural discourse in an elaborate metaphysics of cultural objects when the ground of those very cultural objects

is simply, by Margolis's own account, those same discursive cultural practices that metaphysics seeks to ground. If a culture's linguistic practices are, as Wittgenstein and Margolis argue, the bedrock for all justification and grounding, what need do we have to construct a metaphysics to render these practices coherent? For a pragmatist, the fact that they work coherently and effectively in practice should be proof enough of their legitimacy, especially when such legitimacy always remains, for the pragmatist, fallibilistic and open to revision. When a misunderstanding or malfunctioning of these practices creates conceptual confusion that blocks the path of inquiry, is it not enough for philosophy to carefully explicate or revise them in piecemeal fashion? How does elaborating a metaphysics of Intentional entities either improve or justify our linguistic practice, when language itself is invoked to explain the Intentional by being "its paradigm" (*I*, 52)?

To adapt an image of Wittgenstein, there is no need to elaborate clouds of metaphysics if their justificatory or explanatory function is already condensed effectively in drops of grammar. In other words, after adducing or explaining the linguistic means and consensual practices by which reference is secured, there is no further need of legitimation that impels us to plunge ourselves into metaphysical theories about the deep nature of the cultural objects referred to.

Such metaphysical analyses had much more point and legitimative function when reality was conceived in terms of fixed or necessary essences on which language depended and which it sought to mirror. For in that case, once we achieved an adequate metaphysical account of the real, it would always remain valid and effective as criterion for assessing ordinary understanding. However, once reality (at least in its human, cultural dimension) is grasped as historically contingent flux that is itself the symbiotic product of language, the value of elaborating a metaphysics becomes questionable; for then the metaphysical picture neither can ground our changing linguistic phenomena nor can predict or illuminate their changes. By being historicist, Margolis's metaphysics can at least accommodate linguistic and cultural change and is in this way far superior to nonhistoricist metaphysics of culture. But for radical pragmatism, the question remains: What useful explanatory or legitimative work does such a language-grounded metaphysical system perform that is not already gained by simply recognizing that language structures human thought and practices and that it changes over time through contingent developments and in variant ways?

One could, of course, defend the project of a systematic historicist metaphysics of culture by simply saying that philosophy traditionally demands a metaphysics of everything, so that even if metaphysics has lost its old role of grounding and legitimation, it must be pursued neverthe-

less as a central philosophical undertaking. For what would philosophy be without metaphysical systems? I appreciate the force of this argument and the traditionally central role of metaphysics in philosophy. However, if we recognize that philosophy itself is a cultural practice, and if we take the full measure of Margolis's insistence on cultural flux, then there is also reason to allow that philosophy itself can change and could already be changing in a direction that takes us further away from preoccupation with traditional metaphysical systems. Pragmatism, as I understand it, is urging us in this direction; and Margolis's extremely elastic, contingent, and historicized metaphysics can be seen as a progressive station on the way to this new age of philosophy, though with its face largely turned backward to the metaphysical concerns of the past.

There is yet another way to argue for the usefulness of elaborating a historicized, linguisticized metaphysics of culture *à la* Margolis. Our linguistic practices are extremely complex and confusing; hence their metaphysical import is obscure and requires a systematic metaphysics to provide a perspicuous representation of the reality and objects constituted by language. This purpose is perhaps the most persuasive argument for Margolis's project. But the question remains whether Margolis's metaphysical systematization—with its complex technical terms like "the Intentional" and its subtle distinctions of the "lingual" from the "linguistic"—is indeed more perspicuous than the linguistic practices it seeks to capture and more enlightening than the vivid images of flux and the plastic universe that they were invoked to explain. This raises the further question of the standard or variety of perspicuity that one seeks, and there is also the question of perspicuity for whom. Does Margolis's metaphysical systematization seek perspicuity for academic specialists in metaphysics or perspicuity for general intellectuals who want to understand their cultural world?

Reconstructive pragmatism also recognizes reasons for going beyond our actual concrete linguistic practices. These reasons are not concerned with the metaphysical grounding of actual practice but with its improvement. This reconstructive improvement is pursued by actively seeking change in our linguistic practices, not only by composing narratives to undermine the myth of fixity that would encourage a linguistic status quo, but also by proposing new vocabularies or new ways of talking about certain things that concretely show how coherent linguistic change is possible by actually effecting such change. These strategies of narration and of novel, performative characterization are why I portray reconstructive pragmatism as genealogical and poetic, in contrast to the descriptive-metaphysical pragmatism of Margolis. I now should explain how these reconstructive strategies are used to challenge the metaphysical doctrine of invariance.

IV

The pragmatist strategy of deploying genealogical narrative to undermine the philosophy of fixity is powerfully exemplified in John Dewey's critical account of philosophy's traditional "quest for certainty."[3] According to Dewey, primitive man's deep desire to "escape from peril" in an unmanageable "world of hazards" generated a religious attitude of appeasement and conformity to the transcendent powers assumed to control the humanly unmanageable flux of nature. This primitive religious disposition for fixity and certainty was the underlying inspiration for "philosophy's search for the immutable," a search that would eventually substitute absolute being and its fixed rational laws for the primitive gods and their capricious acts and verdicts (*QC*, 3, 21).

To appreciate the power of this strategy of genealogical narrative, we need a better look at the style and scope of Dewey's story. I therefore quote generously from his account of how "insecurity generates the quest for certainty" and fixity, thus creating a long philosophical prejudice of privileging the theory of the immutable over practices within the flux.

> Absence of arts of regulation diverted the search for security into irrelevant modes of practice, into rite and cult. . . . Gradually there was a differentiation of two realms, one higher, consisting of the powers which determine human destiny in all important affairs. With this religion was concerned. The other consisted of the prosaic matters in which man relied upon his own skill and his matter-of-fact insight. Philosophy inherited the idea of this division. . . . Because of the growth of mathematics, there arose also the ideal of a purely rational knowledge, intrinsically solid and worthy and the means by which intimations of rationality within changing phenomena could be comprehended within science. For the intellectual class the stay and consolation, the warrant of certainty, provided by religion was henceforth found in intellectual demonstration of the reality of the objects of an ideal realm. (*QC*, 203)

The Greeks, therefore, institutionalized a distinction between the certainty of theory and the flux of practice.

> Practical action . . . belongs in the realm of generation and decay, a realm inferior in value as in Being . . . Because ultimate Being or reality is fixed, permanent, admitting of no change or variation, it may be grasped by rational intuition and set forth in rational, that is, universal and necessary, demonstration. [Thus for the Greeks], the unalterably fixed and the absolutely certain are one . . . and [so]

the predisposition of philosophy toward the universal, invariant, and external was fixed. (*QC*, 16)

After the Greeks, the identification of certainty with immutability was reinforced and extended into ethical matters by Christianity. "The authority of ultimate Being was, moreover, represented on earth by the Church; that which in its nature transcended intellect was made known by a revelation of which the Church was the interpreter and guardian" (*QC*, 203–4). Dewey concludes that although the discoveries of modern science have undermined our belief in fixity with respect to practical and material matters, the habit of fixity and certainty still pervades our philosophical thinking and drives us to search for absolute values, immutable categories, unchanging entities, and eternal laws.

Through this compelling, tendentious narrative, Dewey discredits the philosophical prejudice for fixity by tracing it to emotions of insecurity, primitive religion, undeveloped science, and rigid Christian dogmatism. The view that knowledge and discourse require invariant objects is shown to rest not on logical compulsions but on compulsive primitive fears.

The same type of narrative strategy can, of course, be used to challenge other entrenched philosophical views. Dewey deploys it to undermine the privileging oppositions of theory/practice and ends/means, which, apart from their connection with the quest for certainty, are shown to stem from class hierarchies in ancient Greece and primitive conditions of labor there. In *Pragmatist Aesthetics* (chaps. 7, 8), I similarly employ reconstructive-genealogical narrative to challenge the rigid privileging dichotomy of high art versus popular art. By relating historically how today's high art was once viewed (and often condemned) as popular, I show that this distinction marks not permanent, essential aesthetic qualities but changing and alterable social conditions. By tracing the power and aura of high art to its conservative, undemocratic sources in court aristocracy and high church "otherworldliness," I try to discredit its claim to be the exclusive aesthetic vehicle of progressive social value.

Such genealogical narrative may challenge the purity and exclusivity of high art, but it does not suffice for aesthetic legitimation of the popular. Reconstructive pragmatism of culture therefore needs a third strategy for challenging invariance. This strategy can be called "poetic" because it involves linguistic innovation—either inventing new vocabularies or applying familiar vocabularies to things not formerly described in such terms. Rorty's pragmatism highlights such new vocabularies, while I have been more concerned with innovative redescriptions. Thus, in trying to give rap music greater cultural legitimation as art, I insisted on analyzing rap in terms of culturally valued aesthetic and philosophical ideas in which it had never properly been discussed. To speak of rap in such new yet cul-

turally valued ways can help promote a new aesthetic recognition of the genre, because the very concepts of aesthetics and philosophy provide a sense of value that can make us more inclined to see the worth of whatever is discussed in those terms. Moreover, such discourse can help effect revaluation because cultural and aesthetic value is not permanently, ontologically fixed, but rather the product of changing human practices informed by language. Of course, philosophical talk alone cannot provide popular art a full social legitimation. That would require also changes in the discourse and institutional practices of other, more socially powerful, groups than those who read and write philosophy.

The logic behind this third reconstructive challenge to invariance is simple. By actually effecting coherent linguistic change, by adding to the flux, this strategy shows how language varies yet maintains coherence through change. We must, moreover, emphasize that such linguistic change is not merely linguistic; it can amount to a substantive change in the lived cultural world. Take, for example, the fairly new linguistic terms of "sexual harassment" and "stalking." These terms are not simply faithful descriptions of previous, invariant forms of behavior that were always already immoral or criminal before these terms came into currency in the 1980s. Instead, such locutions reconstruct sexual relations to constitute new criminal acts. Earlier in the twentieth century and in the remote past, ardently persistent but unrequited lovers were not stalking sex offenders, even if they were decidedly annoying. Changes in sexual language, like the changes of "politically correct" discourse, have effected substantive cultural change, a change in actual social relations whose effects go well beyond language and even reach the most basic, nondiscursive sensual dimensions of our experience. In many places, the sexual ambience has been radically altered, as have the boundaries of what is sexual; thus not even the presumed permanence of sex escapes invariance.

V

Having described pragmatism's three strategies for challenging the necessity of invariance to ground our discourse and cultural world, I can summarize the difference between Margolis's descriptive-metaphysical pragmatism and the reconstructive-genealogical-poetic pragmatism I favor. Although Margolis concentrates on the first strategy—the ontology of culture—and on metaphysical representations of linguistic practice, reconstructive pragmatism goes beyond this logical solution. It offers the strategies of genealogical narratives and new ways of talking that not only expose the questionable motives and sources of invariance but also contribute to new, variant linguistic practices that can improve our culture.

Margolis is actually quite inventive when it comes to terminology, but he confines his new locutions to what he calls second-order philosophical

discourse, that is, to technical terms of art like "unicity," "Intentional," and "lingual." Margolis insists on marking a clear distinction between first-and second-order discourse and criticizes pragmatists such as Rorty and Stanley Fish for denying a role for deeper-level, second-order projects of theory to justify first-order discourse and practice. Reconstructive pragmatism, as I construe it, recognizes a functional distinction between these levels of discourse but sees that there is considerable seepage and flexibility between them. It moreover affirms that philosophy's reconstructive efforts with language should also be directed at first-order discourse and practice, not simply at deeper justificational levels of theory.

Reconstructive pragmatism is actively interventionist, aimed at effecting—not merely representing or metaphysically accommodating—cultural change. It wants more than a philosophical account of culture: it seeks substantive cultural improvement. Its first stage of argument, which it shares with Margolis, is this: If the world is partly the result of human linguistic practices, then it can in part be changed by changing those practices. Margolis seems satisfied with this important conclusion and devotes himself to showing how such change is compatible with the rigors of referential discourse and how it can be embodied in an ontology of historicized, variant, vague, but still identifiable cultural entities. But reconstructive pragmatism is not so easily satisfied and pursues its argument further: If our cultural world is altered by changing linguistic practices, why should not philosophy play a more active role in such change by advocating linguistic reforms, by advancing new ways of talking that would improve the concrete practices of our actual world and not merely the second-order philosophical practices of ontologically representing it?

There is a familiar objection to reconstructive pragmatism: In taking such an activist role, philosophy abandons its essential posture of disinterested neutrality and its defining role of interpreting rather than changing the world. But two important counterarguments can be offered. First, much of classic philosophy (e.g., Plato's theory of art or Locke's theory of government) is far from disinterested and devoid of reformatory agendas. Second, if we grant the general premise of culture's flux, then philosophy, like any cultural product, is variant and open to change. So even if it once displayed Olympian neutrality, it need not maintain that posture. The crucial question for the responsible pragmatist is, finally, one of long-term cost-accounting: whether the gains of philosophical activism outweigh the advantages of presumed philosophical neutrality. I think they do, partly because of my skepticism of putative philosophical neutrality, but also because the stakes of our cultural struggles are too important to remain neutral about them.

Although I have contrasted the descriptive-metaphysical and recon-

structive-genealogical as rival forms of pragmatism, I would like to think that they are not logically incompatible and can perhaps complement each other. But life is short and so, practically speaking, one is impelled to choose between possible projects. For the reasons already delineated, I prefer reconstruction through genealogical narrative and revaluative redescription.

VI

Margolis attacks my Deweyan position for having "fallen too far under Rorty's spell" and "its illogic."[4] The charge is understandable yet surprising and misleading; understandable because Rorty has strongly influenced my work in pragmatism; surprising and misleading because so much of that work has been devoted to arguing against him. Margolis is not the only one to critique my views by wrongly conflating them with Rorty's, so I shall conclude this chapter by very briefly summarizing the issues where my pragmatism differs most significantly from his and by referring the reader to texts that more adequately elaborate the arguments that motivate these differences.

My position is sometimes identified with Rorty's because we both articulate a Deweyan version of pragmatism that emphasizes the aesthetic dimension. But before considering our differences in aesthetics, let me note some important differences in the other two general areas into which Germans traditionally divide the philosophical field: theoretical philosophy (epistemology and metaphysics) and practical philosophy (ethics and political theory). First, though I respect the importance of interpretation in our cognitive life, I reject Rorty's hermeneutic universalism that regards all understanding as interpretation. In texts like "Beneath Interpretation" (*PA*, chap. 5), I argue for a pragmatic, functional difference between interpretation and the unreflective understandings that underlie and guide our interpretation but that are nonetheless corrigible through interpretation. This distinction between understanding and interpretation, which is endorsed by ordinary usage, provides interpretation with a contrast-class that helps give interpretation a clearer meaning and a grounding background of material from which to work.

Second, I reject the global textualism advocated by Rorty, because it suggests that the world we experience is thoroughly linguistic, that there is no meaningful experience outside of language, and that our selves are but a collection of vocabularies and propositional attitudes. Though language may provide the most pervasive matrix of our lives and thought, there is an important nonpropositional, nondiscursive dimension of experience that, I argue, is important for philosophy to recognize and that can be discerned and cultivated by more attention to somatic experience (*PP*, chap. 6; *PL*, chaps. 7, 8).

Rorty radically rejects the whole concept of experience as philosophically useless and dangerous because it has often misled us into the epistemological "myth of the given," the idea of experiences that are so immediately present that they could not be false and thus can serve as indisputable foundations in justifying knowledge claims. In contrast, by exploring the uses of experience outside the framework of foundational justifications, I argue that philosophy can productively deploy this concept without falling into the myth of the given. The early pragmatists James and Dewey made the concept of experience central to their theories, and I have tried to rehabilitate it, especially with respect to the aesthetic dimension of experience (*PP*, chap. 6; *PL*, chap. 1).

A fourth difference pertains to metaphysics. I have argued that Rorty exaggerates the pragmatist idea of contingency, giving it a sense of idiosyncratic arbitrariness or random accident rather than simply the sense of not being logically or ontologically necessary (*PP*, 75–77). By failing to distinguish between contingencies that are capricious or haphazard and those that are so deeply socially routinized and practically entrenched that they are indispensable ("contingent necessities," so to speak), Rorty is led to take an overly cavalier attitude toward social realities and the social sciences. Following the literary critic Harold Bloom, he describes such sciences as "dismal" (*AC*, 127).

Combining his global textualism and hermeneutics with his notion of contingency, Rorty suggests that philosophy's highest task is personal salvation through linguistic invention. If our world and selves are contingent and linguistic, we can then reshape them to our tastes by virtuoso linguistic reinterpretation. He therefore prefers the inventive literary musings of Jacques Derrida and Harold Bloom to the social analyses of Michel Foucault, and he cherishes "the hope for a religion of literature" (rather than a new social philosophy) to improve our world (*AC*, 136).

Despite this advocacy of literary study over empirical social science, Rorty's political philosophy draws a very sharp distinction between what he calls "real politics" and what he denigrates as "cultural politics." In contrast, I claim there are very substantial continuities and overlaps between these political arenas (because of the political, social, and economic power of cultural imagery and production, but also for other reasons) and that politics—cultural or otherwise—cannot disdain the methods and data of social science. Like many others, I criticize Rorty's rigid way of dividing the public from the private. Though we can sometimes clearly distinguish between public matters and private ones, the distinction requires more contextual flexibility than Rorty allows, and it cannot simply be reduced to a distinction between agreed institutional norms of neutral formal procedures and private values relating to personal visions of the good life (*PP*, 67–87, 122–23).

Rorty, moreover, fails to appreciate how deeply our public social institutions shape what he calls our private visions of perfection. His own ethical ideal of the liberal ironist in constant search for new vocabularies is an obvious echo of the consumer's quest for new commodities, and both are obviously shaped by our public framework of neoliberal capitalism. Likewise, Rorty's definition of autonomy as original, distinctly individualist self-creation seems a clear echo of neoliberal self-seeking. It is a standard so ambitiously voluntaristic, demanding, and elitist that we must question whether many people could really live that way and whether we should morally expect (or even want) them to (*PA*, 255–57). Rorty's championing of neoliberalism, with his emphasis on negative liberty and his one-sided celebration of free-market capitalism and self-centered private values, is a reversal of the socialist ideals that inspired Dewey's pragmatism. It encourages international suspicion of pragmatism as a sinister ideological tool for globalized American domination.

In the cultural field of aesthetics, I have argued against Rorty's Bloomian advocacy of interpretation as "strong misreading." When Rorty asserts that the good critic "simply beats the text into a shape which will serve his own purpose,"[5] I counter that such a policy is destructive of the sense of otherness that makes reading a dialogical hermeneutic project from which we can learn something new. How, one wonders, can Rorty combine his domineering attitude toward texts with his fervent advocacy of the "inspirational value of great works of literature" (*AC*, 125)? His strategy of bullying the text to fit one's purpose is, however, clearly connected to his one-sided demand for novelty of interpretation in our reading of literature, including the literature of philosophy, politics, and science.

But we also need to recognize the valuable role of more common or traditional understandings of texts, which, I argue, can serve as a needed background or basis for the more novel interpretations. Though I appreciate the uses of new interpretations through strong misreadings, I reject their exclusive claim to value in literary experience. I likewise reject Rorty's one-sided identification of the aesthetic life with singular genius and originality—not because I have something against original genius but because this unwisely excludes other rewarding modes of aesthetic life that are less demanding and more accessible (*TSE*, 209–12; *PA*, chaps. 4, 9).

Rorty narrowly sees the value of literary art as the making of new texts and vocabularies to enhance our moral reflection. He neglects the aesthetics of pleasure and beauty and thus reduces art to the poetics of moral tool-making. Aesthetics, I argue, should urge the values of pleasure along with the functions of meliorism (cognitive, ethical, and social) and should emphasize that the former are deeply related to the latter. While Rorty ignores the popular arts as fundamentally unworthy, I insist that they can combine pleasure with social, ethical, and cognitive utility. Indeed, be-

cause they are understood by more people, they can be more effective in sensitizing our society to moral and political injustice. Popular art seems to have a clear pragmatic advantage over high art in making real improvements to the ethical quality of our world. Consider how *Uncle Tom's Cabin* dwarfs Henry James's *Portrait of a Lady* with respect to ethical and political impact. My broader view of aesthetics also explores somatic dimensions of aesthetic experience that Rorty, through his exclusive textualism, is forced to ignore (*PA*, chaps. 7–10).

I conclude by addressing the tricky issue of functionalism in pragmatist aesthetics. Ever since Kant's notion of "purposefulness without purpose," the aesthetic has typically been defined by its disinterestedness or lack of function—an appreciation of objects, images, and experiences for their own sake or intrinsic value rather than for their instrumentality. Must pragmatism's close connection to notions of purpose therefore confine its aesthetics to a narrow functionalism that threatens to be incompatible with aesthetic experience? Here we need to be clearer about what is meant by "aesthetic functionalism." If it means that works of art should be understood, appreciated, and used only for their ethical and social values in order to (as Rorty says) "help us become autonomous" or "become less cruel,"[6] then I am decidedly not a functionalist like Rorty, for whom literature seems almost reduced to a branch of practical ethics. Instead, my pragmatist approach (like Dewey's) stresses aesthetic experience, and it celebrates that experience more because of its immediately felt rewards of pleasure, intensified and meaningfully enriched awareness, and heightened vitality than because of any specific practical purpose outside that experience for which it serves as a means (*PA*, chaps. 1, 2; *PL*, chap. 1).

Although I regard aesthetic experience primarily as a consummatory value rather than simply as a means for other ends, this does not mean that practical (including moral) functions of artworks are irrelevant to their value—and even to their value in aesthetic experience. This is because a sense of the functional aims or import of the work (and of its already-achieved practical effects) can contribute significantly to the work's meaning and thus enrich its aesthetic experience. Conversely, the power of its aesthetic experience can strengthen an artwork's practical efficacy, so that the consummatory and functional values of art tend to be less contradictory than reciprocally reinforcing. Hence, in affirming art's practical uses, pragmatist aesthetics is not confined to a narrow functionalism. Pragmatism can appreciate cultural objects "for their own sake" (that is, for their experienced qualities and meanings) while also appreciating their instrumental uses, just as we can simultaneously relish a work for its cognitive and hedonic effects.

If functionalism is defined much more broadly as the view that the

value of an artwork does not exist in itself in some transcendental realm of absolute or ideal worth but rather depends on its capacity to function in enriching human experience, then my pragmatist aesthetics is indeed functionalist. For I cannot make much sense of aesthetic value that lies altogether outside of human experience (past, present, and future).[7]

12.

Cultural Analysis and the
Limits of Philosophy
The Case of Bourdieu

I

As the products of art are shaped not only by the artist but also by the cultural field in which she creates, so the views of a thinker are essentially structured by the particular social field in which she thinks. This is true even for such putatively abstract, transcendental, and universal domains as philosophy; and it is just as true for the iconoclast who opposes that field (and thus logically depends on it) as for the traditionalist who endorses it (often without recognizing it as such). No one has pressed these points more strongly than Pierre Bourdieu, France's renowned cultural theorist, whose writing is rich in critical engagement with the work of philosophers past and present.

In recent books like *Practical Reason* and *Pascalian Meditations*, Bourdieu develops an extended critique of philosophical intellectualism, which, he argues, has also contaminated the social sciences.[1] However, in elaborating his "critique of scholarly reason" or of the philosopher's "scholastic point of view" (a term he derives from J. L. Austin), Bourdieu paradoxically turns for support to philosophers, and still more strikingly to analytic philosophers. Conversely, his theories of language and culture, by turning toward empirical social science, critically push philosophy beyond its traditional limits and toward a deeper recognition of the sociocultural conditions that shape it and the resultant deformations of thought that these conditions engender. Bourdieu has defined his whole "project [as] a kind of *negative philosophy*," one which tries "to push the critique (in the Kantian sense) of scholarly reason," as far as possible to unearth its deepest unreflective presuppositions (*MP*, 9, 15; *PM*, 1, 7).

Some would deny Bourdieu the status of philosopher. The denial seems true or false according to whether it is made in terms of the narrowest institutional definition of philosophy or instead in terms of a broadly substantive view of the discipline. If being a philosopher means

maintaining an official position as philosophy professor in an academic institution and confining one's methods and horizons of inquiry to the traditional academic methods and limits of philosophy, then Bourdieu (who held the chair of sociology at the Collège de France) could be refused the rank of philosopher—along with the likes of Nietzsche and Marx. But if being a philosopher means being adequately trained in that discipline and working out interesting theories on central philosophical issues while engaging philosophers in debate and commanding their attention, then Bourdieu is certainly a philosopher.[2]

Bourdieu's adoption of the methods of empirical social science does not entail a renunciation of the best traditional forms of philosophical analysis and argument. It is rather a recognition of their limits and the consequent need to supplement them with other methods of inquiry. Even disregarding Bourdieu's systematic theories (articulated through such rich concepts as habitus, field, *illusio*, and symbolic capital), one could still claim he is a critical metaphilosopher. Affirming Pascal's view that philosophy must be self-critical ("the true philosophy pokes fun [*se moque*] at philosophy," *MP*, 10; *PM*, 2), Bourdieu offers a critique of the limits of philosophical reason by examining the historical and social conditions, professional strategies, and disciplinary stakes and constraints that structure philosophical thinking. His sympathetic study of the logic of practice challenges the universal claims of philosophical intellectualism, while studies like *Homo Academicus* expose the hidden interests, structures, strategies, and social constraints that govern the space in which academic philosophy is practiced.[3]

Bourdieu's metaphilosophical project of showing philosophy's limits is also advanced by his practice of going outside the conventional borders of the discipline (as if to view it from the outside) through the methods of sociology and anthropology. In contrast to other models of philosophical criticism that are either confined to the solitary introspective subject of self-critique or to a dialogical set of subjects questioning each other through a web of intersubjective consciousness, Bourdieu's model of philosophical critique makes its "reflexivity . . . as a collective enterprise" go still deeper (*MP*, 12; *PM*, 4). His materialist methodology explores the unarticulated, typically unconscious social conditions and bodily habits that lie beneath explicit consciousness and implicitly structure both subjectivity and intersubjectivity. Bourdieu thus insists that the social nature of a cultural field, and hence the full meaning of its cultural products, must be grasped in terms of the concrete social details (particular stakes, positions, interests, and powers) that structure that field rather than by a vague appeal to general notions of "the social" as typically found in philosophy's abstract concepts of tradition and practice.

If we grant these points, it would seem that a fully adequate account of

Bourdieu's cultural theory requires a very complex social analysis involving a number of interacting, overlapping, and contesting (as well as contested) cultural fields: not only French philosophy and social thought but also Anglo-American philosophy and non-French continental theory. This chapter does not attempt this full-blown analysis, and not merely because space is lacking. I instead appeal to the pragmatic point that the notion of adequacy (like that of exactness or precision) has no absolute standard but depends on the purposes of the occasion

My first purpose here is to show how Bourdieu uses Anglo-American philosophy and takes it a logical, much needed step further toward some of its most central goals. But I also want to show the limits of Bourdieu's program of cultural analysis by critically examining his rejection of philosophy's role as revisionary theory and philosophy's respect for lived experience, particularly aesthetic experience.

II

Bourdieu makes a special point of highlighting his debt to analytic philosophy of language and action, most particularly to Austin and Wittgenstein. He invokes them in the most salient places and with terms of highest praise. From Austin, "who is no doubt one of the philosophers I most admire," Bourdieu outspokenly takes the very titles of two important articles, "Fieldwork in Philosophy" and "The Scholastic Point of View." Wittgenstein, he likewise affirms, "is no doubt the philosopher who has helped me most in moments of difficulty."[4]

These confessions are initially puzzling for two reasons. First, if a theorist's thought is essentially formed by the intellectual field in which he is situated, one would expect that Austin and Wittgenstein would be much less influential than other philosophers who were far more central to the French field of Bourdieu's intellectual production (such as Heidegger, Sartre, Husserl, or Merleau-Ponty). Second, Austin and Wittgenstein actually receive much less discussion in Bourdieu's corpus than most of these other theorists. On the back-cover blurb of the French edition of his *Raisons pratiques* (1994), only analytic philosophers are thought worthy of specific mention ("he puts to the test the analyses of Strawson, Austin, Wittgenstein, Kripke"). Yet these philosophers do not form the philosophical core of the book (and Strawson, for example, is hardly visible at all, not even appearing in the index).[5]

This paradox can be partly explained by distinguishing between oppositional and affirmative usefulness and by recognizing that if one's goal is the intellectual distinction of one's work by its specific originality (hence contrast with other work in the field), then one is more likely to discuss authors and views one opposes than those one accepts. Moreover, given the same goal of distinction (which is always defined in terms of a given

social field), it seems more profitable to positively highlight (e.g., by praise or confessions of debt) authors that lie outside one's immediate field than authors within it who are thus closer, more dangerous rivals. Outside the dominating center of the French philosophical field, but itself constituting the dominating center of the Anglo-American field, analytic philosophy was an excellent source for importing ideas that could help Bourdieu challenge the dominant structure of the French cultural field and thus give his own work greater power.

One of the prime motives in importing foreign ideas is precisely to undermine the dominating authority of the home field.[6] In the field of French philosophy, Bourdieu's particular professional trajectory would tend to marginalize him. By going beyond philosophy and adopting the *métier* of a sociologist, he deprived himself of the institutional identification/authorization as a professional, or "real," philosopher. To the extent that philosophy remains dominant in the larger French intellectual field, this dominance could have a very pervasive limiting effect on Bourdieu's impact if his work were excluded from the field of philosophy.

What better way to frustrate the possible marginalization of his philosophical theories by the French philosophical field than to outflank that field by enlisting the symbolic power of the rival philosophical field of analytic philosophy? The scientific, empirical reputation of analytic philosophy makes this strategy of affiliation even more appealing.[7] Identification with analytic philosophy not only serves to endorse Bourdieu's empirical approach as part of the tradition of "rigorous philosophy" (as does his frequent invocation of the French philosophers of science Gaston Bachelard and Georges Canguilhem), but it also provides him a way of damning by contrast the institutionally dominant French philosophy as unscientific "babble" or "sanctified stupidity" (*CD*, 14–15; *IOW*, 4–5).

If the outflanking strategy of rigorous, empirical scientific philosophy makes analytic philosophy a powerful symbolic weapon to cite and brandish, why should Bourdieu specifically focus on Austin and Wittgenstein? After all, they were ultimately the champions of ordinary language rather than scientific discourse and were often criticized by the more scientistic voices of the analytic community for accepting (and hence promoting) a consequent vagueness? Why did Bourdieu not turn instead to Bertrand Russell, Rudolf Carnap, or W. V. O. Quine, who offer more hard-core examples of scientific philosophy?

Bourdieu's choice here reveals his deep affinity with Austin and Wittgenstein—not so much as exemplars of scientific empiricism in philosophy (at least in the standard English sense of the term) but as social philosophers and theorists of practice. As philosophers of language, Austin and Wittgenstein are exemplary in analytic philosophy for insisting on the essential, constitutive role of social context and history, by ar-

guing that language (hence all thought of which language is the medium) is essentially social. Its meaning and import derive not from autonomous referents or facts in the extrasocial world, but rather from the complex and context-dependent social practices and conventions that help constitute the lived world and that vary with social and historical context.

Opposing the analytic approach of Russell and Moore, which focused on the individual proposition, both Austin and Wittgenstein claim that the meaning of an utterance depends not so much on the words said but on the specific *context* in which they are said. This context is obviously structured and enabled by social conditions, not the least of which is the socially learned practice of speaking a language. As Austin argues, if linguistic utterances are not mere products of reference or intention but are essentially constituted "by convention" (i.e., by social norms of proper performance that vary with social context), then "what we have to study is not the sentence but the issuing of an utterance in a speech situation."[8]

Austin's original doctrine of performatives was meant to show that certain utterances (such as promises, marriage vows, christenings) are more appropriately thought of as social action than as linguistic statement, more as *doing something* than as *saying something*. In such highly ritualized acts of symbolic expression, what counts is not so much the words but the background institutions, conventions, social roles, and given context in which the words' bare verbal meaning plays only a negligible part. We could, for example, imagine such acts successfully performed simply by gestures, without words at all. If Austin's later, more general theory of speech acts challenges the performative/constative distinction, it is only to highlight the fact that all speech is a form of social action, since all illocutionary acts are partly constituted by convention.

The later Wittgenstein also grounds language in social practice, "not agreement in opinions but in form of life." Such forms of life are "what has to be accepted, the given"; thus "conventions" constitute a philosophical "rock bottom."[9] Not merely claiming (like Austin) that linguistic meaning is more a matter of social context than of words, Wittgenstein further underlines a crucial historical dimension to the notion of changing social context, and he applies this idea to the domain of aesthetics in which Bourdieu has keen interest.[10]

For a better philosophical understanding of the meaning of an aesthetic judgment, Wittgenstein insists, we should be "concentrating, not on the words 'good' or 'beautiful,' which are entirely uncharacteristic, . . . but on the occasions on which they are said—on the enormously complicated situation in which the expression has a place, in which the expression itself has a negligible place." Aesthetic judgments and predicates "play a very complicated role, but a very definite role in what we call a culture of a period. To describe their use or to describe what you mean by a cultured

taste, you have to describe a culture." Moreover, such descriptions must be sensitive to historical change, since "an entirely different game is played in different ages."[11] One could hardly find a better philosophical endorsement for Bourdieu's analysis of legitimate aesthetic taste through a full-scale study of the entire cultural field, as well as for his projects of exposing "the historical genesis of the pure aesthetic" and "the literary field."

Such empirical projects show that Bourdieu does not simply follow Austin and Wittgenstein but goes beyond them. Though their analytic project aims to clarify the meaning of language by seeing it in terms of the social forms and contexts in which language is used, Austin and Wittgenstein never really provide a systematic, ramified analysis of the actual social forces, positions, stakes, roles, and strategies that shape the social field and thus structure the contexts of language. "The total speech act in the total speech situation," says Austin, is what linguistic philosophy needs to elucidate in examining questions of meaning.[12] Since this total act and situation are structured by enduring social factors, such factors should be elucidated in a rigorous, perspicuous, and reasonably systematic way.

Wittgenstein and Austin were perceptive masters of the social space governing language, yet neither ever proceeded to theorize this social space in any detail by articulating its network of factors so as to provide a general conceptual framework—or a well-ordered toolbox of social categories and principles—to elucidate the situations that give language its meaning. Instead, Austin and Wittgenstein give only piecemeal social analyses of certain philosophically centered issues. Despite their insights and rigor, their work remains too fragmented and impressionistic to provide a systematic methodology or general model for analyzing the total speech situation and the consequent meaning of linguistic practice.

Bourdieu offers such a model by going more deeply into the social. He thus realizes one line of analytic philosophy better than the analysts, who may have feared (perhaps justly and unconsciously) that the social status of philosophy would itself be threatened by its sociological realization. If it cannot be naivete, then could it perhaps be denial that explains Austin's limits in probing the social? How, indeed, should we take this distinguished Oxford professor's strategic identification of himself (and his elite readers and disciples) with "the ordinary man" and in opposition to what he calls "the scholastic view" of philosophers? To what extent did Austin critically (reflexively) consider the scholastic nature and the social space of his own practice of painstaking analysis of ordinary language? After apologizing for wrongly blaming Austin for the faults of his formalist epigoni, Bourdieu praises him for having gone "as far as he could" in the direction of social fieldwork (*CD*, 40; *IOW*, 29). Is Bourdieu simply

praising Austin's achievement of his limited aims, or in his qualification is he also implicitly critiquing the limits of philosophy?

Wittgenstein is another example of how philosophy can recognize the social grounds and natural conditions of life that shape language but then counter this recognition with a will to keep philosophy essentially independent of the claims of empirical science by confining philosophical inquiry to the grammatical, conceptual level. "Our interest does not fall back upon these causes of the formation of concepts; we are not doing natural science; nor yet natural history—since we can also invent fictitious natural history for our purposes" (*PI*, II, 230). For certain philosophical purposes, this may be sufficient, but as Wittgenstein himself elsewhere saw, *not* for the purposes of explicating the full significance of judgments in aesthetics, ethics, and other cultural domains. Recent analytic philosophers (such as John Searle) continue to affirm the constitutive importance of the social *background*—not only for linguistic meaning and action but for consciousness itself. But they tend to leave its study too complacently in the background, while Bourdieu actually brings it to the foreground through a deeper systematic analysis that allows its theoretical importance to be understood and thus deployed more effectively.

Let me add a word of personal testimony. It is because Bourdieu develops the central line of inquiry in Austin's and Wittgenstein's philosophy of language that I initially found his work attractive and accessible. Having devoted my studies at St. John's College, Oxford, to these analytic philosophers (working with the Wittgenstein specialist P. M. S. Hacker and writing my dissertation under Austin's disciple, editor, and literary coexecutor J. O. Urmson), I began to appreciate just how deeply social structures and practical interests of action shape even the most seemingly abstract of philosophical notions (e.g., meaning, truth, and validity). Yet I felt that philosophers, even Austin and Wittgenstein, never really explored this social and practical dimension in a sufficiently systematic manner. I therefore turned to Bourdieu and to the pragmatist philosophy of John Dewey, whose appreciation of the philosophical import of social science (an appreciation far greater than Austin's and Wittgenstein's) not only enriched his thought but led to the establishment of a fruitful tradition of pragmatist social science that thrived, particularly in Chicago (through the collaborative impact of G. H. Mead), but also elsewhere.

III

Dewey insists that all meaning (hence all thought) is social, contextual, and ultimately grounded in practices that we embodied creatures develop. We develop these practices in order to cope with our social and natural environment (by both adjustment to it and transformation of it) and in order to advance our purposes. These, in turn, are shaped by that envi-

ronment, itself a changing and changeable product of history. Dewey also explains how these social practices that constitute practical sense are incorporated and maintained through habits that work on a prereflective, nonlinguistic level. Although these habits are largely product of social custom, Dewey insists they can still be nonmechanical, intelligent, and even creative without being reflective, and that they can be changed through changing conditions.[13]

Dewey thus anticipates Bourdieu's critique of intellectualism, identifying "intellectualism" as "the great vice of philosophy" and defining the error of taking the eventual products of intellectual analysis for the antecedent givens of experience as "*the* philosophic fallacy."[14] In recognizing that a philosopher's thought is shaped by society, Dewey also emphasizes the theorist's duty to study the ills of society through empirical means in order to find the instrumentalities to remedy those ills. Possessed by a powerfully democratic impulse, Dewey played a very active political role to promote democratic goals. He also urged the formation of interdisciplinary networks of social scientists and journalists to promote the kind of continuous and informed public opinion that is necessary for democracy, free from the systematic distortions of information deriving from the control and exploitation of our news media for pecuniary gain.[15] Bourdieu has taken up these themes in an admirable activism for reform of the news media and for the dissemination of social knowledge through his own public-interest publishing initiatives.[16]

Dewey's approach is not only social but genealogical. The first part of his *Ethics* is thus devoted to a study of the *Sitten* and structures of earlier societies that shape our own. Dewey not only argues that philosophy's problems are primarily the intellectual response to problems in social life, but he tries to show concretely how some of philosophy's most basic concepts and distinctions derive from social formations and interests. He traces the nature of the theory/practice and end/means distinctions to hierarchies in Greek social life, and shows how our elitist "museum concept of art" is not an ontological conceptual necessity but simply the unhappy product of social, political, and economic forces that isolate art from the popular life of the community so as to afford the partakers of art a particular distinction.[17]

Bourdieu admits that his affinities to Deweyan pragmatism are "quite striking,"[18] and his theories could help forge a stronger pragmatism by providing a more precise, sophisticated, and empirically tested system of concepts for the analysis of society's structures and its mechanisms of reproduction and change. One brief example should suffice. Though Dewey is right to insist that our concept of art is largely shaped by historical and socioeconomic factors, Bourdieu's work (with its more fine-grained analysis of class, class fragments, and economic and cultural capital) makes

clear that the relations between wealth and social class and between economic and cultural capital are far more complex than Dewey accounts for.[19] Moreover, Bourdieu's Nietzschean way of emphasizing the deeply intractable social conflict over power and prestige provides a helpful balance to Dewey's seemingly excessive faith that all conflict can somehow be reconciled in an organic social whole.

So far, I have argued that Bourdieu advances the central projects of both analytic and pragmatist philosophy by articulating in a more systematic and empirically richer way the basic structures constituting "the social" that for Austin, Wittgenstein, and Dewey are constitutive of language, thought, and action. Does this mean that philosophy itself must probe more deeply into the (changing) social background that constitutes all discourse, including its own? And does this further mean that philosophers must become sociologists like Bourdieu?

Philosophy, one could argue, involves so many different problems at so many different levels that such radical conclusions need not be drawn. But the very fact that such disturbing conclusions even arise to challenge the philosopher's self-image must surely account for some of the philosophical resistance to Bourdieu. In any case, it seems reasonable that philosophies that explicitly affirm the crucial role of "the social" should themselves take the actual study of society far more seriously; and Bourdieu's amalgam of theory with concrete, comprehensive, empirical research provides an excellent, enviable example. I often wish that philosophers like myself had the research resources (including those of legitimizing professional definition) to undertake such an extensive program of fieldwork.

IV

My close philosophical affinities to Bourdieu do not preclude some strong disagreements. Rather than simply rehashing them here,[20] I shall illustrate them in a more oblique manner by explaining his clear preference for Austin and Wittgenstein over Dewey. The preference is puzzling because Dewey's richer analyses of habit, history, society, and politics should have made him the most congenial and useful for Bourdieu's projects.[21] Though Bourdieu's preference for Austin and Wittgenstein could be understood in terms of the greater institutional power and symbolic capital of analytic philosophy over pragmatism (not just in the English-speaking philosophical world but also in France), I think there are also more substantive reasons.

Before exploring these reasons, however, let me first note another likely motive for Bordieu's admiration of Austin and Wittgenstein over other *analytic* philosophers. Beyond their appreciation of the social, the practical,

the contextual, and the historical, these philosophers show a keen appreciation of *the ordinary*—as expressed in their careful, devoted attention to ordinary language. While recognizing that ordinary language can be misleading when driven beyond its practical context by philosophers pursuing their own theoretical purposes, Wittgenstein and Austin do not think it needs to be replaced by a more logical, rationally reconstructed language. The job of philosophy is to analyze and give a perspicuous overview of our ordinary concepts; and it may for that purpose invent its own technical terms (like "illocutionary act" or "language-game"). But it should not (*pace* Carnap and other constructivists) try to replace or transform our ordinary practical concepts by artificial, rationally reconstructed ones that meet the standards of scientific, theoretical discourse. To do so would be to lose the effective common forms of speaking and acting on which successful theoretical activity, as well as ordinary life practices, ultimately rely.

Bourdieu shares this appreciation of the ordinary. It is evident in his critique of what he calls (paraphrasing Austin) "the scholastic point of view" and in his masterful advocacy for an elementary but socially inculcated "practical sense" having its own effective logic that can neither be adequately represented or replaced by theoretical reconstruction. This recognition of the ordinary is a point of *theory*, but it also expresses (at least for Wittgenstein and Bourdieu) a strong and noble democratic purpose. Paradoxically, however, a complete respect for ordinary language helps to preserve the status quo of the social forces which shape it, and these can be far from democratic or productive. (The contrast between Wittgenstein's democratic ideals and the conservative, elite scholasticism that his philosophy generated at Oxbridge's "High Tables" caused him bitter frustration.)

Austin and Wittgenstein share not only a respect for the ordinary but also a commitment to the traditional notion of disinterested objectivity—philosophy should just portray correctly or clarify things rather than change them. Such commitments suggest a form of quietism in Austin's and Wittgenstein's view of philosophy. In exposing the fallacies arising from misuse of language, philosophical analysis, says Austin, simply "leaves us, in a sense, just where we began." Though shrewdly admitting that ordinary language is not "the last word" and can "in principle" be "improved upon and superseded," he insists that we "remember it is the first word," whose endless and ever regenerating complexities must first be adequately clarified before venturing any improvements.[22] The practical upshot of such prioritizing is the constant deferral of philosophy's attempts at linguistic revision, which, given the reciprocal links between "the linguistic" and "the social," can promote social revision as well.

Although Wittgenstein affirmed the personal transformative power of philosophy as a way of life,[23] his rejection of philosophy as linguistic or conceptual reform is even more explicit than Austin's. "Philosophy may in no way interfere with the actual use of language; it can in the end only describe it. . . . It leaves everything as it is" (*PI*, para. 124).

Dewey is surely as much a philosopher of ordinary practice as Austin and Wittgenstein; and surely a greater champion of democracy. More sensitive to the needs of ordinary people and to the class relations that structure "the social" of language, he realizes that ordinary language is often a tool through which ordinary people are subjected and oppressed by the social masters of discourse, who may themselves become ensnared and hindered by linguistic modes that have outlived their use in the flux of social change. Dewey was therefore not a fetishist of ordinary language and practice but a pragmatic meliorist about them: He argued that ordinary concepts should be revised, replaced, or abandoned when they systematically hinder inquiry, limit freedom, or diminish potentialities of satisfaction. The philosopher, like the poet and scientist, can offer conceptual revisions, which can be tried and tested in the complex, contested, and changing fields of discourse. More than the poet (though less than the scientist), the philosopher is constrained by "the facts," which, however, are themselves largely shaped by our concepts. For Dewey, conceptual revisions (in science as well as in philosophy) are based not merely on facts but on perceived *needs*.

Often Dewey's sense of need too greatly exceeds his sense of fact. His attempt to remedy the oppressive, impoverishing distortions of the aesthetic field by means of a revisionary global definition of art as experience is (as I argue in *Pragmatist Aesthetics* and *Performing Live*) as quixotic as it is helpful. Nonetheless, he is right that philosophy can play a useful revisionary role and that philosophers should not confine themselves to accepting ordinary usage and the ordinary positive facts it expresses. Of course, theoretical persuasion cannot replace reform of material conditions, for which Dewey also tirelessly worked. However, through the reciprocal constitution of language and practice, new ways of talking can influence attitudes and action and thus can help bring about more substantive, material reform. To suppose that theoretical interventions can in no way promote or guide such reform is, for pragmatism, to accept an implausible, pernicious dichotomy between theory and practice.

Although sharing Dewey's democratic drive and vigorous political concern for ordinary people and their problems,[24] Bourdieu displays a politics of theory that seems much closer to Austin's and Wittgenstein's. In fact, he explicitly rebukes as false "magic" some Deweyan challenges to certain confused, oppressive categories in the "ordinary language" of cultural discourse. It is not our categories that need fixing, complains Bour-

dieu, but the material and institutional "conditions" that generate them and the suffering with which they are associated.[25] But why does Bourdieu not recognize the pragmatist strategy of working simultaneously on both fronts, for discursive as well as more material and institutional change? Can we not combine revisionary theory and practical reform, as the double-barreled Deweyan pragmatist policy recommends?

Rather than turn these questions into mere rhetorical critique, let me try to suggest the best reasons for Bourdieu to reject pragmatism's theoretical activism, reasons that even a pragmatist like myself can appreciate and that express the pragmatic character of Bourdieu's own thinking.[26] These reasons have nothing to do with naive objectivism about pure fact. No one knows better than Bourdieu the interested social powers that shape the facts of language and science.

One plausible pragmatist argument against theoretical revisionism is that linguistic change fosters excessive confusion, which in turn threatens our solid sense of reality—our sense of the facts on which substantive material reforms must rely for their data, direction, and instruments. Revisionist theoretical tinkering thus does not enable but disables real practical reform. Bourdieu could further argue that because the socially disempowered seem more vulnerable and less equipped to respond to new changes, the uncertainty and confusion that arise from challenging oppressive categories could end up being far more difficult for them than for entrenched elites, who are better equipped to appropriate the ideological revisions for their own undemocratic purposes. In this way, the elites of communist regimes often have been able to preserve their privilege when their countries turned to capitalism. Bourdieu may be suggesting this kind of argument when he condemns the "radical chic" of self-serving elite intellectuals. The fact that such arguments against conceptual and cultural revision are urged by pragmatic conservatives like T. S. Eliot does not preclude their use for Bourdieu's more progressive social aims.[27]

The force of these arguments, however, seems limited. Very radical and global change may dangerously upset social and cognitive stability, but modest and site-specific conceptual revision need not do this, especially given the degree of conservatism already built into our habitual social selves. Experiments of change are essential to the pragmatist notion of progress, although the dangers of such experiments need to be carefully assessed and minimized so that change may be balanced with stability. Only experimentation can teach us how to do this.

Bourdieu may have another good reason for refusing revisionary theory and insisting that one's aim, qua theorist, is simply to reveal the facts (however ugly and painful) rather than to try to change them. Adopting this position (the traditional hallmark of scientific objectivity) allows Bourdieu to assume all the symbolic power of the natural science tradition

and its conventionally hallowed (though increasingly questioned) objectivist ideology of disinterested description of the naked truth. Still wielding enormous power in the intellectual field (even on philosophy itself), the natural science tradition of objectivism seems to have the most influence in politics. By assimilating this symbolic power and so enhancing his own, Bourdieu can give his views greater authority in the political sphere and thereby improve his efficacy as an agent for sociopolitical reform. Conversely, since Bourdieu's professional status belongs to social science (which lacks the symbolic capital of natural science, largely through doubts about its objectivity), to flirt with revisionary theory could be fatal. Adopting revisionary theory might risk discrediting the objectivity of his work, the veracity of his empirical research, the entire credibility of his views, and thus their power to support his projects of social reform.

The philosopher, in contrast, occupies a different place in our intellectual tradition and cultural imagination because she draws her symbolic power from somewhat different sources than the scientist. Though acquiring the academic title of philosopher only through an educational system committed to the ideology of objectivism and rigorous science, the symbolic power of the name "philosopher" derives from a tradition older and broader than modern science. The philosopher's legendary social role is not simply the describer of facts; it is just as much the revisionary prophet, utopian myth-maker, and transcendental sage; all these figures of philosophy defy, to some extent, the absolute authority of ordinary facts and conventions, even when advocating something humble and down-to-earth like "the simple life."

The strength of this tradition runs very deep in our social unconscious. (How else could society not only tolerate but celebrate so much philosophy that sounds like nonsense!) This visionary tradition gives symbolic power to the philosopher as revisionist that the social scientist cannot claim. Indeed, given philosophy's shrinking authority to speak for empirical science, revisionary theory may be where the philosopher can wield the most effective symbolic power, and she can wield it without resorting to an extremist revisionism that has no respect at all for empirical findings. If revisionary theory is still worth attempting, then the philosopher has a useful task beyond and against the limits of Bourdieu's project, even though performance of this task can profit from Bourdieu's social analyses and sense of fact.

V

The roots of revisionary theory are often nourished from the power of transformative experiences that can surprise and captivate both body and soul with a vivid new vision. The value of experience marks another major difference between classical pragmatism and Bourdieu. Though un-

derlining the pervasive role of nonreflective behavior and nonverbal un-
derstanding, Bourdieu tends to reduce the meaning of such nondiscursive
dimensions of experience to their exemplification (and reinforcement) of
the reigning social relations, institutionally entrenched habits, and discur-
sive structures as explained by social theory.[28] No sympathetic attention is
given to the phenomenological dimension of lived experience, its power
of meaningful, qualitative immediacy, and its potential for the transfor-
mation of attitudes and habits. Bourdieu is understandably wary of ap-
peals to lived experience, since these have been used to justify projects
that highlight individual subjectivity as the foundational building blocks
of theory. In contrast, Bourdieu, a thoroughly social thinker, rightly re-
gards our individual experience, like our individual selves, as largely the
product of social construction.

Yet even if experience is always somehow socially shaped, it also lives
vividly and productively in personal (and in shared) consciousness. I
therefore follow the pragmatism of James and Dewey in affirming lived
experience as a helpful notion for appreciating varieties of meaning,
knowledge, value, and action, while Bourdieu essentially rejects this no-
tion of experience by construing it in a very narrow way: as private sub-
jectivism, self-centered narcissism, and intellectualized phenomenological
consciousness. Understood in this way, the concept of experience seems to
neglect those crucial determinants of behavior and thought that are mate-
rial, social, and beneath reflective consciousness.

However, there is no need to construe experience so narrowly, since the
concept surely includes cases of interaction that are more than personal
and less than explicitly reflective. Experience, as Dewey insists, can be sig-
nificantly shared and can be intelligent without being thematized by ra-
tional consciousness. Bourdieu perhaps construes experience so individu-
alistically and reflectively because of the emphasis on individualized
consciousness advanced by the existentialist and phenomenological phi-
losophy that dominated French thought in the mid-twentieth century and
against which Bourdieu, like Foucault, had to struggle. This is not the
place for an extensive study of the concept of experience and its history,
uses, and abuses.[29] Instead, let me concentrate on Bourdieu's case against
aesthetic experience as a useful tool for appreciating art and for understand-
ing its cultural power. I think his critique is excessive, because it suffers
from a confused and one-sided subjectivist-formalist conception of such
experience.

Like the ancient Greek dogma that sharply opposed experience (*em-
peiria*) to true knowledge (*episteme*), Bourdieu's analysis systematically
sets aesthetic "experience against knowledge." Discrediting the cognitive
worth of aesthetic experience by satirically portraying it as a religious
"mystical union" with God ("like Aquinas's *cognitio Dei experimentalis*"),

Bourdieu claims that aesthetic experience "rejects as unworthy the intellectual love of art, the knowledge which identifies experience of the work with an intellectual operation of deciphering."[30] Aesthetic experience is also blamed as the source of essentialism, "the subjective experience of the work of art" necessarily precluding "attention to the historicity of the experience" and thus erecting (by the "universalization of the particular case") "a particular experience . . . as a transhistoric norm for all artistic perception" (*RA*, 286).

Condemning aesthetic experience for denying "the historical and social conditions of possibility of this experience," Bourdieu claims that it therefore blocks effective inquiry into "questions of meaning and value of the work of art. . . . [These] can only find solutions in a social history of the [artistic] field, linked to a sociology of the conditions of the constitution of the particular disposition which the field calls for." This socially produced disposition, he continues, is "the aesthetic disposition"; it is characterized by "the pure gaze" that disregards interest or function but "attends solely to the properties of form" and relishes in the enriched consciousness of immediate experience (*RA*, 286, 290, 299, 301). This account of the social production of the aesthetic attitude is meant to refute the common claim of the vivid immediacy of aesthetic experience. "The experience of the work of art as being immediately endowed with meaning and value" is, Bourdieu claims, an essentialist illusion that ironically is generated by the mediating institution of the formalist aesthetic disposition, "which is the product of historical invention."[31] In other words, aesthetic immediacy is deconstructed as the product of the reciprocally reinforcing influences of art's institutional field and inculcated habits of formal contemplation that are urged as appropriate to art's objects.

Against this formalist aesthetic attitude and experience, Bourdieu advocates what he calls "the science of works of art," a comprehensive study whose aim of understanding is "to reconstruct the generative formula at the source of the work," a task of sociohistorical research that involves "the whole history of the [artistic] field of production that has produced the producers, the consumers, and the products" (*RA*, 296, 302). Bourdieu thus rejects aesthetic experience as too immediate, formalistic, and anti-intellectual to serve this ramified research project. The only legitimate understanding of art is a scientific one of the sociohistorical genesis of production and reception. "To understand is to grasp a necessity, a *raison d'être*, by reconstructing, in the particular case of a particular author, a generative formula whose knowledge allows one to reproduce in another mode the very production of the work, to feel necessity accomplish itself, even outside any empathetic experience." Bourdieu takes special pains to emphasize that "the labor needed to reconstruct the generative formula . . . has nothing to do with [the] sort of direct and immediate identi-

fication" with the work often attributed to the lived quality of aesthetic experience, whose sense of the "living reading" of texts Bourdieu lampoons as "hermeneutic narcissism" (*RA*, 302–3).

Much as I appreciate Bourdieu's struggle against subjectivism and religiously romantic theories of art, there are many things wrong with his line of argument in rejecting aesthetic experience. First, the fact that aesthetic experience is sometimes described in religious and anti-intellectual terms in no way demonstrates that this experience is typically mystical and exclusive of intellectual content and interest. On the contrary, such experience often thrives on intellectual material, as the powerful aesthetic experiences of intellectual works of high modernism (or even of mathematical proofs) clearly show. There is nothing in aesthetic experience per se to preclude historical and social inquiries about the conditions (of artist and audience) that generate such experience. Instead, aesthetic experience often provides the impulse to such inquiries because the intriguing power of this experience spurs us to learn more of its object and causes. This aesthetic interest (and not the pure scientific interest of discovering generative formulae) is what creates art history and the sociology of art. Moreover, what is learned from such sociohistorical inquiry can in turn be incorporated into future aesthetic experience of the work.

Finally, though Bourdieu is right that rich aesthetic experience ultimately involves *more* than phenomenological immediacy, the value of its lived immediacy is not thereby precluded. Likewise, the fact that such aesthetic experience requires cultural mediation does not entail that its content (through prior cultural funding that is incorporated into our current perceptual skills) cannot be experienced, understood, and relished as immediate. Though it took a long time for English to become a language and for me to learn it, I can still experience many of its poetic meanings with vivid immediacy. Thus, though condemning aesthetic experience as a tool of false essentialism, Bourdieu falsely essentializes aesthetic experience and what he calls "*the* aesthetic disposition" [emphasis added] as if these notions designated only one thing—an ahistorical, contentless formalism of "the pure gaze." But there are varieties of aesthetic experience and aesthetic attitude that simply do not fit his model. Notions of aesthetic experience that instead embrace context, content, interest, and function have been common in theories of art from Aristotle through to the pragmatist aesthetics of today.

Bourdieu also wrongly essentializes the nature of artistic understanding by affirming that there is only one legitimate way of understanding art—"a science of works" that explains the sociohistorical genesis of each artwork and its reception as "a necessity." Let me put aside the question of whether science can really be said to uncover specific generative necessities rather than general probabilities. (I think the view that science deliv-

ers necessary laws that dictate specific necessary outcomes smacks of the same old theological bias that Bourdieu mocks in attacking the mystical notions of union in aesthetic experience.) Whatever our views on science, Bourdieu is wrong to identify the genetic explanation of the artwork and its reception as the only legitimate form of understanding art. It is, rather, only one important form of aesthetic understanding. Structural explanation of the artwork's elements and their integrative workings is another. As Wittgenstein emphasized, there are many different kinds of understanding and explanation in aesthetics and elsewhere. Understanding and explanation in aesthetics can sometimes simply take the form of knowing how to go on in terms of further description of the work and our reaction to it or in terms of being able to perform the work, classify it, or otherwise respond to it properly.

Wittgenstein was highly critical of the view that all aesthetic explanation (and especially "the most important" area of "aesthetic reactions") could be reduced to a science of "causal explanation" based on "statistics of how people react." He scorned "the idea that psychology is one day going to explain all our aesthetic judgements," calling it a "very funny" and "exceedingly stupid" idea.[32] Bourdieu's sociological analysis of art is neither funny nor stupid; it is extremely enlightening. But it risks the power of its insight by wrongly presuming to be the sole valid form of explanation. Very often, when we want to know why we find a figure top-heavy or a poem coarse, the kind of answer we desire is not about the social determinants of our taste (or of the author's), but rather something about some features of the figure or poem that account for or illuminate, to our satisfaction, our aesthetic reactions of top-heaviness or coarseness. The right answer here is the "one which clicks."[33]

One of Bourdieu's principal objections to the concept of experience is its link to the traditional privilege accorded to intellectual self-consciousness. Reliance on such introspection, he cogently argues, will not penetrate to the deeper, unconscious, socially structured strata of the self that help shape individual consciousness. Impersonal sociological analysis can help expose the hidden limits of one's thought by revealing its formative social factors. Much of Bourdieu's work is devoted to critiquing the limits of intellectualism. "I have never really felt justified in existing as an intellectual," he confesses, "and I have always tried . . . to exorcise everything in my thinking that might be linked to that status, such as philosophical intellectualism. I do not like the intellectual in myself, and what may sound like anti-intellectualism in my writings is especially directed at what remains, despite all my efforts, of intellectualism or intellectuality in me, such as the difficulty I have, so typical of intellectuals, of truly accepting that my freedom has its limits" (*MP*, 16; *PM*, 7).

Refusing aesthetic experience to advocate a science of artworks as the

sole legitimate form of aesthetic understanding, Bourdieu betrays how the intellectualist bacillus still infects his work in aesthetics. This is particularly ironic (yet equally understandable), because aesthetics has often been exceptionally friendly to anti-intellectualism and has suffered from gushy emotionalism and the refusal of strenuous thought and empirical inquiry. We can commend Bourdieu's drive for scientific explanation of the deep social determinants of aesthetic experience. But this drive should not obscure appreciation of art's aesthetic surface, nor deny the value of formalist explanations of surface that are far from superficial.

13.

Art as Dramatization

I

"Dramatise, dramatise!" was the insistent cry that haunted Henry James's artistic genius.[1] The celebrated novelist knew himself a failure in the theater: His plays were almost all rejected for production, and one of the only two produced was roundly booed on the London stage. Yet James realized, with brave honesty, that the basic principle of drama nonetheless held the key to artistic greatness. Distinguishing nicely between the terms "Theatre-stuff" and "Drama-stuff"—between concrete stage performance and what he called the deeper "divine principle of the Scenario" (equally realizable in novels, films, and television)—James turned that essential dramatic principle more consciously to work in composing the later works of fiction that crown his great career. "The scenic method," he writes, "is my absolute, my imperative, my *only* salvation." That salvation is evident in his posthumous dramatic success, in the frequent adaptations of his fiction into television dramas, films, and even into two operas by Benjamin Britten (*Owen Wingrave* and *The Turn of the Screw*).[2]

James's view of the drama's superiority could have rested on ancient philosophical authority; but it was also not uncommon in his own time, and after. Friedrich Nietzsche, for example, just a year younger than James, was quick to affirm Richard Wagner's recognition that "the greatest influence of all the arts could be exercised through the theatre").[3] Some generations later, James's native countryman and fellow Anglophile, T. S. Eliot, would reaffirm the supremacy of drama as "the ideal medium for poetry." Combining the power of meaningful action with the beauty of musical order, poetic drama could capture two exquisitely precious and different kinds of aesthetic value not easily synthesized in a single form. And through its theatrical performance, Eliot further argued, drama enabled the poet to reach "as large and as miscellaneous an audience as possible."[4] Eliot therefore made his own sustained efforts to write for the theater, where, however, he enjoyed only little more initial success than did James. (The Broadway hit *Cats*, though based on Eliot's light verse, is a

posthumous dramatization of poetry that he in fact never intended for theater, let alone musical theater.)

Considered from the point of view of practicing artists (rather than that of philosophers), drama's preeminence derives not only from its presumed ability to reach more people and move them more powerfully and completely than other arts (something that may be truer today for cinema than for theater). There is also (dare I say it as an American) the charm that a successful theater play could bring in the quickest—if not always, ultimately, the greatest—income to its author. We know from private correspondence that money was certainly one motive for James's interest in writing for the theater. But the presence of this motive in no way falsifies the sincerity of his adulation of drama, which he praised as "the noblest" of arts, long before he ever seriously thought of a career in playwriting. James thought drama was noblest because it was the most challenging—combining the gravest formal demands of "masterly structure" with the highest requirement of significance of "subject."[5]

In this chapter, I aim to go beyond these more familiar assertions of drama's preeminent influence and nobility in order to suggest that the concept of drama embodies and unites two of the deepest, most important conditions of art and may therefore hold the key to a useful definition of art as a whole.

But what *is* a useful definition of art? We may never entirely agree on what this is, but we should at least realize that it can be something very different from what is typically conceived and sought as a formally valid and true definition of art. Such a true (or "real") definition of art is usually construed either in terms of a set of essential properties that jointly belong to all artworks—and only to them—or in terms of a set of conditions that are necessary and sufficient for something to be an artwork.[6] Advocates of such definition affirm that its purpose is simply "to tell us what is the extension of 'art.' It implies no more."[7] In short, the definition aims to cover or demarcate all and only those entities that are artworks, not to illuminate what is (aesthetically or artistically) important about them or about art.

It remains controversial whether we could ever provide such a definition that not only will accurately and decisively delineate the current extension of art but that will continue to hold for all future artworks. Recurrent dissatisfaction with the definitions offered, together with a recognition of art's volatile, contested history and irrepressible impulse to challenge defining limits in reaching for radically new forms, have raised doubts as to whether it is possible to formulate such a true or real definition that will be satisfactory for all times. Some aestheticians have therefore limited their definitional project to proposing procedures for identifying artworks and thus determining art's extension in that more modest

way. Others, who remain committed to the project of real or true defini-
tion, ingeniously conjure up complex defining formulae that try to be flex-
ible, general, vague, and multi-optional enough (e.g., by positing a dis-
junctive set of overarching functions, procedures, or historical relations of
artworks and art practices) to cover all possible artworks of the future.

But whether such "wrapper" definitions ever prove successful in per-
fect and permanent coverage of art's extension is not, for me, the key issue
in defining art. I am more concerned with whether a definition of art is
useful in improving our understanding and experience of art by illumi-
nating what is important in art, by explaining how art achieves its effect,
or by taking a stand in the controversial struggles over art's meaning,
value, and future.

A definition can be useful for aesthetics without being true in the for-
mal sense of accurately delimiting the current extension of art. For in-
stance, an honorific definition of art that is confined to meritorious works
would be obviously false to the accepted extension of the concept of art
and would be logically problematic in apparently precluding the notion of
bad art. But, if it were accurate in picking out what is good art (or what is
good in good art), then such a faulty definition would be far more useful
for aesthetic purposes than truer definitions of art that succeed better in
the aim of faithful coverage by equally covering art that is bad or indiffer-
ent. From my pragmatist perspective, it is usually more important for def-
initions and beliefs in aesthetics to be useful than to be formally true
(though the two may sometimes coincide). For that reason, in *Pragmatist
Aesthetics,* though I criticize Dewey's definition of art as experience for
being a hopelessly inaccurate definition of art, I also argue that his defini-
tion is aesthetically more useful than another pragmatist option of defini-
tion that seems eminently more accurate and valid in the sense of concep-
tual coverage—art as a historically defined and socially entrenched
practice.[8]

If, for pragmatism, the value of a definition is in its contribution to our
understanding and experience of art, then there are several forms this
service can take. Definitions can be useful for recommending evaluative
standards for art. Thus Morris Weitz famously argues that though real
definitions of art are impossible or wrongheaded, "honorific definitions"
of art could nonetheless be valuable as "recommendations to concentrate
on certain criteria of excellence in art."[9] I would argue that nonhonorific
definitions can also be useful, and not only for supplying the "criteria of
evaluation" that Weitz stresses. Such definitions can serve to emphasize
certain features of art that may not be receiving enough attention and
whose neglect may result in an impoverishing of aesthetic experience and
understanding. Definitions may also help us bring together various as-
pects of art into a more perspicuous constellation by combining features

or reconciling orientations that otherwise seem uncomfortably uncon-
nected or even in conflict.

So if the value of a definition of art depends on its capacity to improve
our understanding and appreciation of art, what use could there be in
defining art as dramatization? It would be wonderful if this definition
could capture and highlight some enduringly important and distinctive
feature of art. But I shall begin more modestly by arguing that this defini-
tion is, at least, useful in integrating and thus reconciling the two most po-
tent general orientations that dominate and polarize contemporary aes-
thetics. We can call them naturalism and historicism.[10]

II

Naturalism defines art as something that is deeply rooted in human na-
ture and therefore finds expression, in one form or another, in virtually
every culture. This view, which is at least as old as Aristotle, sees art as
arising from natural human needs and drives: a natural inclination toward
mimesis; a natural desire for balance, form, or meaningful expression; and
a thirst for a kind of enhanced, aesthetic experience that gives the live crea-
ture not only pleasure but a more vivid, heightened sense of living.[11] Art,
naturalism argues, is not only deeply grounded in natural forces, energies,
and rhythms, but is also an important tool for the survival and perfection
of human nature; hence, for many proponents of aesthetic naturalism, the
highest art, the most compelling drama, is the art of living.[12] Even when
art is significantly shaped by the societies, cultures, and specialized frame-
works in which it is situated, the naturalists insist that art—at its best,
truest, and most potent—expresses the fullness and power of life.

This line of aesthetic naturalism made its mark in German philosophy
through Friedrich Nietzsche. In his early study of drama's origins in an-
cient Greece, Nietzsche argues that art was born of natural roots, an ex-
pression of "overflowing life" or "lively action" arising from "the inner-
most ground of man," "even from the very depths of Nature" and
deriving its power "from an overflowing health" or "fullness of Being."[13]
The heightened experience of aesthetic ecstasy, which Nietzsche traces
from early Greek tragedy back to the religious frenzy of Dionysian cult, is
championed as "the highest, namely Dionysian expression of Nature." In
contrast, he condemns "the culture of Opera" and its "stilo rappresenta-
tivo" as "something so completely unnatural" (*DG*, 63, 121; *BT*, 57,
113–14). Emerging from the deepest wells of Nature, true art celebrates
through its "aesthetic delight" the principle of "eternal life beyond all ap-
pearance and despite all destruction." For Nietzsche, then, "art is not sim-
ply an imitation of nature, but its metaphysical supplement," a "justifica-
tion of the world as an aesthetic phenomenon" (*DG*, 108, 152; *BT*, 101–2,
142–43).

John Dewey's pragmatist aesthetics plies a similar doctrine of naturalism: "art—the mode of activity charged with meaning capable of immediately enjoyed possession—is the culmination of nature," while " 'science' [itself an art of sorts] is properly a handmaiden that conducts natural events to this happy issue."[14] Dewey's *Art as Experience* begins with a chapter entitled "The Live Creature," and the book is largely aimed at "recovering the continuity of aesthetic experience with normal processes of living" (*AE*, 16). Aesthetic understanding, Dewey urges, must never forget that the roots of art and beauty lie in the "basic vital functions," "the biological commonplaces" man shares with "bird and beast" (*AE*, 19–20). Even in our most sophisticated fine arts that seem most removed from nature, "the organic substratum remains as the quickening and deep foundation," the sustaining source of the emotional energies of art whose true aim "is to serve the whole creature in his unified vitality." Dewey concludes: "Underneath the rhythm of every art and of every work of art, there lies the basic pattern of relations of the live creature to his environment"; so that "naturalism in the broadest and deepest sense of nature is a necessity of all great art" (*AE*, 155–56).

The impassioned aesthetic naturalisms of both Nietzsche and Dewey share a common but insufficiently acknowledged source in Ralph Waldo Emerson, the transcendentalist prophet who ardently (and everywhere) preached the gospel of nature in all its manifold forms, uses, and resplendent spirituality. Art is just one example. "Art" as Emerson defines it "is nature passed through the alembic of man."[15] Rather than art serving merely for art's own sake, its aim is to advance nature by enhancing the life of its human expression; thus "art should exhilarate" by engaging one's "whole energy" and serving fully "the functions of life." "There is higher work for Art than the arts," Emerson concludes. "Nothing less than the creation of man and nature is its end" (*RWE*, 192–94).

Praising nature for providing our experience and language with beauteous forms and useful symbols, Emerson anticipates Dewey's argument that art also takes its very forms and symbols from our natural environment: for example, the pointed style of Gothic architecture emulates the forest's towering trees. Emerson likewise prefigures the celebration of the intense sublimity of aesthetic experience that both Dewey and Nietzsche later emphasize as the highest achievement of culture, peak experiences that are more profoundly transformative and creatively insightful than any discursive truth of science. "The poet gives us the eminent experiences only—a god stepping from peak to peak." "Poetry," Emerson continues (in a phrase that Nietzsche made more famous) "is the *gai science* . . . and the poet a truer logician," one "who unlocks our chains and admits us to a new scene" (*RWE*, 443, 455–56).

The aesthetic naturalism of these philosophers is more than romantic

sentimentalism. Contemporary science lends it significant support. Evolutionary researchers now recognize that, by and large, the things that naturally give us pleasure are good for the survival and propagation of our genes, since we have survived and evolved not by conscious planning but by making the choices toward which natural pleasures have unreflectively drawn us. The intense pleasures of sex, for example, impel us toward procreation, even if it is not in the individual's rational best interest to take the risks involved in such dangerously close encounters. Art's beauties and pleasures, it can be argued, have evolutionary value not only for sharpening our perception, manual skill, and sense of structure, but also for creating meaningful images that help bind separate individuals into an organic community through their shared appreciation of symbolic forms.

Finally, art's pleasures—by their very pleasure—have evolutionary value in that they make life seem worth living, which is the best guarantee that we will do our best to survive. The long survival of art itself, its passionate pursuit despite poverty and oppression, and its pervasively powerful transcultural presence can all be explained by such naturalistic roots. For, as Emerson, Nietzsche, Dewey, and other life-affirming aestheticians have realized, there is something in the vividness and intensity of art's aesthetic experience that heightens our natural vitality by responding to deeply embedded human needs.

The quickening, transformative power of aesthetic experience that the naturalists stress as the energizing core of art need not be confined to wholly positive experiences of unity and pleasure, as my quotes from Emerson, Nietzsche, and Dewey might suggest. Naturalism extends beyond happy affirmations of organic wholeness, since nature not only unifies but disturbs and divides. Fragmentation and vivid encounters with disagreeable resistance can also stimulate an invigorating, life-enhancing aesthetic experience, as theorists of the sublime have long recognized. If contemporary art's most intense experiences often belong to this disruptive yet vitally exciting kind, then an updated naturalism can accommodate such an aesthetics of resistance, one that sees art's value in its ability to disturb and oppose social conventions through its experiential power of defiance, even if that oppositional power also partly relies on social conventions.

In critical contrast to aesthetic naturalism, historicism defines the concept of art more narrowly as a particular historical cultural institution produced by the Western project of modernity. Partisans of this view construe earlier and non-European artistic forms not as art proper but as objects of craft, ritual, or tradition that at best are precursors or imperfect analogues of autonomous art. The historicists stress the point that our current concepts of fine art and aesthetic experience did not really begin to take definite shape until the eighteenth century[16] and that they only achieved their

present "autonomous" form through social developments of the nine-teenth century that established the modern institution of fine art and that culminated in the turn of the century notion of "art for art's sake." In the words of the French sociologist Pierre Bourdieu, probably the most rigor-ous and systematic of recent aesthetic historicists, it is not at all in nature that "the foundation of the aesthetic attitude and of the work of art . . . is truly located [but rather] . . . in the *history* of the artistic institution" which creates the very *"social conditions of possibility"* for art and aesthetic experi-ence. Thus, "although appearing to be a gift from nature, the eye of the twentieth-century art lover is really a product of history."[17]

Twentieth-century art, the historicist argument continues, has taken this autonomy and turned art into its own preeminent purpose and its own prime subject matter. Just as art is held to be the product of its socio-historical differentiation from real-world contexts, so art's meaning and value are seen as constituted simply by the social, institutional setting which distinguishes art from the rest of life. It is, of course, the sociohis-torical institutional setting which makes a readymade object into a work of art and distinguishes it from its ordinary nonartistic counterpart. Mu-seums, galleries, and other art institutions do not, therefore, simply dis-play art, they help create the social space without which art cannot even be properly constituted as such.

Bourdieu is joined by the analytic philosophers Arthur Danto and George Dickie in stressing this point. These and like-minded historicists therefore conclude that it is only through the historically changing social framework of the artworld that an object becomes an artwork; its status as such, therefore, depends not at all on beauty, satisfying form, or pleasur-able aesthetic experience, which contemporary art has shown to be inessen-tial, if not altogether dépassé. Some historicists moreover insist that even the seemingly wider notions of aesthetic object and aesthetic enjoyment (with-out the further, more distinctive claim of *artistic* status) are likewise deter-mined by the historical institution of art, because that institution is held to have determined the general form that any aesthetic appreciation should take by having defined the very meaning of the aesthetic.

How, then, should we choose between naturalism and historicism? It seems folly to simply choose one of these polarized views, since each has severe limitations.[18] If the naturalistic view does not sufficiently account for the social institutions and historical conventions that structure art's practice and govern its reception, the sociohistorical view cannot ade-quately explain the ends for which art practices and institutions were de-veloped, what human goods they are meant to serve, and why non-West-ern, nonmodern cultures also pursue what seem to be artistic endeavors. To define art simply as the product of modernity puts in question the deep historical continuities that constitute the tradition of Western art from

Greek and Roman times through medieval and Renaissance art into the modern period, where art is said to originate.

Another reason why we should not simply choose between aesthetic naturalism and historicist conventionalism, or between lived experience and social institutions, is that these notions are as much interdependent as they are opposed. Our very notion of a natural language, which is nonetheless constituted by social conventions and history, shows the folly of the natural/sociohistorical dichotomy. Natural life without history is meaningless, just as history without life is impossible.

But if it seems foolish to choose between viewing art as natural and viewing it as nonnatural (since sociohistorical), a troubling tension remains between the two approaches. On the one hand, naturalism sees art's most valuable essence in the vivid intensity of its lived experience of beauty and meaning, in how it directly affects and stimulates by engaging themes that appeal most deeply to our human nature and interests. On the other hand, there is the historicist insistence that art's crucially defining feature has nothing at all to do with the vital nature of its experience, but rather resides in the historically constructed social framework that constitutes an object as art by presenting it as such and institutionally determining how it should be treated or experienced. On one side, we see the demand for experiential intensity and meaningful substance; on the other, the requirement of a social frame without which no artistic substance, hence no experience of art, seems possible.

III

I want now to suggest that the idea of art as dramatization provides a way of reconciling the residual sense of conflict between these poles of aesthetic naturalism and sociohistorical contextualism by combining both these moments within its single concept. In contemporary English and German, there are two main meanings for the verb "to dramatize" or "dramatisieren" that parallel the two moments of experiential intensity and social frame. In its more technical meaning, to dramatize means to "put something on stage," to take some event or story and put it in the frame of a theatrical performance or the form of a play or scenario. This sense of "dramatize" highlights the fact that art is the putting of something into a frame, a particular context or stage that sets the work apart from the ordinary stream of life and thus marks it as art. Art is the staging or framing of scenes. The familiar French synonym for this sense of dramatize is *mise en scène*, a convenient term which Nietzsche himself used in *Ecce Homo* to praise the artistic genius of the Parisians: "Nowhere else does there exist such a passion in questions of form, this seriousness in *mise en scène*—it is the Parisian seriousness *par excellence*."[19]

Besides the idea of staging and framing, "dramatize" also has another main meaning that suggests intensity. To "dramatise," says the *Chambers 21st Century Dictionary*, is "to treat something as, or make it seem, more exciting or important."[20] The *Duden Fremdwörterbuch* makes the same point for German: "dramatisieren" means "etwas lebhafter, aufregender darstellen." In this sense of art's dramatization, art distinguishes itself from ordinary reality not by its fictional frame of action but by its greater vividness of experience and action, through which art is opposed not to the concept of *life* but rather to that which is lifeless and humdrum. Etymologically, our concept of drama derives from the Greek word "drama" (δρᾶμα) whose primary meaning is a real deed or action rather than a formal framing or staged performance. This suggests that drama's power derives, partly at least, not from the framing stage but from the stirring energy of intense action itself; for action is not only a necessity of life but a feature that invigorates it. But how can we make sense of any action without grasping it through its framing context or situation?

I shall return to explore this intimate connection of action and place, but let me first underline the point already made: that dramatization effectively captures both moments—active intensity and structural frame—that the naturalist and contextualist theories respectively and contestingly advocate in defining art. The idea of art as dramatization may therefore serve as a handy formula for fullness, synthesis, and reconciliation of this longstanding and, I think, futile aesthetic debate.

To ensure that we are not building too much philosophy on the meaning of the single word "dramatization," let us turn to the synonym that many in Germany prefer to use: "Inszenierung," a term which clearly echoes the French term "mise en scène." Both terms, of course, derive from the Latin "scaena" (the stage or scene of the theater) which derives from the Greek "skene" (σκηνή), whose primary meanings were not initially theatrical but rather generic designations of place: a covered place, a tent, a dwelling place, a temple. The concept of *mise en scène* or *Inszenierung*, with its direct invocation of scene as stage or place, seems to emphasize art's moment of frame rather than intensity of action or experience.

But we should not conclude that it therefore ignores this other moment that we found in the concept of drama. First, mise en scène implies that something significant is being framed or put in place; the scene of mise en scène is not a blandly neutral space but the site where something important is happening. Even the very word "scene" has come to connote this sense of intensity. In colloquial speech, the "scene" denotes *not* just any random location, but, as one says in English, "where the action is." It denotes the focus of the most exciting things that are happening, for example, in the cultural life or night life of a city. To make a scene, in colloquial speech, is not simply to do something in a particular place but to display or

provoke an excessive display of emotion or active disturbance. In short, just as the action of drama implies the frame of place, so the place of scene implies something vivid, vital, and exciting that is framed. For similar reasons, the English word "situation" (in locutions like "We have a situation here") is now often used colloquially to suggest the heightened intensity of a disturbing problem (argument, accident, emergency, breakdown, etc.).

This reciprocity of heightened experience and specially significant place, we need to emphasize, is not a mere superficial linguistic coincidence of English and German. The notion of scene as the locus of the most intense experience goes back to the deepest ancient sources. Tellingly used by Euripides to denote a temple, the word *skene* (along with its derivative *skenoma*) also served as the ancient Greek term for the holy tabernacle of the Old Testament where God's presence was said to dwell. In the original Hebrew, the word for tabernacle is מִשְׁכָּן, which is derived from the word for divine presence, שְׁכִינָה, both sharing the trilittoral stem *skn* (שכנ) that means to dwell.[21] Thus, the scene of *skene* meant not simply the place of a play but the dwelling of God, the sacred site of divine activity and experience, a locus of overwhelming exaltation. For, as the Bible repeatedly declares, "the glory of the Lord filled the tabernacle" (Exodus 40:34, 36), exuding so much divine intensity that even the steady Moses was overcome. This Hebrew *skene*, the *Mishkan*, was the theater that God commanded Moses to build for Him from the voluntary donations of precious metals, cloth, and jewels collected from all the Hebrew people. Its crucial, sacred importance is witnessed through the detailed description of its complex construction and ornamentation, which fills the final six chapters of the book of Exodus. Thus, the divine roots of drama or mise en scène, its role as a holy locus of intense experience, is vividly present also in ancient Hebrew culture, not just in the Greek cult of Dionysus to which Nietzsche (a minister's son, after all) later pays tribute.

IV

Drama, as Aristotle long ago described it, is the presentation of heightened action within a well-structured formal frame of "a certain, definite magnitude," "a well-constructed plot" with a clear "beginning, middle, and end."[22] If the deep drama that defines art in general is a complex play of heightened experience and formal frame, then good art should ignore neither of these moments. To concentrate solely on the frame will eventually degenerate into bare and barren formalism where art remains alienated from the inspiring interests and energies of life. However, to dismiss art's respect for cultivation of its frame because of a frantic lust for experiential intensity would threaten a parallel artistic wasteland: the empty clutter of shallow sensationalism devoid of any enduring form, so that we

might eventually lose the very capacity to distinguish particular artworks from each other and from other things. Even those genres (like performance art and happenings) that most effectively challenge the rigidity of art's separating frame nonetheless rely on some sense of this frame in order to claim their artistic status and give themselves the meaning they intend.

But if good art must be fundamentally dramatic in the double sense we have identified, namely, as intense experience captured and shaped within a special formal frame, how then do these two dimensions of drama—intensity of experience (in action or feeling) and formal staging—fit together? How compatible can they be? They *seem* to pull in different directions, especially when we accept the popular presumptions that lived fervor cannot tolerate formal staging and that art's distancing frame conversely subverts real-life intensity of affect and action. But art's power might be better understood by challenging these dogmas. So I shall conclude by arguing that the apparent tension between art's explosively vital life-feeling and its formal frame (a tension that underlies the conflict between aesthetic naturalism and artistic historicism) should be seen as no less productive and reciprocally reinforcing than the familiar tension between content and form to which it seems obviously related.

A frame is not simply an isolating barrier of what it encloses. Framing focuses its object, action, or feeling more clearly; and thus sharpens, highlights, and enlivens. Just as a magnifying glass heightens the sun's light and heat by the concentration of its refracting frame, so art's frames intensify the power its experienced content wields on our affective life, rendering that content far more vivid and significant. But, conversely, the intensity of feeling or heightened sense of action that is framed reciprocally justifies the act of framing. We do not frame just anything. A frame with nothing in it would be unsatisfying, so that when we find an empty frame or plain white canvas hanging on a gallery wall, we automatically project a significant content onto the apparent emptiness, even if it be the interpretive content that art need have no other content but itself and its essential aspect of framing. Other arts can provide their own similar examples. Think of composer John Cage's famous 4′33″ or choreographer Paul Taylor's *Duet* (two dancers motionless on stage).

In short, just as action makes no sense without the notion of a framing place where the action occurs, so our sense of frame, place, or stage has the *prima facie* implication that some significant activity (recalling the original Greek root of drama) inhabits that frame. Great writers like Henry James are therefore praised for rendering their fictional scenes so captivatingly vivid and real, not by providing intricately long descriptions of their physical setting (since such description can be tediously deadening), but instead through the compelling intensity of action that takes place within

that setting, including the action of passionate thought and feeling. This lesson of aesthetic realism finds confirmation in the psychological theories of Henry's famous brother, the philosopher William James, who argues that our immediate sense of reality "means simply relation to our emotional and active life. . . . In this sense, whatever excites and stimulates our interest is real."[23]

Although art's dramatizing frame can heighten reality through its intensification of feeling, we must not forget the frame's other, contrasting function that is far more familiar to our thinking about art. A frame not only concentrates but demarcates; it is thus simultaneously not just a focus but a barrier that separates what is framed from the rest of life. This important bracketing effect, which tends to "derealize" what is framed, not only helps explain the long aesthetic tradition of sharply contrasting art to reality but also forms the fulcrum for influential theories of aesthetic distance. This bracketing aspect of the frame clearly inspires aesthetic historicism, which, as we have seen, defines art and the aesthetic by their social differentiation from other realms, entirely in terms of the special, historically constructed institutional framework that makes an object an artwork or renders its appreciation a distinctively aesthetic experience.

In this knot of productive tension that binds art's heightened experience to its formal staging, another strengthening strand should be noted. This further twist in drama's dialectical play of lived intensity and separating frame is that precisely the bracketing off of art from the ordinary space of life is what affords art its feeling of lived intensity and heightened reality. Because art's experience is framed in a realm alleged to be apart from the worrisome stakes of what we call real life, we feel much more free and secure in giving ourselves up to the most intense and vital feelings. As Aristotle already adumbrated in his theory of catharsis, art's frame permits us to feel even the most disturbing passions of life more intensely, because we do so within a protected framework where the disruptive dangers of those passions can be contained and purged, so that neither the individual nor society will suffer serious damage.

Art's restraining frame thus paradoxically intensifies our passionate involvement by removing other inhibitions to lived intensity. Art's fictions are therefore often said to feel far more vividly real than much of what we commonly take as real life. It is as if the bracketed diversion of art from ordinary reality allows us an indirect route to appreciate the real far more fully or profoundly by putting us somehow in touch with a reality that is at least greater in its experiential depths of vivid feeling. This argument seems clearly prefigured in Nietzsche's famous praise of drama for piercing the everyday veil of solid, separate objects—an Appollonian dreamworld of clear forms and distinctive persons governed by the *"principio individuationis"* so as to deliver our experience to the deeper Dionysian

reality of frenzied "Oneness" and flux, the ground reality of "omnipotent will behind individuation, eternal life continuing beyond all appearance and in spite of all destruction" (*DG*, 62–64, 108; *BT*, 55–58, 101–2).

Some might protest that such arguments corrupt the very meaning of reality, which must be reserved for the world of ordinary life and kept absolutely distinct from the notion of art with its frame of staging—the sign of the unreal. To reply to such protests, one could invoke the constructed fictions and staged experiments which form the respected realities of science. But we should also note that the realities of everyday life are everywhere played out on the stages set by diverse institutional frames. Indeed, from certain lofty yet familiar perspectives, it seems that "all the world's a stage," as Shakespeare tells us, where life itself is but "a poor player that struts and frets his hour upon the stage, and then is heard no more."[24] In the ancient quarrel between philosophy and poetry, one wonders whether art has so often been denigrated as a staged imitation of life because real life itself is modeled on dramatic performance.

I shall here not venture further into the question of the real nature of reality. This seems a hopeless question, partly because "reality" is an essentially contested concept but also because it is based on a grammatical substantive derived from the very flexible adjective "real," which, as J. L. Austin showed, is so peculiarly variable and complexly contextual in usage that any attempt to find a significant common core that constitutes reality "is doomed to failure."[25] Instead, let me conclude by recalling the paradox that art's apparent diversion from real life may be a needed path of indirection that leads us back to experience life more fully through the infectious intensity of aesthetic experience and its release from affective inhibitions. This suggests that the long-established art/life dichotomy should not be taken too rigidly, that we have here at best a functional distinction which surely seems to dissolve with the idea of the art of living.[26]

Notes

Chapter 1. On Analytic Aesthetics

1. Analytic aesthetics first came to prominence in the form of journal articles and anthologies of articles rather than in full-blown monographs. William Elton (ed.), *Aesthetics and Language* (Oxford: Basil Blackwell, 1954) was the first influential collection in the field. Another trove of important analytic papers is Cyril Barrett (ed.), *Collected Papers in Aesthetics* (Oxford: Basil Blackwell, 1965). Other influential papers reflecting the growth and change of analytic aesthetics can be found in the three editions of *Philosophy Looks at the Arts*, edited by Joseph Margolis (the first from New York, Scribner, 1962; the second and third from Philadelphia, Temple University Press, 1978, 1987). In 1989, I edited a collection of papers specially commissioned to assess the nature, methods, achievements, and problems of analytic aesthetics. Entitled *Analytic Aesthetics* (Oxford: Blackwell), it included papers by important analytic philosophers as well as contributions from influential theorists outside the analytic tradition.

2. See, for example, Nicholas Wolterstorff, "Philosophy of Art after Analysis and Romanticism," in Shusterman (ed.), *Analytic Aesthetics*, 32–58.

3. See J. O. Urmson, "The Methods of Aesthetics," in Shusterman (ed.), *Analytic Aesthetics*, 20–31; and Anita Silvers, "Letting the Sun Shine In: Has Analytic Aesthetics Made Aesthetics Clear?" *Journal of Aesthetics and Art Criticism* 46 (1988): 137–49.

4. G. E. Moore, *Principia Ethica* (Cambridge: Cambridge University Press, 1903).

5. See Arnold Isenberg, "Analytic Philosophy and the Study of Art," *Journal of Aesthetics and Art Criticism* 46 (1988): 125–36.

6. See, for example, Bertrand Russell, "Logical Atomism," in David Pears (ed.), *Russell's Philosophy of Logical Atomism* (London: Fontana, 1972), 162.

7. See C. H. Langford, "Moore's Notion of Analysis," in P. A. Schilpp (ed.), *The Philosophy of G. E. Moore* (La Salle, Ill.: Open Court, 1942), 319–42. Moore's response is on pages 660–67.

8. Some testimony for this view (and the preeminence of Wittgenstein's influence) can be found in Elton (ed.), *Aesthetics and Language*, 11–12.

9. See P. F. Strawson, "Carnap's View on Constructed Systems versus Natural Languages in Analytic Philosophy," in P. A. Schilpp (ed.), *The Philosophy of Rudolf*

Carnap (La Salle, Ill.: Open Court, 1963), 503–18, and Carnap's reply, 933–40. For Urmson's parallel critique of constructivism in aesthetics, see his "The Methods of Aesthetics," in Shusterman (ed.), *Analytic Aesthetics*, 20–31.

10. See Nelson Goodman, *Languages of Art* (Oxford: Oxford University Press, 1969), 177–221.

11. See Bertrand Russell, "Logical Atomism," and "The Philosophy of Logical Atomism," in Pears (ed.), *Russell's Philosophy of Logical Atomism*, 33, 162.

12. W. B. Gallie, "The Function of Philosophical Aesthetics," in Elton (ed.), *Aesthetics and Language*, 16–17, hereafter *FPA*.

13. See Beryl Lake, "The Irrefutability of Two Aesthetic Theories," in ibid., 100–13.

14. One of Isenberg's central arguments in recommending analytic aesthetics is simply that since other aesthetic philosophizing has left things in such a muddle, analytic aesthetics—as committed to clarity—deserves a chance to prove itself and could hardly make matters worse. See Isenberg, "Analytic Philosophy and the Study of Art," 128.

15. See J. O. Urmson, "What Makes a Situation Aesthetic?" reprinted in Margolis (ed.), *Philosophy Looks at the Arts* (1962), 24, 25; Morris Weitz, "The Role of Theory in Aesthetics," in ibid, 53; Monroe Beardsley, *Aesthetics: Problems in the Philosophy of Criticism* (New York: Harcourt Brace, 1958), 529; and Frank Sibley, "Aesthetic Concepts," reprinted in Margolis (ed.), *Philosophy Looks at the Arts* (1962), 63–87.

16. Arthur Danto, "The Artworld," *Journal of Philosophy* 61 (1964): 581.

17. See George Dickie, *Art and the Aesthetic: An Institutional Analysis* (Ithaca: Cornell University Press, 1974), 19–52. Dickie's theory has often been criticized for its circularity and for its lack of sensitivity to constraints of structure, hierarchy, and history in the institution of the artworld. Such critiques are made even by people who favor an institutional approach to defining art. See Steven Davies, *Definitions of Art* (Ithaca: Cornell University Press, 1991).

18. See Arthur Danto, *After the End of Art* (Princeton: Princeton University Press, 1997), 25; and Danto, *The Philosophical Disenfranchisement of Art* (New York: Columbia University Press, 1984), 13; George Dickie, "The Myth of the Aesthetic Attitude," *American Philosophical Quarterly* 1 (1964): 56–66; and Dickie, "Beardsley's Phantom Aesthetic Experience," *Journal of Philosophy* 62 (1965): 129–36; Joseph Margolis, *What, After All, Is a Work of Art?* (University Park: Pennsylvania State University Press, 1999).

19. Analysts were particularly fond of making this point by reference to the historical research of P. O. Kristeller's "The Modern System of the Arts," *Journal of the History of Ideas* 12, 13 (1951, 1952), 496–527, 17–46.

20. J. A. Passmore, "The Dreariness of Aesthetics," in Elton (ed.), *Aesthetics and Language*, 44. See also Stuart Hampshire, "Logic and Appreciation" and W. B. Gallie, "The Function of Philosophical Aesthetics," in ibid.; W. E. Kennick, "Does Traditional Aesthetics Rest on a Mistake?" *Mind* 47 (1958), reprinted in Barrett (ed.), *Collected Papers in Aesthetics*, 1–21; and Morris Weitz, "The Role of Theory in Aesthetics," *Journal of Aesthetics and Art Criticism* 16 (1956): 27–35.

21. Passmore, "The Dreariness of Aesthetics," 50, 55.

22. See, for example, Peter Kivy, *Philosophies of Art: An Essay in Differences* (Cambridge: Cambridge University Press, 1997).

23. Hampshire, "Logic and Appreciation," 169.

24. Benedetto Croce, *Aesthetic* (London: Macmillan, 1922), 150.

25. See Monroe Beardsley, *Aesthetics: Problems in the Philosophy of Criticism* (New York: Harcourt and Brace, 1958), 524–30.

26. Danto, *After the End of Art*, 28, 95, 197.

27. See Richard Shusterman, *Pragmatist Aesthetics: Living Beauty, Rethinking Art*, 2d ed. (New York: Rowman and Littlefield, 2000), 39–45; and chapters 12 and 13 of this book. Philosophers who follow Danto and Dickie in seeking essentialist definitions of art include Stephen Davies, Jerrold Levinson, and Robert Stecker.

28. See Hilary Putnam, "A Half Century of Philosophy, Viewed from Within," *Daedalus* 126 (1997): 189.

29. See C. L. Stevenson, "On the Reasons That Can Be Given for the Interpretation of a Poem," in Margolis (ed.), *Philosophy Looks at the Arts*, 124; and Beardsley, *Aesthetics*, 524–43; Joseph Margolis, "The Identity of a Work of Art," *Mind* 67 (1959).

30. Consider, for example, Weitz's literary scholarship in *Hamlet and the Philosophy of Literary Criticism* (Chicago: University of Chicago Press, 1964). The Beardsley–Wimsatt essay I refer to is "The Intentional Fallacy," in W. K. Wimsatt, *The Verbal Icon* (Lexington: University of Kentucky Press, 1967), 3–39.

31. See Richard Wollheim, *Art and Its Objects* (Harmondsworth: Penguin, 1975), 112–13.

32. For more details, see George Dickie, "The Myth of the Aesthetic Attitude" and "Beardsley's Phantom Aesthetic Experience"; Ted Cohen, "Aesthetic/Nonaesthetic and the Concept of Taste: A Critique of Sibley's Position," *Theoria* 39 (1973): 112–52; and Richard Shusterman, "The End of Aesthetic Experience," in *Performing Live: Aesthetic Alternatives for the Ends of Art* (Ithaca: Cornell University Press, 2000), chap. 1.

33. See Danto's *The Philosophical Disenfranchisement of Art*, xiv–xv, 1–21; and Nelson Goodman, *Languages of Art*, 248–64, and *Of Mind and Other Matters* (Cambridge, Mass.: Harvard University Press, 1984), 138–53.

34. See Northrop Frye, *The Anatomy of Criticism* (Princeton: Princeton University Press, 1957), 18.

35. Beardsley not only offered canons of evaluation, but a theoretical ground for them in terms of aesthetic experience. See *Aesthetics*, 524–30.

36. See Wollheim, *Art and Its Objects*, section 65. Although this section remains unchanged, Wollheim adds a brief essay on evaluation in the second edition of his book (published by Cambridge University Press in 1980).

37. Nelson Goodman, *Problems and Projects* (Indianapolis: Bobbs-Merrill, 1968), 121. See also Goodman's *Languages of Art*, 261–62, where he states, "Excessive concentration on the question of excellence has been responsible, I think, for constriction and distortion of aesthetic inquiry. . . . And a criterion of aesthetic merit is no more the major aim of aesthetics than a criterion of virtue is the major aim of psychology." The theme is continued in Goodman, *Of Mind and Other Matters*, 164–66.

38. According to Kennick, the very assumption that a definition of art is used

or needed when properly evaluating art represents the second grave mistake (after essentialism) on which traditional aesthetics rested. See Kennick, "Does Traditional Aesthetics Rest on a Mistake?" For a study of analytic arguments (by Hampshire, Isenberg, Macdonald, and Sibley) denying that evaluation needs guidance from a general theory, see Richard Shusterman, "Evaluative Reasoning in Criticism," *Ratio* 23 (1981): 142–59. See also chapter 4 of this book.

39. See Weitz, "Role of Theory in Aesthetics," and W. B. Gallie, "Art as an Essentially Contested Concept," *Philosophical Quarterly* 6 (1956): 97–114.

40. See, for example, George Dickie, *Aesthetics* (New York: Bobbs-Merrill, 1971), 97–108, and *Art and the Aesthetic*, 19–52.

41. For a critique of the whole project of defining art in a purely classificatory sense, see B. R. Tilghman, *But Is It Art?* (Oxford: Basil Blackwell, 1984), and Shusterman, *Pragmatist Aesthetics.*

42. Passmore, "The Dreariness of Aesthetics," 54.

43. See Pierre Bourdieu, "The Historical Genesis of a Pure Aesthetics," in Shusterman (ed.), *Analytic Aesthetics*, 147–60.

44. See, for example, Monroe Beardsley, *Aesthetics from Classical Greece to the Present: A Short History* (New York: Macmillan, 1966); and Peter Kivy, *Reid's Lectures on the Fine Arts* (The Hague: Nijhoff, 1973), and *The Seventh Sense: A Study of Frances Hutcheson's Aesthetics* (New York: Franklin, 1975).

45. Wollheim, *Art and Its Objects*, 167; Danto, *The Philosophical Disenfranchisement of Art*, 204; Jerrold Levinson, "Refining Art Historically," *Journal of Aesthetics and Art Criticism* 47 (1989): 21.

46. Danto, *Philosophical Disenfranchisement of Art*, 204. Roger Scruton similarly insists, against Marxian views, that art history be viewed as having the "autonomy constitutive of genuine independent subject" in *The Aesthetic Understanding* (London: Metheun, 1983), 167.

47. For Richards's admission of Moore's important influence, see the interview in his *Complementarities: Uncollected Essays*, ed. J. P. Russo (Manchester, U.K.: Carcanet, 1976), 257–58. For Wittgenstein's critique of Moore's focus on the aesthetic predicate "beauty" and on the propositional form "this is beautiful," see Ludwig Wittgenstein, *Lectures and Conversations on Aesthetics, Psychology, and Religious Belief*, Cyril Barrett (ed.) (Oxford: Basil Blackwell, 1970), 2–3. Wittgenstein's critique shows his early recognition that the very meaning of art and aesthetic judgment is mainly a function of its complex, socially embedded role in a particular culture, a role which can change through more general social change. Though the target of Wittgenstein's critique, Moore played an important role in disseminating Wittgenstein's aesthetic views (that had been left unpublished) by publishing his own account of them in the journal *Mind* (1955). This account, in an essay entitled "Wittgenstein's Lectures, 1930–33," is reprinted in Moore's *Philosophical Papers* (London: Allen and Unwin, 1959), 252–324.

48. See, for example, Mary Mothersill, *Beauty Restored* (New York: Oxford), 1984; Eddy Zemach, *Real Beauty* (University Park: Pennsylvania State University Press, 1999); and Peg Brand (ed.), *Beauty Matters* (Bloomington: Indiana University Press, 2000). Along with the renewed interest in beauty, analytic aesthetics is also showing more interest in nature and the environment. See, for example,

Alan Carlson, *Aesthetics and the Environment: The Appreciation of Nature, Art, and Architecture* (New York, Routledge, 2000).

49. Moore writes: "It appears probably that the beautiful should be *defined* as that of which the admiring contemplation is good in itself." However, "there can be no single criterion of beauty," since it, like goodness, must be intuitively perceived in terms of the particular organic unities that manifest it (*Principia Ethica,* 201–2). For his later views, see G. E. Moore, *Philosophical Studies* (London: Routledge and Kegan Paul, 1922), 253. For more detailed discussion of Moore's theory of organic unity and its relation to aesthetics, see Shusterman, *Pragmatist Aesthetics,* chap. 3.

50. Moore, *Principia Ethica, 197–98.*

51. Ludwig Wittgenstein, *Philosophical Investigations* (Oxford: Blackwell, 1968), para. 77.

52. Beardsley, *Aesthetics,* 17–29, 454–70.

Chapter 2. Logics of Interpretation

1. Some analytic aestheticians do, however, consciously make critical recommendations as such. Monroe Beardsley's "intentional fallacy" is a case of legislating against authorial intention as the prime goal or standard of criticism. See M. C. Beardsley, *The Possibility of Criticism* (Detroit: Wayne State University Press, 1970).

2. See Arthur Symons, *Studies in Elizabethan Drama* (London: Routledge and Kegan Paul, 1920). Discussion of these impressionist critics can be found in T. S. Eliot's "The Perfect Critic," in Frank Kermode (ed.), *Selected Prose of T. S. Eliot* (New York: Harcourt and Brace, 1975); and in Harold Osborne, *Aesthetics and Criticism* (London: Routledge and Kegan Paul, 1955), 318–20.

3. Matthew Arnold, "The Function of Criticism at the Present Time," in *The Portable Matthew Arnold* (New York: Viking, 1949), 234.

4. E. D. Hirsch, *Validity in Interpretation* (New Haven: Yale University Press, 1967).

5. See the articles by these authors in Gary Iseminger (ed.), *Intention and Interpretation* (Philadelphia: Temple University Press, 1992); citations from 224–25, 251.

6. See my "Interpreting with Pragmatist Intentions," in Iseminger (ed.), *Intention and Interpretation;* but more extensively in *Pragmatist Aesthetics* (Oxford: Blackwell, 1992; 2d ed. New York: Rowman and Littlefield, 2000), chap. 4.

7. See Joseph Margolis, "The Logic of Interpretation," in Joseph Margolis (ed.), *Philosophy Looks at the Arts* (Philadelphia: Temple University Press, 1978); and Morris Weitz, *Hamlet and the Philosophy of Literary Criticism* (Chicago: University of Chicago Press, 1964), hereafter *HP*. Margolis later revised his foundational descriptivism with respect to the facts on which interpretation is based. His new theory is critically considered in chapter 11 of this book. More detailed criticism of his early theory (including his sharp distinction between describing facts and making interpretations) can be found in Richard Shusterman, "Interpretation, Intention, and Truth," *Journal of Aesthetics and Art Criticism* 46 (1998): 399–411. See also the criticism of Margolis in Robert Stecker, *Artworks: Definition, Meaning, Value* (University Park: Pennsylvania State University Press, 1997).

8. Quoted from Joseph Margolis, "The Identity of a Work of Art," in Francis Coleman (ed.), *Contemporary Studies in Aesthetics* (New York: McGraw Hill, 1968), 39.

9. Beardsley, *The Possibility of Criticism*, 43.

10. Virgil Aldrich, *Philosophy of Art* (Englewood Cliffs, N.J.: Prentice-Hall, 1963); Arnold Isenberg, "Critical Communication," in Margolis (ed.), *Philosophy Looks at the Arts*, 142–55; C. L. Stevenson, "Interpretation and Evaluation in Aesthetics," in Max Black (ed.), *Philosophical Analysis* (Ithaca: Cornell University Press, 1950), hereafter *PHA*.

11. Francis Fergusson, *The Idea of a Theatre* (Princeton: Princeton University Press, 1949), 101.

12. F. R. Leavis, "Diabolic Intellect and the Noble Hero," in *The Common Pursuit* (London: Pelican, 1976), 138.

13. Ibid., 140.

14. Richard Wollheim, *Art and Its Objects* (New York: Harper and Row, 1970), 103.

15. M. Macdonald, "Some Distinctive Features of Arguments Used in Criticism of the Arts," in Elton (ed.), *Aesthetics and Language* (Oxford: Blackwell, 1954), 130, hereafter *AL*.

16. See, for example, Arthur Danto, *The Philosophical Disenfranchisement of Art* (New York: Columbia University Press, 1984). For a critique of Danto's view that interpretation is always necessary for the existence and understanding of art, see Shusterman, *Pragmatist Aesthetics,* chap. 5. For a critique of his transcendental account of the metaphysics of interpretation (and of Warhol's art), see chapter 10 of this book.

17. Stanley Fish, *Is There a Text in This Class?* (Cambridge, Mass.: Harvard University Press, 1980), 327.

18. Helen Gardner, *The Business of Criticism* (Oxford: Clarendon Press, 1963), 17.

19. Ibid., 51.

20. See Lionel Trilling, *The Liberal Imagination* (New York: Doubleday, 1950), 186; and Lascelles Abercrombie, "A Plea for the Liberty of Interpreting," *Proceedings of the British Academy* 16 (1930): 130.

21. J. Dover Wilson, *What Happens in Hamlet* (Cambridge: Cambridge University Press, 1935).

22. M. C. Bradbrook, "Marlowe's Faustus," in W. Farnham (ed.), *Twentieth Century Interpretations of Doctor Faustus* (Englewood Cliffs, N.J.: Prentice-Hall, 1969), 22.

23. C. L. Stevenson, "On the Reasons That Can Be Given for the Interpretation of a Poem," in Margolis (ed.), *Philosophy Looks at the Arts*, 124.

24. Stevenson, "Interpretation and Evaluation in Aesthetics," in *PHA*, 370.

25. J. Smith, "Faustus as Allegory," in Farnham (ed.), *Twentieth Century Interpretations*, 27.

26. See Aldrich, *Philosophy of Art*; Isenberg, "Critical Communication"; and Paul Ziff, "Reasons in Art Criticism," in Margolis (ed.), *Philosophy Looks at the Arts*, 158–77.

27. G. E. Moore, "Wittgenstein's Lectures in 1930–33," in Moore's *Philosophical Papers* (London: Allen and Unwin, 1955), 315.

28. Osborne, *Aesthetics and Criticism*, 320.

29. Isenberg, "Critical Communication," in Margolis (ed.), *Philosophy Looks at the Arts*, 148.

30. John Casey, *The Language of Criticism* (London: Methuen, 1966).

31. F. R. Leavis, "Literary Criticism and Philosophy," in *The Common Pursuit*, 214.

32. Beardsley, *The Possibility of Criticism*, 30.

33. F. R. Leavis, "Mr. Pryce-Jones, the British Council and British Culture," *Scrutiny* 18 (1951–52): 227.

34. F. R. Leavis, *Revaluation* (London: Penguin, 1972), 133–34.

35. See Richard Shusterman, "The Logic of Evaluation," *Philosophical Quarterly* 30 (1980): 327–41, "Evaluative Reasoning in Criticism," *Ratio* 23 (1981): 141–57, and *The Object of Literary Criticism* (Amsterdam: Rodopi, 1984), chap. 6.

36. See Weitz, *Hamlet and the Philosophy of Literary Criticism*, 246; and Stuart Hampshire, "Types of Interpretation," in Sidney Hook (ed.), *Art and Philosophy* (New York: New York University Press, 1966), 107.

37. Shusterman, *Pragmatist Aesthetics*, 92–93.

38. See for example, Annette Barnes, *On Interpretation* (Oxford: Blackwell, 1988); and Alan Goldman, "Interpreting Art and Literature," *Journal of Aesthetics and Art Criticism* 48 (1990): 205–14.

39. Jerrold Levinson, *The Pleasures of Aesthetics* (Ithaca: Cornell University Press, 1996), 198–99.

40. Ibid., 183–84.

41. For Stecker's extensive critique of my views on interpretation, see his *Artworks*, 218–27, 241–42, where he identifies my position entirely with a monistic performativism that rejects all notions of interpretive truth and concern for authorial intention. Like Levinson, he ignores my arguments that affirm the legitimacy of games with interpretive truth and authorial intention (e.g., in *The Object of Literary Criticism*), perhaps because I devote more efforts to legitimating other interpretive logics that are less well established. Perhaps Stecker and Levinson also think that in claiming that there is no permanently fixed essence or meaning of a work that must always be valid for all interpretive games, I am thereby denying that there can ever be any facts or truths about the work at all in any interpretive game whatsoever. That conclusion simply does not follow, for it involves a confusion of scope. The fact that there are facts in some interpretive games does not mean that there must be such facts in all others. And the claim that what counts as an interpretive fact is ultimately a pragmatic and contextual matter of the interpretive game that is played does not mean that we cannot appeal to such pragmatic facts in an interpretive game that is based on them. To borrow Rudolf Carnap's distinction between "internal" and "external" questions or perspectives, we can affirm that within certain important practices of interpretation there are facts about authors' intentions and also true interpretations thereof, while still leaving the external question open as to whether such facts or truths are really true or necessary independent of our practices of interpretation and in other, logically different interpretive games. See Rudolf Carnap, "Empiricism, Semantics, and Ontology," in *Meaning and Necessity*, 2d ed. (Chicago: University of Chicago Press, 1956), 205–21. We can also continue to ask on

a different external level of inquiry whether the author's intention can ever be individuated in an absolute, permanent way.

42. Levinson, *The Pleasures of Aesthetics*, 199.

43. Shusterman, *The Object of Literary Criticism*, 139–47.

Chapter 3. Croce on Interpretation

1. See Hippolyte Taine, *History of English Literature*, trans. Henry Van Luan (New York: Colonial Press, 1900), 18. A related passage is quoted in William K. Wimsatt and Cleanth Brooks, *Literary Criticism: A Short History* (Chicago: University of Chicago Press, 1954), 534.

2. I provide a more detailed account of this in "Analytic Aesthetics, Literary Theory, and Deconstruction," *Monist* 69 (1986): 22–38.

3. Bendetto Croce, *Aesthetic as Science of Expression and General Linguistic*, trans. Douglas Ainslie, rev. ed. (London: Macmillan, 1922), hereafter *A*.

4. For a brief account of this aspect of Croce and its criticism of Hegel, see John Passmore, *A Hundred Years of Philosophy* (London: Penguin, 1968), 300–301. (The translated citation from Croce's *Saggio sullo Hegel* appears on page 300.) Cf. Jacques Derrida, *Positions* (London: Athlone, 1980), 27–29.

5. See *A*, 26 (cf. also 30); Jacques Derrida, *Of Grammatology* (Baltimore: Johns Hopkins University Press, 1976), 158, and *Positions*, 27.

6. Derrida, *Positions*, 27, 45.

7. See Jacques Derrida, "Différance," in *Speech and Phenomena and Other Essays of Husserl's Theory of Signs* (Evanston, Ill.: Northwestern University Press, 1973), 141, and *Positions*, 58. For Croce's challenge of such classificatory distinctions, see *A*, 13–14, 67–70, 87–92, 114–15, 120, 142.

8. See Hans-Georg Gadamer, *Truth and Method* (New York: Crossroad, 1982), 346: "every translation is at the same time an interpretation."

9. See, e.g., Paul de Man, *Allegories of Reading: Figural Language in Rousseau, Nietzsche, Rilke, and Proust* (New Haven: Yale University Press, 1979), 119–31; Jonathan Culler, *On Deconstruction: Theory and Criticism after Structuralism* (Ithaca: Cornell University Press, 1982), 79–82, 175–80; Harold Bloom, *A Map of Misreading* (New York: Oxford University Press, 1975), 3–105; J. Hillis Miller, "The Critic as Host," in Harold Bloom et al., *Deconstruction and Criticism* (New York: Seabury Press, 1979), 217–53; and Vincent B. Leitch, *Deconstructive Criticism: An Advanced Introduction* (New York: Columbia University Press, 1983), 158–59. I should repeat that most of these theorists augment the Crocean line with other arguments for the essential unreadability (or necessity of misreading) of texts. Consider, for example, de Man's argument for the fundamental and inescapable tension between the constative and the performative in all language, and Bloom's Freudian argument for the reader's anxiety of influence and consequent willful, self-assertive misreading.

10. Culler, *On Deconstruction*, 176.

11. Ibid., 123, 128, and more generally, 121–30.

12. See Ludwig Wittgenstein, *Philosophical Grammar* (Oxford: Blackwell, 1974), 68–69, and *Philosophical Investigations* (Oxford: Blackwell, 1968), para. 189–242; G. P. Baker and P. M. S. Hacker, *Wittgenstein: Meaning and Understanding* (Oxford: Blackwell, 1983), 29–45, 321–46. For application to the interpretation of literature,

see Richard Shusterman, *T. S. Eliot and the Philosophy of Criticism* (New York: Columbia University Press, 1988), chaps. 3 and 5.

13. See Gadamer, *Truth and Method*, esp. 265–78, 293–305; and Stanley Fish, *Is There a Text in This Class?* (Cambridge, Mass.: Harvard University Press, 1980), 11–17, 303–21, 338–55.

14. Nowhere, however, does Croce present a full-blown, self-conscious, and unequivocal pragmatism. His literary criticism can be seen as developing from a strong emphasis on the individuality of the artist and her intuition-expression to a more dominant insistence on the universality of the artist and her work. Significant continuity is maintained, however, for artistic universality is claimed to be necessarily reflected through individuality, in the manner of a Hegelian concrete universal. For a more detailed account of Croce's development as a literary critic, see Giovanni Gullace's "Translator's Introduction" to *Croce, Poetry, and Literature* (Carbondale: Southern Illinois University Press, 1981), xxxix–lxxiv. Croce, however, did explicitly recognize his affinities with the later pragmatist aesthetics of John Dewey, so much so that he implied that Dewey must have been borrowing from him. Dewey did not like the implication and tried to distance himself from Croce's idealism. See their exchange in *Journal of Aesthetics and Art Criticism* 6 (1948).

15. See Croce, *Ariosto, Shakespeare, and Corneille*, trans. Douglas Ainslie (New York: F. Ungar, 1966), 141, 147, hereafter *ASC*.

16. With specific regard to Shakespeare, Croce asserts that the effect of philological and historical studies "is never to clear up or decide anything, but on the contrary, to darken what appeared perfectly certain." Hence we should "resolutely banish them from the mind, and read and reread Shakespeare plays without more ado" (*ASC*, 318).

17. William K. Wimsatt and Monroe Beardsley, in "The Intentional Fallacy," *The Verbal Icon*, ed. William K. Wimsatt (Lexington: University of Kentucky Press, 1954), 282n., also note that Croce's critical practice is not consistent with the intentionalism they see as "the main drive of his *Aesthetic.*"

18. The contingency and conventionality of consensual practice need not be arbitrary in any cognitively vitiating sense. See chapter 6, which argues that the erroneous identification of the conventional with superficial, unjustified arbitrariness rests on confusing two different senses of "contingent": the nonnecessary and the random or willfully arbitrary.

19. I show how both intentionalist and anti-intentionalist theories of meaning objectivism serve the same academic stakes of knowledge production, in "Interpretation, Intention, and Truth," *Journal of Aesthetics and Art Criticism* 46 (1988): 399–411. The most useful overview of the intentionalism debate can be found in the anthology of Gary Iseminger (ed।)., *Intention and Interpretation* (Philadelphia: Temple University Press, 1992).

20. See Culler, *On Deconstruction*, 123, 176; and Jacques Derrida, "Structure, Sign, and Play in the Discourse of the Human Sciences," in *Writing and Difference* (Chicago: University of Chicago Press, 1978).

21. One of the best pragmatist accounts of meaning as a function of ongoing social practices (rather than of special psychic realities) is in G. H. Mead, *Mind, Self, and Society* (Chicago: University of Chicago Press, 1934).

22. See Wittgenstein, *Philosophical Investigations*, para. 179; and John Dewey, *Experience and Nature* (Carbondale: Southern Illinois University Press, 1988), 324.

23. See Richard Shusterman, *Pragmatist Aesthetics: Living Beauty, Rethinking Art* (Oxford: Blackwell, 1992; 2d ed. Rowman and Littlefield, 2000), chap. 5.

Chapter 4. Wittgenstein and Critical Reasoning

1. See John Passmore, "The Dreariness of Aesthetics," reprinted in William Elton (ed.), *Aesthetics and Language* (Oxford: Blackwell, 1954), 36–55.

2. For Wittgenstein's strong interest in music and the arts, see Alan Janik and Stephen Toulmin, *Wittgenstein's Vienna* (New York: Simon and Schuster, 1973), 175–76; and Ray Monk, *Ludwig Wittgenstein: The Duty of Genius* (London: Penguin, 1990). Wittgenstein confessed in his notebooks that his prime interests were "only conceptual and aesthetic questions"; see Ludwig Wittgenstein, *Culture and Value* (Oxford: Blackwell, 1980), 79. Claiming that "ethics and aesthetics are one," in proposition 6.241 of *Tractatus Logico-Philosophicus* (London: Routledge, 1922), Wittgenstein has influenced the contemporary trend to combine ethics with aesthetics and to portray philosophy as an ethical-aesthetic work on oneself. I examine Wittgenstein's contribution to these notions in Richard Shusterman, *Pragmatist Aesthetics: Living Beauty, Rethinking Art* (Oxford: Blackwell, 1992; 2d ed. New York: Rowman and Littlefield, 2000), chap. 9, and *Practicing Philosophy: Pragmatism and the Philosophical Life* (New York: Routledge, 1997), chap. 1.

3. Wittgenstein's discussions of aesthetics in the early *Notebooks: 1914–1916* (Oxford: Blackwell, 1961) and the *Tractatus Logico-Philosophicus* present a fascinating mystical and transcendental aesthetic. But it is Wittgenstein's later philosophy that has proven most important in analytic aesthetics. My discussion of Wittgenstein in this chapter therefore concentrates on his later phase and is based chiefly on his *Philosophical Investigations* (Oxford: Blackwell, 1968), hereafter *PI*, and on his lectures on aesthetics in 1932–33 and in the summer of 1938. Parenthetical citations to part 1 of *Philosophical Investigations* are by paragraph number. A report of the former lectures can be found in G. E. Moore, "Wittgenstein's Lectures in 1930–33," reprinted in Moore's *Philosophical Papers* (London: Allen and Unwin, 1959), 252–324, hereafter *PP*. The 1938 lectures have been transcribed from students' notes and published as part of Wittgenstein's *Lectures and Conversations on Aesthetics, Psychology, and Religious Belief*, Cyril Barrett (ed.) (Oxford: Blackwell, 1970), 1–40, hereafter *LA*. Many brief but useful remarks on aesthetics can be found in Wittgenstein's various notebooks that are collected in *Culture and Value*.

4. See Morris Weitz, "The Role of Theory in Aesthetics," reprinted in Joseph Margolis (ed.), *Philosophy Looks at the Arts*, 2d ed. (Philadelphia: Temple University Press, 1978), 121–31; see also W. H. Kennick, "Does Traditional Aesthetics Rest on a Mistake?" *Mind* 67 (1958): 317–34.

5. For representation as "seeing-as," see Richard Wollheim, *Art and Its Objects*, 2d ed. (Cambridge: Cambridge University Press, 1980), 12–22. Wollheim eventually revised his view to prefer the notion of "seeing-in"; see his supplementary essay "Seeing-as, Seeing-in, and Pictorial Representation," in ibid., 205–26. For

the use of "seeing-as" to explain the aesthetic attitude, see Virgil Aldrich, *Philosophy of Art* (Englewood Cliffs, N.J.: Prentice-Hall, 1963), 20–24. Philosophical transformations are not always a matter of providing new theories for familiar questions; they are often constituted instead by fundamental changes in the very questions and problems that interest the philosopher. Wittgenstein's transformation of aesthetics is to some extent of this second kind: a redirection and reconstruction of aesthetic inquiry in ways that this chapter outlines.

6. Wittgenstein moreover suggests that not only is exactness not an end in itself but it makes no sense in itself, for it always depends on the goal or aim in question. "Thus the point here is what we call the goal" (*PI*, 88).

7. The special logic of this second group of aesthetic concepts has been very much discussed since Frank Sibley's seminal treatment of them in "Aesthetic Concepts," reprinted in Margolis (ed.), *Philosophy Looks at the Arts*, 64–87.

8. R. G. Collingwood, *The Principles of Art* (Oxford: Oxford University Press, 1958), 280.

9. See Morris Weitz, *Hamlet and the Philosophy of Literary Criticism*, paperback ed. (London: Faber, 1972), 156–86, 272–75; and Richard Shusterman, "Evaluative Reasoning in Criticism," *Ratio* 23 (1981): 141–57.

10. Joseph Addison, "Criticisms on *Paradise Lost*," reprinted in E. D. Jones (ed.), *English Critical Essays (Sixteenth, Seventeenth, and Eighteenth Centuries)* (Oxford: Oxford University Press, 1943), 280.

11. See Arthur Danto, "The Artworld," *Journal of Philosophy* 61 (1964): 571–84; George Dickie, "Defining Art," *American Philosophical Quarterly* 6 (1969): 253–56; and *Art and the Aesthetic: An Institutional Analysis* (Ithaca: Cornell University Press, 1974), 19–52. See also Wollheim's *Art and Its Objects*, 143–52.

12. See, for example, T. J. Diffey, "On Defining 'Art,' " *British Journal of Aesthetics* 19 (1979): 15–23; Noël Carroll, "Art, Practice, and Narrative," *Monist* 71 (1988): 140–56; Jerrold Levinson, "Refining Art Historically," *Journal of Aesthetics and Art Criticism* 47 (1989): 21–33; Nicholas Wolterrstorf, "Philosophy of Art after Analysis and Romanticism," in Richard Shusterman (ed.), *Analytic Aesthetics* (Oxford: Blackwell, 1989), 32–58; Graham McFee, "The Historicity of Art," *Journal of Aesthetics and Art Criticism* 38 (1980): 307–24.

13. For my critique of "wrapper theories" of art, see *Pragmatist Aesthetics*, 39–45.

14. For discussion of the performative theory of critical evaluation, see Richard Shusterman, "The Logic of Evaluation," *Philosophical Quarterly* 30 (1980): 327–41.

15. Wittgenstein could hardly be more derisive about psychological aesthetics: "People often say that aesthetics is a branch of psychology. The idea is that once we are more advanced, everything—all the mysteries of Art—will be understood by psychological experiments. Exceedingly stupid as the idea is, this is roughly it" (*LA*, 17). "People still have the idea that psychology is one day going to explain all our aesthetic judgments, and they mean experimental psychology. This is very funny—very funny indeed. There doesn't seem any connection between what psychologists do and any judgment about a work of art" (*LA*, 17, 19).

16. See paragraphs 6.41–7 in Wittgenstein, *Tractatus Logico-Philosophicus*, and *Notebooks*, 74–86.

17. See Shusterman, "Evaluative Reasoning in Criticism."

18. See John Wisdom, "Note on Ayer's *Language, Truth, and Logic*," reprinted in *Philosophy and Psycho-Analysis* (Oxford: Blackwell, 1957), 247.

19. See Northrop Frye, *Anatomy of Criticism* (Princeton: Princeton University Press, 1957), 3–29; and Roman Jakobson, "Linguistics and Poetics," in T. A. Sebeok (ed.), *Style in Language* (Cambridge, Mass.: MIT Press, 1960), 350–77.

20. Sibley, "Aesthetic Concepts," 79–87.

21. See T. S. Eliot, "The Function of Criticism," in *Selected Essays* (London: Faber, 1976), 32.

22. This critique is made in Hartley Slater, "Wittgenstein's Aesthetics," *British Journal of Aesthetics* 23 (1983): 34–37.

23. Ludwig Wittgenstein, *The Blue and Brown Books* (New York: Harper, 1958), 24.

24. Stuart Hampshire, "Logic and Appreciation," reprinted in Elton (ed.), *Aesthetics and Language*, 166, 169.

25. Margaret Macdonald, "Some Distinctive Features of Arguments Used in Criticism of the Arts," reprinted in Elton (ed.), *Aesthetics and Language*, 121, 129.

26. Sibley, "Aesthetic Concepts," 79–87.

27. Arnold Isenberg, "Critical Communication," reprinted in Elton (ed.), *Aesthetics and Language*, 137–38. John Casey draws heavily on Wittgenstein in describing critical reasoning as "persuading . . . to see . . . in a particular way," but goes even further than Isenberg (and Wittgenstein) by maintaining that sameness of vision entails identical value judgments. See Casey, *The Language of Criticism* (London: Methuen, 1966), 172–73.

28. We can see this slide quite clearly in the following passage from Casey: "The idea that particular judgments, if they are to be objective, *have* to be deduced from general principles, or entailed by general descriptions, is the fundamental fallacy. To defend a judgment of a poem one *has to* go on describing it, relating it to other poems and so on, until the person one is trying to convince is satisfied. There are no general laws which will take the place of this." Casey, *The Language of Criticism*, 138, my emphasis. In opposing the fallacy that reasoning must be deductive, Casey falls into the fallacy that such reasoning cannot be deductive or nonperceptually persuasive.

29. Ludwig Wittgenstein, "Philosophy," in *Philosophical Occasions, 1912–1951* (Indianapolis: Hackett, 1993), 181.

30. See T. S. Eliot, "Johnson as Critic and Poet," in *On Poetry and Poets* (London: Faber, 1957), 162–93.

31. Weitz, *Hamlet and the Philosophy of Literary Criticism*, 275. Casey (*The Language of Criticism*, 138) also argues that adequate general "standards . . . neither can exist, nor can have the function" of convincing premises in a deductive argument. Weitz, besides questioning the conclusiveness of evaluative principles in criticism, also rules out evaluative deduction on the basis of an argument which commits a "speech-act" fallacy of denying the compatibility of description and praise. For criticism of Weitz's argument, see Shusterman, "Evaluative Reasoning in Criticism," 152. For a general discussion of such fallacies, see John Searle, *Speech Acts* (Cambridge: Cambridge University Press, 1969), 131–56.

32. See Shusterman, "Evaluative Reasoning in Criticism," 143, 151.

33. Graham Hough, *An Essay on Criticism* (New York: Norton, 1966), 176.

34. The pragmatic turn does not, however, mean a rejection of descriptive analysis. For, to paraphrase the great analyst J. L. Austin, even if analysis may not be the "the last word," it is still a very necessary "first word."

Chapter 5. Of the Scandal of Taste

1. The texts from Hume and Kant that I employ here are David Hume's "Of the Standard of Taste," in *Essays Moral, Political, and Literary* (Oxford: Oxford University Press, 1963), hereafter *ST;* and Immanuel Kant's *The Critique of Judgement*, trans. J. C. Meredith (Oxford: Oxford University Press, 1952), hereafter *CJ*.

2. See, for example, Pierre Bourdieu, *Distinction: A Social Critique of the Judgment of Taste* (Cambridge, Mass.: Harvard University Press, 1984), and Terry Eagleton, *The Ideology of the Aesthetic* (Oxford: Blackwell, 1990). This view could be countered by noting that most mainstream "bourgeois" aesthetics is not concerned with judgments of taste at all but with such issues as the logic and objectivity of interpretation, the nature of expression, representation, metaphor, fiction, etc. The Marxian could reply that these other topics are nevertheless typically pursued under the aegis of our concept of fine art, which is both a product and a support of sociocultural distinction and domination. John Dewey's pragmatist aesthetics embodied some of these Marxian insights without the materialist tendency to reduce aesthetic experience to social factors and political economies. See John Dewey, *Art as Experience* (Carbondale: Southern Illinois University Press, 1987); and my account of his theory in *Pragmatist Aesthetics: Living Beauty, Rethinking Art* (Oxford: Blackwell, 1992; 2d ed. New York: Rowman and Littlefield, 2000).

3. Philosophical discussions of Hume's essay typically praise its astuteness and the ingenuity of Hume's proposed solution, but go on to explain why his case for aesthetic objectivity is ultimately unconvincing or in some way deficient. See, for example, Peter Kivy, "Hume's Standard: Breaking the Circle," *British Journal of Aesthetics* 7 (1967): 57–66; Carolyn Korsmeyer, "Hume and the Foundations of Taste," *Journal of Aesthetics and Art Criticism* 35 (1976): 201–15; and Noël Carroll, "Hume's Standard of Taste," *Journal of Aesthetics and Art Criticism* 43 (1984): 181–94. Like most philosophers, these commentators see Hume's theory of taste as concerned more narrowly with epistemological rather than also with social issues.

4. One might argue that Hume earlier provides an additional requirement: "A perfect serenity of mind, a recollection of thought, a due attention to the object; if any of these circumstances be wanting, our experiment will be fallacious, and we shall be unable to judge of the catholic and universal beauty" (*ST*, 237). This, however, seems more a requirement for the "circumstances" in which a good critic should judge than a specification of the qualities required of a good critic.

5. Carroll, "Hume's Standard of Taste," 191.

6. Ibid., 192.

7. The liberal dilemma between concern for individual freedom and concern for a standard of rightness is discussed with respect to other important philosophers in Charles Dyke, "Collective Decision-Making in Rousseau, Kant, Hegel, and Mill," *Ethics* 80 (1969): 21–27.

8. See Paul Guyer, "The Standard of Taste and the 'Most Ardent Desire of Soci-

ety,' " in Ted Cohen, Paul Guyer, and Hilary Putnam (eds.), *Pursuits of Happiness: Essays in Honor of Stanley Cavell* (Lubbock: Texas Tech University Press, 1992), 37–66; citation on 51. Though Guyer recognizes that Hume's theory may have some social motivation, he is mainly interested in showing how Hume's idea of an authoritative standard of taste has specifically aesthetic advantages in augmenting aesthetic pleasure through social reinforcement. Augmentation comes from the pleasure of agreement with others, and the standard is sought to maximize such agreement and consequent pleasure. Neither Guyer nor Hume seriously questions whether truly universal agreement on refined taste is possible or desirable. Would our aesthetic pleasures really be increased by maximal agreement? Part of the social pleasure of taste seems to derive from the entertaining diversity of judgment. There may also be a form of snobbish, self-satisfied pleasure that one's taste is not shared by everyone but only by one's enlightened peers in superior distinction from people of less refinement, delicacy, and culture.

 This line of challenge, which closely connects taste with the socioeconomic conditions of its acquisition and sees taste as motivated by the desire for differentiating distinction rather than for unifying competing classes and class fragments, is elaborated in great empirical detail with respect to mid-twentieth century French culture in Bourdieu's *Distinction*. Though appreciative of Bourdieu's arguments, I also recognize the pleasures of agreement, and I remain skeptical of his sociological reduction of aesthetic experience and rejection of a popular aesthetic. For my critique of Bourdieu, see chapter 12 of this book and my *Performing Live: Aesthetic Alternatives for the Ends of Art* (Ithaca: Cornell University Press, 2000), chap. 2.

 9. This solution was adopted by Hume's contemporary, Lord Kames, who claimed that the universal assent demanded of taste "must have a foundation in nature," an independent ontological foundation outside the vagaries and contingencies of human preferences so "that individuals *ought* to be made conformable" to it. See Lord Kames [Henry Home], *Elements of Criticism*, A. Mills (ed.) (New York: Huntington and Savage, 1849), 467–68. It is interesting that an aristocrat like Kames, more assured in the "natural" superiority of his station, was more confident in grounding the idea of superior taste in the realm of nature than was a middle-class figure like Hume, whose career and livelihood depended partly on the taste of readers whose purchase of his books allowed him a literary-philosophical career.

 10. James Shelley is forced to concede this point in a thoughtful paper critiquing an earlier version of my arguments. But he tries to save a partial measure of naturalism in Hume's theory by making a distinction between the naturalist claim that there is a reaction of pleasure from the perception of certain forms or qualities that is natural and uniform in all men, and the further claim that the ability to perceive those forms or qualities is shared only by some who have the right talent and social training. Shelley (like Hume) gives no real argument to justify the naturalist claim. He is instead concerned with showing how Hume's naturalism can be made consistent with the need for social training that goes beyond the merely natural. See James Shelley, "Hume and the Nature of Taste," *Journal of Aesthetics and Art Criticism* 56 (1998): 29–38. For a defense of my reading of Hume that is reinforced by a detailed study of the eighteenth-century history

of taste, see Preben Mortensen, *Art in the Social Order* (Albany: State University of New York Press, 1997). For further discussion of the social and historical factors that helped shape the discipline of aesthetics in the eighteenth century, see Paul Mattick (ed.), *Eighteenth-Century Aesthetics and the Reconstruction of Art* (Cambridge: Cambridge University Press, 1993).

11. Kames, *Elements of Criticism*, 472.

12. Hume's younger contemporary, Joshua Reynolds, displays similar unease in trying to resolve the same fundamental tension of nature versus social privilege as the necessary basis for artistic taste. To reconcile them, Reynolds resorts to the contorted idea that true nature is simply that which is defined by (or pleasing to) the socially superior and culturally refined, while "the vulgar will always be pleased with what is natural, in the confined and misunderstood sense of the word." Like Hume, he senses the basic *differential* nature of taste, that is, that "the higher excellencies" of art are defined in contrast to vulgar beauties or "lower ornaments" and are apt to be "degraded" by close association with these latter. Good taste must likewise, for its very definition as good, set itself apart from the common or vulgar. Reynolds therefore warns of the dangers of public exhibitions of art, which threatened to degrade good art and taste by encouraging works aimed at "pleasing indiscriminately the mixed multitude of people who resort to them." See Joshua Reynolds, *Discourses on Art* (Indianapolis: Bobbs-Merrill, [1797] 1965), Discourse V, especially pages 61, 69, 70.

Hume's questionable conflation of culture with unprejudiced human nature is poignantly exposed in those parts of his essay where human nature, if freed from benighting prejudice and "superstition," is shown to bear a remarkable resemblance to the social dispositions of an eighteenth-century liberal Briton with strong prejudices against Islam and Roman Catholicism (*ST*, 233, 254).

13. Hume also makes this point in his essay "The Sceptic." After noting that secondary qualities and the aesthetic and ethical properties of "beauty and deformity, virtue and vice" are not properly in the object itself but are subject-dependent, Hume asserts: "There is a sufficient uniformity in the senses and feelings of mankind, to make all these qualities the objects of art and reasoning" and to provide them with sufficient "reality." See Hume, "The Sceptic," *Essays*, 168n.

14. With today's controversy and revision of the literary canon, we could readily challenge Hume's claim that consensus of taste is sufficiently wide and stable to justify his standard, especially when Hume asserts that "Terrence and Virgil maintain a universal, undisputed empire over the minds of men" (*ST*, 320). If we hesitate to challenge this, it may be because the social power of taste (through the cultural authority of its entrenched past judgments) tends to make such a challenge seem a breach of good taste.

15. Kant says that "this universality [of taste] is not to be based on a collection of votes and interrogation of others as to what sort of sensations they experience, but is to rest, as it were, upon an autonomy of the Subject passing judgement on the feeling of pleasure (in the given representation), i.e., upon his own taste. . . . [The judgement of taste] is required to be an independent judgement of the individual himself. . . . Taste lays claim simply to autonomy. To make the judgements of others the determining ground of one's own would be heteronomy" (*CJ*, 135–37).

16. In a similar way, Kant later tries to maintain both imagination's freedom and its submission to understanding's law by saying that its subsumption is not under understanding's concepts, but "under the *faculty* of concepts, i.e., the understanding" itself (*CJ*, 143).

17. "Critique of Aesthetic Judgement" is the first part of Kant's *Critique of Judgement*.

18. For Kant, pleasure from the satisfaction of an interest cannot be aesthetic, because it is not a free pleasure but dictated by the given interest, which "deprives the judgement on the object of its freedom." Thus, "taste in the beautiful may be said to be the one and only disinterested and *free* delight; for with it, no interest, whether of sense or reason, extorts approval" (*CJ*, 49). We see here how closely Kant associates the realm of the aesthetic with freedom and individual autonomy, and thus how resistant he would be to any recognition that such autonomy should be coerced into consensus rather than freely and naturally issue in one. The free disinterestedness of aesthetic judgment already implies Kant's other substantive criterion of a pure aesthetic judgment, viz. its concern with only the form of the object and total disregard of any possible use it may have, including any agreeable sensation, emotion, or charm it provides for us. The other two moments of Kant's definition of pure aesthetic judgment—conceptless universality and necessity—are more logical in nature.

19. "Taste that requires an added element of *charm* and *emotion* for its delight, not to speak of adopting this as the measure of its approval, has not yet emerged from barbarism" (*CJ*, 65). Given both these explicit and implicit admissions of the necessity of culture for the appreciation of natural *beauty* (rather than merely nature's charms), we should reject Guyer's claim that in "Kant's mature theory, it is hardly plausible to suppose that we must learn how to take pleasure in beauty, and thus that we should need education in society to do so." See Paul Guyer, "Pleasure and Society in Kant's Theory of Taste," in Ted Cohen and Paul Guyer (eds.), *Essays in Kant's Aesthetics* (Chicago: University of Chicago Press, 1982), 21–54. The role of cultural education is, of course, still more crucial and clearly recognized in the appreciation of beauty in fine art.

20. Refinement of taste is certainly valuable through its sharpening and enlarging of our aesthetic perception. However, the ideal that we must strive for a uniform standard of good taste through refinement harbors not only the threat of a tedious conformism but also a dangerous logic of spiraling cultural snobbism. If good taste and refinement are differentially defined by their distinction from bad or ordinary taste, then they require that they continually differentiate themselves from what is less refined or more common. If common perceptions are raised to coincide with the perceptions of good taste, then a new standard of refinement must be sought to ensure continued distinction. Such differentiation of taste can be expressed not only by changing the objects of taste but by changing the manner in which those objects are appreciated. This helps explain changing fashions of interpretation and criticism.

21. For an anthropologically based argument regarding the reasons why the cultural cannot be conceived as any sort of superficies detachable from and not partly formative of the natural, see Clifford Geertz, *The Interpretation of Culture* (New York: Basic Books, 1973), 55–83.

Chapter 6. Convention

1. Hilary Putnam, "Convention: A Theme in Philosophy," *New Literary History* 13 (1981): 1–14, quotations from 1 and 5; hereafter *CTP.*

2. Ludwig Wittgenstein, *Philosophical Investigations* (Oxford: Blackwell, 1968), para. 355, and *The Blue and Brown Books* (New York: Harper, 1958), 24.

3. Stanley Cavell, *The Claim of Reason* (Oxford: Oxford University Press, 1979), 111. The citation comes from a chapter entitled "Natural and Conventional."

4. J. L. Austin, *How to Do Things with Words* (Oxford: Oxford University Press, 1976), 105, 119.

5. *The Shorter Oxford English Dictionary,* 3d ed., vol. 1 (Oxford: Univ. Press, 1978), 417.

6. Bertrand Russell, *The Analysis of Mind* (London: Allen and Unwin, 1921), 190.

7. See W. V. Quine, foreword to D. K. Lewis, *Convention: A Philosophical Study* (Cambridge, Mass.: Harvard University Press, 1969), xii, hereafter *CPS.*

8. For a good general account of the notion of opposition and contrast and its pervasive role in semantics, see J. Lyons, *Semantics,* vol. 1 (Cambridge: Cambridge University Press, 1977), 240–91, 45–50.

9. C. K. Ogden, *Opposition: A Linguistic and Psychological Analysis* (Bloomington: Indiana University Press, 1967). See also I. A. Richards's introduction to this book, where he claims that "perception of oppositions is thus the active principle of language and of all *sign-situations*" (13).

10. J. L. Austin, *Sense and Sensibilia* (Oxford: Oxford University Press, 1964), 15; see also 70–71.

11. T. S. Eliot, "Sweeney Agonistes," in *The Complete Poems and Plays of T. S. Eliot* (London: Faber, 1969), 122.

12. For an interesting discussion of nonverbal conventional acts and the use of this notion to distinguish between Austin's theories of performative utterances and speech acts, see J. O. Urmson, "Performative Utterances," *Midwest Studies in Philosophy* 2 (1977): 120–27.

13. Note Austin's warning about "the deeply ingrained worship of tidy-looking dichotomies" (*Sense and Sensibilia,* 3)

14. For a more detailed account of this distinction, see Lyons, *Semantics,* 271–79.

15. E. Sapir, "On Grading: A Study in Semantics," *Philosophy of Science* 2 (1944): 93–116.

16. I. A. Richards, *Poetries and Sciences* (London: Routledge, 1970), 80.

17. For Lewis's analysis of coordination problems and their solutions, see especially *Convention,* 8–36. Briefly, "coordination problems are situations of interdependent decisions by two or more agents in which coincidence of interests predominates and in which there are two or more proper coordination equilibria" (24). For a more detailed study of these games and of games of conflict, see T. C. Schelling, *The Strategy of Conflict* (Cambridge, Mass.: Harvard University Press, 1960).

18. Lewis also gives a simpler but less accurate definition of convention (one not allowing for any exceptions) and also a quantitative definition (*CTP,* 76, 78–79). He later provides a somewhat less complicated formulation of his final

definition in D. K. Lewis, "Languages and Language," in *Minnesota Studies in the Philosophy of Science*, vol. 7, K. Gunderson (ed.) (Minneapolis: University of Minnesota Press, 1975), 3–35.

19. Lewis, however, cautiously allows that "perhaps not all of us do share any one clear general concept of convention"; and thus when he finds his theory contradicting established usage, he claims that he can only undertake to analyze his own concept of convention (*CPS*, 3, 46).

20. Originally Lewis defined conventions so that situation *S* had to be a particular coordination problem. But because of difficulties in distinguishing particular problems in certain cases of continuous coordinative activity, Lewis translates the essential import of *S* being a coordination problem into requirements 3–5 of his final definition. See *CPS*, 42, 58, 68–76.

21. Perhaps it may be possible to extend Lewis's analysis to situations where conflict of interests dominates, or to reinterpret such situations (when conventions apply in them) as situations of community of interest, in terms of some limited shared interest. However, it is far from clear how or whether this could be adequately done.

22. This requirement of common knowledge has been criticized by Tyler Burge, "On Knowledge and Convention," *Philosophical Review* 87 (1975): 249–55.

23. Indeed, one dictionary illustrates the meaning of "convention" by the common phrase "a slave of convention." See *Longmans English Larousse* (London: Longmans, 1968), 252.

24. The Longmans dictionary in fact defines one sense of "convention" as "an arbitrary but consistently observed usage" (252). Urmson, in "Performative Utterances" (124), explains a conventional act in terms of the arbitrary; and Jonathan Culler is one example of the many who interchangeably characterize the linguistic sign as "arbitrary or conventional." See Culler, *Structuralist Poetics* (Ithaca: Cornell University Press, 1975), 5, 16–17. Note, however, that Lyons, after echoing the platitude that the linguistic sign is conventional or arbitrary, goes on to suggest "that the notion of arbitrariness is rather more complex than at first it appears to be" and "that 'arbitrary' and 'conventional' are not equivalent" (*Semantics*, 101).

25. These conventions are posited by Culler in *Structuralist Poetics* (115–30), who explains them and their mastery as analogous to linguistic conventions and competence.

Chapter 7. From Natural Roots to Cultural Radicalism

1. See Alain Locke, "Values and Imperatives," in Leonard Harris (ed.), *The Philosophy of Alain Locke* (Philadelphia: Temple University Press, 1989), 34, hereafter *PAL*. In another essay, "Good Reading," Locke further notes "the continuous role and function of philosophy as sometimes the guide to life and sometimes merely the trail that shows the paths man's mind has taken" (*PAL*, 105). In this chapter, I also cite extensively from Locke's own important collection, *The New Negro: An Interpretation* (New York: Boni, 1925), hereafter *NN*.

2. Richard Shusterman, *Pragmatist Aesthetics: Living Beauty, Rethinking Art* (Oxford: Blackwell, 1992; 2d ed. New York: Rowman and Littlefield, 2000), hereafter *PA*.

3. What made my ignorance of Locke particularly poignant was the bond of personal history I share with him: both of us born of ethnic minorities in Philadelphia, both graduates of its Central High School, and both postgraduate students of philosophy at Oxford. Like Locke, I appreciatively pursued nationalistic movements of ethnic pride (though my contribution to Israel was far more meager and military than Locke's gift to the Harlem Renaissance); yet, again like Locke, I share the cosmopolitan wanderer's fear of the sectarian provincialism that ethnic and nationalistic enthusiasms too readily foster.

4. John Dewey, *Art as Experience* (Carbondale: Southern Illinois University Press, [1934] 1987), 155–56, hereafter *AE*. On this issue of naturalism and in much else, Dewey's aesthetics owes a clear but insufficiently acknowledged debt to Emerson's theories of art. For more on this topic, see my "Emerson's Pragmatist Aesthetics," *Revue internationale de philosophie* 207 (1999): 87–99.

5. Although the word "Negro" is generally no longer used and can be considered demeaning, I use it in some instances here in accord with Locke's usage and his desire to give the term a culturally positive meaning.

6. Locke's choice of the term "instinct" is unfortunate. It suggests physiological hard-wiring of fixed reactions rather than the sort of unreflective, habituated feeling and action that is experienced as natural, since it emerges spontaneously, without deliberation, from our familiar natural-social environment.

7. Locke explicitly insists on African art's "lesson of discipline, . . . of technical control pushed to the limits of technical mastery" as an especially needed inspiration for the contemporary African American artist (*NN*, 256).

8. Alain Locke, "Art or Propaganda?" in Jeffrey Stewart (ed.), *The Critical Temper of Alain Locke: A Selection of His Essays on Art and Culture* (New York: Garland, 1983), 27, hereafter *CTAL*.

9. This is shown, for example, by his close study of social science on the issues of race and culture and also his collaboration with the social scientist Melville Herskovits. See Mark Helbling, "Feeling Universality and Thinking Particularistically: Alain Locke, Franz Boas, Melville Herskovits, and the Harlem Renaissance," *Prospects* 19 (1994): 289–314.

10. A longer study of jazz and its evolution from the blues can be found in Alain Locke, *The Negro and His Music* (Washington, D.C.: Associates in Negro Folk Education, 1936).

11. See Tommy Lee Lott, "The 1960s Avant-Garde Movement in Jazz," *Social Identities* 7 (2001): 165–77. Sterling Brown, a poet colleague at Howard whom Locke admired, reports that Locke's distaste for blues was such that he would close the window if he heard someone singing it outside. For more critique on Locke's attention to the blues, see Paul Burgett, "Vindication as a Thematic Principle in the Writing of Alain Locke on the Music of Black Americans," in Samuel Floyd (ed.), *Black Music in the Harlem Renaissance: A Collection of Essays* (Knoxville: University of Tennessee Press, 1993), 29–40.

12. To advocate the general aesthetic principle of mixing, does not, of course, mean accepting the value of all mixtures. Locke himself disapproved of one "hybrid treatment" of spirituals which, in trying to merge them with the dominant high art concert convention, omits their choral accompaniment to highlight solo artistry (*NN*, 208). Locke was also critical of Gershwin's mixing of "art-music

and folk music" by an "easy-going formula of superimposing one upon the other" (*CTAL*, 111).

Moreover, Locke worried about the dangers of mixing interaction between the lower "unfavorable" levels of the white and black races. Displaying what might seem like a rather undemocratic sentiment (but may just be a prudent sense of the limits of his time), Locke argued "that the only safeguard for mass relations in the future must be provided in the carefully maintained contacts of the enlightened minorities of both race groups" (*NN*, 9). Locke later showed greater respect for "the mass Negro" in "Who and What Is 'Negro'?" published in 1942 (*PAL*, 209–28).

13. I therefore define my pragmatist position on popular art as "a *meliorism*, which recognizes popular art's grave flaws and abuses but also its merit and potential. It holds that popular art *should be* improved because it leaves so much to be desired, but that it *can be* improved because it can, and often does, achieve real merit and serve worthy social goals" (*PA*, 177).

14. Similar uses of the notion of race can be found among contemporary African American philosophers like Lucius Outlaw in *On Race and Philosophy* (New York: Routledge, 1996), though there is also the tendency to critique race as a distorting fiction, as in Anthony Appiah, *In My Father's House: Africa in the Philosophy of Culture* (Oxford: Oxford University Press, 1993).

15. "Race operates as tradition, as preferred traits and values, and when these things change culturally speaking ethnic remoulding is taking place. Race . . . is . . . that peculiar selective preference for certain cultural-traits and resistance to certain others which is characteristic of all types and levels of social organization" (*PAL*, 195).

16. Alain Locke, *The Negro and His Music* (1936; reprint, New York: Arno Press, 1969), 70.

17. For my more detailed account of rap's philosophical significance, see *PA*, chap. 8; and my "Rap Remix: Pragmatism, Postmodernism, and Other Issues in the House," *Critical Inquiry* 22 (1995): 150–58, and *Practicing Philosophy: Pragmatism and the Philosophical Life* (New York: Routledge, 1997), chap. 5.

18. Locke's efforts in educational reform are usefully documented by Leonard Harris. See *PAL*, 5–10, 239–76.

19. The pragmatic idea of philosophy as a life-practice and guide for living is, in fact, very ancient, and this practice has often been conceived in aesthetic terms. For a study that links its ancient roots to twentieth-century pragmatism, see my *Practicing Philosophy*.

20. In advocating better material conditions for black jazz musicians, Locke claims that "there is a direct connection between any economic improvement in this field and the artistic quality of the product" (*CTAL*, 119). The subsequent history of commercialization of jazz and rap may make such a claim more contestable today.

21. Locke also edited *Four Negro Poets* (New York: Simon and Schuster, 1927), *Plays of Negro Life: A Source-Book of Native American Drama*, ed. with Montgomery Gregory (New York: Harper, 1927), and *The Negro in Art: A Pictorial Record of the New Negro Artist and of the Negro Theme in Art* (Washington, D.C.: Associates in

Negro Folk Education, 1940). In addition, Locke authored critical studies on *The Negro and His Music* and *Negro Art: Past and Present*, both published in Washington, D.C., by Associates in Negro Folk Education, 1936. In discussing Locke's practical criticism, one should also note his frequent yearly reviews of black literature written for *Opportunity* and later for *Phylon*. For a very helpful collection of Locke's essays on art and culture, see Stewart (ed.), *The Critical Temper of Alain Locke*.

22. For more detailed critique of Dewey on this point, see my "Popular Art and Education," *Studies in Philosophy and Education* 13 (1995): 203–12.

Chapter 8. Eliot and Adorno on the Critique of Culture

1. See T. S. Eliot, "Arnold and Pater," *Selected Essays* (London: Faber, 1976), 352–93, hereafter *SE*.

2. Eliot's cultural criticism is taken seriously only by conservatives, particularly by traditionalist Christian thinkers. Most secular progressives either try to ignore this aspect of Eliot so as to concentrate more positively on his literary and philosophical achievement, or they instead read all of Eliot's work in light of his religious and political conservatism, usually with baneful consequences for our appreciation of his thought. Though the first option can be very fruitful—since most of Eliot's arguments in the philosophy of criticism do not in any way depend on his religious or political doctrines, the latter path is more often pursued. Eliot's outspoken conservatism in religion and politics is largely responsible for the frequent disdainful dismissal of his literary theory and critical practice among today's secular literary theorists, who generally see themselves as politically progressive. I document this in Richard Shusterman, *T. S. Eliot and the Philosophy of Criticism* (New York: Columbia University Press, 1988), chap. 1.

3. This is especially true since Eliot comes close to identifying culture with religion, where religion is widely conceived "as the *whole way of life* of a people, from birth to the grave," and culture is similarly holistically construed. See T. S. Eliot, *Notes towards the Definition of Culture* (London: Faber, 1962), 31, hereafter *NDC*. Eliot does not quite identify the two, but regards culture as the incarnation of a people's religion.

4. See T. W. Adorno, *Minima Moralia* (London: Verso, 1978), 192, hereafter *MM*.

5. See T. S. Eliot, *The Varieties of Metaphysical Poetry* (New York: Harcourt, Brace, 1993), 41. Further quotations in this and the following paragraph are from pp. 78–83.

6. See T. S. Eliot, *Knowledge and Experience in the Philosophy of F. H. Bradley* (London: Faber, 1964), 138.

7. See T. W. Adorno and Max Horkheimer, *Dialectic of Enlightenment* (New York: Continuum, 1986), 3.

8. See Shusterman, *T. S. Eliot and the Philosophy of Criticism*, chap. 7, which is devoted to an analysis of the concept of tradition and where the philosophical views of Gadamer, Wittgenstein, and the pragmatists are related in detail to Eliot's theory of tradition.

9. See T. S. Eliot, *After Strange Gods* (New York: Harcourt, Brace, 1934), 18, 31.

10. See *NDC*, 94, and T. S. Eliot, *To Criticize the Critic and Other Writings* (London: Faber, 1969), 76, hereafter *TCC*.

11. See Eliot, *Knowledge and Experience in the Philosophy of F. H. Bradley*, 14–15.

12. For a detailed discussion of Eliot's changing notions of objectivity and his hermeneutic, historicist turn, see Shusterman, *T. S. Eliot and the Philosophy of Criticism*, 41–76, 107–33.

13. See *TCC*, 104, and T. S. Eliot, *The Use of Poetry and the Use of Criticism* (London: Faber, 1964), 141–42, hereafter *TUP*.

14. See T. S. Eliot, "Experiment in Criticism," *Bookman* 70 (1929): 225.

15. See *NDC*, 120. Eliot's cultural ideal is "variety in unity," where "the variety is as essential as the unity." See *NDC*, 120, and Eliot's *On Poetry and Poets* (London: Faber, 1957), 23, hereafter *OPP*.

16. See T. S. Eliot, "Religion without Humanism," in N. Foerster (ed.), *Humanism and America* (New York: Farrar and Rhinehard, 1930), 108, hereafter *RH*.

17. T. S. Eliot, *Essays Ancient and Modern* (London: Faber, 1936), 114–15, hereafter *EAM*.

18. See T. S. Eliot, "Literature, Science, and Dogma," *Dial* 82 (1927): 239–43.

19. See Hilary Putnam, *Meaning and the Moral Sciences* (London: Routledge, 1979), 72–73; and Michael Polanyi, *Personal Knowledge* (London: Routledge, 1958).

20. See T. S. Eliot, "Commentary," *Criterion* 12 (1933): 644. Later, in *The Idea of a Christian Society* (London: Faber, 1982), hereafter *CS*, Eliot continues to admit the possibility of a secular alternative to Christianity as a remedy for cultural and social regeneration from the negative fragmentation of liberalism: "My thesis has been, simply, that a liberalized or negative condition of society must either proceed into a gradual decline of which we can see no end, or (whether as a result of catastrophe or not) reform itself into a positive shape which is likely to be effectively secular. . . . But unless we are content with the prospect of one or the other of these issues, the only possibility left is that of a positive Christian society" (*CS*, 55). Eliot later went so far as to recognize that class revolution might be necessary and justified for the regeneration of society. This could occur when "the ruling class" loses touch with the "essential interests" of society so that social "harmony" is "broken." "Or the social circumstances may alter, through economic or other developments, so that the centre of power shifts, or should shift, to another class. History has found various methods of dealing with a ruling class, when such a situation has arisen." These remarks are from a letter Eliot wrote in August 1943, which is reproduced in part in Roger Kojecky's *T. S. Eliot's Social Criticism* (London: Faber, 1971), 191.

21. See also Adorno and Horkheimer, *Dialectic of Enlightenment*, 3–42, 81–96.

22. T. W. Adorno, *Aesthetic Theory* (London: Routledge, 1984), 454–55, hereafter *AT*.

23. See, for example, Robert Fogel, *The Fourth Great Awakening and the Future of Egalitarianism* (Chicago: University of Chicago Press, 2000).

24. Adorno's most concentrated critiques of the culture industry and its effects of mass conformism and deception are found in Adorno and Horkheimer, *Dialectic of Enlightenment*, 120–67, and Adorno, *Aesthetic Theory*. Eliot notes that because of the homogenizing effects of industrialization and the bureaucracy of

étatisme, the cherished liberal "domain of 'private life' becomes smaller and smaller, and may eventually disappear altogether" (*CS*, 51).

25. Eliot's critique of liberalism throughout the 1930s (and later) must not be read as an endorsement of any sort of fascism, which he most strongly deplored for its very similar "totalitarian worldliness" (*CS*, 52, 82–83). Indeed, Eliot remarks that he was stimulated to write *The Idea of a Christian Society* in 1938 out of his opposition to Hitler and his perception of England's moral weakness in the 1938 appeasement, a weakness he thought symptomatic of great social and cultural decay.

26. Eliot, *Knowledge and Experience in the Philosophy of F. H. Bradley*, 105, 152, 161.

27. Adorno further claims: "Not only is the self entwined in society; it owes society its existence in the most literal sense. All its content comes from society, or at any rate from its relation to the object. It grows richer the more freely it develops and reflects this relation, while it is limited, impoverished, and reduced by the separation and hardening that it lays claim to as an origin. Attempts like Kierkegaard's, in which the individual seeks abundance by retreat within himself, did not by accident end up in the sacrifice of the individual" (*MM*, 154).

28. See Richard Shusterman, *Practicing Philosophy: Pragmatism and the Philosophical Life* (New York: Routledge, 1997), chaps. 2 and 3.

29. See *TUP*, 21: "Such changes as that from the epic poem composed to be recited to the epic poem composed to be read, or that which put an end to the popular ballad are inseparable from social changes on a vast scale, such changes as have always taken place and always will." And later, more globally: "Any radical change in poetic form is likely to be the symptom of some very much deeper change in the society and in the individual" (*TUP*, 75). Eliot cites with approbation Trotsky's affirmation of the deep dependence of artistic change on social forces (*TUP*, 135–36). Adorno makes a similar point in *AT*, 298.

30. Eliot, *After Strange Gods*, 19–29.

31. Eliot writes in *After Strange Gods* (36, 68) that a "tradition, simply by its influence upon the environment in which the poet develops, will tend to restrict eccentricity to manageable limits: but it is not even by the lack of this restraining influence that the absence of tradition is most deplorable. What is disastrous is that the writer should deliberately give rein to his 'individuality,' that he should cultivate his differences from others; and that his readers should cherish the author . . . because of them."

32. For elaboration of this point, see Shusterman, *T. S. Eliot and the Philosophy of Criticism*, chap. 6.

33. See T. S. Eliot, "Commentary," *Criterion* 11 (1932): 678, 682. Eliot felt that any poet would like to reach "as large and miscellaneous an audience as possible," confessing "I myself should like an audience which could neither read nor write" (*TUP*, 152). Eliot, like Adorno, distinguishes between traditional popular art and the more meretriciously manipulative mass media art of the culture industry. Both of them specifically express their approbation of "music-hall" art (*SE*, 456–59; *TUP*, 154; *AT*, 156).

34. For a detailed demonstration of this point, see Richard Shusterman, *Prag-*

matist Aesthetics: Living Beauty, Rethinking Art (Oxford: Blackwell, 1992; 2d ed. New York: Rowman and Littlefield, 2000), chap. 7.

35. For Eliot's definition of poetry as "a superior amusement," see T. S. Eliot, *The Secret Wood* (London: Methuen, 1968), viii.

36. In many great artworks, Adorno admits, "their perfection monumentalizes force and violence" (*AT*, 229). But art, he argues, remains superior to the social world in that its repression is metaphorical and results in true integration and beauty. "Works of art cannot help continuing the work of repressive reason, for they contain that moment of synthesis which helps organize a totality. While disavowing real repression, art heeds the principle of repression in a metaphorical, we might also say truncated and shallow-like, manner" (*AT*, 423–24).

Chapter 9. Deep Theory and Surface Blindness

1. See, for example, D. M. Anderson, *The Art of Written Forms* (New York: Holt, Rhinehart, and Winston, 1969); A. Fairbank, *The Story of Handwriting* (New York: Watson-Guptill, 1970); and W. Chappell, *A Short History of the Printed Word* (Boston: Godine, 1980).

2. Chappell, *Short History of the Printed Word*, 12, 28–38.

3. Richard Shusterman, "The Anomalous Nature of Literature," *British Journal of Aesthetics* 18 (1978): 317–29.

4. These visual effects are of different kinds and have different roles: some have aesthetic impact in themselves, some serve to foreground and thus enhance the aesthetic effect of other aspects of the literary work, and some, perhaps the most effective, do both. For a detailed analysis of the various visual effects, see R. P. Draper, "Concrete Poetry," *New Literary History* 2 (1971): 329–40. For a historical study of visual poetry, see Willard Bohn, *The Aesthetics of Visual Poetry, 1914–1928* (Cambridge: Cambridge University Press, 1986).

5. See, for example, Benedetto Croce, *Aesthetic* (London: Macmillan, 1922), 100; Roman Ingarden, *The Literary Work of Art* (Evanston: Northwestern University Press, 1973), chap. 14; and Mikel Dufrenne, *Le poétique* (Paris: Presses Universitaires de France, 1973), 70–71. Other examples are cited in J. J. A. Mooij, "On the 'Foregrounding' of Graphic Elements in Poetry," in D. W. Fokkema et al. (eds.), *Comparative Poetics* (Amsterdam: Rodopi, 1976), 90–93.

6. M. C. Beardsley, *Aesthetics* (New York: Harcourt, Brace, 1958), 116.

7. J. O. Urmson, "Literature," in G. Dickie and R. J. Sclafani (eds.), *Aesthetics* (New York: St. Martin's, 1977), 338.

8. R. Wellek and A. Warren, *Theory of Literature* (London: Penguin, 1970), 144, 154–56. For a detailed critique of Ingarden's view, see Richard Shusterman, "Ingarden, Inscription, and Literary Ontology," *Journal of the British Society for Phenomenology* 18 (1987): 103–19.

9. J. Derrida, *Marges de la philosophie* (Paris: Minuit, 1972), 376. See also the account of his views in J. Culler, *Structuralist Poetics* (Ithaca: Cornell University Press, 1977), 131–33.

10. These citations from *Phaedrus* are from *The Dialogues of Plato*, vol. 1, trans. B. Jowett (New York: Random House, 1937), 281. For discussion of philosophy as more or other than a practice of writing, see Richard Shusterman, *Practicing Phi-*

losophy: Pragmatism and the Philosophical Life (New York: Routledge, 1997). For an account of philosophy as an art of living that makes writing and the creation of a literary personality the center of that life, see Alexander Nehamas, *The Art of Living* (Berkeley: University of California Press, 1998).

11. P. B. Shelley, "A Defence of Poetry," in E. D. Jones (ed.), *English Critical Essays (Nineteenth Century)* (Oxford: Oxford University Press, 1945), 121, hereafter *S*.

12. G. W. F. Hegel, *Introduction to Aesthetics* (Oxford: Oxford University Press, 1979), 88–89.

13. Urmson, "Literature," 334–41.

14. See Shusterman, "The Anomalous Nature of Literature."

15. O. Wilde, "The Critic as Artist," in *The Works of Oscar Wilde* (London: Collins, 1954), 955–56.

16. J. Mukarovsky, "Art as a Semiotic Fact," and "Poetic Reference," in L. Matejka and I. R. Titunik (eds.), *Semiotics of Art* (Cambridge: MIT Press, 1976), 9, 160–62; Roland Barthes, *Critique et vérité* (Paris: Seuil, 1966), 11–16; Beardsley, *Aesthetics,* 129; and Nelson Goodman, *Languages of Art* (Oxford: Oxford University Press, 1969), 252–55, and *Of Mind and Other Matters* (Cambridge, Mass.: Harvard University Press, 1984), 135–38.

17. Goodman, *Languages of Art,* 229. I should note that Goodman himself ultimately decides to treat the literary work as syntactically articulate rather than replete, thus treating typography as inessential to the work's identity. However, Goodman admits that this decision is not based on "aesthetic" grounds but rather motivated by the desire to provide a rigorously precise notational definition of the literary work by equating the work's identity with the syntactic identity of its text. Goodman more generally defines work-identity as independent of the work's aesthetic properties (115–22, 207–71).

18. Goodman, *Languages of Art,* 229.

19. The precise graphic shape of the tale-tail has varied in different printings. For more details on the mouse-tail poem, its original version, and its proposed revision, see Martin Gardner (ed.), *The Annotated Alice* (New York: Clarkson N. Potter, 1960), and *More Annotated Alice* (New York: Random House, 1990).

Chapter 10. Art in a Box

1. I examine these pragmatist aims in much greater detail in *Pragmatist Aesthetics: Living Beauty, Rethinking Art* (Oxford: Blackwell, 1992; 2d ed. New York: Rowman and Littlefield, 2000), and *Practicing Philosophy: Pragmatism and the Philosophical Life* (New York: Routledge, 1997).

2. See Arthur Danto, *The Philosophical Disenfranchisement of Art* (New York: Columbia University Press, 1986), 210, hereafter *PD*. Similarly, I shall be referring to Danto's *The Transfiguration of the Commonplace* (Cambridge, Mass.: Harvard University Press, 1981), hereafter *TC; Beyond the Brillo Box: The Visual Arts in Post-Historical Perspective* (New York: Farrar, Straus, and Giroux, 1992); *After the End of Art: Contemporary Art and the Pale of History* (Princeton: Princeton University Press, 1997), hereafter *ATE;* and *The Madonna of the Future: Essays in a Pluralistic Artworld* (New York: Farrar, Straus, and Giroux, 2000), hereafter *MF*.

3. For a more detailed account of this genealogical critique, see my *Pragmatist Aesthetics*, chap. 2, and *Practicing Philosophy*, chap. 1.

4. See George Dickie, *Aesthetics* (Indianapolis: Bobbs-Merrill, 1971), 101, and *Art and the Aesthetic: An Institutional Analysis* (Ithaca: Cornell University Press, 1974). I provide more detailed critique of his theory in *Pragmatist Aesthetics*, 38–40.

5. Danto later urges: "A philosophical definition [of art] has to capture everything and so can exclude nothing" that belongs to the extension of art; it must cover "every kind and order of art" (*ATE,* 36).

6. I critically examine some of these other historical theories (including those of Adorno, Wollheim, Wolterstorff, and Carroll) in *Pragmatist Aesthetics*, chap. 2.

7. In his latest writings, Danto tries to avoid this worry by insisting more on what he calls art's unchanging "transhistorical essence" that "is always the same" than on the developing "historical essence" that he stressed in *The Philosophical Disenfranchisement of Art*. He claims that there is "a fixed and universal artistic identity" or "unchangeable" essence of art, even an "extrahistorical concept of art," but that this essence merely "discloses itself through history" (*ATE,* 28, 187, 193). Likewise, though this defining essence determines the limits of art (by marking art off from what is not art), it does not in any way limit how art can appear, since aesthetic properties are excluded from this essence. So in that sense anything can be a work of art.

The problem with this essentialist strategy is that the definition it provides is not at all helpful in telling us how to recognize a work of art, which is one of the reasons why essentialist definitions were sought. Nor does Danto's notion of essence provide criteria for evaluating art or make stylistic suggestions for creating art, the other important practical motive for seeking definition. Both good and bad artworks, Danto realizes, must have the very same essence, since both are works of art by virtue of that essence and since that essence has nothing to do with aesthetic or style qualities (*ATE,* 197; *MF,* 427). A further failure of Danto's theory is that he cannot define art's essence in an adequate way. His two criteria for the essence of an artwork (which he admits are too "meager" to "be the entire story") are to "have a content or meaning" and "to embody its meaning" (*MF,* xix). Yet iconic signs and all sorts of cultural objects meet these criteria, as do most intentional actions. A real-life kiss has meaning and embodies it. But that does not make it a work of art; though, of course, one could stage a kiss as an artwork or represent one—as Klimt and Rodin did so sensually.

8. Originally depressed by this prospect of no future progress, Danto now tries to console himself with what he calls art's "lateral diversity" (*MF,* 431), a brave euphemism for what his theory defines as art's confused lack of direction once it has reached the end of its road.

9. According to Danto, "there has to be some extrahistorical concept of art for there to be conceptual revolutions in [art]" (*ATE,* 187).

10. See Immanuel Kant, *The Critique of Judgement*, trans. J. C. Meredith (Oxford: Oxford University Press, 1952), 43.

11. Danto, *Beyond the Brillo Box*, 94, 96.

12. Andy Warhol, *The Philosophy of Andy Warhol* (New York: Harcourt, Brace, Jovanovich, 1975), 92. After considerable criticism, Danto is now ready to con-

cede that real Brillo boxes are works of commercial art, but he still insists on distinguishing this from art proper, which he identifies with fine art. He sees the meaning of Warhol's *Brillo Box* as reinforcing the fine art/commercial art dichotomy, but I think Warhol's genius is precisely in questioning it by blending them in one artwork. In designing a shirt from the pattern of S&H Green Stamps and a dress from Campbell's Soup graphics, Warhol further blends commercial art and fine art with fashion art, that is, wearable real-world objects.

13. Danto recognizes this in his treatment of what he calls "disturbational art," exemplified, for example, by performance pieces which, by bringing real risk, danger, or obscenity into art, try to breach "the insulating boundaries between art and life." Such art aims at restoring some of art's old "deep magic" as "a miraculous intervention" in the real, and it works (when it does) by absorbing audience and artists into a commonly constructed aesthetic reality where we suspend our philosophical or aesthetic distance and accept the reality of the experiential. Danto candidly confesses that such art does not work for him because he is "always outside it," that is, always too much the prisoner of philosophy's pose of rational detachment, which nourishes not only the art/reality dichotomy but the idea that aesthetic reception must be distanced and disinterested (*PD*, 121, 126, 133).

14. For a more detailed discussion of these arts, which explains their contemporary prominence in terms of narratives of "the end of art" (including Danto's), see my *Performing Live: Aesthetic Alternatives for the Ends of Art* (Ithaca: Cornell University Press, 2000). For philosophy as a comprehensive art of living and concerned with aesthetic self-realization, see my *Practicing Philosophy*. For a rather different account of philosophy as an aesthetic life through mere writing (rather than more distinctively embodied practices), see Alexander Nehamas, *The Art of Living* (Berkeley: University of California Press, 1998).

15. G. W. F. Hegel, *Introductory Lectures on Aesthetics* (London: Penguin, 1993), 9, 12, 13.

16. Gretchen Berg, "Andy: My True Story," *Los Angeles Free Press*, 17 March 1967, 3. For an interesting study of Warhol's interest in surface and a consequent critique of Danto's interpretation of Warhol as offering an aesthetics of metaphysical depth, see Paul Mattick, "The Andy Warhol of Philosophy and the Philosophy of Andy Warhol," *Critical Inquiry* 24 (1998): 965–87. Danto's more general disregard of aesthetic surface has been castigated by other critics as a distressing limitation on his art criticism. See, for example, Sarah Boxer's "Non-Art for Non-Art's Sake," a review of Danto's *Madonna of the Future*, *New York Times*, 6 August 2000.

17. For instance, the Hirshhorn Museum in Washington, D.C., held a major show in 1999 entitled "Regarding Beauty in Performance and the Media Arts, 1960–1999," and in 2000 the grand Palais des Papes in Avignon was devoted to a huge show entitled "La Beauté." Even Danto is showing new interest in the topic. He contributed an essay, "Beauty and Morality," to the catalog of the Hirshhorn show and a chapter, "Beauty and Beautification," to Peg Brand (ed.), *Beauty Matters* (Bloomington: Indiana University Press, 2000); and his Carus Lectures of 2001 are entitled "The Abuse of Beauty."

18. Responding to an earlier version of this chapter, Danto challenged my in-
terventionist stance as a violation of art's autonomy. "What art chooses to do
with itself is the business of art, not of philosophy"; it should be left completely
"free . . . to go its own way." See Arthur Danto, "Responses and Replies," in M.
Rollins (ed.), *Danto and His Critics* (Oxford: Blackwell, 1993), 214–15. This com-
plaint conflates philosophical engagement with philosophical tyranny. Art—as a
valued, contested social phenomenon or cultural tradition—is the business of all
those involved in the formation and clarification of our culture, philosophers in-
cluded. If art seems unclear of its direction, and if it has often gained crucial
ideas and orientations from philosophy, then the exclusion of philosophical in-
tervention seems a perverse purism that only makes art more vulnerable to
other, more sinister influences. Danto himself affirms a more dictatorial philo-
sophical posture over art when he urges, in a more recent book from 2000, that
any "progress" of art's "self understanding" must be "philosophical progress,
progress in the analysis of the concept" of art, which he narrowly sees in terms of
essentialist definition (*MF*, 428). Suzi Gablik attempts to mediate the debate be-
tween Danto and myself in her *Conversations before the End of Time* (London:
Thames Hudson, 1995), 247–89.

Chapter 11. Pragmatism and Culture

1. See Margolis's trilogy, *The Persistence of Reality*, including *Pragmatism with-
out Foundations, Science without Unity,* and *Texts without Referents* (Oxford: Black-
well, 1986, 1987, 1989); *What, After All, Is a Work of Art?* (University Park: Penn-
sylvania State University Press, 1998); *The Flux of History and the Flux of Science*
(Berkeley: University of California Press, 1993); and *Interpretation: Radical but Not
Unruly* (Berkeley: University of California Press, 1994), hereafter *I*. For Richard
Rorty's pragmatist views on culture, see especially *Consequences of Pragmatism*
(Minneapolis: University of Minnesota Press, 1982), *Contingency, Irony, and Soli-
darity* (Cambridge: Cambridge University Press, 1989), and *Achieving Our Coun-
try* (Cambridge, Mass.: Harvard University Press, 1999), hereafter *AC*. See also
John Stuhr, *Genealogical Pragmatism: Philosophy, Experience, and Community* (Al-
bany: State University of New York Press, 1997); and Richard Shusterman, *Prag-
matist Aesthetics: Living Beauty, Rethinking Art* (Oxford: Blackwell, 1992; 2d ed.
New York: Rowman and Littlefield, 2000), hereafter *PA; Practicing Philosophy:
Pragmatism and the Philosophical Life* (New York, Routledge, 1997), 6, hereafter *PP;*
and *Performing Live: Aesthetic Alternatives for the Ends of Art* (Ithaca: Cornell Uni-
versity Press, 2000), hereafter *PL*.

2. I had already made the point in an earlier essay, "Interpretation, Intention,
and Truth," *Journal of Aesthetics and Art Criticism* 47 (1988): 399–411, which in-
cluded a critique of Margolis's earlier theory of interpretation that posited a core
of fixity in descriptive properties of a work that were contrasted with interpre-
tive properties and served as the necessary substratum for the latter.

3. See John Dewey, *The Quest for Certainty* (1929; Carbondale: Southern Illinois
University Press, 1984), hereafter *QC*.

4. Joseph Margolis, "Replies in Search of Self-Discovery," in Michael Krausz
and Richard Shusterman (eds.), *Interpretation, Relativism, and the Metaphysics of*

Culture: Themes in the Philosophy of Joseph Margolis (Amherst, N.Y.: Humanity Books, 1999), 342.

5. Rorty, *Consequences of Pragmatism,* 151.

6. Rorty, *Contingency, Irony, and Solidarity,* 141.

7. I defend this point against Alexander Nehamas, who criticizes my emphasis on aesthetic experience and its hedonic and consummatory features. See Nehamas, "Richard Shusterman on Pleasure and Aesthetic Experience," *Journal of Aesthetics and Art Criticism* 56 (1998) : 49–51; and my response, "Interpretation, Pleasure, and Value in Aesthetic Experience," ibid.: 51–53. Rorty addresses some earlier formulations of my criticisms in "Response to Richard Shusterman," in Matthew Festenstein and Simon Thompson (eds.), *Richard Rorty: Critical Dialogues* (Cambridge: Polity Press, 2001), 153–57.

Chapter 12. Cultural Analysis and the Limits of Philosophy

1. Pierre Bourdieu, *Raisons pratiques: sur la théorie de l'action* (Paris: Seuil, 1994), trans. as *Practical Reason: On the Theory of Action* (Stanford: Stanford University Press, 1998); and *Méditations pascaliennes* (Paris: Seuil, 1997), hereafter *MP,* trans. as *Pascalian Meditations* (Stanford: Stanford University Press, 2000), hereafter *PM.* With respect to these and other works by Bourdieu, I cite the English edition but occasionally modify the published quotations by my own translation from the French. The contents of the French and English editions are not always identical.

2. A philosophy student at the elite École Normale Supérieure, Bourdieu focused his later graduate work on Leibniz. After Bourdieu passed the *aggrégation* (which qualifies one for a university teaching post in France), his teacher, Georges Canguilhem (who was also Foucault's), tried to convince him to continue his philosophical career in France by pursuing research in the phenomenology of affective life. But Bourdieu left France to teach philosophy at the University of Algiers because of his growing interest in the struggles of Algeria. Bourdieu's continuing fascination with Algerian society led to an ever-deeper immersion in its sociology and ethnology and a consequent professional metamorphosis into something more, or other, than a philosopher. Bourdieu's enduring respect for philosophy and its problems is evident not only in his writings but in the book series he long edited with Éditions de Minuit (which published the likes of Cassirer, Adorno, Marcuse, and Searle).

3. Pierre Bourdieu, *The Logic of Practice* (Cambridge: Polity Press, 1990), and *Homo Academicus* (Cambridge: Polity Press, 1988).

4. See P. Bourdieu, *Choses dites* (Paris: Minuit, 1987), 19, 40, hereafter *CD.* "Fieldwork in Philosophy" originally appeared (in French) in *Choses dites,* and "The Scholastic Point of View," originally written in French, can be found in *Practical Reason.* The Austinian phrases for these titles come from J. L. Austin's "A Plea for Excuses" and *Sense and Sensibilia. Choses dites* appears in English translation as *In Other Words: Essays towards a Reflexive Sociology* (Stanford: Stanford University Press, 1990), hereafter *IOW.* The quotations cited above are on pages 9, 28 of the English version, though the translation is slightly different.

5. The blurb on the back cover of the English version is very different and makes no mention of these philosophers, or indeed of any philosophers.

6. For Bourdieu's recognition of this strategy of importation, see his essay "The Social Conditions of the International Circulation of Ideas," in Richard Shusterman (ed.), *Bourdieu: A Critical Reader* (Oxford: Blackwell, 1999), 220–28. For a detailed case-study analysis of this phenomenon with respect to aesthetics, see Richard Shusterman, "Aesthetics between Nationalism and Internationalism," *Journal of Aesthetics and Art Criticism* 51 (1993): 157–67.

7. Doubts can be raised, however, as to whether this reputation is still deserved or whether (as Hilary Putnam has recently complained) analytic philosophy has become exceedingly metaphysical.

8. J. L. Austin, *How to Do Things with Words* (Oxford: Oxford University Press, 1970), 127, 138.

9. See Ludwig Wittgenstein, *Philosophical Investigations* (Oxford: Basil Blackwell, 1968), para. 241; part II, 226, hereafter *PI*, and *The Blue and Brown Books* (New York: Harper, 1958), 24.

10. Bourdieu's important contributions to aesthetics include *Distinction: A Social Critique of the Judgement of Taste* (Cambridge, Mass.: Harvard University Press, 1984); *Photography: A Middle-Brow Art* (Cambridge: Polity Press, 1990); *The Love of Art* (Stanford: Stanford University Press, 1990); *The Rules of Art: Genesis and Structure of the Literary Field* (Cambridge: Polity Press, 1996), hereafter *RA.*

11. Ludwig Wittgenstein, *Lectures and Conversations on Aesthetics, Psychology, and Religious Belief* (Oxford: Blackwell, 1970), 2, 8.

12. Austin, *How to Do Things with Words,* 147.

13. Dewey's account of the sociopolitical role of habit is sometimes very close to Bourdieu's notion of habitus. Dewey, for instance, describes habit as society's "most precious conservative influence," the precipitate of "objective conditions" of social relations and hierarchies "perpetuating, willy-nilly, [society's] hold and power." "The dependence of habit-forming upon those habits of a group which constitute customs and institutions is a natural consequence of the helplessness of infancy. . . . Habit does not preclude the use of thought, but it determines the channels within which it operates." John Dewey, *The Public and Its Problems,* in John Dewey, *The Later Works,* vol. 4 (Carbondale: Southern Illinois University Press, 1988), 335–36.

14. John Dewey, *Experience and Nature* (Carbondale: Southern Illinois University Press, 1984), 28, 34.

15. Dewey, *The Public and Its Problems,* 339–49.

16. On Dewey's political engagements, see Robert Westbrook, *John Dewey and American Democracy* (Ithaca: Cornell University Press, 1991). Some of Bourdieu's activist political writings can be found in English translation in his *Acts of Resistance: Against the Tyranny of the Market* (New York: New Press, 1999). For a review of his activist efforts, see my "France's *Philosophe Impolitique,*" *The Nation,* 3 May 1999, 25–28.

17. See John Dewey, *Art as Experience* (Carbondale: Southern Illinois University Press, 1987).

18. See Pierre Bourdieu and Loic Wacquant, *An Invitation to Reflexive Sociology* (Chicago: University of Chicago Press, 1992), 122.

19. For more details on these issues, see Richard Shusterman, *Pragmatist Aes-*

thetics: Living Beauty, Rethinking Art (Oxford: Blackwell, 1992; 2d ed. New York: Rowman and Littlefield, 2000), 21–25.

20. They appear quite pointedly in my defense of popular art in *Pragmatist Aesthetics*, in Bourdieu's condemnation of the radical chic of such intellectual efforts to appreciate popular culture, and in my response in "Légitimer la légitimation de l'art populaire," *Politix* 24 (1993): 153–57. See also my "Rap Remix: Pragmatism, Postmodernism, and Other Issues in the House," *Critical Inquiry* 22 (1995): 150–58.

21. These analyses certainly made Dewey a favorite with the great French social theorists whom Bourdieu most admires—Durkheim and Mauss. Dewey, claimed Mauss, is the American philosopher "whom Durkheim put ahead of all the others, and it is a great regret of mine not to have been able to attend the last great philosophy lecture of Durkheim, dedicated in great part to Professor Dewey." Mauss also praises Dewey as the philosopher "who comes closest to the sociologists." These remarks come from a discussion of Dewey's "Three Independent Factors in Morals," reprinted in *The Later Works of John Dewey, 1929–1930*, vol. 5 (Carbondale: Southern Illinois University Press, 1984), 500–501.

22. J. L. Austin, *Sense and Sensibilia* (Oxford: Oxford University Press, 1962), 5; "A Plea for Excuses," in *Philosophical Papers* (Oxford: Oxford University Press, 1970), 185.

23. For an account of Wittgenstein's view of the philosophical life as personal ethical transformation, see Richard Shusterman, *Practicing Philosophy: Pragmatism and the Philosophical Life* (New York: Routledge, 1997), chap. 1; and Richard Eldridge, *On Leading a Human Life: Wittgenstein, Intentionality, and Romanticism* (Chicago: University of Chicago Press, 1997), chap. 4.

24. See, for instance, his monumental and deeply moving *La misère du monde* (Paris: Seuil, 1993).

25. Bourdieu and Wacquant, *An Invitation to Reflexive Sociology*, 84.

26. Bourdieu stresses his " 'pragmatic' view" in treating culture, "especially the culture *par excellence*, namely philosophy" (*CD*, 41; *IOW*, 29).

27. For more on this point, see Richard Shusterman, *T. S. Eliot and the Philosophy of Criticism* (New York: Columbia University Press, 1988). For Bourdieu's critique of "radical chic," see *Raisons pratiques*, 232–33 (*Practical Reason*, 136–37), and *An Invitation to Reflexive Sociology*, 84.

28. For a good example of Bourdieu's treatment of embodiment and nonreflective understanding, see Pierre Bourdieu, "Belief and the Body," in *The Logic of Practice* (Cambridge: Polity Press, 1990).

29. I examine some of these issues of history, use, and abuse in my "Somatic Experience: Foundation or Reconstruction," *Practicing Philosophy*, chap. 6; and "The End of Aesthetic Experience," in *Performing Live: Aesthetic Alternatives for the Ends of Art* (Ithaca: Cornell University Press, 2000), chap. 1.

30. Bourdieu, *Distinction*, 68–74.

31. Pierre Bourdieu, "The Historical Genesis of a Pure Aesthetic," in Richard Shusterman (ed.), *Analytic Aesthetics* (Oxford: Blackwell, 1989), 148, 150 (cf. *RA*, 288–89).

32. Wittgenstein, *Lectures and Conversations*, 13, 17, 21.

33. Ibid., 19.

Chapter 13. Art as Dramatization

1. See Henry James, preface to "The Altar of the Dead," in *The Art of the Novel* (New York: Scribner's, 1934), 265. In this same preface, the variation "Dramatise it, dramatise it" is also thrice invoked, 249, 251, 260.

2. These quotes from Henry James are taken from the introductory essays of Leon Edel, in his edition of *The Complete Plays of Henry James* (New York: Oxford University Press, 1990), 10, 62, 64.

3. Friedrich Nietzsche, "Richard Wagner in Bayreuth," *Unzeitgemäße Betrachtungen IV*, in G. Colli and M. Montinari (eds.), *Friedrich Nietzsche: Sämtliche Werke* (Berlin: De Gruyter, 1999), Band 1, 472, trans. R. J. Hollingdale as *Untimely Meditations* (Cambridge: Cambridge University Press, 1994), sec. 8, p. 227.

4. T. S. Eliot, *The Use of Poetry and the Use of Criticism* (London: Faber, 1964), 152–53. See also his "Poetry and Drama," in *On Poetry and Poets* (London: Faber, 1957), 72–88.

5. *The Complete Plays of Henry James*, 34–35.

6. Morris Weitz's famous critique of the possibility of "true and real definitions" of art was probably what gave the term "real definition" its centrality in aesthetic debate and what led to the subsequent tendency for aestheticians to use the terms more or less interchangeably. See his "The Role of Theory in Aesthetics," *Journal of Aesthetics and Art Criticism* 15 (1956): 27–35; citation on 35. Weitz elsewhere explains more clearly what he means by "real definition," contrasting it with "contextual definition" and ordinary nominal definitions. Real definitions are distinguished from contextual definitions in that the former are concerned with real things, that is, "with complexes which are non-linguistic, i.e., independent of the way in which we use language, whereas contextual definition is concerned wholly with linguistic complexes." Only real definitions can be empirically true or false, while contextual definitions are analytic, a priori, and neither true nor false. Both are contrasted with ordinary nominal definitions in not being arbitrary. See Morris Weitz, "Analysis and the Unity of Russell's Philosophy," in P. A. Schilpp (ed.), *The Philosophy of Bertrand Russell* (La Salle, Ill.: Open Court Press, 1946), 57–121; citation on 120. To the extent that current definitions of art are aimed at capturing our linguistic uses of the term "art" or at defining our linguistically, historically shaped concept of art without presuming that art is also some independent thing or complex beyond our linguistic practices that we are defining, then one might argue that such definitions would not be "real" in the strict, technical sense of Weitz's term, though they still could be true or valid in some other sense.

7. Robert Stecker, *Artworks: Definition, Meaning, Value* (University Park: Pennsylvania State University Press, 1997), 14. Stecker nonetheless firmly advocates the need for such a philosophical definition of art, unilluminating as mere extensional coverage may be. Though he notes my objection that such definitions are not usefully informative (17), he does not really respond to the arguments that motivate this charge. In his attempt to escape the difficulties that plague functionalist, historical, and institutional definitions, Stecker offers a multifaceted disjunctive definition "historical functionalism, or the four-factor theory" that combines elements of the three more basic definitional approaches. One theorist who sensibly prefers to set his sights not on a real definition of art but on a the-

ory or "reliable method for identifying artworks" is Noël Carroll, who offers a historical theory in terms of "identifying narrative." See Noël Carroll, "Identifying Art," in Robert Yanal (ed.), *Institutions of Art* (University Park: Pennsylvania State University Press, 1994), 3–38. A good overview of the major strategies in analytic philosophy's attempts at defining art can be found in Stephen Davies, *Definitions of Art* (Ithaca: Cornell University Press, 1991).

The goal of defining the concept of art once and for all by a single set of necessary and sufficient conditions that neatly and informatively divide all actual and possible objects into those that are art and those that are not art seems problematic to me for many reasons: (1) the multiple meanings and uses of the term "art"; (2) art's open, creative nature; (3) its essentially valued, hence essentially contested, character; (4) the changing conceptions of art over history; and (5) the very different and changing ways that art is deeply connected yet also distinguished from other practices in the different societies in which it is situated. But I also question the explanatory power and the conservative, narrowing effect of such extension-coverage definitions, which I call "wrapper theories of art." For more details, see my *Pragmatist Aesthetics: Living Beauty, Rethinking Art* (Oxford: Blackwell, 1992; 2d ed. New York: Rowman and Littlefield, 2000), 38–45, and chap. 10 of this book.

8. Shusterman, *Pragmatist Aesthetics*, 34–35, 46–61.

9. Morris Weitz, "The Role of Theory in Aesthetics," 35.

10. I am, of course, aware that the terms "naturalism" and "historicism" have many different meanings in aesthetic theory, some of which are much more specific than the general meanings they bear in this chapter.

11. See Aristotle, *Poetics*, 1448b, in Richard McKeon (ed.), *The Basic Works of Aristotle* (New York: Random House, 1968), 1457–58: "It is clear that the general origin of poetry was due to two causes, each of them part of human nature. . . . Imitation, then being natural to us—as also the sense of harmony and rhythm, the metres being obviously species of rhythm—it was through their original aptitude, and by a series of improvements for the most part gradual on their first efforts, that they created poetry out of their improvisations."

12. For more detailed argument of these themes, see Richard Shusterman, *Pragmatist Aesthetics*, and *Performing Live: Aesthetic Alternatives for the Ends of Art* (Ithaca: Cornell University Press, 2000).

13. Friedrich Nietzsche, *Die Geburt der Tragödie*, in *Friedrich Nietzsche, Sämtliche Werke*, Band 1, 12, 28, 35, 61, hereafter *DG*; translated by Francis Golffing as *The Birth of Tragedy*, in *The Birth of Tragedy and the Genealogy of Morals* (New York: Doubleday, 1956), 4, 22, 29, 55, hereafter *BT*. I give page references to both editions, but sometimes use my own translation.

14. See John Dewey, *Experience and Nature* (Carbondale: Southern Illinois University Press, 1981), 269; and especially, *Art as Experience* (Carbondale: Southern Illinois University Press, [1934] 1987), hereafter *AE*.

15. Ralph Waldo Emerson, "Nature," in R. Poirier (ed.), *Ralph Waldo Emerson* (New York: Oxford University Press, 1990), 12. Further quotes from Emerson in this chapter are taken from other texts in this collection of his essays and poems, hereafter *RWE*.

16. See, for instance, the work of Paul O. Kristeller, "The Modern System of the

Arts," *Journal of the History of Ideas* 12 and 13 (1951, 1952), which is very frequently cited by analytic aestheticians.

17. See Pierre Bourdieu, "The Genesis of the Pure Aesthetic," in Richard Shusterman (ed.), *Analytic Aesthetics* (Oxford: Blackwell, 1989), 148–49.

18. Another reason to resist choosing simply one of these dualist alternatives relates to a general principle of pragmatic pluralism that I call "the inclusive disjunctive stance." The familiar logical disjunction "either *p* or *q*" is here understood pluralistically to include either one or both alternatives (as it does in standard propositional logic and in the common occasions of everyday life where one can choose more than one thing, e.g., either wine or water or both). This is in contrast to the exclusive sense of "either/or" where one alternative strictly excludes the other, as indeed it sometimes does in life as well as logic. With pragmatism's inclusive stance, we should presume that alternative theories or values can somehow be reconciled until we are given good reasons why they are mutually exclusive. That seems the best way to keep the path of inquiry open and to maximize our goods. I defend this principle in the introduction to the second edition of *Pragmatist Aesthetics*, x–xiii.

19. Friedrich Nietzsche, *Ecce Homo*, in *Friedrich Nietzsche: Sämtliche Werke*, Band 6, 288–89, 326; or in R. J. Hollingdale's English translation, *Ecce Homo* (London: Penguin, 1992), 30.

20. *Chambers 21st Century Dictionary* (Cambridge: Chambers, 1996). This second sense of dramatize is very similar to the dominant contemporary meaning of the French verb "dramatiser" as emphasizing or exaggerating the importance, gravity, or drama of an event. This meaning is seen as an extension of an older French usage of the term that conveys the idea of putting something into a form proper to drama, e.g., dramatizing a story. This more limited and technical meaning parallels the first sense of "dramatize" already noted in English and German. The French verb "dramatiser" was apparently first introduced in 1801 with respect to Shakespeare. For more details, see *Petit Larousse* (Paris: Larousse, 1959); *Dictionnaire historique de la langue française*, vol. 1 (Paris: Robert, 1992); and *Trésor de la langue française*, vol. 7 (Paris: CNRS, 1979).

21. This Hebrew stem clearly seems related to the Greek stem for "dwelling," from which "*skene*" and "scene" are derived.

22. Aristotle, *Poetics*, chap. 7, 1450b.

23. William James, *Principles of Psychology* (Cambridge: Harvard University Press, [1890] 1983), 924.

24. The quotes are from Shakespeare's *As You Like It*, II.vii.139, and *Macbeth*, V.v.23.

25. J. L. Austin, *Sense and Sensibilia* (Oxford: Oxford University Press, 1964), 70.

26. The logic of this paradox might help defend a concept far more despised than art for its frivolous diversion from reality—I refer to the term "entertainment," which past philosophers have sometimes used to denigrate the dramatizations of opera but which now chiefly serves to condemn today's more popular artistic forms, such as movies, television dramas, and the like. Etymology reveals that the very meaning of "entertainment" (or the German equivalent, *Unterhaltung*) concerns the maintenance of life. If entertainment's much denounced di-

versions from real life serve, in fact, as necessary, valuable detours that enhance life's journey and help recharge the batteries of our human vehicle, then they may also (partly through these functions) allow us sometimes to perceive the world far more fully and deeply. On the basic sensorimotor level of perception, if we release from the stress of chronic voluntary muscular contractions, the increased muscle relaxation will allow for heightened sensitivity to stimuli and therefore provide for sharper perception and deeper learning. This particular line of argument calls for more detailed elaboration and relates to the field of somaesthetics that I outline in *Performing Live: Aesthetic Alternatives for the Ends of Art* (Ithaca: Cornell University Press, 2000), chaps. 7 and 8.

Index